FORMS OF ENCHANTMENT

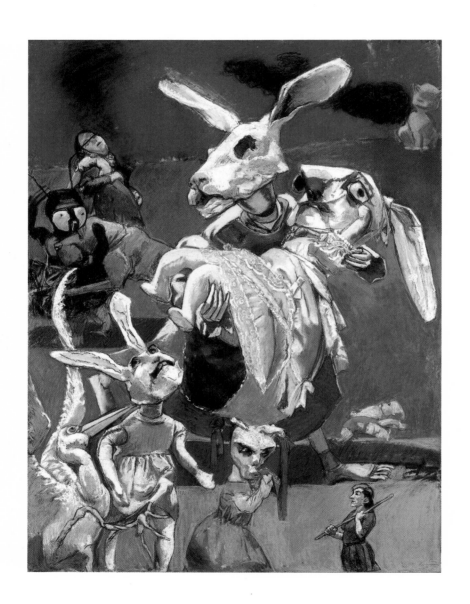

MARINA WARNER

FORMS OF ENCHANTMENT

Writings on Art & Artists

 Thames & Hudson

To Beatrice, with love & gratitude

Endpapers: Al and Al, *Studio Beehive*, 2013

Title page: *Curiosity*, 1709, from Cesare Ripa, *Iconologia*

Frontispiece: Paula Rego, *War,* 2003

Forms of Enchantment: Writings on Art & Artists
© 2018 Thames & Hudson Ltd, London

Text © 2018 Marina Warner

First published in 2018 in the United States of America by Thames & Hudson Inc., 500 Fifth Avenue, New York, New York 10110

www.thamesandhudsonusa.com

Library of Congress Control Number 2018932299
ISBN 978-0-500-02146-0

Printed in China by RR Donnelley

CONTENTS

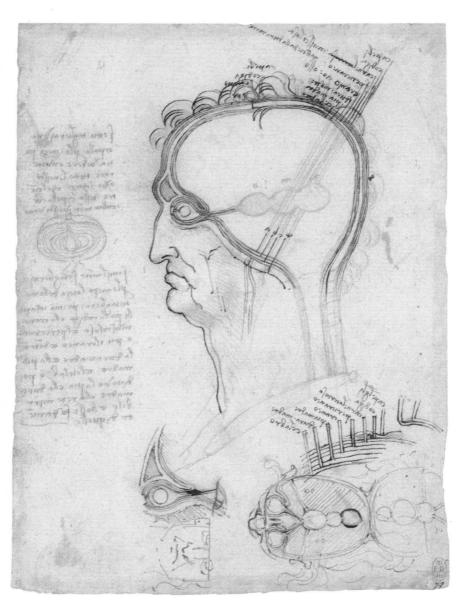

Leonardo da Vinci, *Sections of the Human Head and Eye*
1490–93

PREFACE

A drawing Leonardo made of a section through the skull rejects the classical and medieval models of the faculties which allotted different sections of the brain to intellect and fantasy; instead, the artist connected empirical vision from the eye to reasoned judgment and imaginative recreation, along a continuum leading to memory.[1] He was taking his cue from Dante, whose visions are marked by exceptional graphic and architectural vividness. Both the medieval polymath and his Renaissance counterpart are highly original in refusing to separate the mental processes of reason and imagination, in realizing that the two work together according to the principle Borges calls 'reasoned imagination'.[2]

Their intuitions have been corroborated by recent findings in cognitive psychology: the same synapses of the brain fire whether you are remembering something that has taken place in your own experience, recalling a scene that you once read or saw in a film, or dreaming up an event that has never taken place. In relation to art and artists, this research is especially significant. This new understanding of consciousness confirms a defining dynamic of creativity itself: that the combinatory imagination at work does not engage separate faculties, but demands similar activities from the brain – visualizing, modelling, patterning, linking and building concepts and images. When making something, memories, empirical observation and make-believe continually overlap and interact.

My interest in art and artists arises from a lifelong commitment to understanding the imagination and the part it plays in acquiring knowledge and understanding, for good and ill. Artists have long occupied and planted this territory – indeed, their involvement with the unseen and the unverifiable goes back to images of deities and monsters on cylinder seals and Greek pots, continues strongly with the Abrahamic religions and has reinvigorated contemporary image-making as well as stirring up fresh outbreaks of image-breaking.

My first taste of art as a marvellous and different realm was at Kettle's Yard in Cambridge, in the early sixties. H. S. 'Jim' Ede was still alive when I was growing up in a village five miles away, and he was legendary for his open house, his collection of artists including Henri Gaudier-Brzeska, Ben Nicholson and Barbara Hepworth and his vision of living with art, in the low-lying cottages he had turned into an intimate, personal museum. During my gap year (not yet known as such), I was enrolled in the *Cours des étrangers* at the Sorbonne in Paris, a city where contemporary art was far more alive and sought-after than in London in those days. The Brancusi studio was still at the address where the sculptor had worked and was inspiringly rich in associations and dust; at the Atelier 17, S. W. 'Bill' Hayter was teaching a stream of young artists from all over the world the original processes he had developed for printing in layers of colour; the city was packed with galleries, several of them specializing in various avant-gardes. Artists – many from Greece and Latin America – were bringing a different language of light and movement to contemporary sculpture (beside Calder's mobiles, there were Takis's oscillating wands). These months in Paris, before I went up to Oxford in 1964, began my apprenticeship in modern and contemporary art. I had wide eyes and was finding out how fabulously, utterly involving it could be to spend time looking at things people made.

Several of the writers I most enjoy have engaged passionately with art and artists. Some were professional critics (Denis Diderot, Charles Baudelaire, John Ashbery), while for Marcel Proust, Edith Wharton, Wallace Stevens, Gertrude Stein, Czeslaw Milosz – I could go on – writing about art occupied their word-worlds more than has perhaps been acknowledged. The reasons for this oversight might include suspicions that a literary approach subordinates the artwork in question to another discipline and consequently denatures it, and also that writing about art is not proper criticism, but an accompaniment, as a pianist plays for a singer.

I don't want to make high claims for my own attempts, but I do wish to argue for writerly ways of exploring art, as developed in literary tradition. When I write about artworks and the artists who made them, I try to unite my imagination with theirs, in an act of absorption that corresponds to the intrinsic pleasure of looking at art. Since the Greeks,

ekphrasis has offered a way of capturing visual experience in words – but while I believe in close looking, description is not enough. I like to explore above all the range of allusions to stories and symbols; not to pin down the artwork as if it were a thesis or a piece of code, but to touch the springs of the work's power. Art-writing at its most useful should share in the dynamism, fluidity and passions of the objects of its inquiry.

The inner lives of women have also fascinated me, and the book includes essays on several key figures in contemporary art and performance. The first artist to ask me to write for a catalogue was Helen Chadwick, for her show at London's Institute of Contemporary Arts (ICA) in 1986. The task involved many wonderful conversations at her studio, in our kitchens, at art galleries and science museums, listening to her flow of surprising, inspired ideas and rummaging through archives of her source material. I was used to being on my own, writing, and I found I really enjoyed the experience of communing with an artist. The contact with Helen, with her originality and verve and daring, was exhilarating. When she died in 1996, I felt her loss very sharply. Hers was a rare creative force.[3]

The Greeks' idea of ekphrasis stressed thick description and dramatic evocation – Botticelli was able to recreate a painting, *The Calumny of Apelles*, from Pliny's detailed word-picture of the lost work from antiquity. However, ekphrasis is not only the transposition of an image into words. It presumes that a work of art is active: Homer's description of the shield of Achilles in the *Iliad* reads like an epic film, with the figures in turmoil, the action filled with sound and fury – and pastoral moments of quietness, too. The work of art, the Greeks thought, should possess *enargeia,* or shining vitality, the enhanced vividness which, when present in a work of art, magnifies it not in size but in impact, the quality that makes your eyes widen as the image seems to fasten on your gaze. The Greeks admired naturalistic illusion, and identified *enargeia* with lifelikeness (the bunch of grapes that deceived birds; the curtain painted by Parrhasius that his rival, Zeuxis, tried to draw aside). But I recognize it as the quality of presence that fills one made thing more than another, and charges it with the power to command attention and radiate significance.

I share the premise of ekphrasis: that a representation is not an inert, passive object but is kinetic in its effects, even if it remains still as

a thing in the world. In an age when the image of a work of art circulates globally, the original object often transmogrified by mindboggling amounts of money (think of Damien Hirst, Ai Weiwei – and they are not alone), art is also carrying and circulating ideas and meanings. These have another kind of value, which is related to the monetary amounts paid for the artefact itself but arises at an angle to it, often athwart it (Basquiat's graffiti comes to mind). It is at this point that questions arise about interpretation and authority, and about the interactions between makers and receivers.

Many of the artists who interest me belong to the growing numbers consciously engaging with ethics and politics. This has been a strong, surprising dynamic among contemporaries since the Seventies at least, and it's a paradox that this heightened, polemical expectation of artists – and of the contexts in which they move (museums, art fairs, the public spaces of street and atrium) – seems to track the surging prices they can command in the contemporary art market. I believe that this contradiction echoes a manoeuvre adopted in the Middle Ages and the Renaissance, when prelates and princes vied with one another to spend fortunes on chantries where monks would live in poverty and pray on their behalf, to save them from the consequences of their plunder and power. These oligarchs of the past would sometimes even install a hermit or a prophet close by them, in their palaces, to upbraid them regularly.

The passion for art today and the role of artists in global networks of culture recalls this function of propitiation and expiation. In a non-religious context, the activity of the artist, especially when they dissent, transgress and go to novel, moral extremes of sensation, seems to provide a guarantee of the liberty of individual imagination for us all; even when filthy lucre accrues as a result (according to the unstoppable process of co-option that befall vanguards) the makers of art and aesthetic values strike out for a yet more marginal shore. Ideas about art's purposes are constantly struggling to flee the status of commodity, to reinvigorate art's integrity. 'Organic' or 'outsider' artists, for example, who live and work outside the system, hold out this hope even when their prices begin to soar: they did not – do not – do it for the money.[4] There has been a flurry of exhibitions showing rising appreciation for this artistic equivalent of

Gramsci's organic intellectual. Massimiliano Gioni's 'The Encyclopedic Palace' at the 2013 Venice Biennale, widely praised as the best Biennale show for years, took its title from a work by the 20th-century artist Marino Auriti, an Italian emigré and mechanic whose dates of birth and death are unknown. A reconstruction of Auriti's intricate model of a city encompassing all human discoveries occupied the show's entrance in the Arsenale. It led to further imagined systems of beauty and truth, created by autodidacts and outliers who have constructed detailed accounts of reality according to idiosyncratic personal obsessions and epiphanies. The works share certain aesthetic features: haptic handiwork, scavenged and hoarded materials infused with haunted vitality and, above all, repetition, seriality and dense, often calligraphic patterning across the plane, plaiting through dimensions in an effort to totalize and confront every possible eventuality. As curators, collectors and spectators rush to exhibit – to possess – the crazy minds of outliers, there are unfortunately many reasons for disquiet about this dynamic. The art market is infinitely expansive, and there may be no art that can be safe from its ardent and loving embrace.

To understand this quest for signification and the need felt by audiences to belong to the process, the surrounding conditions need attending to. Appraisals of art and artists today need to take account of the symbolic languages artists are adopting and, sometimes, inaugurating in the pursuit of reconfigured meaning. I think the perception of the anthropologist Alfred Gell is perfectly judged, when in his book *Art and Agency* (1998), he argues that the methods his discipline applies to understanding the meaning of art and aesthetics in a culture that is not its own should be extended to explore contemporary practice at home: 'I cannot tell,' he writes, 'between religious and aesthetic exaltation; art-lovers, it seems to me, actually do worship images in most of the relevant senses, and explain away their *de facto* idolatry by rationalizing it as aesthetic awe. Thus, to write about art at all is in fact to write about either religion, or the substitute for religion which those who have abandoned the outward forms of received religions content themselves with.'[5] Grayson Perry's exuberant show, 'The Tomb of the Unknown Craftsman' (British Museum, 2011), bore out Gell's insights into the resemblance between other cultures' sacred art and our own

more usually profane creations. Perry placed his own works, including his talismanic teddy bear, alongside cult objects from societies the world over; the show's organizing principle recognized how anonymous, holy artefacts of the past can inform the reception and aesthetics of artefacts signed by individual artists now, who do not aim openly at accessing divine grace or protection. Mark Rothko's abstract paintings in the chapel in Houston do not represent any such higher power; although it is called a chapel, it remains secular and non-denominational, and expects no profession of faith in its visitors. Yet the atmosphere is highly charged with numinous power, as I, alongside many visitors, have felt – an effect not unconnected to his work being targeted by an iconoclast (see p. 195).

Galleries, museums and art events in general offer their publics the promise of assembly, a congregation and a mass pilgrimage; they then make intense temporal demands on them, if only in the form of communal queuing, shuffling and peering, plugged into a shared acoustiguide from which issues an all-knowing, disembodied voice of authority. The philosopher Eugenio Trías has observed that, in the age of the mass media, symbolic events involving movement and assembly are taking precedence over static symbolic images.[6] At art fairs, echoes of the wild trading and feasting at carnival time and other holidays from ancient Rome onwards sound loudly in the throng and the speed, the noise and the competitive displays. Participating in the live event is central, and the body of the artist matters too: even if the performance is filmed, the artwork guarantees that she was there, he was there, doing it.

The individual artists discussed here think in images about images, and their thoughts arise in conversation with controversies and opinions, often across great passages of time. Paul Valéry wrote, 'A symbol is something of a time machine. It's an inconceivable compression of the time taken by operations of the spirit....'[7] A symbol is always something compacted of several elements, crystallized; however the time in which symbolic acts or objects are experienced is not compressed as to duration, but only regarding its intensity. It can be played out over long stretches of time, and such prolongation enriches the qualities of a particular work or artist's oeuvre. I've therefore refused to cleave artists from their predecessors, as if Paula Rego had never encountered the work of Henry Fuseli, or Helen

Chadwick wasn't testing the ethics of the latest reproductive medicine, or Kiki Smith did not roam happily night and day in her huge library.

In my endeavour to understand what art is and what it is for, I've also taken my cue from the philosopher Paul Ricoeur: 'the symbol does not conceal any hidden teaching,' he writes, 'that only needs to be unmasked for the images in which it is clothed to become useless'.[8] He proposes instead thinking of the symbol as a gift to reflection: 'what it gives is an occasion for thought, something to think about', and he then traces a dialectical movement to and fro between interpretation and reverie, between analysis and creativity, between deconstruction and enigma. He sees thought as the voyager in these spaces. He calls for an admission that language cannot attain the status of pure *logos*, but is inevitably compacted with *mythos*, grounded in 'presuppositions'. His hope is clear: 'we seek to go beyond criticism by means of criticism, by a criticism that is no longer reductive but restorative'.[9]

Ricoeur is writing about symbolic language, in the conclusion to his book about the problem of evil, and he is trying to provide his readers with a way of thinking about human beings' propensity to allow, as well as perpetrate, appalling evils. Symbols matter in this process, and have been mobilized all too effectively in modern times for appalling and vicious ends. Ricoeur's approach – his hermeneutic phenomenology – has helped my thinking and writing about art. His powerful insights into the presence of myth, the necessity of interpretation and analysis and of a countervailing movement of reconstruction and repair, illuminate for me the best potential of artists and the resonances of artwork today.

But – and this is a crucial objection – I realized long ago that history must be admitted into the equation in ways that, in fact, prevent it from acting as an equation at all since its elements are continually subject to change. Symbols are not fixed or eternal. Historical vicissitudes continually work on them and alter their meanings from one time period to another and from one cultural setting to another; they are never fixed, nor are their referents somehow permanently attached or intrinsic. Significance is not an independent property of the sign, but is continually made and remade by its beholders and users: the cross enters history as the sign of addition only after the Arabs introduced it to mathematics; the Hindu

symbol of eternity, the swastika, has been polluted beyond retrieval by the Third Reich's appropriation; the banana was the fruit of the Tree of Paradise for the 17th century and became a comic obscenity, then a racist slur.[10] The consequence is that there is no stable set of meanings lying behind a visual image, awaiting discovery and decipherment. Every artefact can be placed in its historical context (the task of an art historian) and an attempt can be made to elucidate its meanings for its current receivers (the crucial role of the art critic). But this will not be an end to the work of interpretation.

I wrote the earliest pieces in this book, on Hans Baldung Grien, Paula Rego, as well as on Chadwick, in the 1980s; the most recent, on Julie Mehretu, Jumana Emil Abboud and Christian Thompson, came out in 2017. Many appeared as essays in artist's books and exhibition catalogues, others as articles and reviews in magazines and papers; some were given as lectures. The selection does not follow a chronological order but is divided into four themed sections. Part One, Playing in the Dark, explores the correspondences between make-believe and making art, between the child's projection of the world through toys and the artist's modelling of experience. Fairy tales, with their weird, cruel plots and characters, and myths, with their excess of incest, rape and murder, have been my long-time concerns; there has been a rise in interest in these ancient products of the human mind, and many artists have undertaken journeys into dark places.

Part Two, Bodies of Sense, takes up explorations of the body chiefly but not only by women artists, who have wrought profound transformations on the art scene itself and on the language artists use, materially and thematically. Many of them contend the principle encapsulated by Baudelaire's remark, that 'woman is the being who projects the greatest light and the greatest shadow into our dreams'.[11] This ironic definition became a notorious Surrealist watchword, after it was enshrined by André Breton in his Surrealist dictionary. The deeply rooted concept of the eternal feminine, of the female body as a vehicle packed with the dangers of beauty, seduction and sin (*kalon kakon*, the beautiful evil, writes Hesiod about Pandora), has loomed over the history of art, and women artists, emerging so powerfully in contemporary art, have done battle with

this monster. Infusing their work with personal experience, subjective feeling and their own embodied knowledge, three generations of post-war women artists have staged a fierce counter-insurgency against this fantasy and wrestled passionately with its multiple, ambiguous meanings.

In Part Three, Spectral Technologies, the focus changes to the potential of new media, since the coming of photography and the cinema, to explore the limits of bodily vision and make visible phenomena otherwise unavailable to the senses. It is a paradox that modern science has spurred a terrific rise in apparitions and phantoms; that the discoveries of kinetic machines and now digital technology have extended art's capacity to represent the innermost intimations of the imagination and to make a leap towards realizing visions of the future.

Part Four takes its title, Iconoclashes, from the remarkable, hugely ambitious exhibition put on by Bruno Latour at the ZKM Center for Art and Media, Karlsruhe, in 2002. His argument was prescient; since then, the wars over images have spread. *Forms of Enchantment* takes as its premise the idea that images have power and can impinge on the world as active agents; Part Four explores how artists consciously catalyse that power.

In *The Redress of Poetry*, Seamus Heaney reflects that we go to poetry to be forwarded within ourselves.[12] The same applies to visual art. Plato warns, in the *Charmides*, that *gnothi auton* ('know thyself') is not enough if one is simply gazing at oneself in the mirror; such knowledge can only be gained in the complexity of social interactions. To be forwarded through art requires engagement with the 'others' evoked by artworks: with their makers and the circumstances of their making; their subjects and the elements from which they are made or which they represent. As Ricoeur has written, 'oneself becomes another'.[13] We can be enlarged through such interchanges, and artists today consciously take up this task, extending art's ethical as well as emotional terrain.

1. PLAYING IN THE DARK

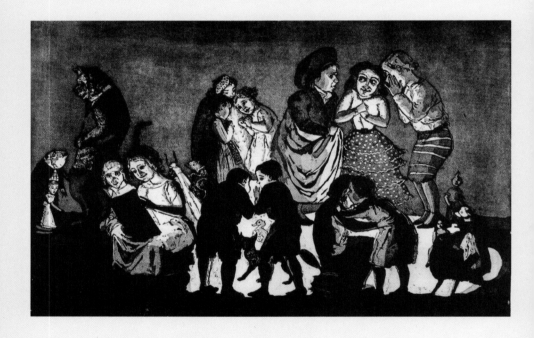

Paula Rego, *Secrets and Stories*, 1989

But all the story of the night told over,
And all their minds transfigured so together,
More witnesseth than fancy's images,
And grows to something of great constancy[1]
WILLIAM SHAKESPEARE, A MIDSUMMER NIGHT'S DREAM

Detractors often scorn art as child's play, and it is true that many artists play – in various senses of the word. Of course, they acquire skills and improvise with materials and methods far beyond children's reach; but many also choose to move to those inner fiery waves in the brain that generate and combine images and light up games of make-believe. Ancient and supposedly innocent childhood activities, from lullabies to fairy tales, are brimful with nightmares. As Theseus comments in *A Midsummer Night's Dream,* 'such tricks hath strong imagination.../how easy is a bush supposed a bear' (5.1.19–23). We are partly the heirs of the Romantics, who saw the child's state of mind as visionary and unfettered and longed to regain those powers of fantasy – as the hallucinatory paintings of the artist Henry Fuseli reveal (he is rumoured to have eaten strong meats at night to stimulate his dreams).

In modern times, the importance of imagination has received support from a less fevered angle. The paediatrician D. W. Winnicott, in his pioneering book *Playing and Reality* (1971), argued for the role of imagination in growing up sane and happy – or at least well-enough happy. He writes of play as an essential form of life practice, crucial to the developing child. In games of make-believe and let's pretend, with dolls or toy soldiers, castles and cars, animals that really exist as well as dragons and goblins, a child at play is building ways of orienting himself or herself. 'Playing is reality,' Winnicott declares.[2]

Artists do not usually acquiesce in putting away childish things. They peer into the dark and make images about what they find there: memory and imagination acting in concert. Artists are like birds sent out from the Ark to assess the state of the rising flood waters, and they return with messages about the continuing danger – or, sometimes, hope.

PAULA REGO

Giving Fear a Face

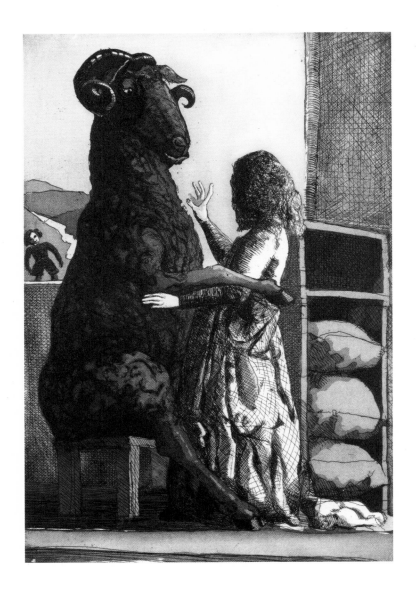

Baa, Baa, Black Sheep
1989

Paula Rego's first solo exhibition opened at London's Serpentine Gallery in 1988, when Alister Warman was the director. He was a consistent advocate of women artists – in those days, his interest and commitment were unusual. Rego was showing some small, freely painted drawings of scenes involving monkeys and dogs – the animals weren't entirely animal, nor were the children entirely childlike; but they all seemed to be at play. Similar, larger paintings, unfurling over the walls, were seething with vigorous gaggles of little girls, creatures and adults in conjunctions which implied that the artist was seeing through the appearance of things and the experience of living in the world, and moving into another zone of feeling and knowledge.

I first met Paula there – she was smiling and wearing a wonderful dress, full and richly coloured. Both the smile and the clothes are entirely typical. Her smile is like her work: it is exuberant and infectious, open and warm, but mysterious, too, and sometimes unsettling. The dress, the brilliance, the lavishness goes with the art as well; Paula Rego has the energy, the wildness and the discipline of a fierce Olympic athlete, and she transmutes all this furious power into a racing imagination that now, after several decades of inspired images, has swept into unexamined corners of experience, leaving thrilling and sometimes terrifying twisters of insight on the canvas.

As a child, she used to draw on the floor. She maintains that making images is a form of play in the strongest sense of the activity, as Winnicott conveys in *Playing and Reality*. In Paula's art, reality appears through her play on what she sees, what she imagines, what she concocts. Her studio is a theatre, where models take up roles, where masks, dummies, costumes, sets, props – mysterious, eerie, often perturbing – lie heaped around her; it is a scene of intensive play where the worlds that lie inside her are pressed out to take form and become manifest externally. Through assiduous, concentrated, prolonged acts of drawing and painting, they materialize on paper or canvas or sometimes in three-dimensional figures. The artist has commented that she 'paints to give fear a face', and her work looks deeply into the depths; but if she is giving fear a face she does so fearlessly, and the results have a raw honesty that can be shattering and sharply awakening to those of us who are admitted into these recesses. Singular and unflinching, Rego explores sexual fantasy and tension; the inner lives of women are her principal interest. If she were a medieval poet, you'd say she expressed the

sorrows of the daughters of Eve. She loves fairy tales and myths, old stories, ballads and folklore, and she sees, in this mostly anonymous literature, a vivid record of experience transmuted by imagination.

In the *Nursery Rhymes* prints she made in 1989 (see *Secrets and Stories*, p. 16), she pictures the enigmas of children's nonsense songs as part of a storytelling tradition, transmitted orally and confidentially from woman to woman, from women to children. These powerful, original illustrations catch the darkness and the comedy of the original nonsense verses, in which everyday banality meets mystery. *Mother Goose's Melody*, the first printed collection, appeared *c.* 1768; the name Mother Goose was borrowed from the French, specifically from Charles Perrault's 1697 collection of fairy tales, *Contes du temps passé, ou Contes de ma mère l'oye*. Mother Goose is Granny, Nan, nursemaid and governess, remembered from childhood. She can be comical – like a goose – and sinister, like a crone or a witch; she's a mother, who feeds her flock with stories and nonsense; she's female because speech is the realm of those who cannot read and write, like children and like peasants and women in the past. When Iona and Peter Opie collected skipping rhymes and other nonsense verse in playgrounds up and down England for their great work on children's play, *The Singing Game* (1985), they found that it is only little girls between the ages of four and fourteen who transmit skipping and hopscotch rhymes and invent new ones. Paula Rego has taken up their tradition and turned it into images.

At the age of ten, Paula Rego was sent to an English school in Lisbon, where she learned to recite the nonsense rhymes. Although her father was opposed to the Church and the school was secular, she was imprinted all the same, and in many ways, she has combined the cruel comedy of the verses with Catholic miracle stories, their goriness and excesses, colour, passion and matter-of-factness. In an interview for BBC Radio Four in 1988, she said, 'It goes with being punished for doing the wrong thing – not hit or anything like that, but experiencing a more subtle sort of forbidding. A mix up of all sorts of sentiments can follow: pain and pleasure get confused.'

When her first grandchild – a girl – was born, Rego rediscovered the nursery rhymes of her own childhood and began the series of etchings which she drew, as a child might, spontaneously on to the plate without preparatory planning of any kind.

The twin régimes of the Catholic church and Salazar's dictatorship during the artist's upbringing created a structure of sexual oppositions which emerge powerfully in the riddling pairs of her images: Miss Muffet and the spider, Baa Baa Black Sheep and the questioner, Polly and her officers' tea party, even Old King Cole and his fiddlers three. In the pictures, the uniforms of post-war Portugal return, costuming her soldier mannikins and imperturbable aproned Misses like national dolls. By remembering the separation of men and women's spheres in her birthplace, and the performances of machismo and womanhood demanded of the sexes, Rego has reinterpreted these familiar, innocent verses with a post-Freudian mordancy. The very meaninglessness of the rhymes gives them fluid and multiple meanings, which the artist has fixed in her work with a certain, unmistakable atmosphere: they have become a theatre where the child anticipates ambiguous dramas of sexual curiosity and conflict.

The nursery rhyme is a form of verse that's almost unknown in the rest of Europe, and the meanings of most have been forgotten, though the inspired sleuthing undertaken by folklorists such as the Opies has solved some enigmas. When we discover who 'Mary Mary quite contrary' might be (Mary Queen of Scots), or which King is in the counting house counting out his money, we realize that the spell of the rhyme lies elsewhere. The classic nursery rhyme's simplicity is funny ('The cow jumped over the moon') and can raise goosebumps (those 'three blind mice'). The very ordinariness of the verse attaches it to general experience, brings it into everyone's back garden, as it were, where it flips over into the oracular. To be uncanny – *unheimlich* – there has to be trust in the idea of home – *heimlich* – in the first place – but a home that's become odd, prickly with desire.

Rego has often returned for her subject matter to stories told her by her grandmother and aunt and the family's maid in Cascais, on the sea near Lisbon where she grew up. Her stern heroines – little girls with bows in their hair intent on their household tasks – recall female saints and martyrs as well as Julie and other heroines of the moral tales of the Comtesse de Ségur, which she was read when she was their age. She likes to step into that disturbing gap between the portrayal of the protagonist's perfections and the wicked feelings stirring inside the child reading about them. Rego's

little girls also owe something to the Surrealists' cult of the *femme-enfant*, to Max Ernst's heroine in his collage novel, *Histoire d'une petite fille qui voulut entrer au Carmel*, and to Balthus's spectacle of young girls' intimacies. She is supremely able to draw out perverse ambiguities in banal popular imagery: 'When you see Max Ernst's book on the little girl entering the convent,' she has said, '…it isn't so far away – the transformation isn't so great after all, is it? The same spooky feeling. It is sex, sex that comes into the Ernst images.'

But she does not come as a voyeur to the scene, nor as a seducer. The artist Victor Willing, whom Paula Rego married in 1959, and who died in 1988, identified her characteristic themes as 'domination and rebellion, suffocation and escape', recognizable conditions of childhood, and especially of girlhood in 1950s Portugal. Rego has always identified with the least, not the mighty, has taken the child's-eye view and counted herself among the commonplace and the disregarded, by the side of the beast, not the beauty. She's commented on her approach: 'suddenly it's as if a dog were to tell its own story'. For she is speaking from the inside, telling tales she knows, from a place – a home base – generally overlooked: the female child's. She not only hears the 'dog', she turns into one. Nursery rhymes are populated with fabulous, talking creatures, with wooing frogs and talking horses, and children and animals have always liked one another, have even been confused by their elders, subjected alike to maltreatment on the one hand, petting and spoiling on the other. But Rego has also confronted, even celebrated, the powers emanating from this quarter: hers are not simplistic tales of victims and oppressors at all, but full of reversals and surprises. The universe of children is subject to adults' authority and brimful of the potency ascribed to instinct, to irrationality, to pre-social (anti-social?) behaviour. Her sympathy with *naïveté*, her love of its double character, its weakness and its force, has led her to supposed children's materials such as *Nursery Rhymes* and *Swan Lake* as sources for her imagery. In 1987, she made a picture of a young girl (*The Soldier's Daughter*) plucking a goose with concentrated energy, yet at the same time caught up in a dream; the intense, intimate pose recalls the embrace in *Baa Baa Black Sheep* (see p. 18).

In 2002, Paula Rego was commissioned by the President of Portugal to create a series of images from the Virgin Mary's life, and she moved

her into scenes of ordinary female experience, represented with realistic intensity – terrible suffering in childbirth, for example – and consequently scandalized and repulsed many viewers. Fairy tales, folk tales and saints' lives aren't only scripts of superstition and ignorance, and Paula Rego has drawn on them for their confrontation with abuses of power, their honesty about opportunism and injustice and rivalry. That is why thinkers like Walter Benjamin and Antonio Gramsci and writers like Italo Calvino and Pier Paolo Pasolini were attracted to the form. The unsparing painting simply called *War* (2003; see frontispiece), inspired by the carnage in Iraq, creates a Goya-like scene of disaster, casting cadaverous floppy pink bunnies and other soft toy-like creatures, disfigured and hybridized, as the heroes and victims: the substitution raises the scathing temperature of the image. In 2008–09, Rego made a series of aquatints on the subject of trafficking: little girls in the charge of their mothers, grandmothers or madams are lying listless, spectre-thin, chained, poppets horribly on display. She does not hold back, and she sees how women sometimes collude in their abuse. She is an artist-activist; but her consummate technical skills translate the power of her imagination, her generous rage and sympathy, so richly that her works, though they hit hard, surpass gritty agit-prop.

The mark of her hand is versatile and experimental, but in every mode she remains consummately skilled – she is one of the greatest living draughtsmen and nobody else since Goya has used the subtleties of aquatint more expressively. Indeed, the ghost of Goya haunts the grotesque and often savage quality of her scenes. She captures the dark *capriccio*-like themes of her chosen rhymes and communicates them with disturbing glee. She has also never distanced herself from illustration. She wants to retrieve what is usually considered a humble artistic category and pay tribute to precursors she admires greatly: the 18th-century cartoonists and illustrators James Gillray and Thomas Rowlandson, and Victorian artists such as Kate Greenaway, John Tenniel, the goblin painter Arthur Rackham and Beatrix Potter, who also loved animals and took their part against gardeners. Like them, Rego treats the fantastic realistically, dresses animals in human costume and introduces dream-like dislocations of scale.

Her appreciation of graphic artists – Max Klinger, Gustave Doré and [Théophile] Steinlen – has been part of her independent-mindedness.

Her work has changed, retroactively, our way of thinking about art and figuration, and British art in particular. But there is another aspect to the affinity she feels for these jobbing artists, these *feuilletonistes*: Rego's fierce delving into the dark places of the psyche unfolds in continuous engagement with ordinary things happening in the world. As in *O Vinho* (2007), the bittersweet, existential cry of the writer João de Melo, her subjects are humans on the edge. It is one of her most remarkable achievements that she conveys a unique subjectivity – the puzzling images are hers and only hers – but at the same time she acts as an unflinching chronicler of our times, compiling, like some angel of destiny, a record of horror and pity. The many works – paintings and prints – which depict clandestine abortion, or the more recent series that imagines devastating scenes of female circumcision and the trafficking of women and children, are unsparingly open-eyed about human beings' treatment of other human beings. The pictures in *O Vinho*, a text she translated with Anthony Rudolf, depicts nursemaids sozzling the babies in their care, women vomiting and bingeing and men passed out in pools of spilt wine and vomit. Later, the narrator declares that he 'loves life at least to the extent of defending its greater vices.' The patrons who had commissioned wine labels from her were dismayed and her work was rejected.

However, being an artist, not a caricaturist, Rego infuses these ferocious stories of human frailty and excess with a whole range of feelings – and wraps us, as we try to take them in, in puzzlement and anguish, horrid laughter and appalled pity. 'Shame is something that interests me profoundly,' she once told me. 'It is exactly those areas of shame that I like to touch on. It makes you sometimes squirm, but why, what is shame? I think shame is one of the most interesting things we have got.'

Even as I try to give words to what I experience looking at Rego's works, I falter – they resist explication. They are above all mysterious in what they face, in what they say. One aspect of the images she made for *Jane Eyre* (2001–02), which picks up most feelingly from the heroine's character in Charlotte Bronte's novel, strikes me now as central: Jane Eyre is lonely. She is a little girl who is orphaned and alone among people who are cold and bullying and cruel, and she grows up to be a solitary figure, isolated by poverty and class as well as temperament – indeed,

the happy ending is not only about romance but also about friendship and equality and escape from servitude.

Rego's *Jane Eyre* series picks out Jane on her own several times, as the artist takes possession of the whole sheet of paper, so that even when Jane is wretched with misery her strength of character comes through. The solitariness of Jane is comparatively unusual in the broader perspective of Rego's work, as she tends to render clusters of people in dramatic interaction, but it illuminates how profoundly this artist engages with passionate and dynamic relations between people – and people with animals and things. In one of the most celebrated images from the series, in which Jane is billing with the huge pelican in her lap, the lonely heroine has conjured a fabulous creature to engage with, a fantastic variation on Leda and the Swan or even a sly parody of the Catholic symbol of Christ as a pelican feeding her young. The great bird is a phantasm of erotic imagination – and indeed many of the dramatis personae in Rego's work are figments, materialized in oil pastel or other media.

Her playing, scene-setting, mime and dramatizations – all that imaginative make-believe that happens in the studio – has made Paula Rego a most powerful storyteller, who deploys a large cast of characters. The models for this theatre of her inner world return again and again: her children have grown up in different roles over the course of her career and her grandchildren have followed them. She works in a family setting in the widest sense: helpers, including Lila Nunes and Anna, as well as her partners and friends, all take up parts in Paula's mystery plays (The writer and translator Anthony Rudolf has modelled in female roles as well as for Mr Rochester in the Jane Eyre series.) In this respect also she has struck out on her own path, against fashion, against the arbiters of the canon. She has put figurative, fabulist, allegorical art back at the centre of valued image-making. Her predecessors are the great narrative painters – proto-cinematic, graphic novelists *avant la lettre* – from Giotto to Guercino. In spite of art's muteness, her paintings and prints and drawings seem to speak; yet it is not easy to know what they are saying. We hear her pictures through muffled ears and that intensifies their compelling quality. In 2009, her home town, Cascais, opened a museum of Paula Rego's work. She gave it its name, La Casa das Historias – the House of Stories – and she has filled it with heroines after her fashion.

HENRY FUSELI

In the Passionate Playground

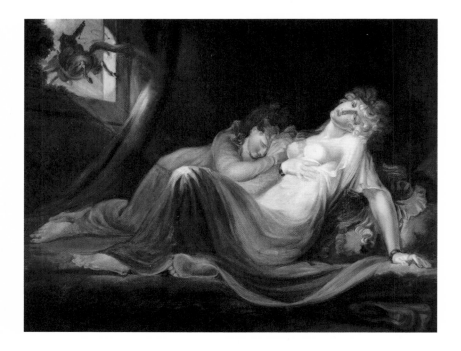

An Incubus Leaving Two Sleeping Girls
1783

Beneath the surface of the visible world exists a 'secret commonwealth', where our doppelgängers, 'fetches' and 'co-walkers' lead another life, eating and drinking, marrying and partying in the company of 'all sorts of spirits which assume light aery bodies'.[1] These elves and fairies are waited on at their revels by 'pleasant children like inchanted puppets' and exercise a range of weird and terrible powers over human lives, abducting mothers to nurse their fairy children while leaving behind a phantom nurse ('like their reflexion in the mirror'), or substituting a changeling in the cradle, who is doomed soon to die. Such are the deeds of the fairies, as reported by the Scottish pastor Robert Kirk (1644–97) in his book about fairyland, *The Secret Common-Wealth of Elves, Fauns and Fairies* (1691). Kirk was an antiquarian and scholar of some distinction, and a great deal of similar lore can be found in earlier, popular sources as well as in Elizabethan poetry and drama: Shakespeare's fairies, Moth, Cobweb and Mustardseed, and his Puck or Robin Goodfellow, are entirely recognizable from the descriptions Kirk gives. So are Robert Herrick's trooping mischief-makers from 'Oberon's Feast' and 'Oberon's Palace'.[2] But the straight, near-scientific language of the ethnographer reporting from the field gives the Reverend Kirk's work an enhanced strangeness: he was collecting the beliefs of his parishioners.

The pastor discusses the fairies' eating habits and the services they perform for humans – mending shoes, sweeping houses and other activities (which led to the naming of the Brownies' section of the Girl Guides). He describes the gift of Second Sight, which allows one to see fairies; surprisingly, he declares that it's mostly men who possess the power, women rarely so. The fairies' social arrangements amongst themselves, as well as their attendance at ours, then busies his pen; and he returns again and again to the belief in changelings and uncanny doubles, how everyone might have a fairy counterpart who is 'every way like the man, as a Twin-brother and Companion, haunting him as his shadow.' Kirk did not condemn his flock for thinking that these things happened; even more startlingly, he explicitly allowed such beliefs in an enchanted other world to coexist with his own Christian faith and that of his followers. His treatise, being a report of matters held to be fact, strikes the contemporary reader as a far stranger document than the fanciful fairy plays and poetry of his predecessors.

The Swiss-born artist Henry Fuseli was older than his contemporary William Blake, and like Blake and Kirk, he was steeped in Shakespeare and Milton. He obsessively arrays his fairies in insect forms, with butterfly wings, antennae, probosces, bulging eyes and attenuated limbs; he also respects the extreme contrasts of scale suggested by Shakespeare and his contemporaries when, for example, 'dainty Ariel' in *The Tempest* sings:

Where the bee sucks, there suck I
In a cowslip's bell I lie;
There I couch when owls do cry.
On the bat's back I do fly
The Tempest, 5.1.98–101

Numerous scenes painted by Fuseli show the miniature population with bats and owls and bees for bedfellows and steeds; the contrast with Bottom's colossal limbs, for example, in *A Midsummer Night's Dream*, compounds the weaver's 'mortal grossness' and sharpens the strangeness of the 'little people' and their frenzied dancing and ogling, the 'nods and becks and wreathéd smiles' described by Milton.[3]

The fantastical hybrid monsters, known as 'grylli', concocted by medieval illuminators and Hieronymus Bosch, might appear to be the forerunners of these sinister visions of faerie; it is however absolutely characteristic of Fuseli, who was a full citizen of the continental Enlightenment, that his creatures are not surrealist confections but real species, painted 'with great care and fidelity', as a contemporary commented, '[which] when taken with the subject…made them frequently incongruous'. Fuseli's passion for entomology inspired him to collect and raise special species of moths – one called *Sphinx atropos* (Fatal Sphinx), no less.[4] A generation later, Richard Dadd continued to conjure bizarre tableaux in the goblin undergrowth: paintings such as *The Fairy Feller's Master-Stroke* (1855–64) reveal a secret, natural world teeming with fairy creatures.

Elizabethan fairylands no longer excite alarm but, seem to us light-hearted products of fancy, designed to charm audiences with their magic, not command our belief – or our fear. Fairies continue to look like Fuseli's interpretations of Shakespeare, but they have shed the unsettling, brooding,

uncanny atmosphere he established and now appear playful and harmless. We feel we can enjoy Oberon and Titania's quarrels, Puck's mischief-making and the night riding of Queen Mab; Victorian and Edwardian stagecraft, the pretty conjurings of Cecily Mary Barker's flower fairies, J. M. Barrie's Tinkerbell and the sprites photographed dancing in the glen at Cottingley in the '20s have exorcised the malignancy of earlier spirit beings. But the vision of Henry Fuseli predates this taming of fairy dangers; his avidity for tales of spells and horror, magic and enthrallment drew on the lore of Britain and Germany and their national literature. His illustrations of Shakespeare respond to the deep strain of supernatural terror in all the plays, be they comedies, tragedies, histories or romances. He transmogrified his sources according to his own sensibility, a sensibility with a taste for excitement, morbidity and turbulence, for a constant rhythm of stimulus and arousal. This led him to fashion his own Shakespeare as a proto-Gothic master of horror and hallucination, a kind of Caligari working behind the scenes, and to perform similar horrid metamorphoses on many of his other literary sources and their materials.

Besides fairies, Fuseli raised nightmares and spectres – from the obvious plays (*Macbeth*, *Hamlet*) and also from lesser known scenes of vision and conjuring – the dream of Queen Katherine from *Henry VIII*, for example. He even surrounds Perdita in her pastoral exile with a bevy of imps, including several of his signature fairies in huge mob caps, and in 'The Nursery of Shakespeare' he gives the infant bard a train of accompanying goblins and genies, including a super-fashionable fairy seductress as the Spirit of Comedy, dimpling at us complicitly.[5] Crucially, Fuseli also pictures the dispute between Harry Hotspur and Owen Glendower, when the Welsh bard boasts: 'I can call spirits from the vasty deep,' to which Harry retorts, 'Why, so can I, and so can any man,/But will they come when you do call for them?' (*Henry IV Part 1*, 3.1.52–54). Later in the same scene, Harry rails against Glendower's 'skimble-skamble stuff' and scorns the way he was 'reckoning up the several devils' names that were his lackeys'. Harry's words catch Fuseli's views far more closely than the supernatural claims of the Welsh wizard: Fuseli, a supreme artist of hauntings and dream states, was also a declared and ferocious advocate of Reason, who proclaimed unwavering allegiance to scepticism. To viewers now, he appears a supreme

painter of the uncanny – and the uncanny has come to seem involved with magic and the supernatural. But at the end of the 18th century, the territory of the unknown was mapped onto the study of the psyche, and dark subterranean realms metamorphosed into the realm of the unconscious.[6] 'It is not by the accumulation of infernal or magic machinery', wrote Fuseli in one of his lectures, 'that Macbeth can be made an object of terror – to render him so you must place him on a ridge, his downdashed eye absorbed by the murky abyss; surround the horrid vision with darkness, exclude its limits, and shear its light into glimpses.'[7]

But, like his peers who created spooky terrors for the stage – Philippe Jacques de Loutherbourg with his *Eidophusikon* (1782) and the Phantasmagoria shows of Paul de Philipsthal and Etienne-Gaspard Robertson – Fuseli liked to plunge his audience into dark depths and to use flickering shadows and sudden flashes of light. The pioneering illusionists proclaimed that through their magical arts they exposed the fallacy and deception governing all such terrors, enlightened the public and steered them away from the terrors of superstition and credulity; likewise, Fuseli seized hold of the potential that spectral delusions offered to fantasy. This non-believing, often blaspheming, self-styled revolutionary *artiste maudit* summons all kinds of terrifying spirits for his audience, and creates a mood of supernatural sublimity without restraint of taste or deference to opinion, in order to stir in his viewers that ambiguous pleasure, the aesthetic state famously defined by Coleridge: the suspension of disbelief.

Fuseli's compositions for Boydell's Shakespeare Gallery – Hamlet's father's ghost, Titania's fairy court, the Witches appearing to Macbeth, Caliban as a monstrous faun – did not succeed commercially as the publisher had hoped, but they have had a lasting influence on the reception of Shakespeare in the mind's eye of readers, as well as on stage designs. Edward Said recalls in his memoir, *Out of Place* (1999), that when he was growing up in Cairo, he read aloud with his mother from a copy of Shakespeare: 'its handsome red morocco leather binding and delicate onion-skin paper embodying for me all that was luxurious and exciting in a book. Its opulence was heightened by the...drawings illustrating the dramas, *Hamlet*'s being an exceptionally taut tableau by Henry Fuseli of the Prince of Denmark, Horatio, and the Ghost.'[8]

PLAYING IN THE DARK

The Swiss pedagogue and theorist Johann Jakob Bodmer was Fuseli's mentor, and as an important early influence on *Sturm und Drang* and continental Romanticism, also shaped Coleridge's theories of creativity. Bodmer advocated the unfettered play of the imagination, the rejection of classical harmony and tranquillity, the mining of native, popular sources and storytelling in art – *ut pictura poesis*. Many of the early German Romantic writers were folklore collectors as well as poets and storytellers. Before the famous tales of the Brothers Grimm (1812), scholars like Clemens Brentano (1778–1842) had begun exploring traditional songs and legends, leading to the famous cycle, later set to music, of *Des Knaben Wunderhorn* (1805–08); in *Peter Schlemihl* (1814), Adelbert von Chamisso (1781–1838) drew on Jewish legends circulating in the literary and philosophical salons of Jena and Berlin to create the eerie story of a man who sells his shadow to a passing enchanter and finds that he has forfeited his soul.[9]

Fuseli extended these writers' innovative approaches from literature to art: he too was a voracious anthologist, gathering up stories and yet more stories from the cultures and languages he acquired with protean faculty. His sources come from Germany, France, Italy, as well as the Celtic lore of his adopted British Isles, and from every era and level of literature, without prejudice. Indeed, he displays an insistent eclecticism, choosing to illustrate material set in the distant Orient or the local churchyard, in remote times past or menacing present circumstances, in historical settings or fantastic wonderlands. He belonged to the same enthusiastic revival of national, bardic and magic literature that brought the supposed Celtic epic, *Ossian*, to the height of fame and eventually inspired poets and musicians to retrieve and recast legends and fairy tales previously despised as the superstitions and literature of the common people; this tendency was to expand into Richard Wagner's music theatre and the mythology of *The Ring* (1848). Fuseli's work shares some qualities with the Romantics: the cruelty and the harshness, the occasionally cloudy bombast, the fascination with female power and sexual perversity.

It is not quite the case, however, that Fuseli told stories in the same way as scholar-writer contemporaries such as Bettina von Arnim (1785–1859), Ludwig Tieck (1773–1853) or the painter Philipp Otto Runge (1777–1810), who retold German fairy tales about incest and infanticide – Runge was

the source for the macabre, unforgettable story 'The Juniper Tree'. Fuseli began as a writer, but had no success. It was Joshua Reynolds, around 1768, who recommended he concentrate instead on the visual arts. But Fuseli remains a confusing narrator; as he well realized, his pictures (and they are very much pictures – scenes, images of events and characters, illustrations of stories) don't convey what is happening at all clearly, even when the viewer knows the material. Long, explanatory titles only exacerbate the problem; as he admitted, 'we turn our eye discontented from a picture or a statue whose meaning...must be fetched from a book'.[10]

If he was so alive to the tendencies of his own bookishness, why did he illustrate stories so intensively? As the critic Werner Hofmann asked, is Fuseli 'simply playing a masquerade with us?' Or does the parade of learned allusions disguise something else?[11]

'The exhibition of character', Fuseli wrote, 'in the conflict of passions with the rights, the rules, the prejudices of society, is the legitimate sphere of dramatic invention. It inspires, it agitates us by reflected self-love, with pity, terror, hope and fear.'[12] As a working concept here, 'reflected self-love' corresponds to Aristotelian catharsis: when Fuseli seizes on certain key scenes and creates memorable, if often extreme, images of turbulence and conflict, they are not altogether attached to their original works but rather become syntheses of certain states of passionate loss, turmoil and crisis. They illuminate human experiences far beyond the precise remoteness of the extreme plots with which we can identify and fear for ourselves. 'Whatever connects [the individual]', he added, 'with [the species], or tears it from the species, may become an organ of pathos'.[13]

The artist so wanted to dramatize the pathos of a distressed and torn human psyche that he would invent a source. *Ezzelin Musing over Meduna, Slain by him, for Disloyalty, during his Absence in the Holy Land* (c.1780) shows the murderer sunk in gloom beside a bed on which his wife lies supine. When asked by a curious Lord Byron about the story, Fuseli admitted that he had 'combined' elements to create the picture. (In Italian, one of Fuseli's many languages, the verb *combinare* is used to convey not so much combining as plotting – using cunning stratagems and devices.) The artist's sulphurous narratives – autobiographical, authorial, imaginary – are nested inside one another, generating their own persuasive reality for his viewers.[14]

Other minds emerge as Fuseli's dominant subject. Supernatural powers and fairy enchantments communicate psychological conditions in material form: airy sprites and hobgoblins, spectre-smitten protagonists and haunted heroines, as in the famous painting of *The Nightmare* (1781) and several other images of incubi (see p. 26), materialize states of mind and degrees of passion beyond the reach of bodily eyes.[15] Shakespeare already suggests as much when Mercutio, teasing Romeo about Queen Mab, deftly sums up what can now be read as a theory of the unconscious:

> …she gallops night by night
> Through lovers' brains, and then they dream of love;
> …O'er ladies' lips, who straight on kisses dream…
> This is the hag, when maids lie on their backs
> That presses them…
> *Romeo and Juliet*, 1.4.70–93

In rather the same manner as Blake's *Ghost of a Flea* (*c.* 1819–20) incarnates the insect's inner nature as a monster of great vigour and malevolence, the trooping sprites, butterfly-winged elves, dark scowling brownies and lumpen goblins of Fuseli's cast of characters function as inner diagnoses of his protagonists' minds, or, to take the same thought in fairy terms, they figure other co-walkers, our doubles, the self's spirit forms. Fuseli marshalled all his powers of theatrical gesture and expression to gain access to them, and seized on bodies as the vehicles of his fantasy, assembling – copying – their anatomy from engravings after Michelangelo and later baroque masters. But the flexed and clenched musculature of his figures, their soaring or tumbling intertwinings and writhing limbs, do not represent a possible physical reality: they embody emotions. As the artist explained in a letter, 'the general form of the human body, its attitude, and manner, the sunken or raised position of the head, between or above the shoulders, the firm, the tottering, the hasty, or slow walk, may frequently be less deceitful signs of this or that character than the countenance separately considered'.[16]

Never preferring restraint to excess, Fuseli offers the whole body as a seismograph of the volcanic eruptions surging inside. In this he was echoing the work of his friend Gaspar Lavater, who chiefly commented on

aspects of character connected to feelings and temperament. Like Lavater, Fuseli observes human propensities and moods at their most pent up and vehement: rage in all its forms, fury, grief, jealousy, madness, sexual desire and, above all, terror, convulse his subjects. He also advocated 'philosophical ideas made intuitive, or sentiments personified' and from the figures' tensed toes to their bristling and shaking locks, Fuseli does personify sentiments, exploring the impact of human passions on the heroic or suffering body. He seems to be striving, through a tireless visual record of stories and their physical sensations, to gain – and pass on – an encyclopedic inventory of every shade and extreme of human experience – beyond reason, beyond intellectual analysis. This is the manner which Edgar Allan Poe, himself a follower of Fuseli in tales of terror and dread, was making fun of in the character Signora Psyche Zenobia, who, wanting to make a career as a writer, is advised: 'Sensations are the great things, after all. Should you ever be drowned or hung, be sure and make a note of your sensations – they will be worth to you ten guineas a sheet.'[17]

Does Fuseli gain insight into the passions? Does he manage to transmit it to us? And if he does, what are its principal elements? Many of his interests have special resonance for the 21st century and its vision of human psychology – or rather, pathology. He shows keen interest in and sympathy with madness, and was inspired, for instance, by the House of Death or Lazar House from Milton's *Paradise Lost*: 'Numbers of all diseas'd, all maladies…/Demoniac frenzy, moping melancholy/And moon-struck madness, pining atrophy….'[18] Rare excursions into first person testimony find Fuseli in hospitals and asylums: he drew a patient in the Santo Spirito in Rome, whom he had seen struggling to escape monks who were trying to administer the last rites. He was crying out that he rejected all religion; Fuseli portrays him in frenzy as the brothers tear at his clothes to restrain him. The artist also penned a vivid pencil sketch of a woman with staring eyes and avid mouth, and labelled it 'Mary Anne' after the disturbed sister of Charles Lamb, who in 1796, in a fit of madness, had killed their mother.[19]

As anyone who comes to Fuseli knows, the crazed subjects of his chief curiosity are almost invariably female: sometimes raving bacchantes or swooning maidens, prostrated in a fit or a stupor, sometimes possessed, sometimes simply driven out of their wits, like 'Mad Kate' from the

PLAYING IN THE DARK

poem *The Task* (1785) by William Cowper, who himself suffered from mental trouble. When it comes to the Greeks' irrationality and fantasies about women, the rational philosopher and Romantic loner becomes a fervent classicist. Maenads, gorgons, furies, harpies and sirens haunt his art. Spellbinders of different sorts – Medusa and Circe – catch his interest, as do several mothers and murderers, or both combined – Medea. His narratives of the psyche – those ideas intuited and sentiments personified – feature women performing myriad permutations of the unconscious and its powers: they faint, they fall into trances, they dream, they sleepwalk, they ride incubi into the night and are themselves ridden, they conjure demons, cast spells and pursue their victims – sometimes their assailants – like Furies.

When Fuseli takes for his inspiration Virgil's lines about the gates of dream in the Underworld, he does not show our hero 'pius Aeneas' taking the way of false dreams and passing through the gate of ivory, as Virgil relates, but stages instead a hyperbolic masturbatory scene, with a phallic elephant goblin poised on the floor, a herm erect and aghast with a finger to his lips and a butterfly hovering near the groin of the dreamer in question – who is, of course, swooning, naked and female.[20]

However, unlike most of their predecessors in Renaissance iconography or their counterparts in Gothic and Romantic fantasy, many of Fuseli's fairies, demons and sorceresses are astonishingly decked out in the height of London fashion, from the trimmings on their extravagant bonnets to the turn of the kitten heels on their boots and the lapdogs they walk on silken leashes (these as often as not manikins, bearded and pot-bellied). It is as if Titania's throng of fairies had been to Bath with Sir Walter Elliott to look over pattern books of the latest imported silks, gloves, hats and ribbons from France (it comes as a shock – a revealing shock – to realize that Mrs Fuseli would have been the same age as Jane Austen, who died in 1817, and that Fuseli and Austen lived in the same time in the same country). The artist's curious flouting of traditional unities, using modern dress for the fantastic denizens of a remote once-upon-a-time, produces the particular frisson of Fuseli's own imagination, as he invites us, through his female characters, into states of heightened emotional tension.

Fuseli's women – inspired again and again by Sophia Rawlins, Mrs Fuseli, of the foxy look and the full overbite – enact the range of his extreme

imaginings, often in explicit sado-masochistic scenarios that remove the Gothic visions of his contemporaries from the doomed medieval castle or enchanted palace to a bedroom in London, w1. It is pertinent that Byron provoked Fuseli's admiration, while the Gothic fantasists pursued the supernatural in a manner he scorned. Whereas Horace Walpole (1717–97) safely removed his crazed and depraved protagonist Manfred to far distant Otranto and some indistinct medieval time and William Beckford (1760–1844) fantasticated far pavilions and Oriental scenery for the wild debaucheries of the Sultan Vathek, Fuseli often stages sexual perversity with women who, while being exceptionally coiffed and arrayed, would have struck any one of his contemporaries as belonging to the world of the here and now (see below).

Fuseli's fetishism, expressed through his obsession with hair-styling, is in many ways simply his own proclivities set down in pencil and paint, his images of sexual play pictures of his own tastes. (Magdalena Schweizer-Hess, a married woman for whom he entertained a brief passion before he came to London, may be responsible at least for his fixation. Among her other eccentricities – she was also a dowser and could sense earthquakes – she would fall into trance while having her hair combed.) Some literary historians have argued that the late 18th century 'invented' pornography as part of rational modernity; that a taste for erotica belonged alongside other enthusiasms of the Age of Reason: flying, for example.[21] This ancient metaphor for bodily bliss found material realization for the first time when a new craze for 'aerostatics', or ballooning, took hold. On one level, the learned Erasmus Darwin (1731–1802) rhapsodized in verse about the hitherto inaccessible views from above the clouds; while on another, the imaginary voyages dreamed up by John

Two Courtesans with Fantastic Hairstyles and Hats, c.1796

PLAYING IN THE DARK

Elliott in 1778 included a visit to the 'Powerful Kingdom of Luxo-Volupto', where flying prostitutes in crinolines swoop down and carry off their prey.[22] Echoing these dreams of sexual transport, Fuseli's objects of desire frequently wear wings, and soar and tread the upper air as a native element. Many of these fantastic inventions wear the recognizable, come hither look of Mrs Fuseli.

Leaving aside acute, personal connections, Fuseli's painted women perform another part when they float and fly, swoon and conjure, dance and dimple, administer their sexual favours or torment their victims. The femaleness of Fuseli's phantoms of desire embodies his inner drives according to an 18th-century tradition that is not primarily sexual. This convention was still vigorous in his time and would have been assumed by the artist's contemporaries, but it has become far less visible to us today than, say, the trope of the swooning maiden or the sexual dominatrix. For William Blake, above all, but also for Edward Young (1683–1765) in the poem *Night Thoughts* (1747) and for many others, female bodies conveyed the inner life of an individual because the soul, or psyche, happens to be feminine in gender. The inner self takes a correspondingly female form in language and image. This idea of the spirit body extends on the one hand to the perceived identification of women with states of madness and on the other to the incarnation of angels, who rarely appear virile. When Blake created his image of Milton's Satan 'in his original glory', the beautiful angel, spreading wings of light and scattering fairy-like sprites from his radiant limbs, appears androgynous to say the least, with small breasts and no genitals. Blake was projecting his visions of ideal beauty onto a far horizon of metaphysics; meanwhile, Fuseli looked through his wife's bandbox and into the mirror of her toilette, an item of furniture that actually became known in the early 18th century as *une psyché*.

Actresses were the new woman of Regency society (the mistress of the Regent, Mrs Jordan, was one).[23] Mrs Fuseli was not on the stage, insofar as the stage did not serve as her favoured theatre; but the masquerade of the actress was part of her persona, as her husband has captured her in images. The actress's necessary use of artifice, her performance on and off stage, her spectral life as a figment or invented character, lent her to Fuseli's artistic concerns with theatricality and psychological expression.

Of course not every one of Fuseli's fairy queens and demonic mistresses is dressed to promenade for quizzing in the streets – some are flimsily draped as classical nymphs – but most are not in fantastic or mythological attire at all. They look like you and I, if we had led fashionable lives under the Regency. We no longer wear the periwigs and flounces so extravagantly assembled by Mrs Fuseli: it is time that has made her outfits look unfamiliar as well as extreme.

In this sense, Fuseli is an artist of modern life, however odd that may seem; he foreshadows Baudelaire's dandified urban perversity, combining into the figure of the desiring and powerful woman a similar, decadent concoction of vice, cosmetics, revolution and misogyny. His ladies of the night are his antagonists, who contend with his heroes to produce images of agitation and animation and expression – his ideal dramatic aesthetic. They act as his 'pleasant children and inchanted puppets', enigmatic doppelgängers who embody permitted passions on behalf of the male artist. His own descendants in this role are many, including Dr Coppelius, the invention of his contemporary E. T. A. Hoffmann (1776–1822) in *The Sandman* (1814) and, more recently, the maker of the marionette Lady Purple who, in one of Angela Carter's savage fairy tales, undresses and dresses his dolls: 'His arms cracked under the weight of her immense chignon and he had to stretch up on tiptoe to set it in place because, since she was as large as life, she was rather taller than he…. Now she was dressed and decorated, it seemed her dry wood had all at once put out an entire springtime of blossoms…. She could have acted as the model for the most beautiful of women, the image of that woman whom only a man's memory and imagination can devise….'[24] This image-doll awakens, rises out of her box, sucks the breath out of puppet-master and then: 'even if she could not perceive it, she could not escape the tautological paradox…had the marionette all the time parodied the living or was she, now living, to parody her own performance…?'[25]

The perverse enchantresses in Fuseli's fairy paintings, epic history scenes and boudoir erotica fulfil his ambitions for art: to depict alluring states of excitement and to perform the passions that fire the human mind.

JANINE ANTONI

Hide & Seek

Loving Care
1993

The atmosphere of *Ready or Not, Here I Come!* (1994) shifts mischievously between fear and pleasure; without sentimental patina, the film captures the scary thrill of a common childhood game of Hide & Seek, which the artist used to play with her father. Varieties of this game consistently involve chasing and capture. In England, they are called 'He' or sometimes 'It'; in the United States, 'Tag'. 'Sardines' involves more players hiding together for the catcher to find them. Janine Antoni says that she wanted to occupy that 'psychological space you feel when you're being hunted'.

In the video, she is at home with her family and she's running from her father to find a place to hide. He gives her time, but not much, before he calls out the game's disjointed catch phrase: it is she who is hunted, who might or might not be ready, but the syntax applies the words to the hunter. This uncertainty will quiver throughout the ensuing game, which plays on the roles of predator and prey, on the polarities of the father's and mother's desires, on the safe haven and the place of danger and on the pleasures as well as the pain of being afraid: the thrill of pursuit for both taking part.

Ready or not, he begins looking for her, playing the 'He' or 'It' of the game. The camera is running in his head, behind his eyes, as it were, as he hunts high and low, roaming through the rooms of a light, spacious, cool house somewhere in the tropics. The camera dips and sways with the father's movements, but the spaces that he rakes with his gaze are serene and domestic; they speak of shelter, of intimacy, of cleanliness: this is the child's secure and familiar world of home.

The first time, the father finds the artist very quickly and easily. She is crouching under the tablecloth in the dining room, and she slips away from him. The second time, ditto, and by now, we who are viewing the video are beginning to know this calm, well-ordered, candid house and its not very secret hidey-holes. But the third time, the seeker cannot find the hidden Janine. The choppy movements of the camera grow disturbing; as the father's quest becomes frustrated and he hunts through the same rooms again and again, his prowling eye-view stirs uneasy overtones of pursuit in thrillers.

David Lynch similarly positioned the hand-held camera behind Dennis Hopper's eyes in *Blue Velvet*, when he came hunting for his quarry, Isabella Rossellini.

Tracking through the familiar home, he/we cannot find the artist. Her absence baffles us and recalls the excitement of when, as a child playing a similar game and hiding in a dark cupboard under the stairs or in the garden shed, you heard people calling for you and held your breath so they would not hear you; and yet, at the same time, you feared that you might indeed be lost, lost for good, made to vanish through the magic of the game's powerful make-believe.

Then, at last, in *Ready or Not, Here I Come!*, Janine Antoni is found: she's concealed under her mother's dress, in the bathroom (see p. 42). (see p. 42) When discovered, she slips away and her father's voice exclaims, spontaneously, 'It's like you being born again…but I got you with no clothes on!'

At one level, chasing games such as He/It revisit the conflict between us and them, good and evil, familiar and stranger, inside and outside. By casting someone who is one of us in the role of the predator, ogre, devil or other danger, we can feel that we control the threat: the game offers a reprieve, the exhilaration of a risk taken and escaped. Even after He/It has seized a player, the victim can be released, revived, restored. In one playground game, sometimes called 'Mother Cripsy-Crops' or 'Mother Hippety-Hop', the children are each baked into pies by a limping old witch who, like Baba Yaga in Russian fairy tales or the witch in 'Hansel and Gretel', has powerful cannibal tendencies. But as Cherry Pie, Peach Pie, Apple Pie and so forth wait their turn to be eaten, the real mother returns and reanimates her brood one by one, giving them a good scolding.

This kind of child's play celebrates survival and sorts good kinds of eating from bad; happy forms of incorporation from unhappy forms of annihilation, as does Janine Antoni's re-enactment of her childhood game and its joyous conclusion when, with a smile, she emerges almost swimmingly from under her mother's skirts and flits from her father's grasp and gaze – even though she has been found. At another level, such games also set up borders between principles and establish rules of order that organize – regulate – relations of family and society. When the artist's father exclaims in unscripted surprise at her body, because his little girl is no longer a child but a young woman, he experiences true recognition – *anagnorisis* – and his wonder is communicated vividly

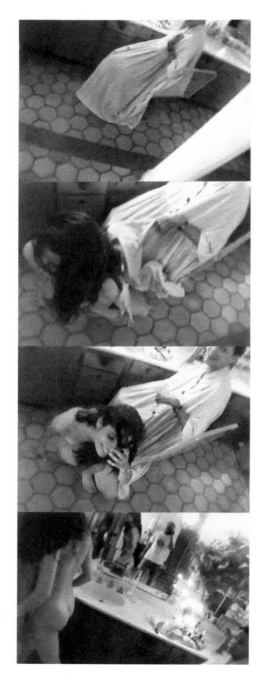

Ready or Not, Here I Come!, 1994

to us. He has come to realize, through the game and the glimpse – the forbidden glimpse – of a nubile daughter, her separateness from him.

Games and stories featuring ogres and their desires (their appetites) dramatize obsessively the ambiguous pleasure/terror of incorporation, of being united in some way with the body of another, and they often announce, to the listeners or readers, the overreaching folly of the ogre's desires. Fairy tales about giants who like nothing better than eating babies dramatize, through the comic horror of cannibalism, the absolute moral necessity of caring for the young. Janine Antoni's video continues, lightly, deftly, touchingly, this work of clarification and warning about the boundaries of gender and generations.

The artist contrasts two forms of incorporation: in make-believe, she returns inside her mother's body to escape from the ogre-ish game of her father's pursuit. The maternal and the paternal are set against one another here, in a permutation of the distinctions that Janine Antoni drew in the earlier photographic sequence, 'Mom and Dad', when she made up her mother to look like her father and vice versa. In 'Mom and Dad', they performed a game of exchanging and substitution that produces a profoundly unsettling feeling in the viewer, for the resulting photographs skew stable ideas of gender and upset the norma-tive foundations of family. In *Ready or Not, Here I Come!* Antoni respects the differences she cancelled in 'Mom and Dad'. However, with similar sympathetic humour, she explores the contrasts between the father who wants to catch her (to do what, precisely?) and the mother who hides her so well that she almost disappears altogether.

The artist's family, who come from the Bahamas, are Catholics in the Caribbean tradition; this background has coloured Antoni's performance of bodily presence and absence, her interest in orality and appetite and incorporation, her aesthetic adventurousness with processes of eating, digesting, regurgitation and washing, as well as her occasional adaptation of self-mortifying practices, as in *Loving Care* (1993; see p. 39). Her aes-thetics are often eucharistic in pattern: achieving communion through eating, abnegation, self-realization through mystic identification with Another. In *Ready or Not, Here I Come!* her silent mother, robed in white, enthroned in the purity of the family bathroom, becomes a Mother of

Mercy, opening her cloak to shelter her children. Antoni's earlier sculpture, *Wean* (1990), focused on the breast as maternal and mourned the inevitable separation from it; in so doing the artist overturned contemporary sexual fetishism in favour of the medieval metaphor of lactation, a link between the ethereal and the corporeal. In her 1994 video, the scene of bodily contact between mother and daughter briefly restores the former child to the primal bliss of union; as in the Vierges Ouvrantes of medieval Catholic devotion, the Madonna encloses the history of salvation within her body. Inside the home, in the bathroom, the place of cleansing and lustration, the safe haven turns out to be the womb.

Since then, this theme has persisted in Antoni's work: *Momme* (1995), a piece that followed the video, returned to the theme of the mother's body and its engulfing/protective powers, with a photo-portrait of her mother, again Madonna-like, calmly seated in a long white robe, while between her feet one can just glimpse the foot of another person hidden underneath her dress. The photograph explores, the artist says, her ambivalence about her mother's generation and its brand of femininity: 'I don't know how much to take from it and how much to reject. There's always the temptation to hide behind her idea of femininity – because it still works'.

The maternal body irradiates Janine Antoni's imagery more profoundly even than the realized presence of her real mother. The artist has consistently challenged the traditional hierarchy of the senses that places smell and taste and touch lower than sight. Inside the mother's body, the world outside may be dimly rosy to the foetus, but eyes are not the principal instrument of knowledge. In *Ready or Not, Here I Come!*, it is highly effective that the only person to be using his eyes is the father; in Antoni's place, we hear him coming, but we see nothing. Other senses become alert and active throughout Antoni's art; other organs apprehend the nature of things. The mouth, tongue, teeth and nose take the place of eyes as the conductors of essential information. Above all, Antoni works with the sense of touch, the faculty that Aristotle singled out as the supremely human power which makes our species 'much more discriminating than the other animals'. In *De Anima*, his treatise on the soul, he develops this idea confidently, placing touch at the apex

of the hierarchy of the senses, in contradiction to later Humanist and Enlightenment preferences for sight: 'This is why he [man] is of all living creatures the most intelligent. Proof of this lies in the fact that among the human race men are well or poorly endowed with intelligence in proportion to their sense of touch, and no other sense....'[1]

The legacy of the Renaissance forgot this aspect of Greek philosophical thought, and the haptic arts and crafts, which involve direct physical contact, handling or processing, were generally derogated or, like tanning, deemed polluting, in contrast with paintings or frescoes.

A baby first knows the body through feeling and suckling and smelling, often with eyes closed, and though developmental psychologists still argue about the stage when a child first understands that the mother is another person, this earliest knowledge of the flesh has filled female bodies with meanings which, in our post-Christian and post-Freudian world, still do not apply to the male, or, when they are applied to male bodies, undergo profound changes. Many contemporary artists and writers, working with motifs of swallowing, devouring and ingestion, have turned around the historically threatening character of carnal appetite.

You grow out of putting things in your mouth – or at least you learn to do it discriminately and in private. This is an agreed process of culture, just as evolutionists hold that when *homo sapiens* stood upright, we elevated ourselves above creatures that forage with their mouths and noses. But the relationship between mothers and infants shows this to be false. (I recently saw a woman on a railway platform trimming her baby's fingernails by nibbling them.) Janine Antoni thinks herself back through her work, into the stance of the foetus, the infant, the toddler who plays with any substance that comes to hand to test its character and who will taste or swallow anything to find out what it is. At a children's party once, where a revolving light scattered spangles round the room, my little niece Nancy Dewe Mathews caught one of the flecks in the palm of her hand and lifted the projection to her mouth – she wanted 'to taste the star', she said.

Janine Antoni acknowledges the importance of her 1970s predecessors, such as Eva Hesse, Louise Bourgeois and Carole Schneeman who, by creating slumped, pendulous forms and introducing new, tactile, even smelly

stuffs and substances, consciously developed a new aesthetic of female, organic experience. The installations of Louise Bourgeois, for example, include scent bottles from her past and clothes which her mother made for her when she was a child which were still, she said, imbued with the fragrance of her body. The specular comes under siege as the tool of false, hubristic rationality, and yields to the sensory tactics of the infant who fumbles for knowledge of self and other through ears and nose and hand and tongue. These developments, which enliven the writings of several poets (Sylvia Plath, Adrienne Rich, Anne Carson, Denise Riley), have sought and found an alternative way of knowing, and in so doing have dethroned the gaze. This approach has inaugurated a new era in the history of values, not only of what is called 'taste'. Significantly, in such female work, signs of baseness that excite the lower senses do not invariably communicate abjection, mess, suffering or pollution. Antoni sees this difference in her attitude to control: 'As a woman', she says, 'working in this way, I have to be careful not to be dismissed – as the women making art in the 1970s were. I do this by working within a rigorous structure that is immutable. Within the safe haven of this structure, I can transgress'.

As part of Janine Antoni's oeuvre, which from *Wean, Gnaw* (1992), *Lick and Lather* (1993) to *Loving Care* has explored a protean range of sensory methods, the 1994 video *Ready or Not, Here I Come!* engages with the polarities of sex, authority and age in a spirit of child's play. Through the simple formula of a well-known game, it revisits from a grown daughter's point of view the power of the father and the body of the mother, and remembers the enjoyment of different intimacies, both permitted and forbidden.

RICHARD WENTWORTH

Things That Talk

Unmatched Pair (Jerusalem)
1986

The house was abandoned; its owners had moved into a new bungalow close by. Though their former home, a wooden farm in the traditional Japanese style, was virtually derelict, Richard Wentworth was fetched slippers to enter it, as though it were still lived in and cared for and should not be dirtied; it was, his hostess told him, a 'ghost house'. She was translating literally, and Wentworth was struck by the phrase because, unlike the English 'abandoned' or 'vacant', the phrase 'ghost house' suggested to him an emptiness which is full, a felt absence.

One of the recurring forms in Wentworth's sculpture is just such an empty house shape, and he often upturns it or tilts it or sinks it into a frame of some kind, so that it offers its hollow inside as the subject of the work. As a dwelling, a home for people who may or may not be ghosts, a house is an interior; but that interior needs an exterior to exist at all. Children, who draw walls, a roof and a chimney when they make a picture of a house, encipher this spontaneously, whether or not they live in a house that looks like that.[1] These are 'the ready-mades of the imagination', Wentworth says; but unlike children's drawings, his houses leave out the windows and the door, condensing the symbol of the Home to its residual cave-like elements, four walls and a roof, and thus tightening control of the inner space they define.

Such a house can be understood as culture itself – not only the domestic roof, but the shelter in which individual consciousness must live, too, shod as required for the purpose. *Making Do and Getting By*, the artist's 1986 film of his ongoing archive of photographs, plays to Ry Cooder's song 'Ain't you glad (that things don't talk)?'[2] For all their provisional character, the images, witty, low-key and affectionate, often wear an air of formal poise. They show day-to-day solutions to living in the city, under culture's roof; they record irreverent adjustments of habitat, the human flair for economical improvisation, for ingenious substitutions. Cast iron railings' majestic finials become spikes for lodging used lunch break styrofoam cups; a child's shoe wedges the window open a crack; a pair of crossed brooms bars an entrance. The 'perpetrators' have vanished, and it is their phantom traces that Wentworth enjoys encountering. There's irony in the words on the soundtrack, for things do talk, especially to this artist; and through

his eyes, through the subjects of his photographs and the objects in his sculptures, things speak to us too.

The idea of trailing the streets, chancing upon the meaningful and the marvellous, picks up on André Breton's procedure in *Nadja* (1923), a novel which turns Paris into a legible city where love and magic and significance lie around to hand, disposed by *hasard objectif* (objective chance) for those who have the eyes to see and respond to them. Wentworth's coincidences turn up for him, too – he knows, following Picasso, that he doesn't seek, but finds things where others don't.

The artist's response to the pattern of daily life takes the Surrealist passion for marvellous-banality to another stage of materialism. Unlike Breton, nothing transcendental or quasi-mystical brings about the actions which Wentworth's photographs praise and represent: this particular system of signs and strategies was created by individuals, circulates comprehensibly among them, and with its precarious and unassuming products, makes no special claims for itself. By recording them, Wentworth brings home the value of the disregarded – without adding a layer of pomposity, without losing lightness, without spoiling the special quality of ordinariness. The effect runs against the current perception of Surrealism, for it undermines rather than continues that movement's love affair with the marvellous and the strange. Wentworth's photographs set out to honour the mundane with minimalist restraint, and to discover the latent genius in the commonplace. By embracing human and social resonances as struck by the object, they also testify to an anthropocentric sympathy that a Sol LeWitt or a Donald Judd typically resists.

Wentworth has pointed out that anthropologists assess a civilization by the number of tools it possesses; the industrial revolution, for example, was distinguished by the explosion of inventions – tools which made tools, or which made other things work – the spinning jenny, the turbine, the escapement. London, where the artist has lived for decades, was formed by such additional, applied tooling; he sees these tools as prostheses for the modern human body, which have combined to make the shape of the apprehensible urban world. He resists alternative visions for what lies to hand. Plundering and scavenging, he reproduces the surrounding city's body parts in numerous forms, from the unmodified retrievals of

his early work (his brand of Duchampian ready-mades, like *Pair of Paper Bags with Large & Small Buckets* (1982) and *Houdinium* (1983–84)), to a more recent emphasis on welded, cast or assembled artefacts (*Other Dynasties* (1986), *Preserve* (1987–88), *World Soup* (1991)). An absorption with forms, evolved over time out of practical considerations, has been consistent throughout; Wentworth's aesthetic stands in line with the modernist devotion to function-led simplicity.

'History,' he says, 'is probably like a pebbly beach, a complicated mass, secretively three-dimensional. It's very hard to chart what lies up against what, and why, and how deep. What does tend to get charted is what looks manageable, most recognizable (and usually linear), like the wiggly row of flotsam and jetsam, and stubborn tar deposits.'[3] This natural metaphor leads to the cultural – to the tideline of washed-up things and bits of tar, a substance which lies like a hyphen between natural and manufactured, being the most commonly available sealing substance of the container, of the boat's seams and the house's roof. (In 1981 he made a piece out of tar – *Black Puddle, White Dip*.) The image of the tideline also reveals Wentworth's search for the uncharted arrangement; dispositions which do not strike the conventionally trained eye. This is key to his sculptures' often riddling character: the juxtapositions and combinations propose an alternative formal system, turning the invisible into the visible, the humdrum into the significant, ground into figure, the dumb into the telling. His buckets, ladles, ladders, water tanks, doors, strainers, ballcocks, dibbers, crutches, tins, tubs, plates and sticks are dumb things which have achieved significance, been articulated in sculptural sentences and thereby made to talk (see, for example, the compressed and politically resonant work, *Unmatched Pair (Jerusalem)* (1986), p. 47).

II

These sculptures' talk is of course elliptical. The works often seem to be teasing the viewer, making improper suggestions which ask to be quelled – and then not. They first invite attention to the object or objects; they make their form visible, so that a rhyme sounds between a ladder and a crutch and springs a surprise on the viewer, because perception normally follows the teleology of an implement, seeing only the downward thrust of the crutch and not the possibilities of ascent implied by its form. Wentworth

treats the geometry of his found objects with a concentration that amounts to reverence, but he also likes to shift the emphasis from their purpose towards other possibilities. He was delighted when his younger son began using a saw with great energy – to produce piles of sawdust.

Topsy-turvy harvests could be merely cute. Wentworth's alterations of received meanings reach much further than that, with both disturbing and oddly satisfying results. By skewing the perception of an object, he helps sharpen the sense of *haecceitas*, of the this-ness or quiddity of things, which Duns Scotus defined in the 12th century and Gerard Manley Hopkins dwelt on for inspiration. Hopkins is looking at phenomena like Wentworth does, when, in 'Pied Beauty', he praises:

Landscape plotted and pieced – fold, fallow, and plough,
And áll trádes, their gear and tackle and trim.
All things counter, original, spare, strange…

This-ness is not, however, allowed to rest within its own boundaries: we can admire the beckoning shiny bowl of a soup ladle and other gear and tackle and trim put to work in the sculpture, but the ladle is up to something beyond itself (see *Fable* (1988), p. 54). And often, though we sense it is indicating meaning, we do not quite know what it might be. Wentworth likes concealment: works like *Lair*, *Housey-Housey* or *Cahin-Caha* literally throw a veil over some thing or hide another under a carpet; others stuff or plug or otherwise cancel the desired serviceability of shelves or chair.

Such enigma arises from language: the objects baffle like a page from a foreign newspaper, where some recognizable bits surface while the rest is legible but incomprehensible. One of the earliest stories about language – perhaps the earliest? – uses the metaphor of building with brick and mortar, each brick a word, each course a sentence, each storey a story, even, as a great tower of universal, mutual transparency grows upwards: the dream of the Tower of Babel is the dream of a single human language, and the angry God of Genesis can't accept the power it implies, so he 'scatters' the builders (Gen. 11:1–9). Utopia, then – one people, one language, one structure made of baked brick; and afterwards, here and now, nothing but Babel and babble, dissension and difference. These clashes in contemporary life tighten

the tensions in Wentworth's work: he leans towards utopia in an urge to restore ruins, to produce an alternative coherence; he pays loving attention to elucidating differences in the prevailing confusion and dirt and makes such differences register with due, fresh value, to set small fires burning in the pleasure centres of the mind. In this respect, he stands closer to Joseph Beuys's acts of magical healing memory than to Duchamp's ironies, though the cool temperature of his work makes him the latter's closer kin.

There's a kind of hidden, pre-Babel, babbling play-language of things in the sculptures; Wentworth has given pieces titles like *Unpronounceable Object*. These titles seem to offer further clues but not solutions, though in their terse, precise quiddity they sound like random entries in a language vocabulary test: *Graft, Staunch, Pent, Dag, Nil By Mouth, Aqueduct, Lure*. They add a term to the riddle, but it still doesn't yield an answer like a crossword or a rebus (though there are elements of such games afoot). They continue to tease – the pleasure of them often lies in this teasing arbitrariness, which isn't imposed or asserted, but produced gently, surreptitiously, even slyly. Wentworth says that making them feels like 'walking backwards through spoken language'.

<div align="center">III</div>

Recovering everyday tackle and gear and trim belongs to the same aesthetic as the fundamental disavowal of monumentality, of Euclidian form and Vitruvian proportion. Yet would it be possible to pose the question, along the lines of Anne Wagner's article about Rosemarie Trockel, 'How masculist are Richard Wentworth's sculptures?'[4] The stress on *homo faber*, the love of tools and gear, the passion for naming and the interest in sorting and applying – do they add up to a variation on the master sculptor's role? Or do these expressions, with their rejection of heroic scale, of champion feats of forging, casting and carving, their domestic attachments, confidingness and intimacy, rather define themselves against the tradition? Wagner argues that Trockel, far from espousing femininity with her brooms and knits, mirrors and garments, is playing with the commodities of modern life in a mode that's much more mordant than some of her feminist partisans would claim. Through a similarly inventive, contrary-minded repertory, Wentworth avoids

obvious male-bonding or even male breast-beating; his work's points of identification lead out of the gender corral, in open and conscious dissent from Great Forefathers like David Smith and Henry Moore. He would rather claim affinity with Claes Oldenburg, especially the Oldenburg of the 'soft sculptures', the hanging drainpipes and floppy icebags; their good-tempered biomorphism acknowledges frankly and humbly the limits of human (male/phallic) aspirations. While achieving presence and scale and other traditional sculptural qualities, they remain offbeat, modest in their inviting – embraceable – plasticity.

Oldenburg's tongue-in-cheek prods at sculpture's traditional mastery (its 'phallologocentricity') brings his brand of American Pop Art into close sympathy with the European post-war generation of sculptors, Italians and Germans for whom the language of the heroic body had been politicized beyond retrieval by Fascist uses. Giovanni Anselmo and Mario Merz, Eva Hesse and Joseph Beuys turned to provisional and transient assemblies of hybrid elements in their contempt for the Hitlerian and Mussolinian aesthetic of portentous, classicizing, eternal anthropomorphy. Wentworth belongs in spirit to this revolt: one in which white marble can only appear with an ironic twist (a lettuce leaf for a laurel wreath).[5]

Wentworth especially likes things which are called by the stuff they are made of: a rubber, a glass, a straw, a tin, a cork, a cane, a chalk. Sometimes, he uses 'raw', 'pure' materials – linen, silver – setting their elemental, pristine qualities in counterpoint to some manufactured, 'cooked' ingredient. When a natural substance, like rubber, has been vulcanized or otherwise treated, Wentworth will sometimes recall the fact of its mutation in the work's name: in *Animal, Vegetable*, the house stands for the animal element, the tyre for the vegetable – both thoroughly distanced from the natural by technical processes. Often, he inclines towards galvanized metals, alloys and plastics, and he likes to make further combinations, stretching affinities, creating unions. When he looks for an apt metaphor for these combinations, he chooses 'emulsion' – the elements bind but do not lose their distinct character. He has said, 'I live in a ready-made landscape, and I want to put it to work.'[6] He questions with his fingers the intrinsic character of materials; touch at times feels more important to him than sight. A tenderness towards things and their placing

(slippers for the ghost house) fills Wentworth's forms. Fascination with the manufactured objects produced by *homo faber* has also inspired work that incorporates an array of utensils, tools, vessels and furniture, both industrial and domestic, as well as a whole range of metals and fabrics. He acts like Robinson Crusoe, his desert island the ghost house of late consumer culture, which he roams to find what can be turned 'serviceable' again, made to make do.

This-ness means here-and-now-ness, too. In 1993, the artist wandered through the streets of London taking more photographs, shooting billboards advertising rum and holidays abroad. Such imagery 'can change the temperature, wallpaper the world with proposals of escape which are confusing,' he says. The flux of images in contemporary life and the scrambled messages of consumer stimuli have accumulated and produced an affectless continuum, which has been defined as the postmodern condition. 'We can beam everything up,' he says, 'even though we can't really be there – it's the difference between listening and hearing.' To this, Wentworth opposes the individual presence of forms, often anchored, sometimes skied. They do not evoke by simulation: his things are themselves. When the world is filled with images, art reclaims the thing itself; when the experience is permeated with mediated pictures of a fabricated elsewhere, resistance concentrates the artist's mind on that which is present and real.

Fable, 1988

Yet the real object, he then finds, will not remain stable; even the most commonplace bucket, broom, chair or table conducts meanings that lie beyond appearance. Language tends to metaphor, not description; its visual representations similarly lead elsewhere. The artist also recoils from the metamorphoses routinely wrought in

contemporary imagery, from the canny jokiness of surreal advertising and the squashy, fluid shape-shifting of Disney cartoons imitated by some sculptors; he seeks to expand the virtuality of the object, to keep faith with it, not to denature it or pervert it. He's aware that this fidelity to implements and their integrity could seem folksy, that a nostalgia for visibly crafted objects and the lost world of universal coherence to which they once belonged might well appear to be his motive, as he trawls through house clearance yards and reclaims old lightbulbs or zinc bathtubs. But he's no throwback ruralist or even Adorno-like artisan, renouncing capitalism's megalomania for handicrafts. His allegiance to ordinary things springs from his quixotic, affectionate relation to the world. He likes Jacques Tati, especially the Tati of *Playtime* (1967) and *Trafic* (1971) and claims him as an influence, alongside much more barbed and sombre observers of the urban scene like Brassaï. Comparing himself to a dog, he says he 'sniffs out what is essentially opaque and resistant'; he then lives with it in the extraordinary jumble of his studio as if with a lot of prize bones waiting to be dug up again and played with and savoured and put back into circulation.

Parts of his studio, mantled in a kind of brown soot rather than dust, look like premeditated still lives – quiet, fierce statements about decrepitude and time; elsewhere, as in a prop room of an abandoned film studio or the backyard of a junk shop, stacks of oddments, of cupboards and galoshes, bicycle wheels and coal shovels, funnels and folding tables defy all laws of category and order. But they are waiting to be assigned their parts – sometimes it happens, sometimes it doesn't. Richard Wentworth doesn't know, and he seldom makes a plan. 'It's as fumbling as that. I like the world revealing itself, I like aberrations, I like seeing the road dug up, I like being reminded that we're just a collection of plumbing though we can't see it.' He also sometimes talks of mudlarks – boys in the banks of the Thames, recouping debris exposed by the ebb of the tide.

In the resulting sculptures, the pall of dust has been lifted, the mud washed away, the jumble lucidly sorted and the soup of leftovers reversed back in time to basic, pristine ingredients. Though Wentworth's sculptures never look romantic, they share one thing in common with romanticism: they partake of ruins in their character, ruins restored, consecrated, by

representation as art. One of the very first things he really wanted when he was a child was a cast numeral from a tree in the school grounds that had been struck by lightning.

Yet he rejects any look of ruin, or of repair. Few of his works, however unaltered they appear, actually reveal their long sojourn among the studio lumber. His desire drives towards the symbol of the tree, as conveyed by its unique number, not its image.

<div align="center">IV</div>

Two principles seem to prompt his decisions to make a particular work out of the surrounding detritus and disorder: first, the aesthetic choice of a form which challenges tradition out of the very heart of tradition; and secondly, the object's potential in a semantic code. The point of Wentworth's ladders and ladles and buckets is that while they are new, often tool-made and mass produced, they could also be very old; as shapes they have been around as long as the pyramid and the column, and longer than the dome. They have, in all their humdrum and throwaway character, a claim to antiquity as legitimate as the great monuments of civilization. As such, they offer an alternative glossary of form, without the noble breeding of their more famous counterparts in the tradition of art.

Curators as well as artists are becoming more sensitive to the existence of such rich formal material, and have begun exhibiting 'low' vessels in amongst 'high' art – the oil jar next to the kouros. The Boymans van Beuningen Museum in Rotterdam has opened a wing dedicated to vernacular design – household equipment of every kind from baby bottles to vacuum cleaners.[7] In a fine essay on Wentworth's work, written for his Lisson Gallery show in 1986, Ian Jeffrey commented, 'If [his] art is like any other art it is like that of de Hooch, a plain dealer in gutted fish, hand pumps, door latches and apple peel, as well as TIME, LIGHT, SPACE and GRAVITY.'[8] In the domestic decorum and tenderness of the Dutch master painter of interiors, Jeffrey defiantly found sympathy with a leading exponent of Goldsmiths' modernism. Yet the modest objects and instruments whose meanings Wentworth bends and alters belong in a sign system of his own devising, and this takes them into a very different realm of representation from the 17th-century painter. The

endurance of such forms as bottles and tubes, tubs and dishes fits them out to function as symbols in a private language, small-scale, succinct, non-invasive, not button-holing or hectoring, intensely felt. The artist doesn't make many visual puns in the manner of Picasso's famous *Jug with Two Apples* (1920), though *Cumulus* (1991), which shows a ladder ascending to a glass shelf of white plates, rhymes on ascension and heaven with a similar light mimicry and economy of means. Generally, however, Wentworth's works play with linguistics' building blocks of signifier and signified, leaving aside anthropomorphic resemblance. He used to incline to pairing – a torch lain on one crisp white pillow, a cold chisel on another beside it (*Early Hours*, 1982), or a rock and a paper bag side by side (*Domino*, 1984); these encounters can suggest couplings, with a hint at absurdity and clumsiness. But they also confront harder issues. *Unmatched Pair (Jerusalem)* (1986) consists of two buckets, welded at their lips where they touch, apparently identical and equally full – but one reaches the height of the other only because it is raised on a yellow cloth. *Fable* (1988) – a shiny bowl set high up, out of reach, contents out of sight from a tall ladder set askew – hints at a different, equally cryptic story of frustration and longing. Such juxtapositions of familiar and dissimilar objects give birth to a third presence, a ghost beyond visibility.

In order to give sense to things, Wentworth plays with weights and measures and gauges and their various systems of notation. The terms of measurement appeal as another language; they are necessarily encoded (it has been a while since the Emperor of China weighed an elephant by first loading the animal onto a barge, marking the waterline, unloading the elephant, piling stones on to the barge until it had sunk to the same level and then weighing the stones one by one). One series of sculptures uses the large, childish faces of dials on scales in conjunction with lightbulbs – there's a conundrum there, pointing to the limits of this particular measuring system. One element, light, won't register like earth or water, either of which would tip the scales. The artist has also often alluded to Mercator's projection and Fahrenheit's code for temperature, and has included globes and tape measures and rulers in other works. These ways of measuring substitute one sayable term for something unsayable – they provide an answer to the puzzle of how to communicate phenomena,

how to speak of heat or cold, how to map the curving world – in short, how to turn the ungraspable into the coherent.

Incoherence tantalizes Wentworth – he wants to touch bottom in it, because, if he can, it will cease to be incoherent. 'I looked more closely,' he wrote to me, 'at the stand of Made-in-China paraphernalia in my newsagents' – notes from the Bank of Toy, plastic coins, fighter planes, dinosaurs, toy guitars, Diana dress-up dolls, Wild West figures, wild animals, doctor's sets – extraordinary for their cultural mixtures, gender divisions, modesty, cheapness and crudity/nominalness. Old-fashioned, one might say, a basic repertoire of playthings which will run and run. I haven't done anything with this probably because they're already ciphers, at one remove from the real thing. Knowing where they're made makes them even stranger.'

Just as children can learn a language which will tie any grown-up's tongue in knots and baffle our brains – Chinese, Xhosa – Wentworth takes up the position of such a stranger, sorting the confusion, finding rhyme and reason in the incoherent. And likewise, just as a child can deploy a symbolic world in the microcosm of a game – take a compact powder mirror for a pond, a twig for a tree, some leaves for dishes and grass tufts for food and their dolls are having a picnic out in the country – he plays at assigning meanings to those things that are counter, original and spare. 'Pretend', used as a noun, is one of Richard Wentworth's coinages, as though it were 'art' or 'sculpture' or a way of being: 'Do you think animals have pretend?' he asks. Part of pretend is assigning names to things, arbitrarily, as part of the game's internal rules. He's both repelled and attracted by this non-sense, meaninglessness at its most mind-numbing yet also play at its most pure. In Japan, he noted that 'when a garment or a product doesn't have a name, it's called *sambichi* – which means "lonely".' He also observed that English is used as a code there, partly to signify belonging in a Western cultural order – words with no referents, as in the slogan, 'Let's go sports for the spirit city!'[9]

Many of the old words for games and play are the same as the words for joking, and they're related to juggling, too, as in Latin, *iocare*, or Old French, *jogler*. Juggling was the art of the *jongleur*, the travelling tumbler and acrobat who also told stories and sang songs and entertained audiences

with jokes, like the stand-up comedians of today. Wentworth's 'pretend' juggles words and things, stories and presences, using sleight of hand to put small and ordinary objects in the place of larger concepts (his line of flags – steel chairs on the roof at crazy angles – for his 1991 show in Copenhagen was an inspired variation). He brings experience down to earth, just as children will play on the floor, but he keeps its mysteries, too, as children also do, knowing in their heads exactly what is going on, impatient with newcomers to the game. There's nothing like a secret language for enticing someone on the outside in.

His work can be laconically funny, showing a dry wit, as in the early *Babar and Celeste* series made of transfigured dog dishes, or the office chairs threaded with a pair of hanging balls (*Lightweight Chair with Heavy Weight* (1983); *Siege* (1983–84)); or, in *Neighbour, Neighbour* (1988), where two of his signature houses, suspended in mid-air, are screwed up together with a single layer of insulating felt squeezed tight between their adjoining walls. Sometimes his cunning permutations strike a darker note, even while they still wear the strolling player's insouciant air: in *Hurricane* (1987), a wire basket of old lightbulbs is plugged with a thick, solid slug of concrete, lying menacingly close to the level of the bulbs – a conflict of textures, thin against thick, fragile against impervious, conveying with deft metonymy the destructiveness of the freak storm that year. Similar materials, but with added bulbs and a thinner crust, evoke the catastrophe of Chernobyl (*Preserved* (1987)), when the radioactive wasteland was entombed in concrete.

Elucidating Wentworth's artworks can feel like a betrayal of their fundamental qualities of allusiveness and tact: am I manhandling them to make them shake out their secrets? It seems oddly apt, in this context, that the Chinese ideogram that most looks like a child's drawing of a house – *He* – does not carry a primary meaning of 'dwelling', but signifies 'closed' or 'shut', or, when it is a verb, 'to join' or 'combine'. This ancient cipher of a shut house symbolizes the fundamental processes of Wentworth's sculpture, the building blocks of his art. His work combines elements to propose an alternative, private, invented ideographic language, using domesticated, common things which somehow retain their secrets. It compels in the same way as a closed door, exciting curiosity, invites entry; as an empty house still stirs.

KIKI SMITH

Self-Portrait as a Beast in Eden

Play (Serpent with Apple III), Play (Serpent with Apple IV), Play (Serpent with Apple I)
2000

Praise to you, my lord, with all your creatures...
Praise to you, my lord, for our sister the death of the body
Which no living being can escape...
ST. FRANCIS OF ASSISI, 'CANTICLE OF THE SUN'

If a questing heroine does a kindness to a tree, a stream, a stone or a cow, a bird or a wolf, the logic of fairy tale means that she will find them at her side when she is in need: a golden tree will shake down dresses for Ashputtel to wear to the ball and the magic speaking horse, Falada, will warn the little Goose Girl of danger – even after he has been beheaded.[1] In probing bodies and their transformations, Kiki Smith has gathered about her a rare, rich collection of companion-helpers, finding them in medieval bestiaries, folklore, fairy tales classic and modern, legends of the saints of the Catholic church and world mythology.

From her earliest works, Smith has been building her own city of ladies, thronged with great foremothers – Lilith and Eve, the Virgin Mary and Mary Magdalene – and teeming with gangs of girls and young women, such as Daphne and Psyche and virgin martyrs from her Catholic childhood. Animals also keep the artist company: deer, monkeys, cats, cows, lizards, wolves and birds, even the dodo and the walrus from *Alice's Adventures in Wonderland*, which she has cast, sculpted, drawn and etched since the early 1990s, form a new mythological bestiary for our time. They promise a return to the prelapsarian harmony of all created things, forming a symbolic self-portrait, the artist as a New Eve as painted by William Blake, echoing the idyllic passage from Isaiah 35 about the golden age – although in Smith's imagery, an ominous presentiment of the future casts a shadow on the luminous vision.

As with amulets worn close to the skin, these imaginary friends, accompanying daemons and alter-egos – from goddesses to monsters, the wolf to the crow, the moth to the worm – have moved with Smith through experiences and dangers, tracing out the paths of allegiances and shaping identity. They do not threaten her with loss of selfhood (according to the direst view of metamorphosis), but bring about regeneration

– even resurrection.[2] With them at her side, she has confronted hideous possibilities and dealt with adversaries and harm, separation and grief.

Smith's evolving concerns with physical transformation have moulded her art for the last three decades; this dynamic carries her early curiosity about every kind of bodily process and her more recent absorption with girl heroes, animals and the question of the animal in the human. Alongside the writing of contemporaries such as Anne Sexton, Margaret Atwood and Angela Carter, she has recast the population of the mythic and fairy tale imaginary, especially where women and she-monsters are concerned, releasing them from the boundaries of the stories as conventionally told. Instead, she transforms her subjects in opposition to ascribed values, putting them to work fashioning a new beauty and a novel ethic from the rubble of Judeo-Christian taxonomies of good and evil, pure and impure. She has admitted, 'I'm stuck with it [Catholicism]. I've always been spiritual. That's always been the most important part of my life, thinking about God or Gods.'[3] But she has not adopted one God or one creed; instead, she roams through them hungrily. She has made a naked Virgin Mary, flayed and bleeding like a medical *écorché*, the mother of God stripped of her immaculate state of exception and become flesh and blood, a woman like any other. She has claimed the serpent from the Garden of Eden as another kindred spirit, and in a sequence called *Play* (2000), she chose the alert, small lizard-like tempter with a woman's face from Hugo van der Goes's 15th-century painting of the Fall and gave the tempter her own features in drawings, first made on a tissue-like paper from Nepal (p. 60) and later transferred in metal paint on glass panels.

She practises a storyteller or fabulist's art, putting narrative to magical use in the making and unmaking of the self and others. As in Ovid's great narrative poem, the *Metamorphoses*, the flux of phenomena has drawn Smith to examine the stuff of the world and its variety of creatures; like Ovid, the intense form of attention she gives her subjects transfigures them. While physical entropy dominates much current art and thought on the natural life cycle of generation and decay, and can lead to a form of existential acedia, Kiki Smith's art pulses with the energy of renewal. She once remarked to her fellow artist Chuck Close, 'You have a certain

Untitled, 1989-90

amount of regrowth. Like reptiles whose tails grow back, or a worm cut in half. We don't tend to think of that, regeneration.'[4]

Through the energy of her metamorphic imagination, the artist seizes hold of a subject and transforms its meaning and its value. She has 'dis-covered' stories, and from the body parts and narrative fragments has pieced and patched them together into 'a ruptured whole'.[5] An entire cast of protagonists, almost exclusively female, has been filled with a new vital sympathy: traditionally scorned and repudiated figures such as sirens and witches and harpies have gained value and positive power. Smith's works of metamorphosis set off a chain reaction, sparking in the minds of her viewers further changes in our ways of seeing and understanding the embodiment experienced by all living things in the world. She has dived deep into zones of abjection, but neither horror nor repulsion is of interest to her as a response, even though several early works leaned toward the grotesque and shocked and stirred viewers.[6] Increasingly, her ongoing chronicle of life-forms seeks to realign physical responses with physical phenomena and to foster a new, creaturely empathy – making a mandala of crystal sperm, for example (see above). Even when conveying profound negation, such as in her works that deal with miscarriage, Smith maintains a spirit of energetic contradiction, rejecting any final denigration of existence. She has improvised with flair and inventiveness to realize her tranformative vision, adopting different materials and applying an astonishing array of methods and approaches; her artistic practice shows the bold and spontaneous spirit of play.

Kiki Smith has said that her way of making art is also a form of playing. She remembers how as a child she 'always made things…I'd make little shrines and mummies for dead animals that I'd find, put necklaces on them, and sew them into little sarcophaguses, then bury them.'[7] Her mother, the opera singer Jane Smith, remarked that Kiki making 'a shrine to Mother Mary', as well as carving boats and 'incredible dolls…. Actually she's doing what she always did.'[8] Smith has never had a separate studio: her dwelling – her house, her home – has always been her work space, and her inventiveness flows through it from kitchen to living room, from the glass doorstop (cast in crystal from a drawn tooth) to uncaged birds – thirty doves and finches used to fly freely in her bedroom. She has frequently remembered how, at home in New Jersey when she was young, she and her two sisters folded paper maquettes for their father Tony Smith's sculptures. This training in discipline, dexterity, routine process and formalism took place at the kitchen table, again without interrupting the continuity of mind-body, *fantasia* and *physis*, the essential bonds between survival of the flesh and of the spirit.

In an essay entitled 'Morale du joujou' (Moral of the plaything), the poet Charles Baudelaire refers to toys as *cette statuaire singulière* (this unusual statuary) and likens the child at play to an artist at work on creating. Baudelaire marvels at children's ability to play without props or models, through fantasy alone: 'All children talk to their toys; toys become actors in the great drama of life, reduced by the camera obscura of their little brains. Children bear witness through their games to their great faculty of abstraction and their high imaginative power. They play without playthings.'[9] Significantly, Baudelaire goes on to make the connection to creativity: '[The child's] facility to satisfy the imagination shows the spirituality of childhood in its artistic conceptions. The plaything is the first initiation of a child to art.'[10]

For influential 20th-century psychologists such as Jean Piaget and D. W. Winnicott, playing forms reality for each of us.[11] Winnicott put play at the heart of mental and social development: 'playing…is a basic form of living',[12] he asserted, '*It is play that is the universal,* and that belongs to health.'[13] Several artists, including Kiki Smith, who have come

to be regarded as formative figures of a certain contemporary aesthetic, have grasped this affinity and developed ways of making and playing through mixed media, mess, masquerade, games routines, beach-combing, bricolage and Wonderland distortions of scale. In particular relation to Smith's art, one could mention Joan Jonas, a friend as well as influence, and Carolee Schneeman; but also, cited less often in her regard, Meret Oppenheim and Paul Thek.

Smith's eclectic methods refuse to sever the connection with a child's powers of fantasy; she still realizes imaginary friends in imaginary scenes using whatever is at hand, transforming the humdrum into the marvellous (a table into a castle, a cotton reel into a chariot, a twist of rag into a baby). As in make-believe, she improvises with the stuff of ordinary living: she likes wax, glass, cloth, paper; with a bower bird's serendipity, she will stick broken twigs into plaster as branches for her *Daphne* (1993) as if making a scarecrow; she will tuft a figure with fur and feathers; she will bead, stitch, tear, puff and crumple her materials and embed them with salt, crystals, jewels; she will select and thereby transmute paltry, even despised street and household items (doilies, detritus, souvenir figurines, tattoo parlour patterns).

Her work's incarnational imagery appeals to the whole sensorium of the beholder: it arouses visceral sensations of pure pleasure, through texture, smell, taste. Light, creased paper has qualities of translucency, ductility and strength-in-fragility; glass casts a glow in lustrous colours; touches of gold and silver add glints to enhance this piece or that. As in child's play, skin becomes an organ of creativity. The tactile sense dominates, aiming past language, past story, past argument. Smith also sees her work as belonging to the lineage of women's work and the domestic sphere: 'I always say that everything I make is my dowry.'[14]

Using fragile, corruptible, everyday materials, Smith peoples her world with despised, relegated outcasts. Although the art often radiates grandeur in scale and theme, its vision is grounded in a love of humble, quotidian forms and processes. It's interesting to note in this regard Walter Benjamin's observation that in the past, the most ordinary business of survival, the routine tasks undertaken from day to day, were the special 'nesting-places' of the storyteller.[15] Smith increasingly acknowledges the limits of representation;

her images do not claim to surpass life through art's power, but only to stumble after organic vitality with every clumsy means at her disposal.

<center>II</center>

Play-acting, from children's games to religious rituals, involves symbolic impersonations and enactments of memories, hopes and dreams. Smith's host of imaginary personae and scenarios raises the fundamental role of Catholic thought in her art: she works through the body and through sensory stimuli, baroque in their diversity and gorgeousness. Incarnate images constitute all her raw materials, but as in the mystery of the Catholic mass, body turns to symbol without change of outward appearance, metamorphosing through transubstantiation (the miracle of the Eucharist) into something beyond its enfleshed reality. All flesh is resurrected through her art, but as aesthetic meta-flesh, packed with passion and meaning and resonances over time, like a relic arrayed in the treasure trove of the world, in gold, glass, gems. 'Catholicism is always involved in physical manifestations of spiritual conditions,' Smith has said, 'always taking inanimate objects and attributing meaning to them. In that way it's compatible with art.'[16]

The most ancient surviving inanimate objects made by human skill are sculptures, and though damaged and missing arms or noses or heads, statues from Sumer, Babylon, Assyria, Egypt, India, China, Ancient Greece and Rome and even Old Europe demonstrate the survival of art in what feels like a magical affinity with eternity. Smith shows supreme sensitivity to this legacy: she has risen to its monumentality by emulation, creating larger than life-size figures. She has reforged and recast new divinities and Olympians, and these standing, often hieratic effigies, gleaming in wax or cast in chalky, matt plaster, possess a ghostly supernatural stillness that recalls the Egyptian funerary pantheon and *korai* of classical Greek statuary.

The sculpture *Lot's Wife* (1996) was made first in salt, then cast in bronze and patinated to resemble salt, then studded with rock crystals. The Old Testament story that inspired it – it is one of the very few metamorphoses in the Bible – relates how angels accompany Lot, his wife and his daughters out of their homes in order to escape God's destruction of Sodom and Gomorrah (Genesis 19:1–28). The angels forbid the family

to look back; Lot and his daughters obey, but Lot's wife cannot prevent herself, and when she does turn to look, she is blasted, changed into a pillar of salt. We are not told her name. In interpretations of scripture, her act is seen as yet another case of female weakness and curiosity; she is also condemned for showing a love of worldly things, of attachment to pleasure and vanity. But Smith has perceived the tragic power of this episode about an anonymous woman who is principally known for her lapse and her punishment. The crust on the sculpture also recalls foam that has been calcified or reduced to residue, like the deposits on the Dead Sea's shore; and because Aphrodite's name derives from *aphros*, Greek for foam, Lot's wife becomes Smith's anti-Venus, with maimed limbs and an incinerated body. The artist hallows her act of disobedience and brings her to our consciousness as a tragic symbol of conflict and destruction. Like the figures who emerged from the lava of Pompeii, like the shadows of Hiroshima's inhabitants seared into the walls of their houses, this woman stands in her burned body like a woman on the road in Gaza or Iraq today.[17]

III

The passage from mineral and earth to flesh and blood – or vice versa, as in the case of Lot's wife – contradicts instinctive feelings about proper categories of material phenomena: the inert sparks into life, the organic is stilled into stone. These two poles of metamorphosis – quickening and petrification – hold creation myths in tension. These stories also bear on artists' creativity: for example, in the *Metamorphoses*, when Deucalion and Pyrrha, the only survivors of the Flood, are ordered by the gods to toss rocks over their shoulders, the rocks spring up as a new race of humans to re-people the earth. But Ovidian stories of petrification also run the other way, and include cruel acts of revenge and sexual assault: Apollo and Diana strike down Niobe and her children and they are changed into statues as they flee; Medusa the Gorgon turns to stone anyone who looks at her eyes.[18]

In 2003, Smith travelled every week to a foundry, the Johnson Atelier in Hamilton, New Jersey, to continue work on several bronzes in production there. These included a life-size naked bronze female figure,

cast from the living body of a close friend. Standing upright in a formal posture, the sculpture recalls once more the stiffness of Egyptian or Archaic Greek statues. Smith conceived this colossus as 'Medusa', owner of the gaze that turns everything to stone – or, to put the story differently, that changes living beings into art, for the life cast becomes a statue, the very process that this sculpture enacts. The time I went with her to the foundry, she had brought with her raw diamonds to set in her Medusa's eyes: this mythological figure was no longer to be a monstrous Gorgon with lolling tongue, tusks and snaky locks, but rather a totem of creative female power.

Nevertheless, the art object's intrinsic lack of animation enfolds a troubling conundrum that lies at the heart of representation: what can Medusa's diamond eyes generate? Ovid returns to the question again and again, and with his triumphant final word, *vivam* (I shall live), he defies death through the permanence of the words he has shaped into the poem. But he is also aware throughout his poem that life is brief; it is only non-life and non-being, the mineral eternity of Medusa's objects, that partakes of the immutable character of a work of art.

For this reason, Smith also contends with sculptural ideals of stability, timelessness and fixity: discussing the stilled quality that results when casting from the face, she has described how 'the single moment...makes a kind of stiffness.... There's something dead about it, especially when you go from the cast into metal. Bronze is a dead material, so you have to have some kind of texture to make it live.'[19] By embracing figurative, narrative imagery, the artist is running against the current; refusing to work in marble, she is also turning away from the most valued material of traditional sculpture. She rebels against the endurance of stone when she chooses instead the resilience of paper, especially the fabric-like varieties which have been hand-milled in Japan and Nepal; she opposes the standard ideals of hardness and imperishability with the softness of wax and other deliquescent raw materials. She has hollowed bodies out of their structure, unstitched the skeleton from its own musculature, suspended male and female bodies like coats from a hanger, strung a paper doll of herself to a puppeteer's rods and explored floppy, flaccid forms as well as drips and leaks, spills and effluents. This lexicon of slop and

droop confronts with rueful wit as well as strong feeling a male – even strictly patriarchal – legacy; it constitutes a self-portrait of the artist as a female animal. Such aesthetic choices communicate the difference of her subject matter. The old gods have been deposed and, in their stead, just as salt and wax have supplanted granite and porphyry, a new Juno squats before a spread fantail of peacock's eyes, figured as amuletic vaginas; Lilith crouches and the Virgin Mary displays her silver veins. In another incarnation, the Mother of God usurps the place of Jesus in the sacrament of the Eucharist, offering her body to be consumed: the votive candle burning in front of her is inscribed, 'Take and eat – this is my body' (*Silent Work* (1992)).

<div align="center">IV</div>

The question of mortality reveals Smith's profound sacramental artistry and spiritual commitment. For the symbolic imagination has limits, and these are co-extensive with art's illusions: the work it can do fails before that supreme (godlike) act of creation, animating the inanimate. A state of lifelikeness, however brilliantly done, can't become life itself – except in fantasy. The art object's eternal horizon cannot command the true mutability of life itself; its freezing of time makes it lose that metamorphic nature that is the essence of vitality.

Kiki Smith's emblazoning of human bodies has been assiduous: with a lively, unspoiled faculty of wonder, she is drawn to the natural capacity of bodies to change – to shed, to bleed, to grow (hair, nails), to scar. This work has led her to the wider field of natural history and biology, for animals' powers of natural metamorphosis far surpass humans. Smith has made drawings and etchings of *White Mammals* (1998) – those creatures that spontaneously turn white in winter, to conceal themselves in snow and ice against predators. Reptiles sloughing their skins attract her (like the female lizard in *Serpent* (2000)). For various artefacts and installations, she has also created butterflies and moths – species that can change their skins and their shape and still not lose their identity. Like Albrecht Dürer, whose draughtsmanship has influenced her profoundly, she studies animals in close-up, reproducing carefully the swirls and eddies of fur, the quills and colours of feathers.

Throughout her career, this scrupulous gathering of physical intelligence has meant that she is forced to contemplate death, and that her art, in its stillness and timelessness, has gradually become death's analogue. If that sounds morbid, it would be an injustice. For, just as Smith's figuring of the human body moves through the most abject zones but does not excite horror, so the appearance of dead creatures, bird and animal specimens – *White Mammals*, *Jersey Crows* (1995), *Black Bird* (1996), *Crèche* (1997) – do not provoke frissons or shudders.

She once had a dream telling her to make 'a Noah's ark as a death barge of singular animals.'[20] How telling this reversal is: she has taken of the Bible's emphasis on pairing and breeding in the interest of creation and survival and turned the famous story upside down, with the place of safety becoming a catafalque, solitude ('singular animals') the state of the creatures on it. Smith's fascination – even obsession – with the organic conditions of time and change leads her to accept their ineluctability at the very same time as she finds in art a place of escape from their laws. Throughout her artistic life, Smith has probed this particular frontier of art, which can arrest mortality but cannot embody or reverse it. She has evolved a mortal art, which paradoxically escapes Medusan immortality by looking unblinkingly at the vitality of dead things.

Smith has suffered several deaths among her immediate family and her friends, and it is possible that play-acting death works to keep it at bay through a form of sympathetic magic. She was certainly profoundly affected by her journey to Mexico in 1985, when she stayed to take part in the rituals enacted for the Mexican Day of the Dead. The joyous magic of the *calavera* tradition infuses her own prophylactic images, an influence she acknowledges, along with the prints of José Guadalupe Posada.

She is moved by portents of death and repeatedly includes them in her works, as if repetition could ward off the danger or perhaps transform it into something beautiful by giving visual expression to her lament. After she read in the newspaper, for example, that a flock of birds had dropped dead out of the sky in New Jersey, Smith laid out twenty-seven crows on the floor in different stricken attitudes, while on the walls female bodies were twisted and hung in effigies suggesting crucifixions and other torments.[21]

She often dreams of birds, she says. Above all other symbolic creatures, birds communicate spirit, and, as one critic perceptively commented, 'Smith has here posed plainly the perplexing question about the gender of spirit.'[22] The *Ba* hieroglyphic of a bird stands for the soul in Egyptian eschatology, and appears on paintings of the deceased at the moment of parting from the body.[23] In Christian symbolism – itself profoundly shaped by Egyptian beliefs – a dove represents the Holy Ghost or third person of the Trinity, and hovers above the Virgin Mary at the Annunciation, as the embodiment of the animating or quickening power that makes her conceive Jesus at that moment. In Greek, this spirit is feminine – *Hagia Sophia*, Holy Wisdom – and spirit can be female in gender in Latin, too, when it is named *anima*, as in the terminology Carl Jung adopted for his concept of the feminine archetype.

Winged creatures of various species have inspired images of souls and spirits, and the 1990s saw Smith approaching this folklore in myriad ways: a light sprinkling of jewel-like tin moths (*Faeries* (1993)), and a formal emblematic bronze head exhaling a single blue-and-gold butterfly (*Moth* (1993)). *Anima* also means breath, the chief sign that life itself is present, and Smith has made some exquisite drawings of birds being breathed out of her own mouth. Like the flowers that fall from the lips of Flora in Botticelli's *Primavera*, these birds seem to quiver with the essence of vitality, even though they are neither pretty nor radiant, but black and even a little battered.

The many different species of birds she has observed are also spirits of a kind, animal forms of the inner self as in Egyptian myth and, closer to home, in Native American belief. The crow, for example, is the totem bird of the Tlingit tribe, a profoundly respected symbol of wisdom and oracular knowledge. When drawing from museum collections, Smith decided to select only local American species: she was seeking to revivify the historic, local mythic associations of such creatures in their native habitat, refusing to allow them to fade into unstoried and nameless case studies for forensic science.

Egyptian embalmers sought to overcome mortality through mummification, and the faces of the dead were painted on the cartonnage or mask of the mummy, so that they looked as if they were still alive.

But when Smith sculpts and draws specimens of animals and birds in museums, she rejects the pretence of lifelikeness which has been the conventional goal of dioramas, natural history illustrators and modellers. Instead, she lays the creatures out as if in a mortuary, sometimes with the taxidermist's cotton still over their eyes. Contrary to the tradition of Dutch still life panoplies of fish and fowl, she does not ground our relation to dead animals in our appetites, or flourish them as part of an embarrassment of riches.[24] The mystery of death absorbs her, as it did when she first wound small creatures in mummy bands as a child, and she maintains her subject's actual scale – often startlingly large for a print or a drawing. Her observation paradoxically forces us to face art's closeness to the threshold of death; through such sculptures and drawings, we enter the intrinsic artistic condition of material inanimateness, which embraces death as a form of reality, equal in presence to life. It is difficult to convey how radical this is, this refusal of art's powers of deception, this bowing to the failure of human skills to stop time, decay and corruption.

<p style="text-align:center">v</p>

In 1990, Kiki Smith told the art writer Christopher Lyon that she suffered from 'the persistent idea that she was stillborn' and that her work is 'about trying to get born, trying to be here.'[25] This terrifying feeling spurs an increasing engagement with stories about survival, in one form and another, while she generates her crowd of spirit alter egos and cast of animal familiars. Maria Tatar has written that fairy tales give us 'ideas as matter',[26] and through tales such as Little Red Riding Hood and the *Alice* books, Smith sets up points of identification for herself and her viewers: a girl child wanders into the forest and, disobeying her mother, dallies on the way and talks to a stranger, or enters a topsy-turvy world where adults exercise their authority with the utmost capriciousness and injustice. These heroines are trespassers, and their trespass takes them across a prohibited boundary, gains them knowledge and gives birth – to themselves again, as in the coloured drawing of Red Riding Hood and her grandmother rising intertwined from the wolf's body.[27] Smith sometimes plays the role of the wicked

queen with her poisoned apple, sometimes casts the protagonist as herself when young, or rises, a powerful, fully-grown naked woman, from the wolf's belly (*Rapture*, 2001) – a female resurrection, a pendant to Sylvia Plath's famous poem 'Lady Lazarus.'

A magnificent bronze called *Born* (2002), as well as the fierce, lyrical, large-scale drawings of the same name (2001), show a naked woman emerging fully formed from a doe, sometimes with her arms crossed to cover her breasts and an expression of anguish on her face. The image interprets freely the legend of Genovefa, a Queen who was falsely accused of infidelity and was saved from execution when a huntsman spared her, abandoning her in the forest. There she survived six years with her daughter, nursed and fed by a doe, until the king discovered his error and they were reunited. Her story has possible historical connections, and has merged with another pastoral dream, the legend of Saint Geneviève, the patroness of Paris.

The plot of the wronged heroine reverberates in numerous fairy tales, including Snow White, in which dwarves – another kind of earth-spirit – replace the helpful animals. Although many metamorphoses present the transformation into a beast as a curse (Bottom 'translated' into an ass in *A Midsummer Night's Dream*), myths about heroes and heroines who survive in the wilds under the care of animals charge the experience with heroic grandeur: Romulus and Remus were suckled by a she-wolf and went on to found Rome. 'Donkeyskin', 'The Hind in the Wood', 'The Firebird' and many variations on 'Beauty and the Beast' relate how the protagonist gains in wisdom and strength through inhabiting animal form. Alice's adventures with beasts – fabulous like the Griffon, extinct like the Dodo or familiar like the Dormouse and the Caterpillar – have rendered her the most recent heroine of Smith's illustrations, one who inspires acute empathy when she swims for her life with the creatures while the waters rise and rise in the Pool of Tears (see, for example, *Pool of Tears I* and *II* (2000)).

Another heroine, *Daughter* (1999), a freestanding mixed-media sculpture, presents Smith's riposte to Degas's *The Little Dancer*. Wearing a real red cloak over her furry beast body, this little girl is the offspring of the wolf and Red Riding Hood's encounter in bed, the natural outcome

of Angela Carter's fable 'The Company of Wolves', which closes, 'See! sweet and sound she sleeps in granny's bed, between the paws of the tender wolf.'[28]

Smith found the hirsute Daughter in the annals of medical freaks: such hairiness was considered a visible sign of monstrosity, exceeding the limits of animality acceptable in a human being. But she never communicates prurience at such anomalies. Just as she makes the contemplation of death a creaturely act of fellow-feeling, neither morbid nor fastidious, so with she-monsters: she embraces them as cherished alter egos, part of the natural world which art can worship only through poor imitations. Her Harpies wear tatterdemalion feathers and end in chicken feet, while her Sirens are composed of women's heads on plump pigeon bodies.

An artist's acts of recuperation are also a kind of metamorphosis, communicating values. A metamorphosis can be a punishment, of course, as when Arachne is turned into a spider or Lycaon into a werewolf; but in many stories, the event also *transvalues* its subjects, and the monster or beast acquires another character by drawing new perceptions toward his or her condition. Smith's transformed beasts and monsters express her defiance, her subversion of accepted hierarchy in nature, of which female bodies are both a symbol and a part. As she has said, 'I always think that you use what is used against you, you turn it around to your advantage.'[29] Her art is charged with political, feminist, anti-imperialist currents, transvaluing formerly despised and rejected lowlife forms – insects and corpses, abject, *informe* and monstrous functions and processes and, above all, women from history, myth and fairy tale. Myths are dismissed in colloquial speech as lies and illusions, while fairy tales, even more acutely, attract condescension as childish fantasies. As John Updike once wrote, 'Folktales are not just a kind of beach glass washed up on the shore of the present day by the sea of history... their inner glint, their old life, is escapism. They were the television and pornography of their day, the life-lightening trash of preliterate peoples....'[30] But they belong to that realm of creative imagination that has been identified as the child's, which artists now inhabit more and more fruitfully, and they function as the equivalents of those disregarded

domestic skills and objects that Smith has always prized: they are the crochet-work, the tatting, the doilies of literature.

The axioms that have traditionally structured base, even loathsome living things and relegated certain categories of being to the lower strata of existence are themselves undergoing metamorphosis. The logic of the imagination might be composed of constant mythopoeic elements – as the philosopher Roger Caillois observed, certain phenomena (spiders, stars, octopus) intrinsically stir the imagination. But this logic does not ascribe fixed values and responses to the objects in question; they undergo a continual process of metamorphosis.[31]

Smith is one of several artists, writers and thinkers who are at work redrafting the story of creation, in which we humans acknowledge our kinship with animals and no man is overlord. Wendy Doniger's writings about Sanskrit mythology give an exhilarating perspective on this issue, as do the perceptive meditations of Annie Dillard and Rebecca Solnit and the poetry and natural history writing of Ruth Padel.[32] The gender of these writers – and of their precursors, Marianne Moore, Rachel Carson, Ursula Le Guin – points to the struggle underlying their sympathy: in some real sense, they have grasped the old, vexatious axiom 'Biology is destiny' and have decided not to refute it, but, like judo-acrobats taking the impact of their adversary and turning it to their own advantage, to accept it in order to draft it anew. Work in this field, as with Smith's anatomies and stories, expands the range of biological meaning itself, until biology no longer coerces species (women or wolves) into subordinate and disparaged roles. It is interesting to note that in 1983, Kiki Smith designed a poster for an event-cum-show at The Kitchen, New York, called 'The Island of Negative Utopia'. In many ways, that title catches an enduring tendency in her art: to create an inverse paradise where any negation rises into plenitude.

2. BODIES OF SENSE

Louise Bourgeois, *Nature Study*, 1996

When the poet John Donne grieves for Mistress Elizabeth Drury, he brings her up in his mind's eye so that we can see her too, through his words. His lines depend on the assumption that this was possible – as Duncan blithely says, 'there's no art/to find the mind's construction in the face' (*Macbeth* 1.4.14–15). For Donne, Elizabeth Drury's physical presence beams out her virtuous, beautiful inward processes, inner matching outer.

His final phrase, 'her body thought', means above all that her appearance was as thoughtful as her inner soul, that the division of flesh and spirit was wondrously healed in her special case. However, taken on its own, the phrase acquires a passive sense: her body as *being* thought, as the poet looks on her memory in his consciousness. His language clothes her, his verbal picturing summons her into our own minds and transports her there for us to think with her and about her, projecting her into a future where Donne envisages his poem might ensure that you and I are imagining her now.

The artists in this second part of *Forms of Enchantment* are likewise thinking about and with bodies, making sense of their own and others', ringing variations on the long tradition of embodied symbolism integral to classical and Judeo-Christian culture. The body, as they explore it, merges subject and object: the artists examine and use themselves in every facet – teeth, hair, feet, skin, blood, semen, sweat. Bodies become their theme and instrument, their representation an arena for extending and interrogating the long tradition of the female nude, for communicating values and beliefs both personal and theological and repossessing, defying, hollowing out and transvaluing long ingrained strictures about the flesh. One of the strongest developments in contemporary art

has seen several generations of artists, as they struggle with ethical issues about hierarchies in nature, seeking to forge a new language of forms to correspond with fresh approaches to knowledge and beliefs. One or two of the artists here were or are self-declared feminists; others were or are making art without explicitly joining any political or social movement; but for all of them the body remains the principal arena of debate and the chief subject of representation. They are working in ways close to Paula Rego and Kiki Smith, discussed in the last section, but the question of the female body as both personal and symbolic dominates their concerns. The body also lends itself to the artist as raw material: Helen Chadwick and Zarina Bhimji, among others, incorporate bodily leavings, hair, effluvia. The search to understand more about ourselves and our relations with one another and the world turns out still to be, in our supposedly secular age, a struggle to reach more carnal knowledge.

HANS BALDUNG GRIEN

The Fatal Bite

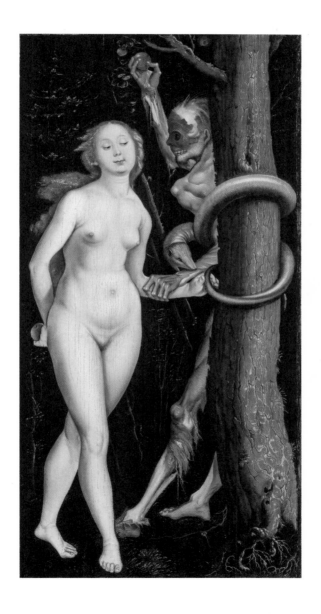

Eve, the Serpent and Death

c. 1530

Sumens illud Ave
Gabrielis ore
Funda nos in pace
Mutans nomen Evae.
(Receiving that Ave from the lips of Gabriel,
establish us in peace, changing Eva's name.)[1]
AVE MARIA STELLA, C.8TH CENTURY

The smile in art seldom shows its teeth; archaic goddesses' lips curve in mysterious pleasure and seem to bless us with their grace, but their mouths do not open. The famous merry youth in Antonello da Messina's portrait keeps his lips closed, too, conveying a private knowledge that he isn't going to impart. As for the Mona Lisa, her expression needs no comment. In the safety of monochrome stone or bronze, portrait heads by Houdon and nymphs and fisher boys by Carpeaux sometimes reveal inoffensive, small teeth, the kind usually referred to as 'pearly'. Yet these sculptors show boldness in opening the mouth at all, when no sign of salaciousness or menace is intended. For the smile can quickly flip and become a leer: satyrs grin on Greek pots and death produces its own rictus, as the medieval makers of *memento mori* recorded. In traditional imagery, bestial features – fur, nails, hooves and tails – mark out devils and their lord, who are the only beings to frequently bare their teeth, which are often exaggeratedly long and sharp. A glimpse of the interior of the mouth can be terrifying, as Francis Bacon liked to explore in his paintings of howling popes, screaming monsters at bay on the cross of the Crucifixion and twisting male figures with jaws agape. Bacon was inspired by Georges Bataille's critical dictionary, published in the journal *Documents* in 1930. Under the entry for 'la bouche', Bataille described the mouth as the instrument of animal impulses in the human creature: 'On great occasions, human life is concentrated bestially in the mouth, anger makes one clench one's teeth, terror and atrocious suffering make the mouth the organ of tearing cries…' Bataille drew the connection between the two terminal orifices of the body, mouth and anus, and reflected on how they reflect one another: 'man can liberate these impulses in at least two different ways, in the brain, or in the mouth, but the moment the

impulses become violent, he is obliged to turn to the bestial manner to liberate them. Whence comes the narrowly constipated character of a strictly human attitude, the magisterial aspect of the face with its mouth closed, beautiful as a strong box.'[2]

Like strong boxes, the apostles, saints and Christ himself look out from the golden fabric of a wall or from under the ogees of an altarpiece; it would be startling to see a grin from St Peter, the teeth of Jesus or the tongue of Mary. Bataille himself concentrates on the male form and the expression of his passions; in the case of a woman's body, however, the mouth's primary association is with her sex. The animal aspect which dominates perceptions of the female is her role in reproduction; metaphors of digestion, evacuation and defecation yield in importance before her fertility, of which her naked body is the prime sign.

<div align="center">I</div>

In the paintings of Hans Baldung Grien, the mouth – male and female – becomes a crucial motif in his personal mythology of damnation. Its primary connotations are almost invariably sexual. The male mouth, when it appears in a Baldung image, reciprocates the female, its expression influenced and even elicited by her ascribed condition. Her mouth conveys inward motives and feelings: it can communicate crafty knowingness when she half-smiles, or, when open in a grimace, it can convey intense anguish, the lips twisting downwards at the corners, as in Baldung's grim painting of around 1517, *Death and the Woman*.

Neither smiling nor grimacing preoccupy Baldung as much as biting; from the extensive Christian imagery of torments he selected this diabolical activity above all. At least three of his paintings, as well as others attributed to him, show teeth fastening on flesh. In *Death and the Woman*, the tattered skeleton, in a state of gradual decomposition, seizes the half-draped woman from behind. The swift rapacity of his attack inspires a shudder – his parted legs are so widely spread that his body could not be convincingly assembled if her drape did not conceal it from view – yet his hand only touches her lightly, under her arm, while his teeth sink into her chin in a mockery of a kiss. In *The Knight, Death and the Maiden* (1503–05), attributed to Baldung, the figure of Death grasps the

skirt of the maiden not with his hands but with his teeth, to pull her down from the horse where she is riding pillion. Although the knight is trying to retain her and she locks her arms around his waist, Death is prevailing over them.

The ghoulish rhetoric of these images loses its own bite, however, when set beside the masterpiece of Baldung's fantasy: *Eve, the Serpent and Death* (1525–30; see p. 79).[3] In this painting, the serpent is wound around a tree – maybe the Tree of Knowledge in the Garden of Eden, although its leafless appearance, the cracked bark and visible, withered roots, imply death rather more vividly than knowledge. The serpent's gleaming grey body makes another, higher loop around the trunk before its small, flat head appears, above the hand which Eve places lightly

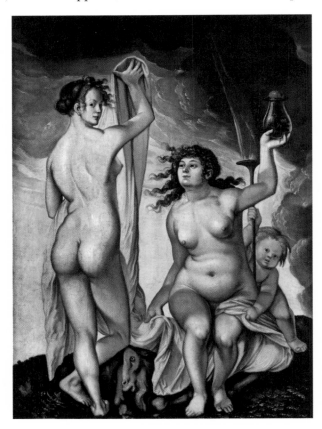

Weather Witches, 1523

on its tail, to squeeze it in a gesture that resembles a suggestive caress more than restraint. The serpent bites down, but the decomposing arm of Death, emerging from behind the tree, interposes itself between the reptile's jaws and the hand of Eve, and grips her forearm as the snake's mouth opens and impresses itself on him instead. Is this tattered flesh Adam after the Fall, already changed into a mortal man after taking a bite from the fruit which he holds up? God's curse condemned humanity to death, and Eve's complicity with the serpent, evoked here so tightly by Baldung, brought mortality upon all her children. Or is the figure simply Death personified? In Baldung's painting, Eve herself has not yet been blighted; she holds an apple coyly behind her back, uneaten.

The painting brings to dramatic visual life a play on words familiar in medieval rhetoric: that through the bite (*morsus*) of the apple, death (*mors*) entered the world, and after death, punishment.[4] One of the prevailing metaphors for the torments of the damned is consumption: in hell, sinners become food, roasted, boiled, spitted for eternity in the flames, a sacrifice that never achieves expiation. The souls of the damned devour one another, like Ugolino and his children in Dante's *Inferno*, or gnaw at one another's heads, like Gianni Schicchi. Devils bite the sufferers, too, and in the mystery plays and numerous medieval images and carvings of hell, Satan engulfs them all in his huge mouth. Peter Damian described the scene: 'There the sounds of grief, agony, weeping and gnashing of teeth, the roar of lions and the hissing of serpents: all mingle with howling and weeping.'[5]

When St Paul cried out in his Epistle to the Corinthians. 'O Death, where is thy sting?' he was echoing the words of the prophet Hosea. 'Where is your plague, Death? Where are your scourges, Sheol?' (Hosea 13:14). St Jerome, in the Vulgate translation of the Old Testament, first produced the adventitious rhyme of the Latin words: 'ero mors tua O mors/ero morsus tuus inferne.' (Death, I shall be your death; hell, I shall be your sting [bite].) In Corinthians, however, Jerome did not echo his own rhetoric, choosing instead the word 'stimulus', which elsewhere in the Bible denotes the goad or whip used on a beast of burden. The different images of *morsus* and *stimulus* depend on a single crux, the idea of a sharp and piercing wound; the goad pricks, the sting of a snake

punctures the flesh. The first sin, the getting of knowledge, when taken in a restricted sexual sense rather than existentially, involves just such a perforation: the penetration of Eve by Adam. There have been many arguments about the character of sexual union in the Garden of Eden before the Fall (if it happened at all), but all authorities agree that even if Adam and Eve did make love, the first mother's virginity would not have been damaged, since the idea of physical corruption only enters the world at the Fall.[6] As St Paul writes in reply to his own rhetorical question, 'The sting of death is sin' (I Corinthians 15:56). Death wounds the physical corpse, just as sin destroys the soul: corruption and integrity possess equal value as physical description and spiritual metaphor.

The 'sting' of sin becomes transmuted, according to a favourite conceit of the artist Lucas Cranach the Elder, a contemporary of Baldung's and Luther's, into the sting of love, an effect of lust, one of the seven deadly sins. Cranach plays with the metaphor in a series of variations on the theme of the goddess of love and her infant son. In *Cupid the Honey Thief Complains to Venus* (1545), the god of love holds up a honeycomb swarming with bees for his mother's inspection, while they both lament the stings they suffer. The inscription, adapted from an idyll of Theocritus, warns: 'While the boy Cupid plunders honey from the beehive, the bee fastens on his finger with a piercing sting; so in like manner the brief and fleeting pleasure which we seek injures us with sad pain.'[7] The Latin 'Furanti... cuspite', when translated into German yields the same word, 'stachel', that Luther used for St Paul's famous line, 'O death, where is thy sting?'[8] Cranach's manner is arch and worldly; by contrast, in *Eve, the Serpent and Death*, Baldung sternly dramatizes the cluster of equivalences at the centre of Pauline doctrine about death, sex and sin, mediating them through the metaphor of the bite – another sting – of the serpent (see p. 79).

The sequence of encirclements in this painting – the snake around the tree, Eve around the snake, Adam/Death around Eve – closes with the snakebite: the painting has a peculiar nastiness which stirs deep feelings of disquiet and horror in the viewer. Eve, her lambent body candidly disclosed, appears more blameworthy because she has not yet been touched: her pre-Fall lack of shame in her body here spells out her shamelessness.

BODIES OF SENSE

Hans Baldung Grien lived at the time of Luther's rebellion against the Church, and was acquainted with many outspoken Reformers in Strasbourg, where (bar a spell in Freiburg) he worked from 1509 until his death in 1545.[9] He was living in the most confused of times, before the Catholic Church marshalled its response to the Reformers' criticism and ideas – he died the year the Council of Trent opened – and his own position, as far as it is known, was equivocal. The transition to Lutheranism in Strasbourg was slow and bitterly contested; the artist worked for the local Catholic bishop, yet had close contact with prominent reformers like Martin Bucer. In his paintings, he compresses both his Catholic inheritance and new Protestant attitudes to sins of the flesh. Tensions arising from changed loyalties and betrayed ideas show in his work, intensifying its feelings of dread and revulsion, while at the same time the promise of new ideas opened up possibilities – Baldung could indulge in the enamelled nudity of young women (preferably wearing hats and little else), as expressed again and again by Cranach, Luther's favourite painter.

The female body, at once the site of eulogy and blame, obsesses Baldung; it is striking that whereas medieval images of Death the Reaper, like the epic fresco in the Campo Santo in Pisa, depict the tattered skeleton sweeping all before him – kings, popes, princes, bishops as well as laymen and women – the Maiden emerges in 16th-century art as Death's most vulnerable and fitting victim. Death had become ever more deeply intertwined with the idea of penalty for sinfulness, and women were both sinners and occasions of sin and therefore doubly guilty. The Lutheran doctrine of justification by faith alone, and the corresponding weakening of the concept of free will, also emphasized the ineradicability of the human taint. Although it is not clear how committed Baldung was to Reform, he was buried in the new Protestant cemetery in Strasbourg.

The composition of Baldung's nude paintings of Judith, Eve, Venus and Lucretia position the female body to expose it, often frontally against a dark background in the manner of Cranach, so that the nacreous flesh of the living woman beckons the viewer like a beacon. Baldung proffers his female nudes' bodies, often twisting them round to display breasts and genitals even when they do not look out at the spectator, but exchange

intimate glances with the serpent alone. In some of his paintings, for example the *Weather Witches* (1523; see p. 82), one woman casts a look of knowing seductiveness over her shoulder towards us, placing us, the viewers, in the position of the tempted. In *Death and the Maiden* (1509–10), a little girl starts at the sight of Death and tries to shield herself with the skimpy and woefully inadequate veil of the maiden, who is too intent on her looking-glass to notice. We the onlookers are invited to share in the child's proleptic vision of what lies in store for her; we too become witnesses to the imminence of Death.

<div align="center">III</div>

The artist was Dürer's pupil, and he reproduces some of his master's themes, but turns the screw tighter on his female subjects, forcing them to make exhibitions of themselves that verge on the grotesque. Many of his paintings would be absurdly lugubrious if they did not pinch so hard on a common nerve, the fear of death. His temptresses belong to the Western tradition of representing female beauty as untrustworthy – Eve as the gateway of the devil, the source of all evil. But the first woman and her companion crew of witches and seductresses are granted an even more lethal beauty through Baldung's contact with the teachings of the Lutheran Reformation and the contemporary German fascination with the possibilities of *maleficium*.

Luther was hostile to the Aristotelian theory, propounded by St Thomas Aquinas, that woman was an imperfect male, though he did insist on the subordination of woman to man and wife to husband in the social order. On the one hand, he accused those who despised women as botched men of being 'monsters and the sons of monsters', but on the other, he maintained: 'It is evident [therefore] that woman is a different animal to man, not only having different members, but also being far weaker in intellect (*ingenium*). But although Eve was a most noble creation, like Adam, as regards the image of God, that is, in justice, wisdom and salvation, she was nonetheless a woman. For as the sun is more splendid than the moon (though the moon is also a most splendid body), so also woman, although the most beautiful handiwork of God, does not equal the dignity and glory of the male.'[10] The Protestant emphasis on the God-created goodness of

the sexual bond (in marriage) and on the splendour of woman's natural form and its fitness for the function for which it was made (the bearing of children and keeping house) furnished a pretext for German painters of the early 16th century to dwell on woman's flesh without incurring accusations of lasciviousness. In fact, Luther did find Cranach's nudes too 'coarse' for his tastes, commenting, 'Master Cranach…might have spared the female sex because they are God's creatures and because of our mothers.' His view of Baldung is not recorded, but the painter certainly reproduces Lutheran ambivalence towards women (there's rather too much of Molière's Tartuffe about Baldung: he often seems to be wagging his finger at what most excites him, like a police censor reading pornography).

In the Sistine Chapel, Michelangelo gave the serpent the face of a woman, Eve's sister, if not her double; Hugo van der Goes is one of many other artists who represent 'the most subtle of all the beasts of the field' (Gen. 3:1) with a woman's face. Eve was thought to resemble this reptilian manifestation of the devil in a multitude of ways: during the Renaissance, medical thought developed the original Greek notion that women in their humours were colder and more moist than men.[11] Above all, Eve, the first mother, the prototype female, showed herself to be the true daughter of the serpent in the Garden through her oral transgressions – beyond just tasting the fruit. The serpent tempts Eve with cunning words, and Eve then tempts Adam in turn with her account of the serpent's promises, so leading him astray. The seduction of woman's talk was feared almost as much as the seduction of her body; it was also condemned as improper *per se*. The Pauline injunction that women should keep silent in the churches was extended to encompass everywhere else except perhaps the nursery. In this matter, Catholics and Lutherans were in agreement: garrulousness was a woman's vice, and silence – which was not even considered appropriate for the male – was one of the chief virtues they should cultivate. The speaking woman turns herself from a passive object of desire into a conspiring and conscious stimulus: the *mulier blandiens* or *mulier meretrix* of Ecclesiasticus (25:17–36) and Proverbs (6:24–26) comes in for vituperation, while 'A man's spite is preferable to a woman's kindness' (Ecclesiasticus 42:14) provoked much nodding of male heads. Eve's mouth, the organ of speech as well as of experience, becomes culpable.

In an early 17th-century English morality play on the Five Senses, each sense appears personified on stage, debating whether to admit Lingua – Tongue – to their company. Lingua, portrayed as female in keeping with the word's grammatical gender and dressed in a scarlet robe, no doubt intended symbolically as well as literally, begs to be included as their equal. They debate her case but decide against her, and she is shut up in the house of Taste to keep her quiet.[12] The English Reformers were as eager to bridle women's tongues as their colleagues in Europe (their obsessiveness reveals their lack of success; women struggled on heroically to make themselves heard.)

The tongues of women were associated with curses and spells, the central activity of witches: living in Germany during a period of acute fascination with witchcraft, Baldung picked up on the widespread terror of diabolical magic among his contemporaries. The *Malleus Maleficarum* (Hammer of Witches) was first compiled in 1486 and had been republished in numerous editions by the beginning of the 16th century, when Dürer, Baldung, Hans and Sebald Beham and other German artists were producing their excitable and dangerous fantasies about witches.[13]

Witches were believed to summon spirits and exorcise ghosts, change shape and fly, inflict harm or work wonders, whistle up a wind and blight crops, all through the use of charms and rhymes – ordinary speech transformed into magic. In Baldung's 1510 drawing of a Sabbath, in the Louvre, three witches in the foreground appear to be crying out as if chanting or imprecating; in another drawing made four years later, the younger witches' lips are parted as they become transported by the effect of the potions they are brewing. One of them even seems to be exploring her genitals – her nether mouth – in order to bring forth something more material than speech. The morality imputed to witches did not stop at their cunning with words: according to the *Malleus Maleficarum*, a witch manipulates the world through food, elixirs and distillations and inverts the rituals of the Church in unholy suppers with the devil. Baldung's Sabbath drawings and paintings present evidence of witches' brews, as the covens flourish cooking utensils over steaming pots on every side while hideous fragments suggest the ingredients' profanity: the half-eaten, mangled hand and forearm of a corpse, the skull of a donkey. The artist vividly conveys process and metamorphosis; his scrupulous renderings

BODIES OF SENSE

of decaying flesh, his spewing animals (a cat in one of the Sabbath drawings) and his spouting vats and steaming pots suggest that something is always happening out of view before and after the stationary moment of the fixed image. Baldung's *Judith* (*c.* 1530) crosses her legs in a gesture designed to focus attention on the cleft she hides, and bears the knife and the head of Holofernes; in this context, she looks like a sorceress about to toss it into the cauldron. Baldung is not alone in stirring this revolting association. It is common in images of Judith's double, Salome, who often presents the head of John the Baptist on a charger as if it were just another dish among the many at Herod's table. Dürer's engraving of 1511, showing Herod inspecting the head, gives the impression that the Precursor is being served up as the next course.

The horrors of kitchen equipment and the transformations of cookery permeate many fairy tales later collected in Germany ('Jack and the Beanstalk', 'Hansel and Gretel'); in Baldung's *Weather Witches*, one of his most resolved, least queasy works, a flayed donkey's skin hangs between the two fatal beauties against the flaming sky. Again, processes of transformation, unpleasantly distorted to convey that the subjects are satanic, play an important part in the characterization of the female, who was of course usually in charge of housekeeping, cooking and preparing the meats. It is striking that the most sinister equipment of witches – the cauldron and the broomstick – are merely the routine tools of a housewife at her daily duties.

The power over food wielded by women assumes special significance when food is in short supply: many of Baldung's images can be understood in the context of the Peasants' Revolt of 1524–26. Poverty, feudal service and hunger all played their part in provoking the people to rise, and the violence of death was daily apparent; about 100,000 men and women were killed when the rebellion was brutally crushed. Incidental details of Baldung's imagery – Eve's disintegrating skull, the picked shoulderblade in his Crucifixion altarpiece in Berlin, the dog stealing a bone from a decomposing cadaver nearby in the Crucifixion from the High Altar of Freiburg – predate the events of the Peasants' Revolt, but give us an insight into the gruesome conditions which contributed to its outbreak.

The Sabbath drawings in the Louvre include young, sumptuous witches, as well as the crones and hags more familiar from later fairy

tales and witch lore; alluring girls are the favourite devil-worshippers of 16th-century Northern masters' work. They sometimes appear surrounded by the fripperies which moralists decried almost as vociferously as women's wagging tongues – make-up brushes, mirrors, fashionable trimmings, feathered hats. In *Death and the Maiden*, as mentioned previously, the naked protagonist gazes at herself admiringly in a mirror and fails to see Death approaching to wither her. When Baldung's fallen women are not sinning by mouth, they are sinning through the lust of the eye, both by appraising themselves so thoughtfully and by exciting desire in others who behold them. The minimal but luxurious apparel worn so frequently by Venus or Judith in German art (Baldung himself usually favours stark nudity) characterizes her as a cautionary allegory of Vanitas, as well as a goddess or heroine.

In post-Reformation Northern European art, allegories of the Five Senses borrow the attributes of the Vanitas genre: rotting fruit and pitchers of wine stand beside Taste, while the mirror of Vanity accompanies Sight and musical instruments, denoting the transience of life, appear beside Hearing. In Flanders, Martin de Vos (d. 1603) painted the Foolish Virgins busy cultivating their senses with books (trashy romances, no doubt), music, food and drink, jewels and pretty clothes. Baldung's allegorical painting of *Music* (1529) in Munich includes a huge white cat, a direct reminiscence of the large, somnolent pet in Dürer's *Adam and Eve* (1507) and the more malevolent creatures of his Sabbath drawings. Such a feline was an established, perjorative emblem of sensuality, a witch's favourite familiar and a notorious and rampant participant in nighttime sacrilege.

The obsessive censoriousness of Baldung – his monomania can become wearisome – may be connected with something Erasmus wrote in a letter of 1515: 'St Jerome addressed his book *On Virginity* to Julia Eustochium, and in it depicted the character of bad virgins so clearly that a second Apelles couldn't set it so vividly before our eyes.'[14] Erasmus is referring to Jerome's hallucinations in the desert, when he saw, however hard he tried not to, 'bevies of girls' parading themselves to tempt him. It is significant that Erasmus shifts quite naturally from the category of a written description to painting, from a fantasy in the mind's eye to an episode involving historical characters in an artist's studio, picking

out the artist who was famously commissioned by Alexander the Great to paint his mistress, Campaspe. When the emperor saw the results, he was so overcome by Apelles's skill that he made him a present of the girl then and there, saying that the artist had a greater right over beauty than an emperor. Campaspe the model became indistinguishable from the work of art which could be passed from hand to hand, between men. Erasmus's reference assumes without afterthought that beauty, the seductiveness of women and art, Jerome's sexual fantasy and the mastery and ownership of women by men are all interlocking parts of the same notion. In German, the nexus becomes more tightly meshed semantically, for the word for painting is *Malerei*, for painter *Maler*, from the Latin *macula*, a mark. *Macula* belongs to the stem of *malus*, evil, hence 'mark' in the sense of stain, and its opposite, a conventional epithet of the Virgin Mary, *immaculata*, immaculate. Eve, witches, Judith and other avatars of female beauty and wiliness are turned into marks on the canvas or the panel by painters who, like Baldung, intend to reveal the maculate condition of humanity and of female flesh in particular.

Painting is a seducer's art, communicating fantasies of desire, and so, as Erasmus let slip in his remark about Apelles, seductresses constitute a most appropriate subject. The strenuous moralizing of Baldung's pictures sometimes seems to be trying to excuse the pleasurable and worldly character of picture-making itself, let alone the delights attendant on its subject matter. The medium – painting or drawing – partakes of the same folly which it explicitly condemns, and struggles with the quandary it has imposed on itself.

IV

With the publication of Sebastian Brant's *The Ship of Fools* in 1494 and Erasmus's *In Praise of Folly* in 1511, the fool was established as a motif in Northern art: wearing the jester's cap and bells, with asses' ears, a fallen coxcomb, often holding an obscene staff, his *marotte*, the figure of the fool enters the iconography of parables and cautionary tales.[15] But the fool is not entirely a fool. The laughter the fool provokes upsets preconceptions, brings about self-consciousness; his special skill with words, sallies and insults displays his own disregard of decorum (the *marotte* of Quentin Massys's painting *The Fool* shows another jester 'mooning' – dropping his

trousers and flashing his bottom). Fooling requires folly on the part of the fool, heedlessness and bravura. But the lore of fooling also implies that the fool has access in his simplicity to greater wisdom than the ordinary folk who obey the rules, as Viola says in *Twelfth Night*:

This fellow is wise enough to play the fool
And to do that well craves a kind of wit…
…This is a practice
As full of labour as a wise man's art.
Twelfth Night, 3.1.53–59

The paradox governs many of the fool's appearances in art: he is the only one to see through human behaviour, recognize its pretensions and grasp its transitoriness – in short, its folly. In Lucas van Leyden's engraving *Mary Magdalene Shown the Worldly Delights* (1519), Magdalene dances demurely among couples feasting and loving in a woodland glade while two musicians serenade them. Only the fool, peeping from behind a tree at the scene, laughs and raises a finger in warning.[16] In 1515, Hans Holbein illustrated Erasmus's *In Praise of Folly* with marginal sketches. Mockery and recognition meet in the vision of the fool, who sees himself and knows himself, if he has sense enough to act the fool at all. As Seneca commented, 'When I want to look at a fool, I have only to look in the mirror.'[17]

If we look at Baldung in this context, his black humour, his morbid and satirical manner, his tendency to the grotesque, becomes much more understandable; he intends to provoke the laughter that is not mirth, but the shamefaced and self-mocking splutter of the guilty who have been caught out enjoying something. He is the spectre at the feast, the only man present wise enough to see that it is a wake.

The painter's negatively coded sensuality announces a theme that recurs continually thereafter, most powerfully in the 19th century. Flaubert wrote to his lover Louise Colet, 'la contemplation d'une femme nue me fait rever à son squelette' (the contemplation of a naked woman makes me dream of her skeleton),[18] and in Baudelaire's *Les Fleurs du mal*, the interplay of necrophiliac and erotic imagery is constant. The motif of Death and the Maiden inspired Edvard Munch to paint Marat's death as a bedroom scene;

in Vienna, Gustav Klimt, in the painting *Death and Life* (1916), shows the robed figure of Death grinning at an intertwined family group sleeping, while many of his emblazoned seductresses and allegorical figures of Justice or Truth depict Woman dealing death to the victims of her charms.

<div style="text-align:center">v</div>

The motif travelled into early cinema, enriching itself on the way with the popular literature of vampirism and developing the mordant tradition of German art. In two masterpieces of the silent screen, F. W. Murnau's *Nosferatu* (1921) and *The Cabinet of Dr Caligari* (1919), scripted by Carl Mayer and Hans Janowitz, Death appears in the shape of a bloodsucking, emaciated, black-clothed tatterdemalion and preys on young and beautiful maidens. In *Nosferatu*, a shrouded plague ship carries the vampire to Bremen, where the virgin Nina offers herself up in sacrifice to redeem the stricken town. The vampire's power is undone when he lingers at her side, his teeth sunk into her neck, and the dawn breaks. With the bite of the vampire and the voluntary sacrifice of Nina, the film offers a curious revision of the Christian story.[19] According to the scheme of salvation, the sting of death resulting from the Fall is reversed by the consent of the Virgin Mary to the passion and death of her son. She thereby redeems the fatal act of the first woman, Eve.

In *Nosferatu*, Nina consents to the salvation of Bremen but is herself the victim, not merely the instrument. Fanged Nosferatu embodies the principles of sin and mortality, just as Satan's twin aspects, the snake and the skeleton, body forth evil in such paintings as *Eve, the Serpent and Death*. Even the Expressionist make-up which streaks Nosferatu's cheeks and hollows out his eyes, so imitated by children dressing up for Halloween today, derives originally from the revenant imagery of German necrophobia.

The history of *The Cabinet of Dr Caligari* casts a sharper light on the motif of female beauty and its fatefulness in the imagery of an artist like Baldung.[20] In the original screenplay, the malignant Dr Caligari, fascinated by the black arts, subjects an innocent youth – Cesare – to his experiments and changes him under hypnosis into a vampire who roams somnambulistically and kills at his master's command. In his enchanted

state, Cesare attacks Jane, the heroine – pure, beautiful and symbolically clothed in white raiment – and destroys her sanity with his vampire kisses.

Fritz Lang was to direct *The Cabinet of Dr Caligari*, but was detained on another film, and Robert Wiene was appointed instead. Wiene insisted on framing the Janowitz and Mayer story within another, representing Dr Caligari as the benign superintendent of an asylum and the whole vampire story as the lurid fantasy of Jane, a deranged inmate on whom he lavishes nothing but tender care. The meaning of the finished film thus runs counter to the original script, transferring blame from Caligari to the young woman, from the male authority to the female victim, in the same way as the nude paintings of Baldung ascribe guilt to the smiling Eve or the oblivious, vain maiden and not to Death, incriminating the female sex in general for human ills, rather than holding the serpent, or Adam, or all of us, male and female, responsible.

Eve and her daughters, the nuns taught us when I was at my convent school, must bear the penalty for the desire we stir: we were 'occasions of sin.' The sting of sin and the pangs of love-lust excited by women are transferred and altered in imagery into the bite of death, the kiss of the vampire, penalties designed to punish the subject in the picture and by these means assuage the suffering beholder. Such disturbing erotic fantasies conjure pleasure only to damn it as unworthy; Baldung is the natural father of the horror movie, not the drama of passion, for his work inspires a grim kind of laughter mixed up with terror. It is gallows humour, with all its complex of conflicting feeling, entertainment, fear and a certain pornographic frisson of sadism. Although Baldung's paintings of the Temptation and the Fall take up a tragic theme – perhaps *the* tragic theme – he rarely achieves a tragic tone. And just as tragedy eludes him, so does devotional or religious simplicity. These visions of the female nude are compellingly profane, adulterated images.

The ancient Greeks, it is often forgotten, rounded off the cycle of the great tragic dramas with a satyr play or a bawdy comedy; Baldung, who fastens as grimly on his morbid subject matter as his figures of Death on their prey, misses the sympathetic depths of the tragedian for the dark, misanthropic cautions of the satirist.

LOUISE BOURGEOIS

Cut & Stitch

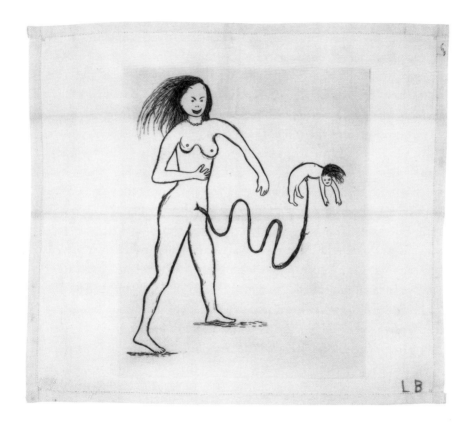

Umbilical Cord
2000

In Louise Bourgeois's 1999 show at the Serpentine Gallery, London, a little over ten years before the artist's death, two sawn sections of marrow bone were inserted side by side, like binoculars, into the chicken wire mesh of the cage straddled by a giant 'Spider', the pièce de résistance of the exhibition. These oculi drew attention to the way in which we, the viewers, found ourselves peering – peeping? – into the protected enclave between the monster's angular bronze legs, into the chamber where worn scraps of French tapestries covered a central, low armchair. Threads were dangling down, with a gold locket and two small fob watches suspended at their ends; more fragments of torn and shredded tapestries were stuffed into the lair. Like Bourgeois's mother, who was a tapestry restorer, this spider was at work on repair, on weaving and patching pieces of past comfort and luxury which she had caught in her web. The artist once told the critic Robert Storr, 'The female spider has a bad reputation – a stinger, a killer. I rehabilitate her. If I have to rehabilitate her it is because I feel criticized.'[1]

Bourgeois was an acute and fascinating commentator on her own work, declaring, 'My body is my sculpture'. Her way with bodies – her own and others' – does not represent them as they present themselves to the eyes of others, but rather smelts them in the forge of her fantasy to become something more than image.[2] Significantly, she also remarked, 'By symbols I mean things that are your friends but that are not real,' and her way with symbols is intimate and intensely subjective.[3] She spun her own private web of such 'friends', casting spiders as mothers: when she installed another even more colossal spider in the Turbine Hall at Tate Modern the following year, she called the work *Maman* and, high up, between the creature's legs under her swollen abdomen, she suspended a mesh basket of glass vessels standing in for eggs.[4] Glass vessels recur in Bourgeois's series of *Cells*, symbolizing the artist as a little girl, while various other burgeoning and fragile bulbs, made of marble, stuffed cloth, cast latex or carved wood evoke with wayward sensuality the soft bulges of female flesh. These huge spiders are no simple redemptive avatars of Arachne, celebrating neglected female skills of weaving: they are self-portraits of the artist as a hoarder and a predator, who attracts loathing and repulsion because her love can also be lethal.

'Working oscillates from extreme aggression to repair and a need for pardoning,' the artist added,[5] and she often spoke of the ambivalence at the

heart of her enterprise, her fantasies of murder as well as fierce mother love: 'If I'm in a positive mood I'm interested in joining. If I'm in a negative mood I will cut things.'[6] *Femme Couteau* (2002; see p. 98) viciously captures this mood (as opposed to the more passive and anguished series called *Femme Maison*, 1946–47). Bourgeois has also created headless, sutured figures copulating – in 1996 she staged an eerie sexual pageant using similar figures in the corners of the belfry of St Pancras Church, titled *The Visible The Invisible*. At the Freud Museum show in 2012, the curator Philip Larratt-Smith paid homage to this streak in her imagination when he suspended a huge sharp knife, like a guillotine blade, above another sad, limbless assemblage curled up on a couch. The artist very much admired Francis Bacon, and one can see why.

For the series of monumental sculptures of an ithyphallic animal mother, variously called *Nature Study* and *She-Fox*, made between 1984–94, Bourgeois began by carving resistant stone, then cut off the creature's head and slit her throat ('a double mutilation'), leaving the polished columnar stack at the neck, above the *magna mater* torso, where 'each one [breast] [is] harder and better than the last'[7] (see p. 95). The monumental black granite version of 1984 also presents a many-breasted animal, and here again the lack of a head creates an ambiguity: the swelling gourds rise in a phallic column in both sculptures. Yet according to her own account, the towering symbolic animal raises a powerfuwl monument to her own mother: 'I have been inhabited by a ferocious mother-love', Bourgeois also told Storr. In one of these *She-Fox* sculptures, the artist placed herself, embodied in the tiny figure *Fallen Woman* (1981), 'in a kind of nesty place' under one paw, 'pleased as Punch because she is protected.'[8] The choices of materials and colours underline the carnality of the animal: red wax, pink latex. Yet another version is carved in pink marble from Portugal: queasily lucent and glabrous, without grain or veins or speckles, the sculpture presents its powerful, headless figure squatting on its haunches, with a phallus displayed between its legs. It combines the fertility symbolism of the Ephesian Cybele with the vigilance of an ancient tomb or household guardian. Bourgeois once said, 'The phallus is a subject of my tenderness. After all, I lived with four men [She was the mother of three sons]…I was the protector.' To which she then added, 'Though I feel protective of the phallus, it does not mean I am not afraid of it.'

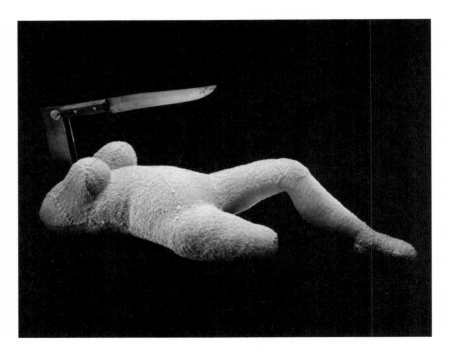

Femme Couteau, 2002

Bourgeois could have called the sculpture 'Vixen', but that word evokes a less formidable, more simply crafty creature than the massive, carnal she-monster she has summoned. At the artist's own admission, *She-Fox* is also a self-portrait. It's not impossible that Bourgeois was aware that in Chinese and Japanese legends, the fox is a magical creature who can change sex. Such formal expressions of Louise Bourgeois's inner turbulence combine protuberances which strike the onlooker's eye as swelling, soft and sinuous in a female mode – *sinus* being both breast and lap in Latin – with hard, turgid, stem-like swelling in a phallic mode. Vulva and labia recur obsessively, reaching towards primal hermaphroditism, the foetal stage before sexual difference. Bourgeois's swelling, burgeoning forms are at once phallic and uterine; penises and breasts echo one another's tumescence. Certain complex scenarios flaunt the fusion of the two, sometimes with lurid and frightening enigma, as in *Janus fleuri* (1968)[9] and *Fillette* (1968), the phallic girl-child sculpture which the artist mischievously tucked under her arm when Robert Mapplethorpe took her picture in 1982.

In the decades following, needles and scissors largely replaced the chisel and the knife as the artist's preferred tools. Where once she gouged stone, she began suturing stuffed bodies, using crude, overlapping stitches to create troubling part-objects, amputated torsos, twisted, patched and stitched bodies, all of them metonymies conjugating secondary sexual characteristics. Stuffed berets stood in for breasts, hot water bottles for female trunks, with holes suggesting uses for penetration. The predominant pink flannel textures and podgy, lumpy shapes hinted at the nursery, even while the imagery was deliberately adult. Bourgeois was punning on states of her psyche through embodied forms: broken and maimed, puffed up with conflicting emotions, coiled tight in tension.

For this artist, needlework was a personal legacy from a beloved mother, as well as a symbolic act. Her mother came from a line of tapestry merchants and menders, and pioneered a method of restoring fragile Aubussons and Gobelins fragments. From the age of seven, Louise Bourgeois would sketch and draw in the family workroom, supplying designs of feet and other parts (in some cases, even the cupids' genitals had been excised) for the weavers to copy. She was still revisiting that time in her nineties, as she cut and sewed discarded items from her

own wardrobe until they resembled Haitian *grigris*. She suspended her vacated dresses and undergarments, which were often made of luxurious gauzes, sheer silks and satins, from poles; she hung them on the shoulders of massive ox bones like the shed skins of former selves, husks of a metamorphosing insect.

Louise Bourgeois became a sculptor after she moved to America in 1938, aged 27, because, she said, Americans tip their belongings on to the street when they move – and they are often on the move. 'In France it is not like this,' she said. 'It is tidy. Everybody has a place, and everything is saved in France.' Nevertheless, it is astonishing that even after she began living in New York, raised three boys and made art for decades, she managed to keep chemises which her mother had stitched for her with consummate delicacy when she was a child. Yet the artist's lifelong, furious ambivalence about motherhood tenses the mood in many of her works – not only sculptures but watercolours, drawings and journal sketches that remember the bond: in a drawing from the year 2000, when she was 89, she represented it as an uncut umbilical cord (see p. 95).

Her staying power outstripped Picasso's and drew past Titian's, yet Bourgeois had to wait to achieve the acclaim and worldwide official recognition that wraps her reputation now. When she first took up carving – in 1967 – she was already older than many artists at the time of their deaths. Born in 1911, she belongs to the generation before Eva Hesse (b. 1936), who killed herself in 1970 and whose influence is strongly felt in Bourgeois's work: the love of pendulous forms, homely fabrics, skills with a domestic lineage (plaiting, knotting) and the use of repetition as a charm against terror and anguish. She attributed her emergence to the younger generation: 'I am [also] grateful, she said, 'for the fact that my former work, which was anti-establishment, appeared very suddenly and new when it was actually twenty-five years old. I was not a discovery, I was a rediscovery.' The late arrival of success and adulation introduced into her art a mood of maternal reparation, moments of supremely economical grace and occasional outbursts of bubbling gallows humour.

Bourgeois claimed to be 'a woman with no secrets', but her art lies in suggestion and enigma. Her commentaries and interviews, appearing in art journals over half a century, are helpfully collected by Marie-Laure

Bernadac and Hans-Ulrich Obrist in *Destruction of the Father Reconstruction of the Father: Writings and Interviews 1923–1997* and in the two-volume catalogue *The Return of the Repressed* (2012), which includes a valuable collection of her psychoanalytic writings. The artist's thoughts spin two threads of explanation, one autobiographical and the other aesthetic; these parallel accounts weave a cocoon around her symbols and her process that wraps them for public view in much the same way as some insects wrap up mating gifts for prospective mates, or indeed, as spiders tie down a fly for cold storage. She is bold and incisive about her art and its place in aesthetic history, and she makes the highest claims for art's purposes. She is often merciless: her remarks about male artists – Mark Rothko and Ben Shahn – playing court buffoons to New York society bring a scathing, Austenian eye to the ways in which success and fame are achieved. She was in a strong position to observe this privileged world and to learn from it: her husband was Robert Goldwater, one of the pioneering scholars of African art, who in 1938 published an influential survey, *Primitivism in Modern Art*. No woman artist is reproduced or discussed in his book. In 1949 he curated a manifesto exhibition, 'Modern Art in Your Life', at the Museum of Modern Art. It ranged from Abstract geometric forms to Surrealism, across high and low objects – houses to Kleenex boxes, paintings to advertisements. Again, not a single woman.

Goldwater was the first director of the Museum of Primitive Art from 1957 to his death in 1973; the collections there were primarily from Nelson Rockefeller's and were moved to the Metropolitan Museum in 1971, where they form the core of the spectacular display there. Through all this activity, the hum of a ferocious conversation with Louise Bourgeois the artist is taking place, and her journals record her anger as well as her attachment to a husband who effectively disappeared her for so long.

Honesty is an Enlightenment virtue, as developed by a French education, and Bourgeois kept true to this taxing ideal. She turned mirrors inward, often against herself: 'Reality changes with each new angle,' she writes. 'Mirrors can be seen as a vanity, but that is not all their meaning. The act of looking into a mirror is really about having the courage it takes to look at yourself and really *face yourself*.'[10] Tate Modern has a little print she made of herself in the bath. *Woman in Bathtub* (1994) is a deceptively

simple study of the complications of looking at oneself: Bourgeois has cut herself in two, her legs are upside down and of course she cannot see her face except in the mirror. The image is also saying something to grand old men who paint bathing nudes (she is often caustic).

In spite of condescending to Freud (she savaged his art collection – mere 'toys'), she presented herself as a pathological study in the style of his cases. 'Louise' could be the name of another Dora. Indeed, the theatrical scene-setting of many of her sculpture-installations, for example the series of *Cells*, recall the psychological plays and films of Marguerite Duras. Bourgeois was very fortunate, she declared, that she had direct access to her unconscious.

Louise was named after her father, Louis, who, as she often repeated, had hoped for a son. The Bourgeois family drama centred on this elegant, charming figure, who had a love affair for a decade with the English governess he had employed for his daughter. Louise saw this as a double betrayal: she found competition with the mistress, who had been chosen by the father, far more bitter than Oedipal rivalry with her mother. In this haunted case history, the governess was even called Sadie. [11]

The story provided a scaffold on which Louise Bourgeois set sequences of deeply troubled pieces, filled with painful passions, incestuous secrets and domestic voyeurism. In 1974, she made a large piece, *The Destruction of the Father*: 'at the dinner table…' she explained, 'my father would go on and on, showing off, aggrandizing himself…suddenly there was a terrific tension, and we grabbed him – my brother, my sister, my mother…and pulled him on to the table and pulled his legs and arms apart – dismembered him, right? And we were so successful in beating him up that we ate him up. Finished. It is a fantasy, but sometimes the fantasy is *lived*.' [12]

The table/bier of bulging blobs, hollows and caverns alongside the artist's bulbous Cybele-like costume for the performance, hardly convey the violence in the script. In the Serpentine show, *Cell (Clothes)* (1996) returned to this drama from her childhood. Inside a palisade of French windows and closed doors, a little girl-sized headless dummy in black stockings was slumped on a three-legged chair, while an infant's blue dress hung over a lamp and, on one of the lavatory glass doors forming the enclosure, the words 'Man/Hombre' were scrawled.

The story of Bourgeois's childhood is perhaps less revealing than it seems: if an adulterous liaison of a sort common among the French bourgeoisie provided sufficient grounding for such intense, personal symbolic language, she would not be the peculiar and original artist that she is. But the scenario offers a compelling way of looking at her art that contemporary audiences recognize and respond to. It roots her inspiration in an experience of erotic awakening and vulnerable youth and acts to give narrative cohesion to the conflictual states of feeling she communicates so powerfully, just as the film *Love Is the Devil* (1998), about the relationship between Francis Bacon and George Dyer, made Bacon legible and consistent: an exceptional individual, but one regulated according to a determined psychological structure. Bourgeois's retrospective obsession with a sexualized childhood which took place during the First World War made her a woman of our time.

The characteristic effect of her symbolic bodies is grotesque, combining fascination and disgust; their flavour suits the disquiet around sexuality today. Her attraction to lopped limbs, her fascination with braces and prostheses, her frank gaze at genitals, the way she 'hacks' (her word) at her materials and beheads her subjects are all in concord with the fractures of the new millennium. The works – drawings, sculptures, installations – insinuate themselves as familiar spirits, coming not only from inside her but matching some monstrous inclinations inside us; she invites us to lose ourselves in looking at them. The interest in internal organs, the violently fragmented and even dismembered forms, have identified her as a great progenitor of the contemporary figurative imagination – and not only in art. Those throngs of children in art galleries who sit on the floor, quietly drawing her spiders and her contorted sex dummies, do not find them horrible or strange. Their generation and the one before them is familiar with the creeps, well acquainted with Shelob in her lair in Tolkien and with the bristling and splattered bugs and aliens of horror movies. They've also been accustomed to visceral intimacy by their generation's official instruction in internal anatomy and sexual hygiene; while Bourgeois was initiated, her art tells us, by her Edwardian family secrets.

ZARINA BHIMJI

Sheddings

Monster
1995

When Zarina Bhimji first became Artist in Residence at Charing Cross Hospital, she was attracted by the ceremonies of flowers: she began exploring the reasons people bring bunches to friends and loved ones in hospital, make wreaths for the dead or lay bouquets on the bier.[1] Such gestures are part of a common language, one that isn't necessarily religious or liturgical, but a custom, like a handshake or a kiss of greeting and farewell. The act exists in a space between rituals and ordinary actions: not quite one or the other, but simply culture according to custom. When omitted, the omission doesn't break any rules, but causes a tremor, a sudden silence. Nobody in hospital would complain that you haven't brought them flowers; rather, they express pleasure – and surprise – when you do. Yet failure to make the gesture can open a gap of disappointment.[2]

The artist set out to explore these fault-lines, perhaps even bridge them. She began looking at the way in which such gestures can be tender in both senses: a consolatory caress and a spot of soreness. She created photographs in which clumps of hair, pulled or snipped, bear mute witness to moments of separation, uprooting and supplication. In many cultures, including our own, hair, concealed or revealed, provides a language of identity; the cutting of hair, especially women's, often announces a new departure, a threshold crossed into a new identity. Bhimji's work characteristically conveys unspoken intimacies, and shorn strands of hair, blue-black and gleaming, recur as a favourite synecdoche for the implied subject. Photographs from the sequence *I will always be here* (1992), for instance, return to the enigmatic scattering of hair on the naked body of a young man, or on the fine muslin which acts as a veil. These are images of partings, mementoes that are quieter than any official ceremony, more sensitive and discreet than any autobiographical account of family quarrel or rupture in a play or a novel.

But the artist's language of gesture includes violations far more horrific than the cutting of hair. The chemical techniques that the photographic medium demands have given her control of other forces to convey intrusion, change and pain. Burning recurs in her work as a metaphor for that fluctuating character of experience, and serves to convey vividly – one might say, searingly – acts of unpredictable cruelty (she has been inspired by Elaine Scarry's remarkable study, *The Body in Pain*).[3] In *I will always be here*, the small, white kurtas of three year old children, hanging as innocently

as laundry, are scorched, defiled by burns. Their destruction suggests, with that inwardness and delicacy that characterizes Bhimji's touch throughout, her own childhood: she grew up in Uganda during the civil war and she was kept indoors for her safety.

Shoeboxes were her principal toys at that time, and have returned again and again in different forms in her work. The system and order of their regular shape, the possibility of sorting and classification and tidying up they provide, counterbalance the fleeting images of partial recall, the fragments of nostalgia, subjectivity, memory, which make up the past in one's head. The Italian philosopher Gianni Vattimo has written: 'Our new experiences have meaning only insofar as they carry on a dialogue with all that the coffer of death – history, tradition, language – has transmitted to us.'[4] Bhimji's images take part in this dialogue; they approach that 'coffer of death' that is the past, personal and historical, through reflection, replication, refusal, violation. Any reaching out for the meaning of the past implicitly confronts mortality, and the artist's initial impulse to examine flower ceremonies resonates with her earlier explorations of mortality. Many of her photographs – of chillis and fabric, of petals and spices – look like offerings at shrines to propitiate the fates; the glass cases enclosing similar scatterings resemble the forensic boxes that offer the spoor of some vanished individual for examination. That vanished identity can be brought back by art – it's worth recalling that the word 'culture' applies to things that change and grow, like agriculture and like biological 'cultures', developed in the laboratory for analysis. When Bhimji reproduces conflicts of identity, she is growing another culture. Vattimo again writes perceptively about this aspect of modern existence: 'The pretension of having a relation to values which is not governed by memory, nostalgia, supplication, is a demonic pretension.'[5]

Although the residency at Charing Cross Hospital did not in the end lead to the artist working with flowers, it took her to a related, more disturbing encounter with issues of mortality, authority and the violated individual when she discovered the hospital's Pathology Museum, filled with specimens kept for medical research purposes in what is still a great teaching hospital.[6] The museum is an adjunct to a laboratory, and still in action. The artist found some of the material shocking, unspeakable, made

BODIES OF SENSE

monstrous by mutilation and preservation.[7] The body parts float, drained of blood and drained of story, too. A severed foot, suspended in solution in a glass box, is one of the items offered as evidence of the body, of its functions and its dysfunctions.

Who were the people to whom these parts belonged? The artist has photographed fragments, wounded, anonymous, unexplained, cut from the body and framed for inspection. In this medical archive, the clash between the privacy of persons and the investment of society in knowledge for the common good becomes visible. Or, rather, it shows the general acquiescence to higher authority in matters of interpreting what knowledge is, and what the common good is that is served by that knowledge. Of course Bhimji doesn't make large hortatory statements, nor is she an agit-prop artist. But her approach to the hospital's pathological samples is rooted in reading Michel Foucault on systems of controlling individuals through the organization of information.[8] Her images of anatomical fragments belong in the still life tradition that connects Géricault's portraits of severed limbs to Damien Hirst's formaldehyde spectaculars, but they try and keep social context in the mind of the spectator, and raise questions about the institution and its archival practices.[9]

The pathology museum is not open to the public except by permission. By and large, it is secret. In this, as well, it finds an important place in Zarina Bhimji's imagination; she is drawn to secret codes as sites of power. 'What is unseen, yet intellectually and emotionally acknowledged by spectators, must be considered part of the work of art,' writes Henry Drewal on Yoruba women's sculpture.[10] Bhimji once made a series of works under the title: *She Loved to Breathe – Pure Silence* (1987). Her work plays with the eloquence of photography's muteness, and it also trails all manner of invisible associations behind the epiphanies she creates, stirring her audience's wonder: Who was this person? What happened? What does this mean? There aren't answers, or at least not the forensic answers which such archives as the hospital's pathology museum exist to deliver. Bhimji's enigmas are conveyed through the blurring, the indeterminacy, the veiled look of the objects and bodies in her photographs and installations. As Mary Nooter writes, 'The contents of the secret [are] less important than the use of secrecy as a strategy…the visible

function [is] to keep the invisible invisible.'[11] Those gestures, which are not written down in the handbooks – from hair-cutting to anatomical dissections in the morgue – contain worlds of insight into values and prejudices. The images of crime victims, mutilated twice over – in life and after death – convey a multitude of sins, some more often condoned than others. As Bhimji says, 'One asks what will happen to my body? What will they do to me when I am dead?'

The artist does not take the easy path of open indignation, or relish denouncing the handling of information by authorities with dishonest righteousness. She admits that the horror she felt/feels at the shelves of anatomical specimens is accompanied by a profound sense of their beauty – the foot looks carved in wood, the specimens swim in the kind of subaqueous twilit world that other aesthetic sensibilities of our time, such as Gerhard Richter and Peter Greenaway, have made into a visual analogue for the unconscious.

This spectral fluid relates to photography's techniques, to the chemicals, the baths, even to the bloodlessness of the image, however real it makes its subjects appear. Bhimji has worked with filmy materials, with tissue paper, with crêpey muslins, with the fine pale rubber used for surgical gloves and a thicker black variety which she buys from a fetishists' outfitter, for whose clients it acts as a substitute for skin. The practices of portraiture and of medicine are related through a historical development of skin as symbol of the self: a person's hide or pelt contains the idea of an almost magically direct and intimate image. Michelangelo, for example, famously included his anamorphic self-portrait on the flayed skin St Bartholomew is holding in the Last Judgment in the Sistine Chapel. St Bartholomew was martyred when his skin was flayed, and he is the patron saint of doctors (and indeed of Bart's, another of London's great teaching hospitals). He's usually represented carrying a knife as well as his own skin. Skin-deep need not always mean superficial; as Hugo von Hofmanstahl once remarked, 'Depth lies hidden. Where? On the surface.'[12]

The issue of surface appearance, of skin, returns in Zarina Bhimji's work as a medium through which identity is conveyed (the Aborigines call their clans 'skins'), but also one through which hierarchies are instituted, as in apartheid's tabulations of colour. Her photography mines the

medium's own affinity with skin, being absorbed with producing gauzy, silky textures on the sheeny surface of the photographic image.

In a large-scale installation commissioned for 'Antwerp '93' (Antwerp was European Capital of Culture in 1993), she actively engaged with theories of eugenics, which in the 19th century included human beings in its inquiries into breeding and cross-breeding. The artist asked over two hundred people of mixed race to sit for her for half an hour as she took a long exposure portrait photograph with her large-format 4 x 5 camera. Adopting a scientific method from the Victorian age, she set about producing a taxonomy of faces and calling ideas about history and identity into question. Julia Margaret Cameron was one of her inspirations: the pioneering Victorian portrait photographer commented that she wanted to catch the inner life of her sitters, not only their outer appearance.[13] But whereas Cameron used clamps to keep her models still for the duration of the image-making, Bhimji did not; in fact, after talking to them for ten minutes, she left them alone in the room for the rest of the half-hour. She hoped that in this way that their features would relax and she would capture their most characteristic look, their 'soul'.

The wall of faces that results reverses many of the norms of portraiture: they seem subaqueous, twilit, mysterious, only tentatively visible, suggesting hauntingly the fugitive, precarious, provisional character of any statement about a person. They also issue a powerful challenge to all racial stereotyping, in an oblique but intense criticism of commonplace attitudes (at the end of the 1980s, Bhimji explored representations of black people in packaging and advertisements). As her subject's features dissolve and blur, so they erase any generalized preconceptions about genetic predictability.

The artist's liking for evanescent, metamorphic appearances, for swathed and veiled forms, is connected to her deep sense of vulnerability – others' as well as her own. Her work sometimes conveys an impulse to protect, to use the image to ward off dangers to its subjects. The sculptor Eva Hesse has been an inspiration, partly because of the dislocations and migration in her biographical circumstances: Hesse and her sister were put on a train from Hamburg in 1938 to save them from the Nazis. Bhimji relates very closely to Hesse's choice of friable-looking materials, the translucent, wafer-thin resins and latexes, her fingertip pleasure in weak, 'poor', abject

stuffs such as string and netting, and she pays a sculptor's sensory tribute to matters that ooze, such as wax and amber. She also shares the patience of Hesse's work; Bhimji will keep things in her studio for months – a coil of hair, an almost invisible hairnet, a child's toy, a Gujurati steel bowl for making chapatis, a piece of cloth – before she finds a way of including or featuring them. Though this procedure isn't intrinsically feminine (see pp. 47–59; the sculptor Richard Wentworth also lies in wait for ordinary, daily objects to reveal themselves to him as artefacts), it has been followed by women artists who seek to redistribute values, to uncover their relation to time and history through images of humdrum, common things, which are frequently part of domestic everyday tasks.

The recent, obsessive concern of artists with imaging the human body derives partly, it seems to me, from the disappearance of widespread belief in the soul as the seat of unique identity.[14] Material evidence of individuality, from the particular hallmark of DNA to the shape of a nose or a thumb, has been invoked, represented, underlined more and more in an effort to ward off mortality. Christian Boltanski, an artist with whom Zarina Bhimji has a strong affinity, has collected multitudes of faces and framed them to memorialize them, even in the anonymity emphasized by his titles: *364 Dead Swiss* (1990). Rachel Whiteread's cast sculptures of rooms, furnishings and a whole house come with titles such as *Ghost* (1990), and create solid forms out of empty space, turning absence into phantom presences that are elegies for the lost objects they delineate. Their claim on permanence is doomed – as in the specific case of *House* (1993), Whiteread's monument to precariousness, which was itself demolished.

Despite the difference in their chosen subjects, Boltanski and Whiteread share another quality with Bhimji: a preference for materials that are unsettling in their sensuous appeal. Boltanski's heaps of discarded clothes communicate unqualified nostalgia; Whiteread's sumptuous use of latex and resin cuts across her minimal forms to intensify the sense of immediate, tactile, and even olfactory materiality. Similarly, Bhimji's images and arrangements of objects protect against disappearance. They reclaim the past as alive, by awakening the viewer's sensory responses – the smell of red spices, the feel of red tulip petals like satiny skin, the shudder of dread at the ghostly limbs in their glass boxes.

BODIES OF SENSE

HELEN CHADWICK

The Wound of Difference

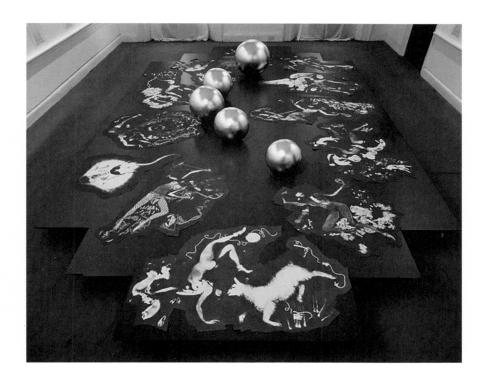

The Oval Court
1984–86

In the *Self-Portrait* made by Helen Chadwick in 1991, the artist holds out a brain towards us, confronting us with a risky, stripped analogue for the face. The image is a challenge: it begs the questions 'How am I me?' 'Is it the mind that makes me me?' 'And is this mind in the brain?' 'And how is this brain different and individual inside?' As so often with this artist's inventions and reversals, her ironic, contrary fantasy doesn't resolve into the jester's nihilism or the rationalist's mocking laugh; it doesn't collapse back into normative tranquility, as happens with the subversion of the carnivalesque or the hubbub of charivari. It makes us think harder and shakes up received ideas.

By exchanging outside for inside, the image recognizes that the mind is embodied, too, not in conventional beauty, but in those convoluted folds of soft tissue, close to innards or guts. Chadwick once wrote: 'To me, earthworms are a source of pleasure…Perhaps by focusing on [them] it might be humbling for man, perhaps we could get back some perspective on things….' This image of self is just one in the series she made as she investigated what it means to be made of flesh. Her 'Soliloquy to Flesh', written in 1989, began with the words: 'My apparatus is a body x sensory systems with which to correlate experience. Not exactly real, I am none the less conscious, via physicality, of duration, of passing through.' She spent the short time she was allowed to pass through this world examining how that consciousness translates into matter and can be made visible, in every way she could.

Helen Chadwick (1953–96) struggled throughout her life to change the way we map identity, and consistently inaugurated new elements of iconic language. The titles, writings, catalogues and invitation cards she made were all chosen with the same care she gave to every seam and edge in her work; and of all the words she used, *Enfleshings* is the one she chose for the book which she wrote and designed in 1989, with a photograph of glowing raw, red meat on the cover. She wrote, 'Selfhood as conscious meat – I am MC_2, my mass times the power of my light. At its most bald, this is our fleshhood – a red mirror….'[1]

Even *Self-Portrait* can't altogether escape, however, from the tradition of external appearance: in the matter of her hands, which are offering the brain for view, it still conforms. And Chadwick had small, stubby-fingered

BODIES OF SENSE

hands, muscly as a pianist's, scored and knobbly from the processes of her art, with several gold rings on every finger and sometimes on both her turned-out thumbs as well, the nails distorted, stunted and ridged from contact with toxins in the course of printing and other processes. These artist's hands are there, in the photograph, holding the brain.[2]

Sudden, early death does not only cut off all the expectations and plans of the life and the work; Helen Chadwick's future was seething with ideas and promise, with schemes for tens, if not scores, of exhibitions. Her own fertility, as she increasingly probed the meanings of fertility and infertility, of the quick and the dead, seemed inexhaustible; yet answering its demands seems to have exhausted her. The unexpected early death that ended her uniqueness now changes the past, too: it sends a high-voltage shock retrospectively through the achievements and wonders of her lifespan and makes it a different story, no longer of beginnings, or of improvisations or of experiments, way stations on a continuing journey, but of final statements that have become part of a concluded opus.

Their age at the time of their deaths, and the way they died – John Keats, Percy Bysshe Shelley, Wolfgang Amadeus Mozart, Samuel Taylor Coleridge, Emily Brontë, Sylvia Plath, Eva Hesse – make a difference to the way we know and appreciate their work; they gave abundantly and it looked as if the flow wouldn't fail, yet, when they go, this is it, completed, willy nilly. It seems more amazing, not less so, that so much could have been achieved, so magnificently. At the same time it reminds us of what might have been: it contains the tragic potentiality of all that they still could have done. The work of people who die 'in the fullness of years' exists in the dimensions of ordinary linear narrative, active mood; the present turns naturally into the past as their story unfolds. But those who die before their time, like Helen Chadwick, are caught up in the haunted, ambiguous shadow world of what might have been – an unrealized future. And the shadow of loss falls across the work, retrospectively, bringing out, in Chadwick's case, proleptic glimpses of her mortality which we didn't take to be warnings at the time.

She confronted the mystery of the life cycle and of natural processes of growth and decay again and again, with what now seems an uncanny

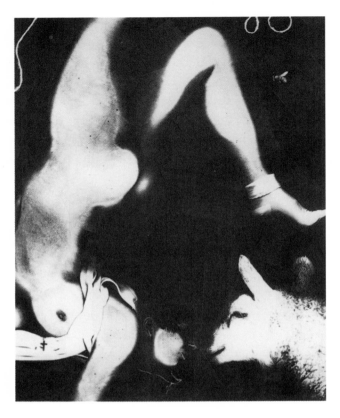

The Oval Court, detail, 1984–86

sense of the issues' particular urgency in relation to herself. *Ego Geometria Sum* (1983–86), made before she was thirty, looks back at her birth, childhood, adolescence: a personal cycle materialized in the permanent solids of Euclidian geometry.[3] She counterposed the vulnerability of the naked human body (her own) with the abstract and enduring products of the mind, embodied in a cube, a sphere and a pyramid. She recorded her own premature birth in the first piece of the sequence, in which she photographed herself curled up foetally in an incubator, as she was in the first weeks of her life.

Two predominant currents flow and charge Chadwick's oeuvre: one carries her ever more deeply under the skin of the visible, in order to discover new ways of picturing the invisible, the life-giving cambium layer, the secret substrata and recesses of matter and bodies; while the

other brings her to meditate, almost like a Zen mystic who has learned how to laugh, on the way that *in extremis* – literally at the end of all things – difference has a way of vanishing, and opposites not only attract but fuse. So, for example, for her 1986 installation *Of Mutability*, the teeming excesses of fronds and frills, fleece and flowers and flesh that create *The Oval Court*, a cornucopia of natural plenty overflowing in variously staged tableaux of pleasure and abundance, were paired with a glass column called *Carcass*. She filled this with the actual debris of flora and fauna used to make the images in *The Oval Court*, including a lamb, a swan and a monkfish (see p. 111 and opposite page), and added refuse from her neighbours' bins. All this was packed into a towering vertical compost heap, where it rotted and liquefied and bubbled and emanated.

When the managers of the ICA, horrified by the overwhelming stench – there was a heat wave that summer – took down the piece without asking her permission, Chadwick was enraged, and remained so. She didn't understand their panic, their disloyalty to art. To her, *Of Mutability* lost its point without its counterpoint, without the memento mori of *Carcass*. It was the baroque Vanitas tradition that had originally inspired *Of Mutability* and other works of that period, including one actually called *Vanitas II* (1986) in which the artist herself, adorned like a court lady posing as Venus, looks at the splendours of her nakedness in a mirror; the implication is, she is learning that they pass.

Chadwick firmly defended her liking for exploring the erotics of the gaze and the dialectic of sexual conflict around the female body, and took on the tradition of the nude at a time when the politics of contemporary feminism largely condemned it. For her it was intimately intertwined with the tradition of the *nature morte*, the still life, but it would be a mistake to linger on the morbidity of some of this early imagery to the exclusion of the artist's other moods; her passion for the flesh rose with humour and energy from her huge, healthy appetite for knowledge. In 1988, she made a remarkable piece, *Blood Hyphen*, for a chapel in Clerkenwell. From a wound-shaped rent in the blind over one high window in the vault, a bright red laser beam fell and dissected the nave; it transfixed a projection onto an altar made from a smear of the artist's cells. Here she was comparing the searching and all-seeing

eye of God, penetrating the walls of a place of worship and landing on a most sacred spot, with the breakdown of the frontier between visibility and invisibility in state-of-the-art medical technology.[4] The work also unfurled the unruly, rhythmic forms of biological structures in a manner that *Viral Landscapes* (1989–90) later took up.

Yet again, these works are eerily prescient, for Chadwick represented a virus attacking her: 'On the threshold of living,' she commented, 'the virus hijacks the replication material of the cell to effect its continued proliferation. Essentially it is no more than chemical information, lifeless outside a biological system; a "dissident" cultivating the possibility of change, if prejudiciously for its own ends.'[5] Visually, she struck morphic resonances between stone and earth and water, flesh and lymph and blood, as the interrupted streaks of her cellular tissue were superimposed on panoramic photographs of the rugged and striated Pembrokeshire coast.[6] It's thought that the artist may have died as a result of the virus myocarditis, so these brave, nearly rhapsodic evocations of natural disruption in 'complete abandon' carry a heavy charge of tragic irony.[7]

At this stage in her work, Helen Chadwick was searching out the limits of the visible and beginning to chafe at the western emphasis on sight as the prime instrument of perception. She began to realize the eye's intrinsic weakness in delivering sensation, as compared to the senses of touch, of smell and taste – even of sound. She often spoke of wanting to create through her images 'the discharge of energy that occurs in touch.'[8]

So noises and odours and flavours increasingly accompanied her inventive and unusual choice of textures; all kinds of stuff, spiky, silky, slimy, furry and sticky, began to come into the work; she set out to expand the range of erotic organic stimuli. With determined contrariness, she took up Freud's thoughts on repugnance about any reminders of our animal origin. The hair around the mouths of men and the hair on the crowns of women promises the fertility and life of those hairy parts which must be kept hidden (kept in the right place). When Freud analysed the symbolism of feet, he linked them to hair: 'Thus the foot or shoe owes its preference as a fetish – or a part of it – to the circumstance that the inquisitive boy peered at the woman's genitals from below, from her legs up; fur and velvet – as has long been suspected – are a fixation

BODIES OF SENSE

of the sight of the pubic hair, which should have been followed by the longed-for sight of the female member.'[9] Chadwick sometimes mixed hair with organic substances: the pig's bladder membrane tissue wound with golden hair in *Loop My Loop* (1991; see below); the mink cuff on a cast cactus in *With This Ring I Thee Wed* (1993). Showing macabre wit, she mingled human hair, animal fur and other materials, for example in the punning piece *Nostalgie de la Boue* (1990), which shows a crown of black hair in a sump of muddy water. Another piece offers a wreath of gleaming, browny-red brandling earthworms, fishermen's bait; their wriggling inspired the artist to compare them to consciousness, burrowing down. Chadwick revelled in jolting the viewer from one response to another, mining disgust and repulsion with glee as she made unsparing images of nostrils, navels, arseholes, in conjunction with the sickly pink glare of Windolene (or is it Germolene?), the shrieking poison green of Swarfega heavy-duty soap, the airy froth of washing up liquid, the shiny ooze of hair gel and slick shimmer of cling wrap, all wickedly composed according to the most accepted, even banal laws of aesthetic decorum in *Bad Blooms/Wreaths to Pleasure* (1992–93), triumphantly exhibited in her last full-size solo show, 'Effluvia', at the Serpentine Gallery, London, in 1994.

Explorations into synesthesia, the correspondence between the senses which Swedenborg formulated in the 17th century, intrigued her, and she tilted at the boundary markers around correspondences, either upsetting or exposing some unspoken truth about them: the stem hole of a plum has never looked so like a clandestine orifice as it does floating on a pool of engine oil. She was a mischievous mistress, delivering funny feelings whether you liked it or

Loop My Loop, 1991

not. Neither chocolate nor perhaps coprophagia has ever seemed quite the same since her fountain, *Cacao* (1994). She sought out incongruous juxtapositions – buttercup petals and an oyster in *Eat Me* (1991), a rococo cherubic cluster of baby rosebuds and pink petals in the toy phallus of *Wreath to Pleasure #10* (1993), in which the different textures of scrotal and penile skin were configured in different blossoms. Her art purposefully set out to excite mixed feelings, where disgust and pleasure jostle. She was mischievously expert at sparking unaccustomed physical sensations, which share ambiguous effects with thrills, wonder and sex: neither exactly pain nor exactly pleasure, not exactly terror, not exactly tranquility, but all these exquisite sensations at one and the same time.

Piss Flowers (1991–92) play similar tricks on the viewer. The sculptures lyricize and eroticize the act that made them – herself and David Notarius taking turns to pee in the Canadian snow. She revelled in this exuberant inversion of commonplace attitudes; this famous work realigns several other habits of mind, prankishly dissolving widely held structural oppositions.[10] Here, snow no longer melts and abject piss becomes pristine and durable, treated according to the defining principles of a most august method: lost wax cast in bronze, painted with pure white sparkling enamel. Dribbly mushrooms are erected like earnest monuments in a gallery or museum space. Above all, *Piss Flowers* deliberately inverts expectations of gender: Chadwick, the female, has made the phallic stem and pistil and Notarius, the male, has contributed the petals, the open face of the flower. As Thomas McEvilley commented: 'There is an inversion of higher and lower in these works in addition to the dialectic of inner and outer. The spirit plunges orphically downard and descends into the flesh; the flesh shines upward toward a transfiguration of its determined tendency to decay.'[11]

For the huge survey show 'Féminin-masculin' at the Centre Pompidou, Paris, 1995–96, *Piss Flowers* was strategically placed: at the entrance to the exhibition, Louise Bourgeois's huge piston pumped up and down a railway track, making enormous puffing noises (*Twosome* (1991)); then came Gustave Courbet's 1866 *L'Origine du monde*, the tenderly painted close up of a woman's vulva (significantly, the work had belonged to Jacques Lacan); then, in the next space, *Piss Flowers*. Bourgeois's burlesque

monolith poked at male prowess; Courbet fetishized female difference and thus epitomized 19th-century exaltation-denigration of Woman; and Chadwick's work, by contrast, indicated another track on the map of desire, neither parody nor worship, neither the battle of the sexes nor the Eternal Feminine but something combinatory, mutual, humorous, acknowledging human baseness without wallowing in abjection.

That sculpture is predicated on polarity all the same, on a neat mesh of inversions, and Chadwick was driven by her desire to cancel this and other oppositions. For the *Lamps* series in 1989, she had written about 'the incidence of a mutual twinning, doubled being. The momentum is ambiguous, an excited equilibrium between synthesis and schism.'[12] She went on exploring themes of twinning, doubling and synthesis through a continued look at sexual difference. In the series *Trophies* (1993), she blazoned the male body and its orifices, photographed in close up and mounted on heraldic shapes, to reveal its kinship with the female body's traditional qualities of openness, softness, receptiveness. The tower of tongues in *Glossolalia* (1993) also blurs genital particularities and celebrates sexual pleasure through the combining of male and female, penis and vagina into one repellent-attractive artefact. She believed, she said, 'in our inherent bisexuality'. The sign of infinity – the figure of eight – that she used for *The Philosopher's Fear of Flesh* (1989) also deliberately erases the sex and the species of the bodies in the photograph. She commented, 'Undeniably erotic, we seek to quantify what we are looking at, but there is an inherent instability. Is this animal or human? Singular or plural/ Or neither...? Chadwick knew Georges Bataille's analysis of the erotic potency of disgust; but she also derived these ideas from monitoring her own personal living in and out of gender, her polymorphousness of mind, desire and energy.

The case of Herculine Barbin touched her: Barbin was a hermaphrodite who lived contentedly as a woman among women until forced to take on explicit male gender, which did not work for her. She committed suicide at the age of 30.[13] 'That happy limbo of a protected non-identity,' commented Helen, 'those tender pleasures she describes ended in tragedy.... Question: Why do we need to establish gender and wish absolutely to sex the body that confronts us...?'[14] She was battling

against the anthropological and psychoanalytical doctrines that place the law of gender difference, such as the incest taboo and the laws of kinship, immutably at the foundation of human society. The longing for symbols of oneness stretches right through Helen Chadwick's work: the Omphalos at Delphi, which represents the navel of the world and is marked by a conical stone criss-crossed by cords, was a monument she often invoked. She identified the cords with the 'navel-strings' of babies brought to the oracle for blessing.

She was always curious about new ideas and practices, and consistently extended the range of her perceptions by using prostheses – microscopes, photocopying machines, Polaroids and lasers, computerized enhancements, analyses and magnification. After the exuberant studies in sensory pleasure that chiefly occupied her from 1986 onwards, she returned, for what were to be the last two sequences of her life's work, to optical experiment and the problem of spectacle, especially in the sphere of reproductive technologies.

Her assault on representations of fertility and motherhood, one of the most deeply ingrained areas of received ideas – of 'misconceptions', as she put it – began with *One Flesh* (1983), her Madonna and Child icon, a collage of photocopied images she made of the punk performance artist Cosey Fanni Tutti (Christine Newby), who was a friend and neighbour and had just had a baby with the Situationist Genesis P. Orridge. In this profane icon, the mother is pointing to the sex of the baby (a girl). Chadwick uses gold, vermilion and ultramarine, the heavenly colours of Christian icons (she was Greek Orthodox through her mother), but into this otherworldliness she reintroduces the memory of flesh: the mother is cutting the cord with a pair of surgical scissors and the placenta is floating above mother and child like a profane halo, beside another, enigmatic form. These are Cosey's labia, which are infibulated with several rings, in position above like a winged cherub.

It's a wilfully blasphemous yet opulent piece, the mother and child in bloom, drapery and broderie anglaise in flounces around them. It is also a kind of Vanitas, one of those medieval lover's emblems that opens to show a cadaver inside – for at a second glance, it displays blood and pain, cancelling its first impression of maternal harmony.

The installation *Lofos Nymphon* followed in 1987, a study in her own filial relationship. This was another innovation: a self-portrait of an artist with her mother, naked. In one of the five panels, she shows herself cradled against her mother's breast, with the city of Athens, her mother's birthplace and home, in the background. The ovoid shape of the framed icons is intentional: 'Once knots in the navel-string were used to prophesy the future,' Helen wrote, 'Here, looking back to the source of self-hood in that first and fatal life-giving cut, are five loci for reading, nodes on a thread, to re-evoke the egg, the cartouche of that swollen, pendulous body....' She wrote with intense feeling of making this piece: 'Facing open rupture, the wound of difference, what a solace it would be to construct a haven for the disembodied memories of pleasure at the mother's breast – a chamber where the oscillations of dread and longing merge together and I might resurrect this lost archaic contact safely....'[15]

After this intense homage to her own mother, she began tackling one of the most sensitive and inflammatory questions of our time – embryo research. She was spurred on by an important essay by Rosalind Pollack Petchesky about anti-abortion campaigners' visual propaganda, in which the embryo as a viable child-form entity appears entirely separate from and seemingly independent of the maternal body, as if the pre-embryo, the embryo and the foetus existed alone in difference.[16] Petchesky points out how urgent it is to generate new imagery of origin, and Helen Chadwick's copy of the essay is underlined and annotated throughout with obvious passion; she rose to the rallying cry and set out to create an alternative iconography, to communicate the original enfleshment of us all and the mystery of fertility and infertility.

Nebula (1996), which returns to the associations of the colour blue as struck in *The Oval Court* – the blue of cosmic space and of the blueprint – is Helen Chadwick's last tribute to the bliss of undifferentiation and engulfment, about which she wrote in *Lofos Nymphon*: 'As a modern, with no centre, no core of belief, it is possible to encounter the void of Origin, to give it form and a body, and so return to the site of beginning.'[17] The artist who had made *One Flesh* consciously placed the interdependence between woman and future child in the field of vision: the cells that swim

like starry galaxies in the works are not individual beings but beings *in potentia*. That potentiality has not been fulfilled, because it can only be so after implantation and gestation in the mother's body.

It was one of her many strengths as an artist that she was a stickler, a consummate practitioner, whose assaults on the canon of the ideal were always, in whatever medium, finished to perfection. This immaculate craftsmanship helped her smuggle her ideas across the border of convention – never more so than in the exquisite *Nebula* and related last works, where she was finding yet another pictorial form for the time when the wound of difference has not yet opened.

When Helen Chadwick visited the Hunterian collection of medical specimens in London, she was confronted by an atlas of difference, drawn according to the 18th-century medical vision of normality and abnormality; among the specimens are many infants and foetuses. Hunter's astonishing range of examples of creatures and their organs and reproductive systems had also been very important as a teaching tool, and had helped institute the hierarchy of beauty, proportion and appropriateness which had consistently fascinated her. After the conventions of decorum and the aesthetic canon, after sexual polarization and taboo, this system of regulatory classification by species and health became another territory for her to explore.

She brought to the task her own marked enthusiasm for what is 'strange' – a staple of the humanist cabinet of curiosities from which Hunter's museum derived. When she first saw the 'Cyclops baby', for example, she spontaneously found him 'utterly beautiful'; she felt no revulsion, but found her imagination instantly began to play on his features with a kind of passionate sympathy, like love. For her the monster was a natural occurrence and should not be set beyond the pale; she believed that famous hybrids of myth, like the Chimera with three heads, represented creatures which had existed and whose difference had been exaggerated by the terror and the prejudice of observers. She chose to work with him and two other specimens – a chimpanzee and a 'Pigmy' woman. At the time of her death, she was planning to add Hogarth's 'Line of Beauty' to the *Cameo* she was making of the woman and she had turned the baby's body around in the photograph, so that the dissection

would not show. These works in progress, the last time I saw her, made her studio feel like a reliquary chapel, in which the dead saint's remains are still somehow uncannily imbued with life – the blood might liquefy, the eyes might open.

Of Mutability tilted the artist's interest towards decay; in these Hunterian pieces, left unfinished at her death, her interest was leaning towards resurrection. In her last fax to me, she wrote 'I seem to be projecting imagined psyches onto seen physical phenomena....'[18] She went on to recommend Martin Jay's *Downcast Eyes* (1993), a lucid, comprehensive study which examines philosophical and artistic attitudes to seeing from Descartes' legacy to Luce Irigaray and Jean-François Lyotard.[19] It throws suggestive light on Helen's last enterprise and the direction she was taking in her lifelong challenge to prevailing epistemology. She was continuing to reorient the tradition of aesthetics towards shaping a better fit between representation, sensation and knowledge. Her art developed from the immediacy of experience gathered through her senses, but she tested this against an inherited set of values, encoded in images and formal standards. In Helen Chadwick's work, Mannerism meets Fluxus, the rococo merges with Situationism.

A decade before she died, she wrote: 'Art, like crying, is an act of self-repair, to shed the natural tears that free us, make us strong.'[20] Chadwick's work draws us into protean, repeated, infinitely original acts of reparation, and we need them now more than ever, now that she is no longer enfleshed, except in art.

TACITA DEAN

Footage

Footage
2011

The feet of gods and goddesses' stone bodies make no sound, and their steps are stilled, but they give pulse and scansion to the walls and temples and tombs in which they appear, buildings which are intended to open the passage to other worlds. Long feet, slender feet, naked or shod in light sandals made of reeds, so delicate they must have been worn once or twice only; straight toes, long and thin; slender ankles like those of the goddess Persephone and the sea-nymph Ino/Leucothea from the *Odyssey*; feet as revealed in ancient Egyptian, Greek and Hellenistic sculptures pledge the ethereal beauty of their owners.[1]

When divinities or heroes or saints ascend, they sometimes leave their footprints behind, evidence that they have made the passage but are still somehow with us. Many of these traces are very highly charged: I've come across several and they are sacred, magic and funny at the same time. In the Chapel of the Ascension near Jerusalem, Jesus has left the imprint of his feet on the rock where he stood before he took off, and the stone has been enshrined in the floor and is venerated as the last spot that the incarnate Saviour touched in this world. At Bolsena, north of Rome, the young virgin martyr Santa Cristina, who was horribly tortured before she was put to death, is buried and worshipped in the Duomo. According to her legend, her pagan persecutors tried every torment they could think of, but when they failed to kill her, they tied her to a millstone and threw her into the lake of Bolsena. She soon came bobbing back up to the surface, standing on the stone, which floated and carried her back to the shore. The miracle was marked for ever by the imprint of her feet – two very small and narrow depressions – on the rock. It is now framed in Renaissance splendour in a side chapel.

The most wonder-working stories of all ascribe animation as well as presence to holy footsteps: they are alive, sometimes even fragrant, and they give life to growing things. Something of this clings to the carol 'Good King Wenceslas', when the King tells his page to tread in the prints he is making in the snow and the boy finds that they keep him safe and warm. The Buddha's footprints are venerated; and in Persia in the 16th and 17th century, the *Falnama* (or *Book of Omens*) describes how, in the footsteps of a holy man, Imam Reza, hyacinths and basil sprang up.

Our human feet aren't like these – except very rarely. Ours are crooked and cracked, calloused and knobbly, especially after a few decades walking on them, and at times they are horribly smelly. Taking off our shoes to expose these humble working parts offers respect to divine bodies who don't show the marks of time in the same way. Placing our feet bare on the ground also draws attention to our earthboundedness as mortals. Feet serve to remind us of the division between earth and heaven. They return us to the idea of this world and the other(s) and of walking between them, and summon up the longing for knowledge of the underworld as represented by those tomb figures of ancient Egypt. For Freud, the stone relief of Gradiva ('she who walks'), carved in the 4th century BCE, became a talismanic image; he placed a plaster cast of it at the foot of his psychoanalytic couch, for those lying there to look at if they opened their eyes while they talked. Gradiva is stepping forward lightly, ardently, as if in a chorus dance. She represented the energy and motion Freud wanted his patients to feel – to regain.

II

A foot is a measure based on the body, like *une pouce* (thumb) in French, for an inch, or 'two fingers' of Scotch in a glass. It is also a measure of poetry: the hexameter has six feet; the iambic pentameter, the common 'running rhythm' of English blank verse and also of much ordinary speech, has five feet and it lists as it moves, going *di-dumm* or *da-doum*. A foot of words, like a bar of music, marks the beat and gives out the rhythm of the song and dance. When Gerard Manley Hopkins experimented with poetic meters, he sprang the rhythm and introduced catches and halts: 'The strong syllable in an outriding foot', he wrote, 'has always a great stress and after the outrider follows a short pause.'[2] These outriding feet prolong the line, tango-style, to a swoop before the turn. At another point, Hopkins coined 'footfretted' for the jolting beat he sought.[3] The suspense created by an uneven beat was sometimes called *scazon* in Greek – from the verb for limping.

Steps taken between worlds are not always effortless or even; more mysterious symbolism has gathered around the halting and the lame. A hobbled, irregular rhythm and asymmetrical limbs designate many of

the most powerful gods and goddesses, heroes and heroines and fairy tale tricksters and survivors – from the Olympian Hephaestus to the little boy who follows the Pied Piper with all the other children but can't keep up because he's lame. He alone is spared when the Piper leads them all into the mountain which swallows them up for ever. Hephaestus was hurled down as a baby from the mountain of Olympus and his twisted limbs later caused the other gods to mock him. But their laughter does not diminish him: he is the god of the forge, master of fire and inhabitant of volcanoes; his technical mastery is unparalleled; the first woman, Pandora, is his handiwork. In his forge he's served by golden handmaidens whom he has also made; they look like real girls, Homer tells us. He also wrought a colossus of bronze, Talos, whose name means 'heel' because his vital fluid is stored there in a magic membrane.

When Ray Harryhausen, the master of special effects, worked on the cult classic *Jason and the Argonauts* (1963), he displayed to wonderful effect the affinity of film media with uncanny myth. Like Hephaestus, Harryhausen animates the inanimate: the bronze giant Talos cracks and topples after Jason attacks him through the heel, and a macabre, clanking army of skeletons rises up to fight the Greek heroes.

Hephaestus isn't the god of art and poetry – that is Apollo – but as metallurgist, blacksmith, creator of automata and sculptor, he would have made a perfect patron of all artists. Crippled gods and goddesses are frequently involved in making, and the word poetry comes from Greek *poein*, to make (a poem is an artefact, too). Syncopated motion or a stumbling gait taps out verbal rhythms and marks interstices between the ordinary measure of regularly taken breath or steady clockwork; in that suspension – that *rubato* – something else enters and forms new meanings.

The lame god and his bronze man with the vulnerable heel have famous counterparts: Oedipus, a word which means 'swollen foot', was given this name after he was found by a shepherd exposed on a hillside with a spike through his ankles; Jacob, after he wrestled with the angel, was left with a twisted hip (Gen. 32: 22–32).

An inventory of lame heroes would be very long; it includes historical figures, not only ancient gods or heroes or robots, as Tacita

Dean's drawing, *Oedipus, Byron, Bootsy* (1992), recognizes. It's an understated work, a fugitive thought on paper, but coming across it later, its imagery gave her a great jolt; it seemed uncannily to foreshadow so much in her life and work.[4] 'The name Oedipus means "swollen foot",' she wrote in *The Story of Perfect Feet*, 'and Oedipus was the father/brother of Antigone. And Antigone is my sister's name and so that word…has always had a huge importance in my life. It was probably one of the first words I ever learnt to say.'[5] In 2018, the figure of Oedipus's daughter returned with the film *Antigone*, which represents the latest chapter in a long, loving involvement: *Blind Pan* (2004), a monumental five-part sequence of monochrome photogravures, tracks the blinded, self-mutilated King of Thebes being lovingly led and cared for by his youngest daughter as they leave Thebes and wander in the wilderness until they reach sanctuary at Colonus.

This preoccupation also led to a fascination with the poet Byron, who suffered from a club foot, and with a close family friend, who was her sister Antigone's godfather and was affectionately known as 'Boots' or 'Bootsy' because he had a built-up shoe. In 2003, Dean made the film *Boots* with this mysterious and romantic family friend, whose patch over one eye also fascinated her as a child. His footsteps dominate the piece and his two sticks ring on the marble floors of the Villa Serralves in Porto, Portugal: *da-dum, da-dum, da-dum*, the listing footfalls of the iambic. 'He effectively is an Oedipus, a swollen foot', she says.

Throughout the nineties, she remembers, she was also 'endlessly drawing legs' – the legs of Adam and Eve from Masaccio's fresco of the Expulsion from the Garden of Eden, and *The Story of Skipiod* or 'shadow foot', inspired

Oedipus, Byron, Bootsy, 1991

by travellers' tales about a people who shaded themselves by hanging their one big foot over their head.[6] These were followed by the complex multimedia piece, *Foley Artist* (1996), for which she worked with 'Beryl the Boot' and 'Stan, Stan, the footsteps man'. 'They are sometimes called "Footsteps artists",' she says, 'but they also do human sounds and kisses,

body movements, body falls, because these are things you can't simulate. And everybody falls differently or walks differently.'[7]

Visiting Delphi on her own one winter, Tacita Dean found the *Delphic Charioteer* in the Museum there: 'He has perfect, the most perfect ankles, the most exquisite examples of ankles I have ever seen', she says. The sight brought Oedipus again to mind. Divinely beautiful feet summon up their counterpoise, their opposite, as imagining the soul and its lightness recalls the drag of the body. Until she rediscovered her early works from the early '90s, she had forgotten that her interest in the theme predated the rheumatism which has now made her limp too: 'In 1991 I didn't have any intimation of the arthritis that I now have quite radically in my body.'[8] The artist had intimated her own affliction in her art.

And then, two years ago, as if this weren't enough, after she had found this pattern of concerns in her own prophetic imagination, her right ankle began hurting even more than usual, and the doctors diagnosed a different, genetic condition: she has a wing-bone, or bone-tail, in her ankle, with the medical name *processus posterior tali*. 'I felt very much', she said later, 'like my Achilles heel had been discovered.'[9]

It was after talking to the artist about these things, and about the many myths that involve limping and the many theories that have been inspired by them, that she wanted me to write this for her.

'I work always…slightly underneath the level of consciousness', she has said, 'and I usually don't know what or why I do things until a long time afterwards.'[10] It feels awkward and almost brutal to try to draw out some of the threads from the marvellous, unconscious weave in Tacita Dean's work, and they must not be tampered with and brought too far up into consciousness. I've tried to pick out some of the patterns; as Paul Ricoeur has written, 'the symbol gives rise to thought.'[11]

III

The Homeric Hymn to Demeter opens by recounting how the goddess of the spring, Persephone 'with the slender ankles', was abducted by the god of darkness to preside at his side over the underworld, and how her mother, Demeter, goddess of harvests and summer and plenty, goes wandering about the world looking for her.[12] During her long search, the grieving

mother disguises herself as a broken old woman and sits down on a rock – the 'Laughterless Rock' – by a well called the 'Maiden Well' or the 'Well of the Fair Dances'.[13] There, the four beautiful daughters of Keleos, ruler of Eleusis, and his wife Metaneira, find Demeter, weeping. The goddess in disguise asks them to give her work in their household with a child or baby; the girls sense something magnificent about the stranger and they invite her to become the nurse of their new baby brother, Demophoon, a late and much loved arrival.

But Demeter is inconsolable and silent in her sorrow:

When Demeter arrived in the house,
she just sat there, wasting with longing
for her deep-breasted daughter,
until Iambe, so sensitive and thoughtful,
changed the mood of this sacred lady with jokes
and many jests and made her smile and laugh
and put an end to her sadness.
In later times also it was Iambe
who pleased the moods of the goddess.[14]

After this entertainment, Demeter promises to take care of the new baby Demophoon and ward off all dangers: 'For I know a charm more cutting than the Woodcutter/and I know a strong safeguard against harmful witchcraft.'[15] She raises him secretly as if he were a god, giving him ambrosia to eat and 'at night she buried him in the heart of the fire,/ like a torch, without his dear parents knowing.'[16]

On one of these nights, the baby's mother catches sight of the nursemaid as she is laying the baby in the flaming hearth; her screams interrupt the goddess, who throws him from her and reveals herself in her full glory, cursing the mother by the waters of the underworld river Styx and reproaching her bitterly that now her beautiful boy will be mortal like everyone else.

The Homeric Hymn was written in the 8th to 7th centuries BCE; it's a ritual hymn, which moves in mounting ecstasy from grief to delight, from barrenness to fruitfulness, from obscurity to illumination. Demeter

condemns the world to winter while her daughter is held in the Underworld, but when Persephone returns so do spring and summer. The goddess is mute in her sadness at the beginning, but the long poem also includes the story of Iambe, and the episode involving her unfolds a densely woven enigma about sex and poetry, art and walking, life and laughter. The goddess regains her mirth, first when Iambe dances and jokes with her and then at the end, when she's reunited with her daughter. The poem catches us, the readers, up into a blast of new energy by means of the central dynamics of art – the rhythm of speech and its correlate in dance, which Nietzsche discusses so passionately in *The Birth of Tragedy* (1872).

The terrifying scene of the goddess putting the baby in the fire doesn't specify what limb or part of Demophoon was not annealed to become divine, but it recalls Thetis plunging the baby Achilles by his foot into the Styx to render him immortal, except for the ankle by which she was holding him.

Demeter and Persephone were worshipped in the mystery rites at Eleusis, which were closed to men, and the story told in the poem narrates stages in this all-important religious cult, conducted exclusively by women. In this context, Iambe's jesting takes on a more specific character, for the Eleusinian rites involved wild, jolly rudeness – coarse obscenities and self-exposure. They reprised Iambe's cavorting, which had successfully cheered the goddess, as they celebrated the return of fruitfulness in the drama of Persephone's release from Hell. The iambic meter was specifically associated with this kind of performance; it is used in very early texts for strong satire, ribaldry and mockery.[17]

This kind of sacred profanity, deploying grotesque insults and ugliness, can grate on contemporary sensibilities: too coarse, too vulgar (except in the broadest stand-up comedy). But in antiquity, rude satyr plays in a sacred setting were meant to shake things up, to shock participants into laughter as a means of renewal, and to spark fresh vitality – to quicken and brighten, as when Demeter restored growth and summer after Persephone returned to the world above.

The character of Iambe undergoes a transformation in later Greek works, and her physical associations with anomaly and irregularity are stressed. She ceases to be the sympathetic young girl of the *Homeric Hymn* and metamorphoses into a bawdy old pantomime dame, sometimes called

Baubo, who acts up to jolt Demeter out of her inconsolable sorrow.[18] In the 2nd century BCE, Apollodorus calls her 'an old crone', using the word *graia*, hag, when he too describes how her capers made the grieving mother-goddess laugh. This is the origin, he writes, of the ritual jests at the other great secret women's ritual of the Greeks, the Thesmophoria.

Such antics struck later Christian commentators as the epitome of pagan horror – indecent and blasphemous. Clement of Alexandria, for example, writing in the 2nd century CE, assumes that Iambe exposed herself to Demeter with the gesture of lifting her skirts. The gesture has its own term in Greek, *anasyrma*, and the child god of love, Eros, appears in this guise in figurines: a naughty boy showing his genitals (Freud collected Erotes and had a fine example of this laughing type). Obscenity – both verbal and physical (mooning front and back parts) was an established part of ancient rituals and Clement, a Christian apologist, is naturally shocked. He quotes an Orphic hymn in which the crone, cavorting, shows the goddess 'a sight of shame'.[19] The old woman's listing dance steps, jokes and rude horseplay promise reinvigoration: they will secure the survival of children (the goddess's daughter) and avert the threat of melancholy and death.[20]

Iambe/Baubo's character resembles the magical protectors on the amulets hung from cradles throughout the Middle East to keep off predators such as the 'woodcutter' of whom Demeter spoke. Typical guardians of women in childbirth and newborn babies include the Egyptian hippopotamus goddess Tawaret, wonderfully swollen-bodied, and the bulbous genie Bes, a dwarfish and misshapen figure with a lolling tongue and a ghastly grin.

The poet Paul Muldoon consciously identified himself with this tradition in his collection *Maggot*: 'to act the maggot means something like "to play the fool, to clown around"…. This usage resonated powerfully with me', he writes, 'since I'm fascinated by the notion of the cleansing role of the poet in society, the role of thorn in the side, the role of motley in the mortuary. It's a tradition that runs from Aristophanes through Abbot and Costello to modern stand-up, but it also runs from Boccaccio through Byron to Beckett and beyond.' He invokes the use of maggots in medicine, where they are used to clean wounds, before winding back to the imagery

Footage, 2011

of dancing: 'The sense of "maggot" as a "whimsical or perverse fancy, a crotchet" is one that is even more to the fore…. It includes the meaning associated with that musical term, "crotchet", whereby the "crook" at the heart of "crotchet" connects the maggot's hook-jaw to the physical shape of the musical notation.'[21]

Muldoon is a Hephaestean wordsmith, a cunning prosodist celebrated for his rhythms and rhymes as well as a joker capering according to whim (to make us smile). It is fascinating to see that this clever poet, thinking over his own devices, still hits upon imagery of the gait: for a crotchet is where the stress falls in the iambic, the *dum* in the *da-dum*, where the *da* is a quaver.

One of Muldoon's most famous poems is called 'Quoof', which was a family word for a hot water bottle. Some of the lumpiness of Iambe, the swollenness of Tawaret the Hippopotamus goddess, of Baubo and of Bes the dwarf demon survives in the cuddly pot-bellied bears and monsters, the quoofs, which children keep close to them at night when every sleeper has to descend into the dark. And we all know how mysteriously a young child clings to wakefulness, doesn't want to go to bed, doesn't want to go down to the place of sleep.

IV

The Canadian writer Margaret Atwood has made a large claim in her lectures, *Negotiating with the Dead*: 'Not just some, but *all* writing of the narrative kind, and perhaps all writing, is motivated, deep down, by a fear of and a fascination with mortality – by a desire to make the risky trip to the Underworld, and to bring something or someone back from the dead.'[22] She is thinking about her own sphere, which is literature; but what she says applies even more illuminatingly to a visual and kinetic art of light and shadow, duration and stoppage, such as the work of Tacita Dean. For beneath the jokes in the myth of Iambe, a deeper reason for the myth's relevance lies in the relation to time, danger, and death.

Tacita Dean has been on many journeys and her work has traced many journeys taken by others – by Donald Crowhurst, the sailor, and Robert Smithson, the artist, for example. She has clothed her concerns with time and death in chronicles of walking, passing through and

passing over. She recognizes that Iambe's role in stalling mortality, and the time-keeping of the iambic meters, have resonances for her art. She herself has been slowed, and her art takes us into 'silence and slow time'. She says she does not know what her art would be like if she could run.

The family friend known as 'Boots', like others whom she has portrayed in film, such as Mario Merz and Merce Cunningham, is a figure from Tacita Dean's pantheon, the family of her imagination, who is stepping, falteringly, towards the threshold of death – in allegory and in reality. Boots taps his way through the illuminated but eerie Villa Serralves in Porto, crossing the thresholds of half-remembered rooms. A mysterious gatekeeper, he allows us to overhear fragments of fascinating worldly, sorrowful and erotic memories.

The unevenness of the steps taken by Oedipus or Byron or Boots casts them as travellers to a different world which they are specially equipped to enter. Irregular motion slices into regular time and steps athwart or askance, making revelations possible: hence the title of the exhibition Dean curated in 2005, 'An Aside', which brought together many artists who see things with a difference, against the grain of common observation.[23]

In *The White Goddess* (1948), Robert Graves, the poet, classical scholar, mythographer and Biblical commentator, develops a universal theory about sacred kingship and the mortal male's relationship to the divine feminine principle, the Goddess of his title.[24] She incarnates art and poetry and acts as muse and lover to the human being attempting to utter – to sing. He then identifies a cluster of gods, kings and charismatic holy men and women who suffered from a damaged foot or a dislocated thigh. He includes Hephaestus, Talos and Achilles, and many, many more from mythologies other than classical: Diarmuid, whose heel is pierced by a bristle of the Benn Gulban boar, and Baldur the Beautiful, who is also pierced in the foot – with a mistletoe arrow shot by the blind god Holder.[25] Jacob's wrenched hip prefigures Jesus, whose feet were nailed to the Cross, according to Christian typology.[26] But Graves's chief interest lies with Dionysus, and he suggests that the high-heeled buskins which tragic actors wore recalled the forced gait of the god – or perhaps his swaying and listing in his intoxication.

Graves's thinking is generally considered eccentric, which is a poet's prerogative. However, the concept of inspired, sacred lameness found a new, far more authoritative advocate in the historian Carlo Ginzburg, whose *Ecstasies: Deciphering the Witches' Sabbath* (1989) explores a vast range of stories from classical mythology and popular folktales, from the Mediterranean to the North Pole, and maps a web of relations between medieval witchcraft and Siberian shamanism. In relation to one such story, Ginzburg comes to the conclusion that 'The severed heels of [heroes] are clearly the distinguishing mark of those who have accomplished the subterranean journey into the world of the dead....'[27]

Ginzburg calls this shamanistic sign 'asymmetrical deambulation' and fills many pages stitching together a great cross-cultural quilt of its symbolism. Later, in an essay reflecting on the book, he describes how he was overwhelmed by the coincidences he had found between the confessions of accused heretics (the *benandanti*, or 'the good walkers' in the 17th century) and earlier beliefs and myths about out-of-body experiences and soul journeys, the safeguarding of communities and visionary knowledge. 'Unlike the inquisitors,' Ginzburg writes, 'I was not in a position to influence the accounts of the *benandanti*. But I too, like the inquisitors, tried to turn into an analogy the anomaly I had come across, by inserting it into an appropriate series. And here the resemblances between the *benandanti* and the shamans forced themselves on me with irresistible evidence. In both cases we are dealing with individuals whom physical and psychological characteristics, often linked to birth, mark as *professionals in ecstasy*.'[28]

He goes on to suggest that the fairy tale of Cinderella, who loses her shoe when she runs away from the ball at the stroke of midnight and limps home, encloses an ancient sacred tale about the descent into the underworld. The story figures her covered in ashes and neglected in mourning for her dead mother; he sees her as a shaman who can travel across to the other side and return to bring news and guarantee the continuing of the light. 'Monosandalism', he asserts, 'is a distinguishing sign of those who have visited the realm of the dead....'[29]

The data Carlo Ginzburg marshals in *Ecstasies* surpasses even Graves's in speculative fertility, and I can't really say one way or another how

convincing as history this huge assembly of material becomes. But if you read the same material as if it were poetry and myth, forged by language and instituted as metaphysical truths through the power of metaphor, then Ginzburg's account does indeed become powerful and inspiring, throwing light on the ritual uses of art to confront death and darkness and release life-giving energy – as in the myth of Demeter and Iambe.[30]

Like Samuel Beckett, with whom her art has many affinities, Tacita Dean draws on silence, which is the sound between sounds, which makes the latter audible and distinct. Beckett obsesses over boots and feet, as in *Waiting for Godot*. He frequently specifies sounds of trudging and shuffling along;[31] a short play called *Footfalls* includes a score for the exact rhythm of the character's dragging steps as she waits for someone offstage – her mother – to die.[32]

Tacita Dean is in sympathy with keepers of the threshold, who touch knowledge of the underworld. So many of her chosen heroes have been lost or died, often soon after she has made her work with them, as if she sensed the passage opening ahead. She recorded Merce Cunningham towards the end of his life; and the poet Michael Hamburger in a tribute to W. G. Sebald. These intense, quiet film portraits have become memorials, elegies. The diminishment of the individuals' powers does not equal diminishment of their stature, significance or the passionate energy of presence in her art. She says she is glad that she has made these films and that they exist in this world: 'it traps something that really is disappearing. I am trying to trap something before it goes. All the things I am attracted to are just about to disappear, more or less. Now it is people, but before it was objects and buildings – the Atomium, lighthouses – also verging on the edge of obsolescence.'

Somatic knowledge, Dean has said, means knowing with your body before your head. Her art often communicates something unexpressed and fragile, lying beyond ordinary reach, as if she were gifted with prescience or serendipity to an otherworldly degree. She is an artist of leave-takings and partings, of journeys and exits. She sets up a counter-rhythm against disappearance. Her art acts to prolong the end of the line from the beat where it would usually fall, as with Hopkins's 'outriding foot' or the Greeks' limping scazon; in this way, she jolts the pulse, steals time from winter.

3. SPECTRAL
TECHNOLOGIES

Joan Jonas, *Reanimation*, 2012

It is the soul that sees, not the eye...[1]

RENÉ DESCARTES, 'LA DIOPTRIQUE'

The primacy of the imagination over bodily sight offers some explanation for dreams, visions and apparitions. The desire to capture mental images beyond empirical experience has been a powerful motive for artists, equal to the need to assist our deficient human faculties with lenses, prostheses and apparatus, which has spurred on optical innovation. The discoveries of photography and cybernetics have lent themselves very fruitfully to this artistic quest: it is a profound paradox that the scientific revolution did not dispel spectres and phantoms, but delivered an array of devices to summon them to the senses. Moving pictures – first the cinema and now digitized media – are especially attuned to the traditional immateriality – the filminess – of the dead, as described by those who made the descent into the Underworld and returned: Homer, Virgil, Dante. Virtual reality is the ultimate optical illusion.

This sphere of inquiry was and is fraught, because, as Plato observes, illusions are intrinsically mendacious: 'the same objects appear straight when looked at out of the water, and crooked when in the water; and the concave becomes convex, owing to the illusion about colours to which sight is liable. Thus *every sort of confusion is revealed within us*; and this is that weakness of the human mind on which the art of conjuring and of deceiving by light and shadow and other ingenious devices imposes, having an effect upon us like magic.'[2]

Medieval theologians distinguished magic according to three categories: first, miracles from God by which the laws of physics were suspended; second, Natural Magic, or the wonderful properties of earthly things; and last, the illusory work of the Devil. These forms are in practice difficult to tell apart, and spiritual counsellors and witch-hunters, early scientists and doctors of medicine all struggled.[3] Consequently, running through the history of magic and its attendant anxieties is a parallel history of optics: if the

Devil could conjure appearances, it was imperative to establish the true status of such manifestations by inquiring into the faculties of perception. Robert Fludd, an Oxford philosopher and esoteric Neoplatonist, pictured 'the eye of the imagination' as a prototype film projector, beaming images onto a screen floating in virtual space somewhere behind one's bodily eyes.[4] In Rome, a generation after Fludd, the Jesuit Athanasius Kircher began experimenting with mirrors and camera obscuras, and staged a series of demonstrations with an early magic lantern.[5] His magnificent volume, *The Great Art of Light and Shadow,* records how he manipulated the natural properties of light and played on the limits of human faculties, but also how he chose to project images of devils and skeletons and souls burning in hell – visions of the inner eye. To increase the effect, he even painted the slides with chemicals so that they changed colour under the heat of the lamp.

In 1969, the artist Robert Smithson, who also plumbed the depths of mirrors and their mysteries, wrote that 'Only appearances are fertile; they are gateways to the primordial. Every artist owes his existence to such mirages. The ponderous illusions of solidity, the non-existence of things, is what the artist takes for "materials".'[6]

This third part of *Forms of Enchantment* includes encounters with artists whose work resonates with Smithson's journeys into the sphere of dreams and illusions.

JOAN JONAS

Future Ghosts

The Shape, the Scent, the Feel of Things
2004–06

Joan Jonas's imagery combines poetic expression, ritual play-acting and figments made possible by new media to face the inevitability of disappearance and to take up the question of future ghosts. In the multi-faceted work *They Come to Us Without a Word* (2015), the ghosts are familiars, not ghouls; they're spectres approaching from the times that lie ahead as well as from memories stretching behind us.[1]

The title comes from a collection of ghost stories, handed down through generations in Nova Scotia, where the artist has spent the summer for many years: *Cape Breton Book of the Night*. Jonas has combined its peculiar, goosebump-inducing hauntings with the classical imagery that has set the metaphors we live by and think with when we imagine the dead of the past.[2] In the dismal gloom of the afterworld in *The Epic of Gilgamesh*, 'Where dust is their food, clay their bread/They see no light, they dwell in darkness,' the ghostly throng are imagined perching, 'clothed like birds, with feathers.'[3] In the *Aeneid*, Virgil consciously recasts Homer's version of the descent of Odysseus into Hades – his *katabasis* – in order to glorify his hero, Aeneas, the future founder of Rome. Evoking the land of the dead, Virgil picks up extended pastoral similes from the *Odyssey* and reworks them in Latin verses of sensitive and patient lyric observation. When Aeneas takes the downward path to the river Acheron, one of the borders of the underworld, he sees the throng of spirits on the bank waiting for the ferryman Charon to take them across – but Charon only accepts those who have been buried with proper ritual. The rest he leaves fluttering and roaming for a hundred years. Aeneas makes his way through the shades, past the place reserved for children who died young; underworlds remember the special sorrow of lives cut off before their time. In a more peaceful glade, watered by Lethe, the river of forgetfulness, the hero sees another numberless throng of souls. Virgil unfurls a gorgeous skein of bucolic, organic imagery:

> Souls of a thousand nations filled the air.
> As bees in meadows at the height of summer
> Hover and home on flowers and thickly swarm
> On snow-white lilies, and the countryside
> Is loud with humming.[4]

It's a paradox that when these writers of the ancient world want to summon ghosts, they reach for images of phenomena from the prodigal bounty and vitality of nature; metaphors which evoke the dead keep calling on forms of life. In Jonas's art many such phantoms appear as portents, not of their own fates but the larger world's. For this ecologically-minded artist, they will have met their death not as single human victims but as motes in the rich and intricate fabric of the larger world and its fragile wonders.

In mathematics, a set can comprise any number of elements – and as such, birds and bees have long acted as metaphors for the innumerable crowds of living things that fill the past: 'so many, I had not thought death had undone so many…', as T. S. Eliot wrote, echoing Dante. Yet creatures that flock and gather in multitudes also hold out hope for something besides death. Birds and bees are species that cooperate and reciprocate, that coordinate their movements and energy towards their own survival, swirling the individual animal into the community of the whole throng or flock. Jonas deploys them in a series of rooms that serve as stations on a contemplative journey about ecological harmony and its disruption. In Dante's *Divine Comedy*, the source of her performance piece *Reading Dante* (2007–10), the artist found dead souls figured as a swarm of bees, but this time gathering in bliss in Paradise. Dwelling on this extended simile, Dante tries to convey the ecstasy of rapturous union and promise of fruitfulness that he witnessed in heaven; these are spirits in bliss, rather than unquiet revenants. Bees soar upwards when they swarm, and establish specialized colonies in the marvellous geometry of the honeycomb; fish swirl in shoals and schools, similar to birds flocking on a field before they all rise together to roost side by side and keep one another warm, or to migratory birds on the wing when they form loose, wavy skeins in the sky as they search for new feeding grounds, one bird now taking the lead, now another.[5] These natural phenomena, evoked by Jonas as she performs with sound and drawing and movement and other stimuli, are present in their own right and convey to the viewer what they are and what they do, the artist deliberately acting as their conductor or messenger.

In *The Shape, the Scent, the Feel of Things* (2005 and 2006; see p. 141), Jonas explored the life and the thought of Aby Warburg, who, during a period in hospital, was known as 'the man who spoke to butterflies'. Part

of his madness at that time was a belief that he was communicating with the souls of the dead (*psyche* in Greek means both soul and butterfly).[6] Warburg has been a profound inspiration for the artist for some time: he developed a view of art as a form of active engagement with the world, through which members of a society or a group strive to promote and guarantee its continuity; and he understood that artists aren't making representations of what is out there, but are working within the flow of natural forces and the structure of phenomena to perpetuate them. Jonas casts herself as a participant in just such energy, bringing its embodiments – birds, fish, bees, horses, a beloved dog – into her work and beaming the life force back to us, her audience, in a condensed form that startles us into new awareness. Drawing attention to the endangered state of so many phenomena, she imbues her masks and drawings with the ominous, uncanny feeling of 'foretokens'.

Homer relates how the enchantress Circe tells Odysseus that if he wants to talk to the dead, he must make sacrifices in the underworld and give the shades the slaughtered animals' blood to drink: only then will they be able to materialize sufficiently to see and communicate with him.[7] But later, when Odysseus throws his arms around his mother Anticleia, she still hasn't been enfleshed by the sacrifice and he finds himself hugging thin air.[8] Virgil reprises this scene when Aeneas meets the ghost of his father and tries to embrace him.[9] This classical vision of the spectral body after death, visible yet immaterial, present yet absent, was never eclipsed by alternative Christian imagery, and indeed religious artists were undecided on how to represent the ghosts of individuals who, before the Last Judgement and the Resurrection of the Dead, would not yet be reunited with their bodies. The white-sheeted Hallowe'en phantom didn't settle down as the conventional image for a revenant until the invention of photography; before then, in the extraordinary scenes of the Last Judgement in Luca Signorelli's frescoes in Orvieto, the dead were figured as generic, naked human bodies, harried and mangled by devils in hell, tormented by flames in purgatory or tenderly wrapped and carried aloft by angels to heaven.

From the High Renaissance to Romanticism, skeletons dominated the morbid imagination, and were subsequently mixed into the fantastic

Gothic population of the undead, semi-decayed walking corpses; they took on the dread and mystery of larval states. Interestingly, the word *larva* was used for a spectre or apparition in Latin, connoting a liminal or transitional form, the first state of an insect as it begins the journey towards becoming a pupa, then a chrysalis and then a fully-fledged butterfly. When applied to the souls of the dead, the word conjures up a pre-natal formlessness, larval and pale. The word was also used for a terrifying phantom – a spectre – and in drama and ritual it captures well the frightening masks that represent such an apparition, such as the improvised paper masks with which Joan Jonas and her co-performers transform their presence, taking on ominous, auratic, somehow larger than life personae.

With the discovery of photography, some of the features of ghosts – for example their wraithlike transparency and immateriality – received unexpected confirmation, and it is a paradox that the epoch of scientific rationalism, when the conditions of the industrial world came into force, saw beliefs in the presence of the dead leap up with new intensity, and the ghostly population grow in variety and strength. Revenants, doubles, poltergeists, zombies, vampires and a host of other kinds of phantom have all become naturalized in cinema since early silent films such as *The Student of Prague* (1913), and have since found new possibilities through computerized digital imaging and virtual reality. Filmic ghosts are often rendered through the ancient metaphors of ethereality and bodilessness, because these can be fully realized on screen: the hero reaches out to embrace his mother and finds that his arms pass through her, as Dante does in hell, following the steps of his classical forebears, and as Jonas re-enacts in *Reading Dante*. The hero of *The Student of Prague*, who has sold his soul to the devil, looks in the mirror and finds that he sees through himself because he no longer casts a reflection. Larval apparitions and disembodied spectres became the staple of psychic photographers, who made images of the dead in order to console the bereaved with a message from the afterlife. In this way, photography adapted and took over the ritual processes of quietening ghosts.

The scholar Jean-Claude Schmitt, in a fine study called *Ghosts in the Middle Ages*, proposes that praying for the dead, as advocated by the Catholic church, was a way of helping the living make their peace with

the departed: the singing and offerings were aimed less at earning the dead reprieve from the flames, even though that was the ostensible motive, than at laying their spirits to rest so they would not return, like Hamlet's father's ghost, to reproach the living with their eternal sufferings.[10] But the Reformers' abolition of purgatory put an end to that, and the stark alternatives offered by Protestantism – elect or damned and nothing in between – ignited fresh terror of hauntings by accursed spirits. The ghost story and its counterparts (tales of vampires and zombies, doppelgängers and possession) flourish as a form of Protestant – Calvinist, evangelical – magic, as we see in the compulsive and brilliant stories of James Hogg, Robert Louis Stephenson, Henry James, M. R. James and – in our own times – Stephen King and Stephenie Meyer.

<center>II</center>

While Joan Jonas's assembly of ghosts recall many of their precursors, they're poised very differently from spooky Gothic, classical elegy or religious memorial. It would be quite wrong to give the impression that Jonas is a Jeremiah of eco-catastrophe or personal loss, for humour is one of her weapons in disrupting our torpor and resisting damage and death. In her quest to stimulate the forces of life against the ghosts of the future, her art mixes profundity and bathos, frailty and clumsiness, gravity and grace, scepticism and irony.

Doubles and apparitions appeared in the artist's early performances and films, when she was a leading innovator in using new technologies to create her first dream personae. But her vision of unseen spirit presences has very little to do with a humanist concept of human exceptionalism or the personal survival of the soul. Above all, filmed elements offer the artist a way of introducing impossible and entrancing visions of animal familiars and other animist apparitions, and of enriching the whole aesthetic shape, atmosphere and feel of her work. Her conjurations show far more sympathy with the animist belief systems of the indigenous peoples of North America and the folk culture of local communities. In these tales, comic, eerie and matter-of-fact, spirits and animals bring messages from the future, sometimes warning of impending danger, sometimes identifying a culprit. The magnificent scenery of Nova Scotia or Iceland,

where the artist has often filmed, takes her into sublime territory – vast vistas of long, empty beaches, watery cloudscapes, geysers and volcanoes, ice floes and islands. But she likes to disrupt this grandeur through the actions of herself and her co-performers, guising as beast-hybrids and showing us the world from the point of view of a young dog wearing a camera around her neck, who springs for sheer love of life on a vast sweep of empty beach seemingly at the edge of the world.

The stories collected in *Cape Breton Tales* are filled with chilling memories: one, for example, describes a local variety of spooky apparition known as a droke: 'We were out dancing one night,' remembered Mary Ann MacDougall, 'me and my husband and when we came out to the door, ready for home, he said to me, "Come and have a look at this. I've often heard you say you've never seen a droke." Well, I had good eyesight then. And it was coming this way, and it was going right queer, making a funny noise. It was up a good piece but still you could hear it…I think it was the next day we heard of a death – I forget now, it was so long – it was only a young child that died…. Then your brother, Gabe, fell off a truck, and was killed. At the age of seventeen, wasn't it…? And I don't know how long it was before this happened…that he saw his own droke…this is how I always believed and I always will till I die – that there are foretokens.'[11]

Jonas is drawn to the mixed feelings – wonder, laughter and fear – that such an anecdote inspires, and among her most important sources she includes the Icelandic writer Halldór Laxness, who perfected a tone of uncanny absurdism; his voice is irreligious and droll, irreverent and dissident, and he stirs up a fantastic brew of metaphysics and comedy, exaltation and bathos, all conveyed with joyously insouciant, outrageous invention. He manages to evoke feelings of transcendence while at the same time undercutting metaphysical pomposity and churchy earnestness. In his 1968 novel *Under the Glacier*, a major inspiration for Jonas's piece *Reanimation* (2015; see p. 138), Laxness confronts the effects of our human presence in nature and the damage we are wreaking in the era that has come to be called the Anthropocene.[12] Jonas is attracted by his humour, since laughter – like the noises, the bangs and clattering, the piping and whirring of her performances – disrupts stasis and kicks it

into motion; laughter can unleash explosive energy, just as now and then, for no known cause, one particle strikes another, becomes charmed, and a new particle enters the universe. The small town in the novel is called Glacier, and the glacier dominates the inhabitants. Its colours change as the story continues, its luminosity and translucency come and go, it appears sometimes very near, sometimes fades into darkness far away; but it acts as a living, breathing organism, capable of life-preserving suspension of time and decay, an active agent in the peculiar, anarchic series of events which unfold, involving a casket buried in the ice which will open to reveal a miraculous resurrection. The return of its contents – the dreamed-of corpse of a mysterious and prodigious being – drives the surprising plot through multiple twists of metaphysics, irony and comic deflation. Generally, all easy solutions are rejected, especially ones with claims to universal application.

Towards the end of the book, Laxness develops this defiant scepticism into a philosophy of folly as resistance: Embi, the narrator, is talking to Úa, the pastor's wife, about the ecstasies of St John of the Cross. Úa has returned after a lengthy, mysterious disappearance, fraught with rumours. She is an adventuress, a goddess, a *magna mater* and the comic embodiment of the Eternal Feminine. The conversation turns around a crucial theme in Laxness's philosophy:

> Embi: "Is such poetry not some kind of mockery on the part of the saint?"
> Woman [Úa]: "…There is always some sort of mockery. From one mockery to another! What should saints and poets take as an example, if not this mockery!"

Later on, she continues:

> Woman [Úa]: "Wouldn't you rather try to take part in human folly, my dear? It's safer. But remember, you have to do it with all your heart and all your heart and with all your heart – and what was the third thing again? Yes, consider the birds of the air, I had almost forgotten that."[13]

Likewise, Jonas adopts the part of human folly – you could say that she performs in order to survive. Her sense of the precariousness of the earth's survival inspires her to weave enigmas and ciphers that have no firm or discoverable referent, that edge into the sublime state of nonsense; she communicates by movement, noise and gesture, elements of a ritual event that eludes capture by paraphrase or analysis. That is the point of the images of bees, kites and the lunar-pale or solar-bright, beautiful dogs she lets loose upon the world and catches in the bowl of light that is her lens or her oracular mirrors. The mood is elusive, but this form of absurd melancholy is a tone for dealing with present calamity.

III

Anthropologists define three predominant functions that govern ritual performances: the first is mimetic, the celebrants representing the life force and the dangers that surround it in order to secure its continuity and their own survival; the second is prophylactic and apotropaic, the performers seeking to anticipate calamity and prevent it by imitating its agents and overcoming them; the third is sacrificial, the participants trying to placate the forces of danger by offering up something valuable in exchange for their mercy, or even a reward. This third form of ritual is often agonistic, as in Greek tragedies such as the *Oresteia* and the *Bacchae*. Joan Jonas's eclectic performance art is noteworthy for its rejection of sacrificial patterning. Instead she sets a hybrid, tragicomic tone; if she performs against death, she does not do so through mimesis – by enacting it or re-enacting it – but by confronting it through these other modes of ritual. She has been reckoning up the dangers that jeopardize the earth and its inhabitants and elements, but her work repossesses vital energy – it is indeed a force for re-animation, as the title of her performance piece proclaims. Some of that vitality depends on the spirit of mischief she brings to oppose the gloom.

Reawakening our senses to the inner vitality of stones, for example, is an essential part of Jonas's work of reanimation, alongside the summons of light and air, flight and motion. As Roger Caillois said, stones are *l'orée du songe* – the shore of dreaming.[14] Joan Jonas's mother collected heart-shaped stones and the artist has continued to do so; she is also

interested in the voices of stones, when struck together or banged with a stick. Nothing in nature is without life and, possessing life, everything also contains mystery. Ice, for example, offers the artist a prime symbol for investigating nature's life force, and has appeared in her work since *Volcano Saga* (1989). In her recent work, the metamorphoses of ice have become a new medium, as she paints with an ice cube, sliding it through ink as it melts, the intrinsic impermanence of ice turning into the visible, more lasting trace left by her gesture and transformed into art, a fragment shored against ruin.

Make-believe is intrinsic to rituals for laying ghosts – for keeping their harmfulness at bay. Indeed, the earliest toys so far unearthed may be those terracotta model farms and dwellings, peopled with tiny figures busy ploughing and cooking, that are found in Ancient Egyptian graves; they have been placed there by relations to keep the departed content in the afterlife and surround her or him with familiar possessions and scenes of home. Jonas's performances take on a similar duty of care: the imagery the artist animates through image and gesture and noise and movement issues a poignant warning – allusively, obliquely – about the imminence of destruction, even extinction.

Mirrors have recurred in the artist's work over five decades, instruments with which to connect to vitality and hold it for a time – the time of the artwork. In the recent film *Beautiful Dog* (2014), the artist and her co-performers capture the vast bowl of the sky in convex mirrors, multiplying reflections in near infinite recession and plunging the double element of the mirror image into a depth that cannot be grasped. With the flying kites that appeared in the Venice Biennale show, Jonas introduced a different kind of instrument to trap energy and reconnect to its flow: the aerodynamics of kites allow them to move as one with the invisible currents of the air. In English, the word 'kite' borrows from the image of the magnificent large raptor; similarly, the Italian *aquilone* remembers the eagle and the north wind, while the French *cerf-volant* alludes to the horned wings of a very large bat. In Japan, giant *odako* kites sometimes trail long, dancing tails of grotesque masks and represent another way of dealing with the dangers that lurk in the unseen world of spectres. 19th-century woodcuts of Japanese festivals show kites crowding the

horizon, a criss-crossing tangle of airy ladders to the sky, light, air-filled, painted with huge faces of warriors or monsters; sometimes they are fitted with pipes and whistles that sound unaided as the air passes through them. Autonomous, angelic messengers between earth and heaven, the conduits of lightning in Benjamin Franklin's famous experiment, such kites are also toys – and the artist has always kept play at the forefront of her performances and installations.

Roger Caillois, in his book about stones, tells the story of the 12th-century Chinese governor, artist, calligrapher and mystic Mi Fu, who plunged so deep into the underworld of his inner vision that he abandoned his worldly duties in his enraptured meditation on nature.[15] Mi Fu, who is also known as Mi Nan-Kong, tried to dissolve the separation between nature and art, between the life of the world and the representations that humans make to capture it. He found landscapes in stones – scholars' stones, objects for contemplation – and he also made stones ring to hear their inner voice. He practised a kind of spontaneous, fluid, rapid callig-raphy (Caillois calls it 'grass cursive' as the letters run 'like the nature of the wind'); he burned or crushed his ink tablets to achieve yet more direct effects; and he was one of the first artists to use blotting – dropping ink on paper, folding it and descrying pictures in the stains, as recommended by Botticelli and Leonardo and later established in the divinatory psychol-ogy of the Rorschach test.[16] To achieve this randomness, Mi Fu seized on different elements to act as brushes – twists of paper, the calyxes of lotus flowers, the detritus of sugar cane. One of his admirers said of him, 'His work had the taste of the clouds.'[17] The British artist Alexander Cozens, in the 18th century, would also take up crumpling paper and making ink blots in his attempts to get as close as possible to clouds and sky and wind and air – to fuse art and nature.[18] But in Mi Fu's case, the intensity of his absorption was such that his legend recounts how he disappeared into a drawing he had made of an entrance to the other world.

Joan Jonas's performance art also seeks out the place where things are quick with life; she too 'lets nature pass into' her,[19] opens passages to the unseen and impalpable and suggests, playfully and yet in deadly earnest, that she might be going there and that she can take us with her.

SIGMAR POLKE

Stone Alchemy

The Ascension of Elijah
2009

Form is never trivial or indifferent; it is the magic of the world.[1]

ALBERT M. DALCQ

I

Tapping with a small hammer at a dull pebble picked up on a beach or mountainside, a collector looking for curiosities to furnish a Renaissance prince's cabinet would be filled with hope that the stone would crack open to reveal treasure inside: the spars and bristling crystals nested inside a geode or the whorls and bands that stripe chalcedony and riband agates. Agate dendrites enclose the lacy fronds of prehistoric trees, and the heart of the rock sometimes encloses a drop of water, water that has survived inside for millions of years, as Roger Caillois evokes, marvelling at this trapped message from suspended time.[2] The interiors of rocks reveal not only unexpected colours, petrified waves and folds, once imprisoned and now scintillating rays and gleams, but also tunnels into the past, into the infinitely distant past of geological and cosmological millennia. The pebble becomes a cosmos; a stone that looks like a million others provokes vertigo – the 'algebra and order' in the making of the world.[3]

Stones have their own history and take their place in an unfolding chronology of events. Agate has been known since antiquity – the word comes from the river Achates in Sicily, and Pliny the Elder describes how its bed and banks were richly studded with these stones, which were especially prized for their power to protect wearers from the stings of scorpions (a necessity in the burning summers of that island).[4] Like chalcedony, onyx, sardonyx and carnelian, agates have been worked for centuries; cameos and *objets de vertu* were carved in Egypt, Greece, Rome and India from these hard gemstones, by artists using fine string-driven drills.[5] But since then, at different intervals in time, several other minerals have been discovered, and new technologies and media have been invented and applied to harvest the particular qualities of stones.

Sigmar Polke has always shown passionate – and mischievous – curiosity about the properties of things: their capacity for transformation, their powers to poison and heal. He's an expert at wonder, one might say; he unites the practice of the artist with the inquiries of a physicist or chemist. He has plumbed ancient knowledge of magic by applying the latest scientific media, collecting and exploring the uses of amber on the one hand, while

on the other experimenting with radioactivity. For the Krischanitz labora-
tory building in Basel, he made a remarkable wall relief sculpture: a stone
calendar of 365 pyrites representing suns.[6] When split and polished, these
rare stones disclose a starburst at their core, etched as finely as the gills of
a mushroom. This 600 million year old iron ore seems to reveal an imprint
of the Big Bang and the power, beauty and symmetry at the beginning of
the world. As the art historian Bice Curiger has written, Polke's work is
'a search for the "world's imaginative interior".'[7]

Unlike the pyrites, the stones that compose seven of the twelve new
windows at the Grossmünster in Zurich have mostly been dyed fantastic
colours. As rough diamonds are transformed into brilliants by a gem
cutter's facetting and polishing, the sections Polke has chosen have been
sliced from common agates and transmuted from *naturalia* to *artificialia*,
gaudily remote from nature's more usual mineral spectrum. Canons of
good taste and decorum traditionally advocate 'truth to materials' and a
restrained palette; but in Polke's windows, the stone panes, blazing with
chemical dyes, look like boiled sweets, candied fruits, children's marbles
or even preserved meats – galantines and salami. The dyes bring out
their rings and veins, splodges and sphincters, reptilian eyes and moles,
distinguishing them from one another so that the whole assemblage gives
the impression of kinetic energy, as if jostling and vibrating. When such
glaring colours flare in nature, they tend to warn of poison: the scarlet of
the toadstool and the poisonous berry, or the Portuguese Man-of-War's
gorgeous blue sail and streamers. If not poison, then flaunted sexuality:
the flamboyance of orchids and some insects, of baboons and mandrills'
displayed organs.

II

Charlemagne and his successors emulated Byzantium's court, and Eastern
and Western Emperors alike clothed themselves and their buildings
in treasure: their walls' costly revetments, their splendid regalia, cloth-
ing, tableware and book bindings were studded with cabochon gems.
These windows' sumptuous glazing of coloured stones sound an echo of
Byzantine and Ottonian splendour, but Polke lifts the tradition airily free
of its familiar conventions: the mosaic tesserae and jewels of Carolingian

and Byzantine decoration, or of Renaissance and Baroque *pietre dure* craftsmanship, could not have been cut to the wafer thinness of the agates available today. Only the enhanced precision of the latest cutting tools can turn lumps of rock into such translucent haloes.

For *The Scapegoat* (see p. 157), the last window in the figurative series and the climax of Polke's iconographic scheme, the artist decided to include a different, rare stone – tourmaline. He left the sections to glow their natural deep to pale rose pink, with some smaller scattered chestnut brown and purple-mauve examples. At their heart, the slices through the columnar stones reveal the naturally occurring triangles-within-triangles of the crystal structure. Set in pale pink and mauve-tinted glass, ornamented with scrolls and fronds of leaf-green vegetation, the tourmalines float weightlessly, unmoored to the figurative image, with the exception of the topmost specimen. There, in the roundel at the apex of the window, located in its brain, where its curved horns are sprouting, it marks the sacred character of the sacrificial animal. Towards the bottom of the window, two deep purple and brown heart-shaped stones add to the sense of the material's wonder. In the artist's oeuvre, purple is the symbolic colour of human ingenuity and its vital motive, transformation: 'Purple is not part of the spectrum; it is a "hole", a gap in the colour circle...' writes Bice Curiger, 'perhaps that is why Goethe saw purple as the "zenith" of the colour spectrum since it contains all other colours, actually or potentially."[8]

In contrast with agates, the mysterious and luxurious tourmaline entered human history relatively recently. Although the black variety was mentioned by Theophrastus, and some of the stone's properties were explored in the 18th century, it was only in the Victorian age of geological exploration that this rock's marvellous qualities and extraordinary structure were fully discovered. Like many crystals, tourmaline refracts light in a specific pattern connected to polarization; but more unusually, it generates an electric current, either when under pressure or when heated differentially. It shares this property with quartz, which is essential to all digital devices. These crystals, extracted from rocks containing rare earth minerals (zircon and fluorite are among the better known of these), were mostly identified only recently, and their special and unique properties have made them essential components of lasers, camera lenses, nuclear batteries, self-cleaning

ovens, television, mobile phones and computer memory. When scientists named them, they recognized the link to ancient wisdom: 'Lanthanum' ('I am hidden'), 'Dysprosium' ('hard to get') and 'Prometheum' (from the Titan who stole fire from the gods).

Such territory used to be called Natural Magic, and one way in which the adepts and magi of the Renaissance discovered the imaginative interior of the world was by deciphering messages in natural phenomena, according to the 'doctrine of signatures': the theory that flora and other natural things were imprinted with meanings both symbolic and practical. Pictures and geometries hidden in nature turned natural phenomena into hieroglyphs, waiting for a keen mind to decode them.[9] Sir Thomas Browne wrote:

> 'Studious observators may discover more analogies in the orderly book of nature, and cannot escape the elegancy of her hand in other correspondencies. The figures of nails and crucifying appurtenances are but precariously made out in the granadilla or flower of Christ's passion.... Some find Hebrew, Arabic, Greek, and Latin characters in plants; in a common one among us we seem to read *aiaia, viviu, lilil.*'[10]

He noted that the uterine shape of the sowbread plant indicated the plant's uses for women's complaints, while the osmond, or water fern, 'presents a rainbow or half the character of Pisces; the female fern a broad spread tree or spreadeackle [an eagle with wings outstretched].'[11]

A practising doctor in 16th-century Norfolk, Browne could not yet know about the heart of the tourmaline, where banded equilateral triangles-within-triangles occur, one more vividly glowing than the rest. Had he seen this, he would not have been able to restrain his praise of this miraculous manifestation of geometry in nature, the symbol of the triune god.

It is characteristic of Polke's art to treat the wondrous casually. His form of magic does not insist or indoctrinate; he doesn't proclaim superior knowledge or promise initiation to deep mysteries; though his interests intersect with the Theosophists and the Anthroposophists, who also explore the properties of stones and the harmonies of geometry, he introduces tourmalines without formal emphasis but with prodigal grace.

The Scapegoat, 2009

Their accidental, aniconic symbolism resonates in this church, which was stripped of its medieval images and decoration when it became the seat of the austere Protestant reformer Huldrych Zwingli.

<div align="center">III</div>

Physics also translates into metaphysics in the other five, figurative glass windows Polke designed for the church. The artist was originally trained as a glass painter, and has treated the material using a variety of complex contemporary processes to produce a range of textures, colours and degrees of transparency. In the *Elijah* window (see p. 152), for example, a luminous mosaic of glass pebbles in pastel shades dotted with darker reds, magentas and greens sets off the fiery ascension of the prophet; the composition follows a Romanesque manuscript *incipit*, showing Elijah's 'chariot of fire' rising upwards within the circle of a smouldering aureole etched with vivid threads of red, green and yellow (II Kings, 2:11–12).[12] The spoked wheel of the chariot carrying the prophet to heaven contains a smaller sphere within it; and both circles rhyme, in turn, with the oculus above, which recurs in the apex of all the original windows of this size. These circles are in turn reprised in the smaller lancets by the opened and displayed cellular structures of the stones. Spheres within spheres create correspondences, which rhyme visually from the cosmic to the microcosmic scale.

As he rides up, Elijah lets fall his mantle – in the Bible, it's a magic cloak which can part waters to let him pass dry-shod with Elisha, his successor (II Kings: 2, 8 and 14); in Polke's window, Elisha, a slender figure whose legs taper into curlicues as if he were himself riding tiny wheels, receives the mantle, Polke indicating its potency through the flow of bright red energy passing from the flames around the chariot, through the cloak to the shoulders of the disciple. This foreshadows a far more elaborate vision which explodes in high drama later in the Bible, in the Book of Ezekiel. There, in pride of place in the first chapter, signs of divine presence excite the prophet to draw on metaphors of gems and jewels, precious metals and 'terrible crystal' (Ezekiel 1:22,27.15) In an intense sequence of rapturous Judaic mystical writing, wheels recur as the manifestation of God's glory, and as they spin under the influence of his living spirit, they mutate into annunciations of the four

evangelists and into cherubim and seraphim, all dazzling with gems:

> The appearance of the wheels and their work was like unto
> the colour of a beryl: and they four had one likeness: and their
> appearance and their work was as it were a wheel in the middle
> of a wheel…. As for their rings, they were so high that they were
> dreadful; and their rings were full of eyes round about them four….
> This was the appearance of the likeness of the glory of the Lord.
> (Ezekiel 1:16–18, 28).

This ecstatic sequence of images foreshadows the sight of the Heavenly City of Jerusalem descending to earth like a bride adorned for her husband, in the promise of eternal bliss that closes the New Testament (Rev: 21:18–21). It inspires spirituals that sing about the coming glory: 'Elijah Rock', which plays on the double meaning of rock, as well as the celestial symbolism of the wheel, in 'Ezekiel and the Wheel'.[13] Whirling, bejewelled imagery – angels as Catherine wheels – keeps reappearing in the rosettes of the Grossmünster's windows.

Ezekiel and Elijah's ascents raise another theme which flows through Sigmar Polke's iconographic scheme: who is the seer and who is the seen? And what exactly is it that the seer sees? The agates' rings hint here and there at eyes forming in the rock, though the artist avoids heavy-handed use of pareidolia, instead drawing our attention to the instability of perception in several instances. The *Son of Man* window, the only monochrome design of the series, plays with mirror-like symmetry along the lines of Wittgenstein's rabbit/duck diagram. Looked at one way, the window presents tiers of different faces in profile; looked at another, the window glows instead with a lambent ladder of chalices. It draws attention to the fallibility of our human senses; the effect is troubling, and after the joyous brilliance of the coloured gems, it continues the thread of uncertainty in Polke's forays into the nature of matter.

Sigmar Polke reflects on the multiplicity of vision: other people may see things that you or I cannot see or have not noticed, and what we do see may or may not be there. As an artist, he is looking for meaning, probing the mystery of forms themselves as he stages metamorphoses of light and stone.

AL AND AL

Visions of the Honeycomb

Superstitious Robots

2011

The woman Paris carried off to Troy wasn't the real-life Helen but her *eidolon*, a mere idol, her phantom double, an image indistinguishable from her, a simulacrum as beautiful as the flesh and blood woman herself. Made by Hermes at the order of Hera, as living and breathing as that one and only unique Helen, she served to safeguard the honour of marriage, Hera's special sphere of interest. The real Helen wasn't an adulteress, no, she had been spirited away to Egypt by the merciful gods; after the ten terrible years of the battle for Troy, Menelaus finds his wife, living in a palace in the Nile Delta under the protection of the king of Egypt, Theoclymenus, and realizes that the Greeks had fought for nothing but a dream.

Some readers of this myth, which is dramatized most fully in Euripides's *Helen*, take it as an allegory of the futility of war: the prime *casus belli* was a misunderstanding and the Trojans were dupes of a divine stratagem to maintain the honour and status of the beautiful demi-goddess, daughter of Zeus and Leda.[1] But this myth about the unreason of war also touches depths of meaning about the power of imagined reality and the persuasive, unsettling interchangeability, in the realm of perception, of the subject and its reflection, the thing and its copy, myself and my image doubles. Helen's *eidolon* in Troy is no more unique than a photograph of Marilyn Monroe or an icon of the Virgin Mary, and yet, like them, it has potency – as Andy Warhol, using new technologies, intuited so powerfully when he made serial simulacra, icons through which flowed the glamorous enchantment of the original subject.

The Ancient Egyptians included in their arrangements for the afterlife the concept of the *shabti* ('whisperer'), a double who would work on behalf of the dead person, performing all the laborious tasks that continued to be necessary in the world beyond: the *shabti* is a ghostly double for a ghost. In miniature sets – toy farms, fishing boats or doll's villas with gardens – Egyptian tombs sought to guarantee comfortable and familiar conditions for the departed in the afterlife, doubling in miniature the world they had had to leave. These material models embody the makers' trust in their capacity to engender an alternative reality, for the miniaturized copy of an ideal future serves to produce it. This is magical thought in

action, and its dynamics attempt to intervene in time and steer its future course. In Greek mythology, which is infused with Egyptian myths both conceptually and historically, human beings themselves are created as if they were works of art: Pandora, the first woman, is also called an *eidolon*, a phantom-idol. She is forged by Hephaestus, the god of craftsmen, in the poems by Hesiod that narrate the creation; later, she is adorned and given gifts and capacities by the other gods.[2] Meanwhile, in the *Iliad*, the same god of creative fabrication (forging) is attended in his underground workshop by the golden handmaidens he has created: 'These are golden, and in appearance like living young women. There is intelligence in their hearts, and there is speech in them and strength, and from the immortal gods they have learned how to do things.'[3]

Reading the passage now, it is difficult not to bring to mind the curved and shiny volumes of Futura, the gynoid in Thea van Hardou's script for Fritz Lang's *Metropolis*, or her avatars, the luminous android chess-players and radiant cyborgs made by the artists AL and AL. These figures are *eidola* too – made using code rather than hammer and anvil – all of them the fruits of fire, the spark in amber or stone or metal, the animating principle that is the electromagnetic field. According to the myth, it was in retaliation for Prometheus's theft of fire from the gods that Hephaestus was ordered to create Pandora, by his fiery art, to bring sorrow among humans.

Al (Holmes) has commented: 'We think CGI is the most important formal invention since the camera – it's an aesthetic revolution. There are things being created every day in the world of CGI that have never been done before, so we're in a kind of visual renaissance, and yet few artists are working with it. That's an extraordinary situation to be in when you think that the history of art is actually about being at the frontier of image making.'[4]

In *The Creator (Short)* (2012), Alan Turing figures as an avatar himself, and voices his vision of 'thinking machines' and his hopes that his discoveries will last in time to come – as we in the audience now know they have. At the same time, we understand that the film we are watching is itself not only the result of digitized processing systems but an uncannily animate artefact. Not for nothing has cinema been termed a dream machine; in AL and AL's hands, it is made by and filled with imaginary doubles. You could

say the artists are acting as *shabti* for Alan Turing, working in his afterlife so that his ghost grows and thrives. Their identification with his memory is so intense that, as individuals, they are aiming to dissolve themselves into him (as well as act him, in the case of Al Taylor).

Over the last two decades, AL and AL have been travelling ever deeper into the nature of matter, as computing transforms experience and extends reality beyond sensory verification and into the virtual realm. To the question of the status of material reality – and to the unsettling issues that computerized representations raise – they bring an enthusiasm for knowledge and a delight in aesthetic experimentation that identifies them as inheritors of the Gnostic philosophers and the Renaissance Neo-Platonists, of occult questers such as Philo Judaeus, Marsilio Ficino, Paracelsus and Robert Fludd. They are clear that the stories they tell about the past have a role in the future: their work twists together skeins from history and biography, mythology and physics. It has dramatic shape and urgency, but the underlying sense of purpose is oracular: every imagining, the artists are saying, can play its part in setting the scene for knowledge and passing it on to those who are to come.

AL and AL's new-media dream worlds investigate the mutual shaping forces of fantasy and reality: they set out to absorb us and, at the same time, invite us to stand back and take stock of the power they exert over us. An early film, *Interstellar Stella* (2006), inquired into life on both sides of the screen (the looking glass) in relation to a child model, Stella, played by their niece, Megan. The film focuses on the idea of the redemptive child, a saviour trailing clouds of glory to heal adults' wounds and purify our corruption. Child stars have embodied this promise since Mary Pickford, Judy Garland and Shirley Temple. In this fable, the child embodies the desires of others (commercial, aspirational) but also acts in her own right, repossessing herself in the dream-space of the film and beginning to exercise authority over her image – a squad of image-breakers dressed like special agents carry out her orders. We are called to awareness: the images, the glamour are figments and act on us in bad faith. In a way, the artists are operating by contradiction: they confect an illusion on the screen to show up the facticity, unreliability and false promises of our 'society of the spectacle'.

Eternal Youth (2008) continued this double move into myth and out of it. Made for the Liverpool Biennial, it concerns another heroic redeemer figure in the form of a John Lennon who never dies, or rather is resurrected again and again, especially in his native city. For AL and AL, media-led celebrity now casts the spell – the glamour – that produces myth, and the film rings changes on the figure of the Fisher King who dies and is reborn. Fame dominates the uses of enchantment today and consistently generates sharp hostility; fame renders its hero-victims sacred and the structural order of myth demands their death; the sacred sparks a fuse which in turn ignites profanation. Lennon's murder can be told as a repetition of ritual sacrifice, because public storytelling in the cinema and other mass media outlets still follows the pattern of much older legends.

Both works dramatize the interaction of figments (screen dreams) with actual events, in a mode crystallized by the uncanny, recursive fables of Jorge Luis Borges. In 'The Circular Ruins', Borges imagines a man who dreams a child into being through intense concentration; once he has perfected his creation, he prepares himself to die, but then finds that he can't – he himself is being dreamed. The celebrated scene in which the protagonist – a sorcerer – passes through fire unharmed and so comes to know that he is himself a figment inspired the paranoid fantasies of Philip K. Dick, and both Borges and Dick have directly shaped cult classics such as *The Matrix* and David Lynch's *Lost Highway* and *Mulholland Drive*, films which AL and AL much admire. Borgesian and Dickian literary fantasy found in cinematic illusion its perfectly adapted vehicle, for film makes a space and time dimension of its own: the stars are there, captured in that place and time, forever.

Since the invention of moving pictures, virtual technologies have uncoupled temporal existence from its representations even more deeply. However, there is yet another uncanny aspect of this plot that AL and AL themselves have mined for their work. As in hermetic wisdom, the 'Circular Ruins' or *Matrix*-style plot proposes that a concealed pattern preordains all events and behaviour, that nothing occurs at random or meaninglessly. It is the hero's task to untangle the riddles and grasp the occult order which underlies existence. In some variations, the hidden script is controlled by a player on this plane, not by a higher or external power. For

example, Steven Millhauser's short story 'Eisenheim the Illusionist' (the source of the 2006 film *The Illusionist*) describes how a dazzling conjuror in fin-de-siècle Vienna conjures his own double in order to elude capture by the secret police: his phantom alter-ego takes his place as his saviour.[5] AL and AL deploy – in life and in art – a sequence of doublings which create a similar illusory effect.

From its earliest moments, cinema projected images larger than life: the first phantasmagorias unfurled a dreamscape on a vast scale that overwhelmed their earliest spectators. The earliest close-ups magnified the human face to dimensions only divinities had attained in public before – the goddess Athena's cult statue in the Parthenon with a nose a metre long, the colossal guardians of the Pharaohs in their tombs at Luxor, the Statue of Liberty in New York. Film epics today unfold infinite horizons and deal ever more prodigally in the coinage of the sublime and the apocalyptic; blockbusters multiply monsters, battles, collisions, space voyages, scenarios of doom and ultimately of salvation. But many of these sensational visions originate in miniature: in water tanks and dioramas, figurines and toys, in cunning optical dissolves and superimpositions (developed by the first magic lanternists) and now, of course, in the myriad possibilities created by Computer-Generated Imagery. One of the most fruitful of all techniques was first used to convey the parting of the Red Sea in *The Ten Commandments* (1956): this celebrated scene of Hollywood epic, when Charlton Heston as Moses raises his staff and the entire army of the Egyptian infidels is routed under the roiling mass of water, was forged in a blue screen studio (as AL and AL explored in *Blue Screen Exodus* (2002), a work they lost in a devastating studio theft). Again, the blue screen was anticipated by the methods of travelling showmen and theatre technicians; as in a Pollock's Toy Theatre, in which the actors are moved on stage against changing painted flats and wings, blue screen creates a space of illusion in which worlds expand and multiply, colossi stride and anyone can fly and glow. The cosmos opens up inside a box.

AL and AL's films plunge the spectator into virtual worlds of dizzy dimensions, where the boundaries fall away, dream-like. The laws of physics are altered: the gravitational field no longer holds sway and bodies become weightless; all that is solid melts into air; light cascades

through the field of vision but objects do not cast consistent shadows; time splits, rewinds, fast forwards, doubles, as characters appear, disappear, auto-destruct and reassemble. The artists are the creators of this virtual universe; they work together but on their own, and alone, to create its features and its inhabitants.

For the *Lord of the Rings* trilogy, a sizeable part of the population of New Zealand was recruited to work on the special effects; for each of the *Harry Potter* films, an army of technicians toiled intensively for months. But AL and AL turn the keys of the cyber-sublime from the consoles of their artist's studio.

They have kindred spirits in this studio enterprise: for example, the partnership of the twin Quay Brothers has similarly shaped a unique body of film work, using puppetry and miniatures and other sleight of hand in a small artist's studio (*The Street of Crocodiles* (1986); *The Piano Tuner of Earthquakes* (2006)). Coincidentally, I recently went to a talk about an earlier artist and writer team, Stefan and Franciszka Themerson, who began making films in Poland in 1930; these were avant-garde experiments, absurdist in mood, aesthetically highly inventive. Their oeuvre shows affinities with AL and AL's: they made all their films at home by themselves using only a 'trick table' which Stefan had rigged up in order to develop original formal effects. They also explored illusions of scale, shadow play, mattes and superimpositions in order to realize their cinematic dreams. Like many modernists, they were committed to treating film on its own terms and developing a cinematic language that was proper to the medium, its limits and its potential. They did not conceive of film as a medium to reproduce reality but as an instrument to explore phenomena and plumb new meanings. In 1937, Stefan wrote a book called *The Urge to Create Visions*. AL and AL have referred to their blue screen studio as their 'flying carpet', and it carries them into their own worlds.

Contemporary animation – the digital uncanny – has intensified perturbation around the figure of the double or the *eidolon*, because the principle of the spirit that quickens matter – the animating force – has been central to the concept of the sacred; in contrast with faiths of the past, the contemporary search for the sacred is now mapped onto a cosmology without a personal god or a creator who exists beyond creation. Albert

Camus asked how one could be a saint in a world without God; the question for many writers and artists today. including AL and AL, has become how one might find the divine in material phenomena. AL and AL have a strong attraction to this search, partly because, in Al Holmes's case, he studied for the priesthood when he was young, and partly because they are both committed to the history of the quest. Their art deliberately plunges the viewer into numinous visions of creation and the cosmos. They achieve this by uniting mythical (archetypal) narrative patterns – about the prophet, the sacrificial lamb, the hero, the priest – with the latest speculations and discoveries in geometry and physics. Alan Turing's insights, the tessellation of curved surfaces as in the thinking of Roger Penrose, super-symmetry and infinite series in the theories of Brian Greene, the nano-technological modelling of DNA by Bart Hoogenboom, all contribute to their endeavour, as they have become part of a wider movement to find a way of entering into – touching – the sacred now.

A story or plot provides structure and can be described, analysed, understood; a myth of the doppelgänger, quester or trickster can be told; words fit its contours. But for human beings, the truly numinous lies beyond verbal mimesis, narrative and description altogether. It is, by definition, ineffable – concealed within the unnameable, as in Samuel Beckett's fiction of that title, and extending into an edgeless infinite. In speculative metaphysics, this unsayable and unknowable cosmic divine has been traditionally ascribed harmony, pattern and form, and made manifest in sacred geometries from the astronomical alignments of Neolithic Maltese temples and Skara Brae in the Orkneys, to the triangle of the Trinity and the mandala of Buddhism. Ever since Galileo, at least, scientific inquiry has been in constant tension with the question of the divine, but recent developments – epistemological and technological – have brought about an unexpected fusion between the transcendent projections of the past and hard, scientific discoveries.

In the case of Rosalind Franklin, the special methods and equipment she devised for X-ray photography allowed her to take the first images of DNA – the principle of individual life itself. At the beginning of the play by Ann Ziegler, *Photograph 51* (2015) the character of Rosalind declares, 'This is what it was like. We made the invisible visible. We could see atoms,

not only see them – manipulate them, move them around. We were so powerful. Our instruments felt like extensions of our own bodies. We could see everything, really see it – except, sometimes, what was right in front of us.' She then moves on to remember her childhood love of pattern and repetition: 'When I was a child I used to draw shapes. Shapes overlapping, like endless Venn diagrams. My parents said, "Rosalind, maybe you should draw people? Don't you want to draw our family? Our little dog?" I didn't. I drew patterns of the tiniest repeating structures....' The playwright then attributes to Franklin a Neo-Platonist understanding of microcosmic-macrocosmic mirroring across phenomena: 'And when I first got to use my father's camera, I went outside and found four leaves. I arranged them carefully, on the curb. But the photograph I took was not of leaves. You see, nothing is ever just one thing. This was the world, a map of rivers and mountain ranges in endless repetition.'[6]

AL and AL's work also discovers macrocosmic forms on a microcosmic scale. The computer-generated fractals they unfurl give the viewer similar vertiginous vistas of cellular lattices and vortices, biomorphic shapes swelling and undulating, planes curving and re-curving over themselves, Piranesian perspectives of intersecting arcs, Escherian mind-bending, multi-dimensional puzzles, cosmic pillars of starburst building and falling. In their film *Icarus at the Edge of Time* (2010), these visual conundrums convey a sense of otherworldly temporality. The multiverse defeats representation in the 3-D universe we inhabit, yet, in *The Creator (Short)*, when we enter Turing's head and see with his eyes, using the instruments in his laboratory, the experience conveys the vivid sensation that we are indeed experiencing incidents of travel beyond our usual space-time. These filmed sequences aren't only impressions or metaphors, but visual acts in which the events depicted are not representing them, but making them happen. The simulation is the thing itself, in the same way that the Helen who was at Troy was in every quality Helen of Troy, even though Helen herself was elsewhere. The phenomenologist Mikel Dufrenne has written, 'even if meaning is not constituted by man, it passes through him.... But it may not be enough to say that nature is expressed by the artist. Perhaps we should rather say that it is by means of the artist that nature seeks to express itself.'[7]

SPECTRAL TECHNOLOGIES

This passage is quoted by the critic Andrea Scrima to characterize the aesthetic odyssey and quest for transcendence in *Seiobo There Below* (2008), a metaphysical fiction and tour de force by the Hungarian writer László Krasznahorkai, who probes concerns shared by AL and AL and their projection of Turing. In each of seventeen chapters, rising rapidly in numbers from 1 to 2584 according to the Fibonacci sequence, Krasznahorkai evokes a different solitary individual as he (always a he) undergoes an epiphany. Each of these intense experiences is cathected through an aesthetic object – sometimes an acknowledged masterwork (the Venus de Milo; the Acropolis; an icon by Andrei Roublev) – but in several other scenes, a more ordinary, less aesthetically 'high' artefact conducts incomprehensible terror and beauty: a Noh mask, for example, exactly midway through the book, at its fulcrum. The goddess Seiobo descends, somehow summoned by the mask, into a veteran actor for his performance: '…you have to know that your own experience in this is crucial […] there is no transcendental realm somewhere else apart from where you are now, all that you call transcendental or earthly is one and the same, together with you in one single time and one single space….'[8]

Krasznahorkai and AL and AL share a passionate longing for the incommensurable and the ultimately indecipherable: the artists' films stage the infinite mystery of things, but with an exhilarating trust in their continuity. AL and AL do not convey any of the older Hungarian's existential gloom, although they tell dramatic stories of personal loss and anguish. Interpreting the physicist Brian Greene's modern retelling of Icarus, in *Icarus at the Edge of Time* they picture how the boy travels to the rim of a black hole and returns to find that 10,000 years have flashed by and all that he has known has vanished. To a pulsing score by Philip Glass, the film gives dizzy-making glimpses of the edgeless, curving multiplicity of time and space.

Krasznahorkai is similarly enthralled by vertiginous possibilities, and renders them in unstoppable, intricate sentences: a scene in the Alhambra unfolds in a single sentence spooling over twenty-three pages, imitating the scrolling, infinite generativity of the arabesque tiling that overwhelms his protagonist. He's a visitor to the famous complex of gardens, courtyards and buildings, and becomes possessed by the intricate geometric, honeycombed

vaulting and tessellations of the ornamental walls.[9] At first utterly baffled, this unnamed spectator, transparently a *shabti* for the author himself, decides that, 'The geometrical composition used by that Arab spirit, across the Greek and Hindu and Chinese and Persian cultures, actualizes a concept, namely that in place of the evil chaos of a world falling apart, let us select a higher one in which *everything holds together, a gigantic unity*, it is that we may select, and *the Alhambra represents this unity equally in its tiniest as well as its most monumental elements, yet the Alhambra does not make this comprehensible*, even just this once, it does not demand comprehension but rather continuously demands that it be comprehended…'[10]

AL and AL's Turing embodies the artists' own intimation of that 'gigantic unity' and the hopes that the vast incomprehensibility of creation will yield to the perseverance of their craft, to make the wonder visible.

One of the most tender myths about doubles, the story of Castor and Pollux, tells how the immortal twin Pollux could not bear the death of his mortal brother, Castor, and so made a bargain with the gods of the underworld that he would share his sentence of death with him, and spend half the time in the Underworld in his stead. The twin brothers were worshipped in Greece and Rome as the Dioscuri, and they are emblazoned in the sky as the constellation of Gemini, the sign of the zodiac most strongly associated with all forms of doubling. The boys may have hatched from the same egg as their sisters Clytemnestra and Helen or, after her ravishment by Zeus in the shape of a swan, Leda may have laid two eggs – the sources differ, as do the paintings that interpret them, by Leonardo and Correggio among others. (Pausanias reports that the egg from which they were hatched was displayed in their temple at Corfu – it was probably the remains of the shell of a dinosaur).

Identical twins are biological clones – although the general response to cloning does not recognize how naturally it occurs, and the clones of assisted reproduction, with all their reverberations of science fiction terrors, have introduced a new form of the mythical *eidolon* into the repertory of the imagination. Twins, alters, mirror reflections, rotational symmetries – all forms of the double – permeate the vision of AL and AL. They are themselves personally twinned in many ways, their intertwined lives predestined, it seems, by many auguries, including their first meeting in

Derek Jarman's garden in 1997. The menhirs, obelisks and rippled vortices that Jarman laid out in his stony landscape near the Dungeness reactor reappear transfigured in various ways in AL and AL's imagery, while a clone (a female clone) figures as the principal character in their film *The Demiurge* (2016).

Besides twinning and cloning, there is another element in the story of Leda's offspring, Castor and Pollux, Helen and Clytemnestra, that connects to the multilayered inspiration of AL and AL: their work moves according to an organic vision of natural correspondences, which it communicates through the multiple metamorphoses at the heart of both narrative and technique. CGI is a practice of endless metamorphosis, and the films tell tales that turn on metamorphoses: a transfiguration in the case of Icarus, a terrible curse in the medical treatment of Alan Turing. The organicism runs deeper still, however, in the imagery that AL and AL adopt, which for all its occasional look of high-polish cybernetic abstraction, draws on naturally occurring geometries (the arabesque, the honeycomb, the branching of fractals) and makes manifest the physical laws of space-time by which their art, like our world, is bound.

Joan Jonas, who is one of the innovatory artists of new media whom AL and AL invoke as an inspiration, acknowledged the incongruous conjunction of natural forms and digital technology in the title of a path-breaking work, *Vertical Roll* (1972), the sequel to her film *Organic Honey's Visual Telepathy* (1972). 'Organic Honey' was Jonas's adopted name for her artist persona, as she performed in a gleaming mask, mirrors, feathers and other exotic and manifestly seductive props; she turns herself, in these works, into a beautiful *eidolon*, a Helen, an eerie automaton, while 'vertical roll' was the specific term for the continually ascending images on the camcorder tape she made of her performance in real time. The whole piece explores mythic femininity and eroticism, through cutting-edge media technology and an aesthetic language of gleaming, glassy, metallic surfaces, counterpoised with softnesses – feathers and silks.

AL and AL also conjoin antithetical textures to express the range of their feelings – about love and creativity and death. Their work is in many ways autobiographical, projected through the figures of others, and it constantly interacts with their own lives in a fated, quasi-mythic way, as

if by sinking so deeply in their imaginations into certain processes, they send out ripples of attraction into the real world.

Soon after they moved, for family reasons, to the village of Standish-with-Langtree, Lancashire, a swarm of bees flew into the house and fastened itself to the rafters. During the months that followed, the artists became used to working to the coming-and-going and busy buzzing of the swarm as the bees built their honeycomb in the rafters; conscious of the insects' endangered state, they let them well alone to thrive.

The bees went about creating their hexagonal cells above them; AL and AL worked below on the invisible structures of the universe.

After a few months of co-existence, the artists found honey dripping down the walls. It was time to call in a beekeeper. When he lifted part of the ceiling, they saw that the entire roof cavity had been filled with lobe upon lobe of the honeycomb, the lattice of hexagons forming soft folds that overlapped one another like the shelves of rock at the sea edge of a cliff, or a stack of fluffy pancakes or the inner ribbed walls of a womb (see endpapers). These are 'the pleats of matter', in the eloquent phrase of Gilles Deleuze in his book *Le Pli* (The Fold), in which the philosopher explores the meaning of baroque style – an aesthetic of generativity, close to arabesque.[11] The packed cellular structure the bees had made kept repeating across their ceiling to form the bees' cosmos, another world, another map, ravines and valleys in endless repetition, the largest wild hive the beekeeper had ever seen.

JUMANA EMIL ABBOUD

Dreaming the Territory

Maskouneh (inhabited)
2017

A form of memory-mapping stands at the centre of Jumana Emil Abboud's artistic quest: through dream association and reverie, she quests for lost stories in the landscape and charts them in various media, using drawing, watercolour, sound and film. Reimagining the stories attached to places, picturing them and speaking again the words that make the stories, she traces paths and locations – and their associated memories – that have been erased from the map. Her current free-flowing, multilayered project, under the overall title *In aching agony and longing I wait for you by the Spring of Thieves*, has unfolded over the last two decades.[1] It is inspired by a pamphlet she unearthed in the library at Bir Zeit, called *Haunted Springs and Water Demons in Palestine*, by a Palestinian doctor, Tawfiq Canaan, published in Jerusalem in 1922. Canaan records wells, cisterns and streams in the countryside which were associated with stories of jinn and *marid*, angels and saints and many other spirit beings. Abboud came upon his research while exploring places that were 'off limits' to her as a child, and it sparked an expanded search that still continues: the forgotten booklet has taken her on a quest for the watering places listed by Canaan, which social and historical changes have pretty much disappeared from the map of Israel/Palestine. Collaborating with the cinematographer Issa Freij, who was born in Jerusalem and has lived there all his life, Abboud has walked through the countryside and talked to local people; so far she has rediscovered around fifty sites. Her epiphanies sometimes take the form of existing landmarks and material evidence (a buried culvert; a Bedouin animal shelter; a stream spilling from a crack in a rock under a tangle of thorn), but more often she sketches and paints fantastic apparitions of beasts and spirits, or films fugitive images of enigmatic stirrings in the breeze, elusive emanations to which her visual artefacts – drawings, films, performances – bear witness.

Born in Galilee in 1971, Jumana Emil Abboud emigrated to Canada with her family when she was eight, but they returned twelve years later; she studied art in Jerusalem and has been working there ever since. The title of one video, *Hide Your Water from the Sun* (2016), captures the erratic pulse of the local water supply, as well as the harsh struggle for control of it in places where water is scarce. The origin of streams deep inside the bedrock

preserves the supply from the heat that would dry it, and keeps the water refreshingly cool and sweet: many houses have cisterns and wells deep within, in the basement. Yet, at the same time, the hiddenness of the water source raises fears of the dark and, correspondingly, of danger and harm.

The artist's quest is a form of pilgrimage, for a pilgrimage sets out to remember the special history of a place and its tutelary presences – an apparition that took place there, a saint's relics buried there. But a pilgrimage also inaugurates meaning. A certain site becomes special because a story is being told about it, and that story has often been moved there – the technical word is *translatio* – as in the body of St Mark 'translated' to Venice. An artist-pilgrim walks an itinerary to a place to restore a story to consciousness, and in so doing, to reignite its charisma. It is significant in relation to Abboud's narratives that in Arabic, the root *raawa* gives words for both 'to water' and 'to tell stories': a reciter is a *raawi*. Narration is irrigation!

The wish to know the familiar place for the first time, to echo Eliot's celebrated line, conveys a longing for restoration and an impetus to fold time back on itself, recursively, and to find redress, to quote another poet – Seamus Heaney – and his ideas about the meaning of poetry. But this misreads the archival inspiration of many contemporary artists like Abboud. Awakening cultural memory isn't all retrospection or nostalgia; the process sets in play active re-inscriptions, laying the emphasis on the visionary potential of seeing something afresh. Abboud's search involves telling a different, fresh story about past relations between people and places, and strengthening them in the present.

II

Tawfiq Canaan was a pioneering and long-serving physician in Palestine who specialized in skin diseases and also concerned himself with regional health problems (malaria and tuberculosis). Through the turmoil of the early 20th century, as the Ottomans were defeated – he served in the Turkish army – and the confusion and violence of the First World War brought the British to power in the region, he remained in post as the director of several hospitals, including the leprosarium in Jerusalem; his research helped to find the cure for leprosy. But this generous and most admirably inquisitive man also acted to preserve the culture of his country,

becoming a key ethnographer of Palestinian society: *Haunted Springs* is one of several studies he made to set down local beliefs. A more ambitious, major work, *Mohammedan Saints and Sanctuaries*, followed five years later, in which he set out to catalogue 'the most holy and mysterious shrines of the life of the inhabitants….' From 1916 onwards, he also assembled an unparalleled collection of nearly 1500 amulets, talismans, 'fear cups' and charms against all manner of dangers, many of which he accepted in lieu of payment from his Muslim, Jewish, Druze and Christian patients alike.[2] These objects are homely and uncanny; their function is to keep harm at bay, often by appeasing demons or, sometimes, by tricking them.

Canaan noted that followers of different faiths shared fantasies and practices around sacred places such as the tombs of saints, wells and streams: 'It is an old and widespread belief in all Semitic countries,' he writes, 'that springs, cisterns and all running waters are inhabited.' An 'inhabited source' is called *maskouneh* or *marsudeh*, he continues. All water spirits are called *el-afarit*, he writes (this is the word used of the most alarming and powerful jinn in *The Arabian Nights*) and there are also 'earth spirits', lower (subterranean) spirits, and 'hellish spirits', from even further down below (they do damage by heating up the water). The filthiest and most dangerous water spirits of all inhabit latrines, refuse tips and other foul places, and are known by the name of Satan himself, no less: *Shetan*. Contending forces of good and evil struggle at some fountainheads, where a spring gushes from a crack in the rock: these can take the form of a *hurr*, a freeman/master, or an *abd*, a servant/slave; they can appear as sheep or snakes, monkeys or gazelles, camels and cocks and even the Virgin Mary. The more valuable the resource, the more fraught security of access to it becomes, as contemporary wars show us. The monstrous demons of water sources on the one hand and angels and guardians on the other reflect the preciousness of the supply – and the hard-won right to freedom to enjoy it.

The Tunisian storyteller Nacer Khemir dramatizes the power of a dangerous jinni in his haunting film, *Les Baliseurs du Désert* (The Wanderers of the Desert, 1984), in which the child protagonist regularly summons an apparition from the well in his home; through his eyes, we attribute the vanishing of the young men into the desert to demonic

powers, while the film silently communicates that it is the modern world of labour and money that is calling the young men to migrant labour in the richer nations and draining the life of their village.

Canaan was Lutheran (his grandparents had converted); Abboud was brought up a Catholic. As a doctor, Canaan listened to the fears, dreams and motivations of his patients of many faiths without prejudice, often recognizing the psychological benefits of magical devices and the curative potential of talismans and spells. He didn't dismiss the magical lore he heard as superstition, or attempt to root it out, but paid attention to the underlying messages, trying to learn more about the lives, health and hopes of the local people, about their relations to the land and ultimate survival. He mentions plants that grow by certain streams and their powers to heal skin problems and help menstruation and fertility; as a doctor, he was curious to test folk remedies and active in investigating such local, organic knowledge. With a few of the examples he gives, the functional connection is clear: if you foul a stream by pissing in it – or worse – the demons that haunt it will take revenge. Abboud follows him in showing no scorn for popular practices, inquiring instead into their potential significance for the country and its historical memory today.

III

The stories he tells have beckoned to Jumana Emil Abboud's imagination; they are filled with baffling, ambiguous characters and strange outcomes that often defy ethics or hope. The overall atmosphere of Abboud's art has a strong affinity with hidden water itself, running quietly at a depth. The folklore's lesson is that fate is capricious and we are not in charge. The *genii loci* that lurk in streams and wells, culverts and cisterns are shape-shifters who can help passing humans or prey on them. In *The Arabian Nights*, they can appear to their victims in the shape of an irresistible beauty and then lure them to their table, where they devour them.[3] Abboud has painted these beautiful temptresses, combing their hair and showing their breasts, with blood dripping from their lips. Sometimes they are brides who have died before their wedding and wish to take humans to live with them in the fairy world, as in the ballet *Giselle*, where the unquiet *wilis* avenge themselves on human men, or in

the legends of Thomas the Rhymer and Tannhauser, who are taken by the fairy queen or the Goddess Venus to live with her in her world for seven years. 'One may recognize these djinn ladies by their eyes,' writes Canaan. 'The pupils are perpendicularly elongated.'[4]

The most monstrous jinn of all are *ghuls* or, if they come in female form, as they frequently do, *ghuleh*. Abboud has sought out stories about them beyond the research of Tawfiq Canaan. In her 2013 video-poem, *I Feel Nothing*, she reworks a Palestinian fairy tale about a mother who devours her children – a *ghuleh* who blames her husband's sister for their deaths, smearing her mouth with blood.[5] The story is a variant on the Maid without Hands (present in *Titus Andronicus* and The Handless Maiden, retold by the Grimm Brothers). Abboud does not narrate it as such, but instead explores its themes of numbness and silence with matching reticence. Revisiting the tale in *The Book of Restored Hands* (2016), she follows her maimed, mute alter ego as she recovers her relation to the world and relearns her sense of touch. The protagonist is buffeted by unfathomable forces, and the film exudes a powerful mood of precariousness, resignation and fear of hurt.

The antiquity of many of the tales which have inspired Jumana Abboud is often striking, and for Canaan, it was important to demonstrate continuity with a very ancient past. When he wrote that the folklore he was gathering was 'of the greatest importance for the study of ancient oriental civilization and for the study of primitive religion', he was establishing a *longue durée* for local culture, reaching back to pre-Biblical times, to Egypt and before, preceding the foundation of Christianity and Islam. Alongside similar research undertaken by contemporary colleagues, his ethnography represents efforts to withstand Zionist arguments of ancient occupation and consequent claims to ownership of the land. Hence the emphasis on syncretism and his open-mindedness to magical cult practices; both were anchored in his Palestinian cultural identity. The historian Salim Tamari has discussed how Canaan developed the 'nativist' ethnographical viewpoint: 'Popular religion in Palestine is neither Islamic, nor Christian, nor Jewish, but a local magical adaptation of the sacred texts to the daily needs of peasants.'[6]

When Canaan was collecting folklore in the 1920s, he knew that Palestinian culture was under strain, and that the pattern of life was

changing so fundamentally that its characteristic texture would disappear. In the preface to *Mohammedan Saints* he wrote, 'The primitive features of Palestine are disappearing so quickly that before long most of them will be forgotten.... This change in local conditions is due to the great influences which the West is exerting upon the East, owing to the introduction of European methods of education, the migration of Europeans to Palestine, of Palestinians to Europe and especially to America, and above all, to the influence of the Mandatory Power.'[7]

But not everyone approved of his recording this material and drawing attention to such beliefs: his critics feared it would brand the Palestinians as ignorant and strengthen reasons for their subjugation. However, nearly seventy years after 1948 and the *naqba*, and nearly a century since Tawfiq Canaan was carrying out his research, his inventories have become precious records of the material culture of the country as well as its imaginary: few people living can still match his descriptions to existing places; memories have been muffled; the syntax of place wrenched out of joint and the maps scuffed, the paths overgrown.

It would be a mistake to imagine that the ghost stories and fairy tales associated with certain places are primordial and static; also, while functionalist explanations can be illuminating (the warning against fouling fresh water), they can be a bit glib, forgetting history and its shaping forces. Canaan himself comments, 'I should mention the fact that not all statements one hears from different persons about one and the same spring correspond.'[8] Folklore is no less multifarious and versatile than individuals themselves. Landscapes breed stories, and people make them up among themselves; memories shift over short periods of time; there is no priesthood to determine the canon. Amid the present policies of the Israeli government, Palestinian folk memory has a new and intense historical value, and the work of Jumana Emil Abboud aims to reanimate its significance and repossess her surroundings on her own terms, for the present time. The artist has found that in several cases the names of the sites have changed: one spring, which used to be called Ein al-Sitt Laila, had lost the connection to the beloved woman in Arabic romance and become instead Ein al-Hajjeh, referring to a female pilgrim to Mecca. In Nablus, after a long wandering search following Canaan's indications, Abboud and Freij

learned that a spring once named after a Christian monk (*rabeh*) had been renamed Ein Darwish Ahmad, after a Muslim holy man (dervish), instead.[9] At times, the shifts seemed simply mishearings, as in Chinese whispers, while at other times the disappearances echo more deliberate dislocations.

Abboud's memory-work leads her – and her audience – to unearth layers in time, time being an essential part of the story of a place and its identity. The artist's absorptive looking, mediated through Freij's contemplative camerawork, scans the scene until light flashing from a bubbling spring, a breeze flowing through silky grass, moist fissures in the rock, deep-socketed as eyes, the sounds of doves and crickets, the bells on the sheep and the occasional bark of a dog begin to strike uncanny, pregnant sensations in those of us watching and listening. Black veils or dresses hang from a tree, lifting spookily in the wind (see below). Canaan reports that cloths were tied to trees for protection against harm – as something to confuse a thief in the dark; the artist remarks that these fabrics may have been hung there so that the territory looks inhabited to anyone prospecting to come and settle.

Unlike an engineer, a sculptor of monuments or a land artist, Abboud doesn't seek to inscribe her presence on the landscape or reshape its physical features. In an earlier performance piece, *Al Awda* (*The Return*, 2002), the artist walks away from the camera down a tree-lined, shady woodland path, taking bread from her pocket and dropping pieces of it on the ground,

Maskouneh (inhabited), 2017

where they remain visible for a short while. But the viewer understands that they will soon merge with their surroundings and disappear, like the breadcrumbs which Hansel and Gretel drop – unavailingly – to mark their way home.

Abboud's sensitive methods have affinities with coin or brass rubbings, when the lineaments or details of an image, struck or incised into the metal, have become so worn over the centuries that what it depicts can no longer be made out by the unaided eye but only brought into focus by stroking a pencil over paper laid over it, until the picture emerges from the differences in the shading just as the apparition of a person materializes in the chemical bath of a darkroom.

In the film's voiceover, the artist quietly recites the names of the springs as recorded by Tawfiq Canaan: 'We were in Bir Naballah/Perfume of *zatar* all around us….' Bir Naballah means 'The well of the tooth of god'. Later, she invokes, in Arabic, the spring of the Diamond, of the Nightingale, of Fruit, of the Healing Bath, of Thieves, the Well of the Early Riser and the Well of Oil. When the show was installed at the Kunstraum Gallery in London in 2016, the names were painted on the windows giving on to the street, like a star map. Searching out these often overgrown, trampled or lost sites gives her the feeling of hunting for ghosts, she says; she describes how in one place, 'a spirit of a man with fiery red eyes…turned to me to say, I am the dead forest.' Later, she fell, and 'Falling, I heard a voice say: "Do not be afraid, my child; soon you will be again in your father's house."'.

IV

In 1931, Alfred Korzybski coined the phrase 'the map is not the territory'; he meant that an exact survey, as in an ordnance survey map, does not capture the way we relate to a landscape or a place. He was thinking in neuroscientific terms about the relationship of our minds to what we know, and wanted to point out how every individual's experience of reality is formed by their interactions with their surroundings.[10] Territory is also a shimmering place of the imagination and of memories made by mental imagining – the results of archaeology, art history and creativity in the literature and scholarship of the past, interacting with each and every one of us. In the collection *A Calendar of Love*, George Mackay

Brown has a luminous short story called 'Five Green Waves' which begins 'Time was lines and circles and squares': the tools of the geometer, the cartographer. But twenty pages on, after the child narrator – the 'I' of the story – has been through adventures and misadventures, 'Time was skulls and butterflies and guitars.' The map of the young protagonist's life has become furnished, planted, storied – and become his territory.

Octavio Paz alludes to this process in his lyric 'Vrindaban', about history, remembrance and loss: 'I am a history/A memory inventing itself/I am never alone [...]/I plant signs'.[11] The possibility he imagines, of planting signs metaphorically, evokes the activity of the writer or artist who, while relating history, also makes it up – a memory inventing itself. In *Smuggling Lemons*, a 2007 performance piece, Abboud deliberately plants signs: we first see the artist in her grandmother's shady and fertile garden in Shefa 'Amr, in Galilee, placing some lemons carefully on the ground under the flowering shrubs. We see the lemon trees growing there, and the artist transferring some fruits to a red leather belt with bespoke pouches for each one, as if they were hand grenades. She then walks out into the heat and dust and boards a bus; the camera follows her from behind as she travels across the country on a long dusty journey to the check point at Qalandiya; there she passes the belt and the lemons one by one through security and goes through the turnstile; on the other side, in the occupied West Bank, in a featureless, barren building lot where nothing grows and everything looks parched, she arranges the lemons carefully in a featureless site on the arid soil. The film is wordless and silent, apart from the incidental noise of traffic and babble of comments and orders, but it speaks eloquently of desolation – and of a defiant hope for the future, through the succinct and affecting symbolism of the fruit brought from one side of the divide to another.

The political struggle is all about the map, as Edward Said analysed so powerfully in his essays on the Oslo accords – and as is shown, soberingly, in the map of Palestine today.[12] Nothing is more crucial to survival than access to water; nothing gives greater power than controlling its distribution and its quality. Jumana Emil Abboud is evolving a sensitive and personal aesthetics in response to the processes of power.

Active political realignments are not the only way to redraw the map: stories – counter-narratives – can put up resistance.[13]

CHRISTIAN THOMPSON

Magical Aesthetics

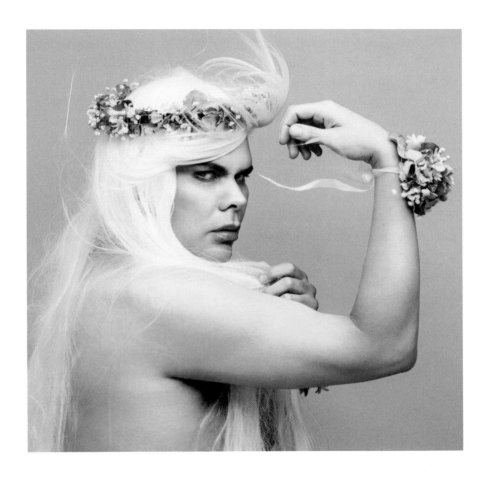

Ellipse
2014

Christian Thompson's personal metamorphoses form a series of acts of resistance and repossession: boardroom portraits, heraldic emblems, criminal mug shots and home videos offer the artist different vehicles for his polymorphous self-portraiture, as he plays with received ideas and prejudices and inserts himself into different histories, changing their meanings.[1] However, the title of the artist's solo show, 'Ritual Intimacy', invites the viewer's attention to enter into communion with the artist's inner world, beyond outward show, costume and the many spectacular visual stagings of self which he has performed before.[2] Thompson's handling of camouflage, masking and disguise has a vivid, stylish, witty aesthetic, but the processes of making these images are private ceremonies, gathering aura around his figure. When he anoints and adorns himself in myriad ways, when he closes his eyes with flowers and crystals and poses in fabrics and cosmetics, with flags and other symbols, he is charging his image with presence; his shape-shifting unsettles ascribed labels and keeps his self, body and soul, fluid, mysterious and elusive. At a basic level, the viewer can't be entirely sure what Thompson looks like: would I recognize him in the street even after seeing his image so many times? At a more complex level, his exuberant shape-shifting becomes a process of continual re-enchantment, as he revisits and re-envisions his own story in relation to his antecedents and his history.

The artist remembers the desert landscapes where he grew up with great reverence in a piece such as *Heat* (2010), and he grounds his work in personal memories. His family travelled around Australia; his father worked for the Royal Australian Air Force, and Thompson was born in 1978 near Adelaide, but belongs to the Bidjara people from central Queensland. However, the artist also revels in moving sinuously from one persona to another, changing class and gender and, above all, confronting and undoing expectations of racial identity. His impersonations run the gamut from reverence for his ancestors and kin, to grieving mockery of received ideas.

The sociologist and leading postcolonial thinker Stuart Hall conveys well the circumstances that Thompson has also experienced. Hall, who

was born in Jamaica when it was a British colony, arrived in Oxford around sixty years before Thompson, yet what he writes still resonates:

> sometimes I feel like the last colonial.... My first sense of the world derived from my location as a colonized subject and much of my life can be understood as unlearning the norms in which I had been born and brought up. This long process of disidentification has shaped my life.[3]

Hall is remembering the 1950s, but distressingly his experiences have not yet become superannuated: 'There was never a single moment in this trajectory which wasn't impelled by my racial positioning.'[4] Like Hall, Thompson takes charges of that positioning, and his art continues that crucial process of reorienting identification.

Influenced by Frantz Fanon's classic book *Black Skin, White Masks* (1952), Thompson knowingly assumes the part of the abject subaltern (bedraggled wig, alcohol, weed) and then, with a switch of costume, props, make up and posture, he puts on one of the 'white masks' of the title – academic *sub fusc* (black and white formal dress), for example. For his 2012 exhibition, 'We Bury Our Own', held at the Pitt Rivers Museum in Oxford, he looked through the musem's collections of colonial photographs, several of which are of Australian Aboriginal people – including, as he later found out, the earliest portrait: a daguerreotype of a man, taken in the 1840s.[5] It is central to the artist's approach that he does not reproduce, or provide details of, these images. The Pitt Rivers is a fabulous cabinet of curiosities, but the assumptions that governed it and other ethnographic museums in the past were unthinkingly racist: images of people from the non-West were collected as specimens, not considered portraits of individuals, and therefore were not assigned to the Photography archives at the National Portrait Gallery or the Victoria and Albert Museum.

Thompson belongs to a lineage of artists who have contested such attributions and values. In some ways, his performances reprise the code-switching, queer self-portraiture of Claude Cahun and, most famously and tenaciously, of Cindy Sherman and Lee Bowery; they

also resonate with the combative impersonations of Maud Sulter (1960–2008), in her inspired sequence of black Muses, and with Gillian Wearing's unsettling shifts of identity, including her recent tributes to – and appropriations of – Cahun. But Thompson also looks outwards, pugnaciously manipulating mythic, public symbols, and in this respect his work has affinities to Donald and Hew Locke's engagement with the imperial past. The father, Guyanese sculptor Donald Locke, made the vitrine display piece entitled *Trophies of Empire* (1970–72), now in the collection of the Tate, one of the most eloquent and scandalous indictments of racial stereotyping and subjugation created by a black artist. The son, Hew, creates gorgeous, baroque installations, at first sight festive but at a closer look, ferocious. He takes on the panoply of power and empire – coats of arms, galleons of privateers and conquistadores, effigies of the Queen – and festoons them in so much bling that he mocks them out of meaning.

Christian Thompson similarly draws on satire and hyperbole, imitation and re-enactment. But he has also adopted and developed another approach to the legacy of colonialism. For his practice-based doctoral research at the Ruskin School of Art, Oxford, he analysed a foundational show, 'Mining the Museum', curated by Fred Wilson in Maryland in 1992. Wilson, an African-American artist born in 1954, acted to revive effaced memories and reconfigure attitudes to artefacts of the past by rekindling awareness of the servants and farmhands, slaves and people of colour who remained for so long muted and invisible in historiography. His strategy was primarily historical: he uncovered hidden stories behind the items in the museum's collection and shifted perspectives on their makers and users. Thompson, by contrast, takes a more subjective, even psychical, approach, in keeping with ideas about dream knowledge and inner worlds as testified in Bidjara culture. 'At the heart of my practice', he writes, 'is a concern with aura: what it is, how it can be photographed and how it can be repatriated.'[6]

In the case of the Aboriginal photographs, such images offer precious testimony to the Australian past; they're historic relics, witnesses to the lives of individuals, the wreckage of the colonial era and its myopia and misprisions. Thompson does not want to consign them to

oblivion. Yet the conditions in which they were made and the prejudices that inform their aesthetics have denatured their subjects; reproducing them runs the danger of continuing to perpetrate their values. Accordingly, Thompson has looked for other means of carrying forward their stories. He would spend long hours in the archives of the Pitt Rivers Museum, contemplating the images, trying to absorb that aura, to meet their ghosts and then set out to reawaken them. It is pertinent that daguerreotypes were enshrined in exquisite velvet and metal cases, like reliquaries, and that the artist often chooses to wrap himself in soft drapes and materials such as feathers and flower petals.

Thompson calls this principle Spiritual Repatriation. Spiritual Repatriation means that the artist does not reproduce the object itself, but acts shamanistically, absorbing its essence and then reanimating it through transformations. Along one axis, it is a form of repossession; along another, an exorcism of negativity and harm. The artist takes upon himself the role that Walter Benjamin invoked when he asked, 'Isn't it the task of the photographer – descendant of augurs and haruspices – to reveal guilt and to point out the guilty in his pictures?'[7] But along a third axis, like a soothsayer, Thompson repossesses figures from history in order to shape future memories. The attempt resonates strongly with Destiny Deacon's work in *Dreaming in Urban Areas* (1993), and her uses of reverie and imagistic magical thinking in taking command of history.[8]

In Thompson's case, he has developed three principal methods to achieve the Spiritual Repatriation he seeks for traces and objects from the colonial legacy of damage: verbal evocation or ekphrasis, cultic adornment and finally the reclamation of vanishing languages. Ekphrasis is the Greek word meaning the dramatic, animated evocation of a work of art in words. The artist was inspired by Michael Fried's account of Diderot's art criticism.[9] In the case of that oldest surviving photographic portrait, Thompson remembers,

When I thought of the collection it was his face that emerged. Uncannily he was a South Australian man and I was born in South Australia, just outside of Adelaide, so interesting biographical synergies were at play. He would emerge as the embodiment of the

collection, as if I was taking his dictation in making aesthetic and compositional decisions about the work. He was there through the whole process; he came to me with such vivid clarity.[10]

This act of ekphrastic translation – a photograph of a once-living being turned into living words – becomes one of Thompson's strategies to remember his history and his forebears, to honour the dead and achieve a different form of presence for the individual. 'My own work', he writes, 'ruptures the tension between the authorship of the non-Indigenous photographer and the voicelessness of the Indigenous subject.'[11]

This approach departs from Fred Wilson's: the older artist rekindled the meaning of the works he was exploring through research into their past, and by setting up telling juxtapositions, with informed labelling and discursive comment. The effect was emotionally powerful, and 'Mining the Museum' marks a vital moment of change and reinvigoration for curatorial ideas regarding the past and its sorry legacies. But Thompson makes things up: 'We Bury Our Own' does not let us see that early daguerreotype, but improvises a series of fugues on its spiritual essence. This is the crucial step Thompson has taken: if you repeat the spectacle you can't escape the past. But if you transmogrify yourself, a spiritual descendant, in keeping with the aura of the original encounter you made with the image, you can 'repatriate' that forebear. Or so the artist desires.

In the 1980s, Maud Sulter set out to assert black visibility in her self-portraits; twenty or more years on, Thompson's performances of Aboriginal memory and belonging stage his presence in counterpoint to visual data. Images are as much acts of concealment, in constant contrapuntal play with the past and its spectacles of racial othering. His approach, which rejects direct reprisal and reconfigures the legacies of history, avoids repeating the formulae he is setting out to destabilize.

Thompson's ideas about Spiritual Repatriation bear most inspiringly on the live debate about the public uses of the past and the stories we tell about it, in our calendars and cityscapes, through monuments and memorials and the naming of days and streets. At Yale University, Calhoun Hall, which was named in the Thirties to honour a man who

was a slave-owner and vociferous anti-Abolitionist, inspired fierce protests and has been renamed. A similar campaign, 'Rhodes Must Fall', began in 2015 at the University of Cape Town and resulted in the removal of their statue of Cecil Rhodes; the protests spread to Oxford, where Rhodes also stands in effigy over a doorway of Oriel College, just up from the Ruskin School of Art in the High Street. In Oxford, the college authorities decided to ignore the outcry. But this will let the injury fester (and indeed the statue is now included on tourist programmes). Meanwhile, elsewhere, feelings are rising against the glorification of historical figures such as Edward Colston in Bristol, whose wealth accrued from slavery. Artists can intervene eloquently in these situations, as William Kentridge has done when acknowledging the crimes of apartheid and imperialism in, for example, his magnificent mural *Triumphs and Laments*, made for the banks of the Tiber in Rome in 2016. The mural has been scratched from the accumulated grime of decades, and such acts of erasure, Kentridge has often commented, must always allow what has gone before to show through. Likewise, Thompson's approach could make a significant change to the perception of a figure like Rhodes, not by removing his image but by altering it so that his history does not get forgotten, but is understood, not glorified.

Could such acts of Spiritual Repatriation become a way of letting regimes – and institutions like colleges and museums – off the hook? Could museum directors and Vice-Chancellors take comfort from the principle in order to avoid the knotty, painful issues raised by history, by the plunder of cultures and the crimes of benefactors? Could they come to rely on artists' interventions to salve their consciences? Thompson argues for artists to move beyond institutional confines: a mobile response, carrying the stories that the images tell from place to place. But the question remains unanswered, perhaps unanswerable, since the success of an artist's claim to be spiritually repatriating an object or image must remain subjective. Nevertheless, I believe that his approach is an inspired way to hold faith with the uncomfortable truths of the past while not consenting to the principles that brought them about, and of continuing to reweave the story to meet our changing values and our hopes for change.

Writing thirty years ago, Alfred Gell anticipated the place of ritual in the work of an artist like Thompson. Gell wondered why the questions his fellow ethnographers routinely asked about art which had been created in the non-West were not generally posed in relation to art made in the contemporary West, and he proposed that there were many insights into the form and the function of artefacts to be gained by doing so. He saw magic and aesthetics as profoundly, universally conjoined. Gell's influence is growing; 'the ethnographic turn', as discussed by Hal Foster and invoked by Thompson, has become central to the work that many artists, including Thompson, are making.[12] Gell places special emphasis on the importance of virtuosity in creating efficacious images. He discusses the complex whorls of facial and bodily tattoos among the Māori, for example, and argues that while clearly highly aesthetic, they also served a deeper social purpose, their artistry being an accomplished technique designed first to proclaim prestige and authority, and secondly to act as protection against hostile forces. Technological ingenuity, Gell proposes, is necessary to enchantment, and the pursuit of enchantment spurs on the devising of more cunning methods and technical artistry. It's not a vicious circle, but a virtuous one.

The arrival of digital media, especially photography with its uncanny qualities of presence-in-absence, and the possibilities of manipulation it offers, has heightened the conspiratorial affinities between the imaginative acts of artists and mechanical/technical representations of reality. The ritual intimacies Thompson has staged and recorded use a range of complex media to achieve his magical re-animations, and adopt many time-honoured ritual processes of making holy – of hallowing. Adornment is central to ritual, a prime way of glorifying and consecrating. Ingenious, lavish forms magnify the object of the decoration – a person, a statue or an icon. They enhance the power of their presence and infuse it with magical efficacy. The difference between a painting of the Madonna by Fra Angelico or Leonardo, and a miraculous icon of the Virgin, such as her cult statues in Seville or Guadalupe, lies in the layers of ornament the wonder-working images have accrued. These objects of millions of pilgrims' hopes and prayers, these totems

of the nation and the people, are richly dressed in jewels and velvet, their luxurious apparel changing according to the liturgical calendar; they are often made up, with false eyelashes and hair; they are covered in offerings of flowers and, sometimes, money. La Macarena in Seville has tears of pearls – or are they diamonds? – falling on her painted cheeks. Russian Orthodox icons are richly panelled all over, with only the Madonna's face and her child's peeping out from the jewel-studded silver and gold. The impulse to adorn stretches beyond the sacred icon itself to the chapel where it stands: the greater the sunbursts of gold and silver and jewels and flowers around these images, the greater their thaumaturgic powers.

The Reformers of Protestant Europe wanted to purify Christianity from papist magic, and image-worship and all its attendant rituals – processions, pilgrimage, candles, incense and relics – were a chief cause of their iconoclastic fury. And so they stripped the ornaments – the luxury, the festivity – from places of worship. The act of anointing is central to sacred ceremonies, to a baptism or a coronation, and it involves an ointment or chrism – from the Greek word for grace, charisma, which gives us English 'charm'. These unguents came in precious, ornamented jars – much like the extremely expensive cosmetics that are the staple of the beauty industry, and necessary to Thompson's auratic portraits.

III

For the series *Polari* (2014), Thompson invokes the history of languages, and turns to sound in order to regain the effaced culture of his forebears. Listening-in becomes the third method of his art, an intimate ritual he enacts as he seeks to reanimate and repossess lost knowledge. 'Polari' is a private language (the word derives from *parlare*, Italian for speak), a kind of code used by sailors, circus and fairground folk and in gay circles; it resembles other slang or codes adopted by certain communities, like *beur*, the argot of Maghrébins in France, Cockney rhyming slang or thieves' cant. In the absence of other possessions and privileges, you can belong to a language and it can be your own prize possession, a proud badge of identity: 'Thou shalt not speak my language', as the Moroccan writer Abdelfattah Kilito has declared in a book about his Arabic and

French bilingualism.[13] The *Polari* sequence warns us that Thompson has a language of his own, which we can overhear but not fully understand: something is being withheld, in contrast to the imposed and implacable exposure of those data collections from the scientific past.

A further series of explorations, in the form of short videos, create a different mood: playfulness mixed with angry irony is still in evidence, but Thompson no longer appears in every piece as the performer. Whereas an argot like Polari provides a refuge from the dominant language of a society and a protest against its norms, the hundreds of languages spoken in Australia before the arrival of the colonists and settlers are mother tongues; they give the clans their names and, in an oral culture, keep the records of relationships – personal, metaphysical – as well as the history and stories of the past.[14] The linguistics scholar and translator Yurranydjil Dhurrkay, of Yoingu country, compares the relationship to a pearl in an oyster: 'The shell is like the people that carry the language. If our language is taken away, then that would be a like a pearl that is gone. We would be like an empty oyster shell.'[15] In the case of Thompson, the language of the Bidjara is one of the Southern Maric group and is in acute danger, but he maintains that if one word can be kept alive, it's a seed, the grit from which the pearl can be made, a memory-trace of life.

A sustained, haunting video stages the silencing with graphic simplicity: in *Dead Tongue* (2015), Thompson's profile faces into the wind like the figurehead of a galleon, a couple of Union Jacks held between his teeth like a muzzle or a scold's bridle; an instrument of silencing. A wild song repeats on the soundtrack, without subtitles, without translation. 'I'm interested in the textures of languages,' he has said, and the soundtrack's deliberate unintelligibility corresponds to the acts of concealment in the images. Every now and then Thompson slowly closes his eyes, as if reminding us that he is a living person, not an effigy, and also that, like the *angelus novus* of Paul Klee's painting, he is facing into the gale of the future, as evoked by Walter Benjamin, which will drive all before it and grind the artist's culture into ruins.[16] Thompson has also made two films for which he invited baroque singers to interpret fragments of Bidjara. The performances are uneasy and

all the more compelling as a result: the singers, framed in close-up, with their torsos bare (as if they were 'native' subjects) look tense and bewildered. The lyrical arias have an intense fervour and the artist does not offer any explanations, so the overall effect is mysterious: who composed them? Thompson tells us that a surviving word, *dhagunyilangu*, means 'brother', and the piece constitutes a magical act of reanimating the language, since when one word survives the language can still live. Significantly, another video is called *Refuge* (2014): here, the artist himself sings softly, in Bidjara, a piece composed by James Young (who worked with the legendary singer Nico, of The Velvet Underground).

Through these conjurings of the language his people spoke before colonization set out to dispossess them of their culture as well as their land, Christian Thompson performs private ceremonies – ritual intimacies – which reach beyond visual statements of personal presence to reawaken the knowledge of his forebears and allow us, his listeners and viewers, into their living story.

4. ICONOCLASHES

Douglas Gordon, *The End of Civilization*, 2012

The future is certain,
it's the past that is unpredictable.[1]

'Iconoclash' is the term introduced by Bruno Latour to describe the struggle over images today: over what they mean, how we interact with them and why they matter so much.[2] The violence at one extreme and veneration at the other reach far beyond the qualities of the image according to criteria such as materials, labour and skill. History lies at the heart of the struggle, and art plays a central role in the way it is told.

City piazzas, parks and streets rise, layer upon layer, to become palimpsestic records of past glories. The stories they tell in stone and bronze are bedded down in strata, in the built environment's haunted unconscious, its places of collective memory, the *lieux de mémoire* explored by historian Pierre Nora. 'The most fundamental purpose of the *lieux de mémoire*,' he writes, 'is to stop time, to block the work of forgetting, to establish a state of things, to immortalize deaths….'[3] But 'The hour of crime does not strike at the same time for every people,' as the Romanian poet E. M. Cioran observes in one of his *Bitter Syllogisms* (1954). That hour will strike for the heroes of one era; and history, as it keeps moving on, will suddenly see them again in a different light. A contest will then break out to reconfigure the story of the past and pull up the old markers.

The waves of iconoclasm that swept through Europe during the Reformation, England during the Commonwealth and France during the Revolution, and which are currently spreading through regions under the sway of the Taliban, Daesh and the Salafists, arise from revulsion against acts of idolatry, an ambition to inaugurate a new history and fury against the message enshrined in the artefact: politics, philosophy and creed can't be disentangled. These political-religious episodes may appear, at a quick glance, to differ from attacks on images in museums, such as the one which took place in the Tate Modern, London, in 2012 and almost damaged Mark Rothko's *Black on Maroon* (1958) beyond repair. In the case

of statues of Cecil Rhodes, or of the ancient Lamassu, the winged creatures of Assyrian antiquity which were hammered into pieces by Isis fighters in Mosul, the subject of the artefact dominates the attackers' motives; however the target is not always the subject matter or the artist, but the status of the object *per se* – the icon as intrinsically blasphemous, the work of art as sacrilegiously overvalued.

The art historian David Freedberg has declared, very simply, that 'the ontology of a holy image is exemplary for all images'; this approach, bearing in mind the ban on graven images in the Ten Commandments and in the First Letter to the Romans, will give us greater insight into the iconoclasm erupting today and the struggle raging over contradictory claims to the story of the past.[4] Freedberg sees the continuum between icon and image and sacred and secular examples as persisting transhistorically; however, the broadening of the sacred to embrace works of art which have no religious or holy affiliation has intensified in the last two hundred years, and this has spurred on the growth in value of the art market. Artworks are charged things; the power of images no longer derives from their likeness to something powerful or to someone reputed for holiness, or even from invoking a referent at all – they are self-sufficient. They have become the site of the sacred, an elusive quality whose very state of preciousness invites destruction, desecration, violation and profanity. The worshipper of images, or iconodule, and the iconophobe, or iconoclast, enter the battle for the ethical high ground – a battle that has been present from the first pictographs in Plato's Cave and will never be resolved. For this reason, iconoclasm becomes the ground for defining art itself, and seems at every turn to present itself as the arbiter of value. Art-making and art-breaking are intertwined, as in a long, passionate lovers' quarrel.

'The world of symbols is not a tranquil and reconciled world', warns Paul Ricoeur, who continues by reminding us of the process which sees symbolic languages hardening and then becoming refreshed, under a compulsion to reassign meaning to these

necessary, surrounding instruments of significance: 'Every symbol is iconoclastic in comparison with some other symbol, just as every symbol, left to itself, tends to thicken, to become solidified in an idolatry. It is necessary, then, to participate in the dynamics in which the symbolism itself becomes a prey to a spontaneous hermeneutics that seeks to transcend it.'[4] In the past, artists were inevitably caught up in conflicts over idolatry and the cult of images, arising from the ban on representation in scripture and religious teaching (in the Bible and the Hadith). Their images often dramatize the fate of worshippers of false gods. Contemporary artists are sensitive – how could they be otherwise? – to the exacerbated role of images in the age of mass media, economic dependency on advertising and consumerism. Many contemporaries have consciously adopted iconoclash as a means of expression; it is perhaps unexpected to find how close the methods of the smashers of idols are to the methods of contemporary artists, how contending and challenging the power of the image lies so profoundly at the heart of what they set out to do.

HIERONYMUS BOSCH

Trumpery, or, The Followers of the Haywain

The Pilgrimage of Life, The Haywain (closed)
1512–15

'All flesh is grass…', the voice cries in the wilderness, according to the prophet Isaiah. 'And all the goodliness thereof,' Isaiah goes on, 'is as the flower of the field…' The prophet evokes the short life of grass in the dry pasturelands of a nomadic people to warn his audience of our mortality: 'Surely the people is grass,' he writes, followed by an elegy and a palinode: 'The grass withereth, the flower fadeth, but the word of our God shall stand for ever.' (Isa 40:6–8). Unlike earthly crops, scripture stands and does not shrivel.

If grass is not left to be scorched by summer's breath, if it is reaped in time, it becomes fodder: husbandry translates wild flowers and weeds into nutritious harvests – into hay. Although hay is sown and harvested, the word also describes forage plants – according to the dictionary, 'herbage', including 'grass, alfalfa, clover….'[1] Hay points forward: harvest-time, food, money. It has retained proverbial meanings, deeply embedded in the memories of rural societies in contemporary phrases from many languages, including Bosch's native Flemish. 'Make hay while the sun shines' conveys an Epicurean message; 'to hit the hay' in English still means 'to go to bed', while 'a roll in the hay' recalls harvest-time frolics (some with consequences). These same circumstantial memories resurface in the myths about classical arcadia and its aristocratic 17th- and 18th-century successors, when shepherds and shepherdesses dally in improvised beds of sweet-smelling newly mown hay. In German, to which Dutch and Flemish are closely related, the phrase 'Ins Heu fahren' ('to drive into the hay') appears in ballads as a routine, bawdy euphemism for adultery.[2] The season of haymaking, for all classes of society, evokes pleasure, summer, youth.[3]

A tinge of moralizing sometimes clings to these idylls: the Epicurean motto implies that the pleasures will soon be over and the opportunities rare, while the passing season also foreshadows the end of dalliance. 'Flesh is grass': the vision in such a painting as Hieronymus Bosch's *The Haywain* (*c.* 1510–16) rises from scriptural and idiomatic associations of transitory pleasure with future damnation. Images of hay and grass, flesh and harvest are still connected to the transience of worldly things, even in contemporary urban settings where little that grows is grown to eat. In Bosch's vision, this

Judeo-Christian sense of the futility of human existence, redeemed only by God's promises, finds expression in his extreme, inventive and grotesque figures, who appear in great numbers in all his work.[4]

The triptych of *The Haywain* is organized on the same principles as an altarpiece, except that the central panel, which would more usually represent a scene of salvation – the Adoration of the Magi, the Resurrection of the Dead, Calvary – shows instead a huge wagon or wain occupying the centre of the scene (see opposite page), while the outer wings, when closed, present a wayfarer, grizzled and haggard, in ragged clothing out at one knee, making his way towards a footbridge across a stream as he looks over his shoulder with an expression of unmistakable anxiety on his sensitive face (see p. 198). Behind him, on the horizon, is a scaffold with a ladder and a loose rope; a small group of figures is approaching this gibbet. Another scaffold stands nearby, of the wheel variety erected by the Spanish for their executions. Elsewhere, a gang of footpads is tying a victim to a tree, ripping open his bundle and scattering his clothing. Further touches of menace and violence add to the disturbing effect: a man pulling along a woman with a kind of rough, dancing movement, and the carcass of a horse, with carrion crows and a snarling dog in a spiked collar. The whole scene is a compelling early example of genre observation, which also hints at allegory through the figure of the wayfarer himself and the rickety footbridge. In a rhetorical flourish, the painter underscores this sense of danger by splitting his protagonist in two when the wings are opened to reveal the picture within, of what, possibly, awaits him.[5] He is an Everyman on the Way of Life, our alter ego, embodying a cautionary tale we need to tell ourselves.

Bosch is a supreme storyteller, and here he is at his most commanding: in charge of his characters' fate and as knowing as any tragic moralist about where they are so heedlessly headed.[6] The future he depicts is so discouraging that many have suggested that Bosch lapsed into heresy: here the Fall leads to sin and then, inevitably, to damnation. Hans Belting writes, '… a linear history is introduced which secretly reverses the post-historic message of the Last Judgment's apocalyptic panorama. The Fall of Man is the start of a sequence that ends in Hell' – not so 'secretly', one might add.[7]

The interior scenes of *The Haywain* offer one of Bosch's boldest visions of the end times, and they're expressed in primarily satirical terms,

The Haywain (central panel), 1512–15

adapted from contemporary secular literature – especially from the corpus of scathing writings about man's folly.[8] Full square in the centre of the composition is the improbably large wagonload of hay, which is shown trundling across from the Garden of Eden in the left-hand wing of the triptych towards Hell on the right. Joseph Koerner has pointed out that the painting's restlessness conveys a concept of mobility, indicted as the frantic round of pleasures sought by sinners as well as the wandering lives of pedlars and beggars, Jews, gypsies and Turks, which the law condemned in Bosch's day.[9]

At the summit of the mountain of hay, Bosch depicts a kind of picnicking idyll with two amorous couples; they are flanked by an angel on their right and a diabolical, winged, blue gryllus on their left, using his nose for a trumpet as he accompanies one of the lovers, who is playing a lute.[10] The composition echoes the conventional deathbed struggle between angels and devils for the soul of the dying, but it grimly focuses on lovers in their prime, again an echo of the dire warnings of the prophets. Behind the bush, someone is peeping: Bosch likes introducing such voyeurs, who present us with a mirror image of our own (possible) prurience. Above, a small, distant Christ the Redeemer, displaying his wounds, looks down on earth from a golden banner of cloud; this diminished saviour does not appear to engage either with the crowded scenes unfolding below, or with the painting's audience.

The huge load on the haywain is being pulled with apparent alacrity by a swarm of revellers and devils, hitched to the wagon in the place of animals and moving towards the fiery ruins of hell; they are urged on under the raised whip of a reptilian demon, while hauliers, who are part-fish, part-bird, part-mouse, part-furry monster, trot along holding the shaft. Are they comical? Or terrifying? Does Bosch's evident scorn for the headlong folly of humanity have some redeeming quality of lightness and humour? It is hard – impossible – to say. His grotesque fantasy brings him close to the spirit of fairy tales, and it depends on our sense of security whether we can take pleasure in the frightfulness of the fate in store ,or shudder from it in terror.

Following behind the wagon itself, a troop of grandees ride in the procession as if in a triumph – like that painted by Mantegna a few years

before,[11] or even Dürer's progress of the Emperor Maximilian in a magnificent chariot, which was engraved around 1512, just after the probable date of *The Haywain*. Bosch's cast of characters includes prelates, potentates, soldiers from east and west. Emperor and Pope appear in dominating positions, with a sceptred king beside them as well as priests, hermits and monks on foot pressing close. In many ways, the company also resembles the princely throng riding to pay homage to the newborn saviour in Renaissance images of the Magi, for example Benozzo Gozzoli's gorgeous fresco in the Palazzo Medici-Riccardi in Florence. But Bosch, by attaching the princes to the progress of a heap of hay and heavily ironizing the familiar, solemn use of the motif, shows more in common with the spirit of a Dance of Death.[12] The motif, part of the popular medieval *memento mori* tradition, was adopted by Humanist mockers of human folly, developing a new tone of biting glee in the learned circle around Erasmus and More and influencing the vision of, for example, Hans Baldung Grien. The stream of people on their way to hell echoes the direction of the wayfarer on the outer wing, but unlike him, none of them is looking back in anxious consciousness of what he might be heading for.

Women figure in the crowd that is emerging from the cave to the left, behind the wagon, but do not appear among the fine company at the rear. The cave itself is surrealistically anthropomorphic, and recalls some of Bosch's most fantastic inventions, like the Tree Man from the hell depicted on the right wing of the *Garden of Earthly Delights* (*c.* 1490–1510). The group issuing from its enigmatic mouth in *The Haywain* are tightly packed and orderly common folk by comparison to the cavalcade; some are looking up at the high pile in front of them, others appear to have shouldered bundles of hay, but on the whole they are the only figures in the painting who do not seem enthralled by the wealth of the wagonload.

By contrast, the harvest loaded on the wain is being stormed by men and women using ladders to scale it and grapnels and pitchforks to plunder it; several of the besiegers have fallen under the wheels, but this does not seem to deter others from making the attempt. The artist depicts some nasty outbreaks of violence: two brawlers are shown being restrained, one by a monk in the centre of the picture, while just below this group, a man's throat is cut by his assailant. On their left, a coiffed

figure is attempting to disarm a man who, capering wildly, raises a stick – a crutch? – against her and seems to be dancing a jig. Cripples, beggars and vagabonds do not elicit sympathetic treatment from Bosch, Brueghel or other Netherlandish artists. In this respect, the Wayfarer on the outer wings of *The Haywain* receives a form of empathetic attention from the artist that is unusual in his oeuvre.[13]

In the foreground of *The Haywain*, a man lies sprawling on a woman's spread skirts, between her legs, and below, on the right, a nun solicits a musician with an offer of a meagre tuft of hay, while beside her some of her sisters fill a sack with more of this – by now clearly illicit and tainted – spoil, at the feet of a very fat and lubricious-looking monk. Hay is a fleeting pleasure: the golden hay, grasped, pursued, exchanged from hand to hand, is also human appetite of another kind. It is currency, a golden calf, a metaphor for mammon. In *Doctor Faustus*, Christopher Marlowe lampoons money as 'a bottle of hay', an illusion conjured by the Devil, after Mephistopheles and the Doctor gull one of their victims, a bishop, into parting with a good horse.

In Bosch's picture, the bed of golden hay strewn around the cart has not encroached on the ground entirely. In the foreground, the characters recall his allegory of the Seven Deadly Sins, while the central figure of the tooth-puller recalls his celebrated picture of a conjuror and his mark; this medicine man has a pocket stuffed with hay and has set out his stall under the banner showing an image of a heart, has laid out flasks, pestle and mortar and other nostrums; he may be a quack in the market of love potions and snake oil, only feigning to draw the tooth and to cure. Themes of charlatanry and fraud form the overarching significance of the painting. On the left-hand wing, for example, the Serpent appears with the lovely face of a woman, Eve's alter ego.

In this context, even apparent acts of kindness arouse suspicion: a woman in *The Haywain*, who is bathing a baby and washing its bottom, with a little pig behind her, does not inspire confidence; nor does the humped older man with the child strapped to his back. Bosch communicates an inventory of unease over ordinary scenes of human contact. In this, too, he shows the scourging spirit of such masters of satire as Sebastian Brant and his list of scoundrels aboard the ship of fools.[14]

Hay past its prime – hay that has withered – becomes almost as worthless as straw; or worse, chaff. Straw and chaff metaphorically convey the hollow and cheating realm of appearances – more deception and illusion, more of the devil's business. One proverb declares, 'An old bird is not to be caught with chaff'. A contradictory set of meanings therefore follows from the withering of hay's goodness. If Bosch is depicting not hay but straw, then the imagery alludes to another strand of recurrent metaphor in the Bible, one that modifies the significance of the ghastly carnival rolling towards eternal damnation. In both Dutch and German, the words for hay (*Heu*; *Hooi*) derive from 'Das zu Hauende' – that which is beaten/thrashed.

In the Book of Job, the ungodly are stubble driven before the wind, 'swept off like chaff before a gale' (21:17). The Psalms reiterate these dark thoughts (1:4 and 35:5); Isaiah twice returns to the imagery of God's anathema driving the fallen like burning stubble and chaff blown 'like a rolling thing before the whirlwind' (17:13). And so it goes on: Jeremiah, Daniel, Hosea and Zephaniah all have recourse to similes of harvesting, threshing, winnowing, with the unwanted residue harried and expelled in the form of burning straw and whirling dust. The metaphor also inspired the iconography of sacrifice, such as in contemporary images of 'Christ seated on a haystack'.

These scriptural associations give a different perspective on Bosch's painting of vanity and greed, and on the evident folly of the crowd trying to seize some of the coveted harvest for themselves and stuff their sacks and pockets. The strewn floor of ripe yellow beneath the wheels of the wagon and the cavalcade conveys an image of a threshing floor, where the grain is winnowed, the corn separated from the husks and the stems in the process to form chaff and straw and, mingling with the earth floor, dust,[15] all of which are recurring Biblical images for damned souls rejected by the angry god of the Old Testament and later of the Apocalypse.

If all this hair-splitting about hay and straw seems a little pedantic, the difference matters because there's a possibility that Bosch's lascivious and brawling procession heading for hell also wilfully inverts, in carnival fashion, the transformation of bread into the body of Christ. The huge tumbril laden with useless human dross is travelling towards the brick ovens of hell, where a tower is rising as a result of the busy work of devils.

Just as Bosch has carefully rendered, in the central panel, the tools and processes of agricultural labour, so he offers as his characters' destination a lively scene of a medieval building site: one devil is using an adze to hew a timber to size, another is climbing a ladder with the fresh mortar in a hod on his shoulder. At the bottom of the tower, another monster is turning the handle of a pulley system, while on the scaffolding two of his mates are laying bricks on the fortifications of hell.

The painter's many other celebrated visions of the damned develop alternative sustained metaphors: music-making and cooking, for example, dominate the hell on the right-hand wing of *The Garden of Earthly Delights*. That picture's vision of a devils' kitchen, bristling with the sharpest chef's knives and equipped with cauldrons and ovens, grills and barbecues, deploys one form of punishment for the sinners delivered to its precinct: to be processed as diabolical food, turned from human flesh into a continuous unholy banquet for Satan and his torturing minions. Here, Bosch dramatizes a Biblical trope which had been vividly elaborated in medieval imagery: Dante's terrifying vision of the *Inferno* culminates in a perpetual cannibalistic cycle, the worst sinners devoured by Satan himself. In *The Haywain*, the transformation of sinners into fodder for a devils' banquet develops differently.

The artist's famous *capricci* of fantastic devils are the visible proof of evil's power to deform and disfigure the human shape, once made in the image of God but distorted by sin. Grotesque hybrid devils form part of the team drawing on the shaft of the cart, made of eclectic combinations of different animals.[16] While they appear to be the offspring of incongruous unions – a monstrous progeny – they also prey on the dead, attacking and devouring them and obliterating their bodily identities in a process that reverses the promise of the resurrection of the flesh. One sinner is being swallowed by a fish, while two other naked, damned souls are being set upon by dogs and serpents, recalling the vicious dog from the scene with the wayfarer on the outside wings. Another victim is impaled on a pike carried by a huntsman blowing his horn; this corpse has been eviscerated. In the distant, red-hot smouldering gloom, the dead are being engulfed in a burning lake, assisted in drowning by monstrous black demons. All such scenes of annihilation are common in Bosch's work; his speciality,

in fact. But *The Haywain*'s Hell conveys a potent though barely conscious suggestion of a different transmutation: sinners are providing the necessary building materials for hell itself, the straw without which you cannot make bricks, as the proverbial phrase, inspired by Exodus 5:13, proclaims. The sinners are being ushered or hauled from the front of the haywain's progress towards the tower that is rising, fired brick by fired brick. One is being dragged across the building ground where the floor appears red, red with dust which is the same colour as the bricks and the fires of hell.

A similar satanic tower in mid-construction appears in an engraving by Hieronymus Cock, after a lost work by Bosch of a lurid, apocalyptic battle between angels and devils over the souls of the dead.[17] This violent melée involves siege engines and ladders, weaponry and equipment like millstones, as well as fantastic and horrible armour for the devil-warriors, such as the artist would have seen in the conflicts of his time. The tower in the background is being filled with corpses, who are carried up ladders by devils and hauled in at the top, as if the building were growing from their bodies. The scene resembles another depicted on the edges of the globe in the later, tapestry version of *The Haywain*.[18]

Could *The Haywain* dramatically present a process which echoes, topsy-turvy, the doctrine at the core of medieval Eucharistic piety: that bread, made from corn and baked into the host, is transubstantiated into the body of Jesus, through whom the faithful are saved and go to paradise? The imagery of bread and wine and communion arose from daily, material experience and it inspired variations in devotional art: one popular image depicted Christ standing or seated in a wine press, the iconography graphically embodying the Eucharistic process of turning his body into wine. Likewise, the Mystical Mill (see p. 208) showed the Virgin Mary and angels pouring grain from bags into a hopper, which leads it to a mill wheel, where the corn is being ground and then formed into hosts.

The motif, which might strike a modern mind as strained and peculiar, presents a process of transformation from body to grain to bread. It offers this miracle as a foreshadowing – and analogy – for the salvation achieved when Jesus dies, and for the sacrifice that is recapitulated in the mass and the eucharist. Here, the processes of transformation require body changing into bread, blood into wine and back again in the miracle of transubstantiation.

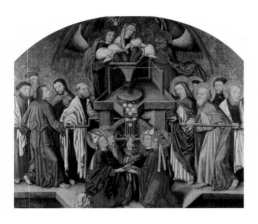

Anon., *The Mystic Mill, c.*1470

Two rather more familiar iconographic motifs express related ideas: the Mass of St Gregory records how the Pope, assailed by doubts about the true presence, was granted a vision of Christ appearing bodily, bearing the marks of his passion, on the altar as he was pronouncing the words of consecration over the host. Hieronymus Bosch painted this most popular miracle story in grisaille on the outer wings of the *Adoration of the Magi* (*c.* 1490–1500).[19]

Another, corresponding narrative emerged later, and also addressed the anxieties of believers about the central tenet of faith in the Eucharist: the story of the Mass at Bolsena records how, in 1263–64, when a doubting priest was saying Mass, the host bled onto the altar cloth and steps.[20] This miracle banished all the celebrant's worries and was eventually commemorated by the great feast of the Catholic church, Corpus Christi, established soon after in 1311.

None of these divine proofs would sway the Protestant reformers when they rejected the doctrine of the true presence. Is it possible that Bosch's painting of *The Haywain* unfolds a raucous inversion of eucharistic orthodoxy, showing its enactment in reverse by greedy, lustful, heedless humans who are being driven to damnation like chaff before the wind?[21]

III

Something wonderfully singular and inventive in Bosch always resists interpretation: it is not just that my suggestions here might be far-fetched, but rather that they and many other theories *might* fit. As Michel de Certeau commented, apropos of *The Garden of Earthly Delights*, 'The painting organizes, aesthetically, a loss of meaning....'[22] The effects of singularity are many, but one is surely that it has magically detached Bosch from his historical time and social background to establish him as a precursor of surrealism. He was a painter of phantasms of such peculiarity

that the court poet Francisco Gomez de Quevedo, in his satirical book about dreams (1627), imagined Bosch descending into hell and finding that the devils themselves complained to the artist that he had turned them into fantasies, into grylli or grotesque hybrids.[23]

A baffling emotional impenetrability also results from his singularity. With *The Haywain*, as with others of his most fascinating works, it really is not possible to respond to the mood of the picture with any confidence. At most, one can say that it tends to the grotesque, with all the serio-comic ambivalence of that genre or style. This is 'merry hell', as the phrase goes in English; or as another old saying puts it, Bosch's cast are all 'going to hell in a handcart'. The phrase does seem to catch something very close to the mood of Bosch's picture. The learned monk José de Sigüenza, one of the earliest writers to comment on Bosch's art, defended the painter against charges that his images were *disparates*, the word Goya wrote on the sequence of pitiless prints he made during the last years of his life (c. 1819–24), which means 'mismatched' or incongruous pairings, and was used to describe farces and follies. With these darkly comic indictments of humanity's inhumanity, Goya did not mean that his vision was nonsensical, but that the acts he represented formed a real part of the folly and disorder of existence.

The Haywain was one of three sumptuous works by Bosch chosen for reproduction as a tapestry, a costly medium; the others were *The Garden of Earthly Delights* and *The Temptation of St Anthony* (c. 1501). All three central panels depict greed and sin, the reverse of salvation, where normally a visitor to a church would expect a vision of Christ or the Madonna or some positive episode in the story of Redemption. As tapestries, the paintings shed the recognizable, sacred form of the usual high altarpiece and become cautionary cartoons.

The painting of *The Haywain* may be a mockery, a topsy-turvy, misanthropic vision, a *disparate*. But it is more than satire. It is, strictly speaking, an act of trumpery. Trumpery comes from the French *tromper* and the Flemish *trompen* – to deceive – and it gives the word 'trumpet', as blown by the devils in Bosch's fantasy. This triptych is a dramatic representation of fraud and trickery, greed and lust, of diabolical powers to beguile and destroy – and it is itself constituted as a false image of a sacred mystery.

DAMIEN HIRST

To Hell with Death

Sympathy in White Major – Absolution II
2006

In 1991 the art critic Louisa Buck rang me up – in those days we didn't text – and said I really should go along to Bond Street and see the butterflies hatching in some disused premises that the artist Damien Hirst had rented. 'It's a truly *beautiful* installation,' she enthused. She described it: the dishes of melting nectar, the chrysalises stuck to the walls and the startling epiphanies as the creatures unfurled, fluttered – tropical, iridescent, huge, ineffable. I didn't get there in the end, but not because I didn't want to. Now the piece has been reconstructed in Hirst's retrospective at Tate Modern, and for many reasons I wish I had seen the original version of *In and Out of Love* (1991). It mattered then and it matters now that Hirst rented the space, a former travel agency, so that he could install his vision of natural beauty and the life cycle there of all places, in the heartland of platinum-plated consumerism and high fashion. Like one of the gorgeous brindled or turquoise insect-mimics he hatched, he was taking colour from his surroundings and showing that he could make exquisite artefacts, delicately skilful, each one unique, precious, rare; he could display how supremely wonderful a real creature is, more so than anything at Asprey or Prada or Cartier.

The museum shop at the exit of the show at Tate Modern (selling numbered Hirst prints for between £205 and 30,150 each) glitters almost as richly as Bond Street, but the oblique claim made by Hirst's early work has faded from view. That claim was manifold, and it was first and foremost a kind of guerrilla tactic, to take art into the redoubts of luxury and money: an artist could be a raider, a member of a flying squad, an Occupy-style activist parachuted in to transform and shock. The YBAs as a group held street markets, improvised shops and mail order art – Tracey Emin and Sarah Lucas together – and installed their work in unusual and distant derelict sites – their inaugural, epoch-defining group show, *Freeze*, which Hirst curated, was at Surrey Docks. Seen in a room in a national monument, the work inevitably loses the social defiance and implicit mockery of that first, daring improvisation.

Just upriver from the Tate, at the Hayward, the exhibition 'Invisible: Art about the Unseen' makes the point about the crucial role of topography, institution, description, naming: one empty white room after another, each of them different and each of them revealing. A space

cooled by an air-conditioner that recycles water from the morgue where the corpses of victims of Mexico's drug war are washed – *Air* (2003), by Teresa Margolles – gives a very different feeling from the white cube called *The Air-Conditioning Show* (1966–67) by Art & Language, an angry manifesto about the way ambience creates value. It sounds insane to fill the Hayward with invisible works of art, but although it may seem an arrant example of the emperor's new clothes, the show, curated by the Hayward's director, Ralph Rugoff, gives an exhilarating lesson in looking and paying attention and, incidentally, provides a history of the forms taken by conceptual art in the 1990s, whose gaudy precipitate is the phenomenon of Damien Hirst.

There's a tendency in writing about Hirst to become portentous and metaphysical, and I don't want to fall into that mode. But Hirst is a symbolist and his symbols reach for transcendence. He chose butterflies, the most metamorphic of animals, for his poor artist's radiant boast in 1991, and in 2011 he published a book of images of metallized butterflies identified by colour as in a paint chart and entitled it *The Souls*. The installation on Bond Street introduced time into the vision of souls, bliss, beauty: Hirst's *objets de vertu* were ephemeral, and fell to the ground after their short span was done. They invert the usual definition of art as eternal, countering time and decay.

The words *tempus* and temple share the same root as *temenos*, a sanctuary, and ultimately derive from the Greek verb *temno,* for hewing, slicing and wounding (it survives, for example, in *tomo*graphy and mastec*tomy*); the word was also used figuratively for a ship cutting a furrow through the waves. The connection with sanctuaries depends on their character as places apart, demarcated and hallowed precincts where the crucial measurement of time and the seasons took place (obelisks acting as *gnomons*, charting the passage of the sun).[1] The connection recalls that the function of a sacred space, in eras before clocks, was to take account of time, or render its flow palpable to the worshipper/visitor and ultimately manageable by society, by observing the movement of the heavenly bodies and translating it into spatial terms.[2] This idea of sectioning and marking off became a metaphor we live by, and produced the Latin *tempus* and *templum* and myriad derivatives – maybe even 'temperature', another kind of measurement.

Galleries and museums explicitly recall temples in their architecture, and they can also double as national mausoleums for remembering time past. They function socially in comparable ways ('temples for atheists'), providing an occasion for assembly, for communal experiences and for finding shared meanings – and offering a different relation to time. Not long before he died in 2013, the philosopher Eugenio Trías observed the contemporary turn towards the sacred in symbolic communal events, rather than in moments of inward prayer or private acts of faith.[3] Such gatherings organize time (and noise) at a different pulse rate from the outside world; time is being told there – marked or counted down – at a different pace that is powerfully seductive to artists and their audience.[4] It's striking how crucial the idea of developing our sensitivity to time has become in contemporary artists' work. 'I do not think I am slowing down time,' Tacita Dean, one of the most delicate time machinists of all, said recently, 'but I am demanding people's time. In a busy world, that is a big demand, but one of the many reasons why art matters is its ability to stop the rush. Art on film makes us conscious of the time and space we occupy, and gives us an insight into the nature of time itself.'

The afterwardness of experience adds layers to memory: a first time keeps changing as it is successively remembered and relived.

In the case of Damien Hirst, three decades of glory, combined with the judicious pruning of this retrospective, have altered our response to his work: they've attenuated the sensationalism far more so than with the art of Francis Bacon, whom he admires and emulates. It's as if the works themselves have swallowed all the barbiturates and decongestants displayed in those gleaming cabinets. So many of them have become iconic that they now wear a classical, self-important air. Hirst taught us to look at cows' heads weltering in their own blood and buzzing with flies (*A Thousand Years* (1990)), and we have learned to do this too well, without flinching. The Tate show is full of young children with clipboards and question sheets, and they're running about, giggling at escaped butterflies and ticking off their finds (three flayed sheep's heads, a thousand cigarette butts, one hairdryer, ten thousand dead flies) as happily as they do among the mummies at the British Museum or the crucifixions and pietàs of the National Gallery.

The butterflies, the skinned carcasses, the stuffed shark and the cloven cow and her calf could belong in a Wunderkammer, but Hirst's way with these natural specimens differs from his precursors' collecting habits. A 17th-century prince was moved by the scientific impulse of wonder and wanted to possess natural phenomena for their intrinsically marvellous properties, not primarily for their signifying afterglow. Hirst, by contrast, looks beyond the thing itself to what it means. He's a natural allegorist, a lover of Vanitas images – a clear case, I think, of once a Catholic. Although he stopped attending Mass when he was eleven, the Jesuits or whoever was teaching him catechism had long enough to shape him forever. He is named after the patron saint of doctors (usually spelled Damian), who, with his twin brother Cosmas, performed the first surgical transplant when he grafted the leg of a Moor who had fallen in battle onto the stump of a white Christian knight. This operation, depicted on altarpieces in the saints' many churches, can't be consigned to the antique glory hole of weird Catholic legend, for it was crucial to Joseph Beuys's dream of revolution: a vision of interracial fusion, of the resurrection and reconciliation art can achieve. In one of his works, Beuys eerily renamed the two towers of the then newly built World Trade Center after the brother saints: did he do so in some wan hope that the towers could be transfigured into instruments of good?

Beuys, needless to say, is second only to Duchamp in importance to the current philosophy of making art. Hirst took to heart Duchamp's message that the action of naming turns anything into art, but his education at Goldsmiths added to this sometimes rather austere cleverness the sparkle of his teacher Richard Wentworth's playfulness (Hirst's hairdryer and ping pong ball from 1994, called *What Goes Up Must Come Down*, has the punning neatness of Wentworth's work). The English comedy of early Gilbert & George and a complicated mockery of class allegiance also lift the solemnity of Hirst's symbolism. His titles range from prayer-like rigmaroles (*Beautiful Inside My Head Forever* (2008)) – known in Catholic parlance as 'ejaculations' – to unadorned litanies of words and direct invocations of Paradise and its opposites (*Sinner* (1988), *Judgement Day* (2009)). The scientific names of polysyllabic substances stand in for unfamiliar saints, following Hirst's equivalence between

belief in religion and belief in medicine, which he associates with going to the chemist's with his mother and her blind faith in the prescriptions her doctor was giving her. And, of course, there's the necrophilia.

Memento mori used to be a sign of profound Christian virtue: a pious man or woman would commission a tomb that showed them alive and fully dressed above, and in a vivid state of wormy decomposition below. There are some splendid 17th-century examples in the Louvre; grisly, decomposing skeletons also figure, more unexpectedly, on later English tombs in Westminster Abbey. By taking stock of the horror, warding it off, the artists perform a kind of sympathetic magic of containment on their own behalf and on behalf of their patrons. Visions of mortification in many of Hirst's works arise from a similar motive. The anaesthetic effect of his art, now that the shock has worn off, shows how effective this process can be. *Mother and Child (Divided)* (1993) shows a profane yet tender Madonna, a pietà that's also a comment on abattoirs, carnivorousness, mad cow disease and other things – but the spectacle has become familiar. I can almost look at it now without looking away, though when some visitors asked me if there was a lamb in the womb of the cow, I found it difficult to examine the dark cauliflower in the gut which they were taking for fleece.

The reason for Hirst's classic status lies partly in this symbolic emphasis. It used to be undercut by cheek, delinquency and the kind of gallows humour the YBAs relished; there's a disturbing video in the Tate show, *A Couple of Cannibals Eating a Clown (I Should Coco)*, from 1993, in which Hirst and Angus Fairhurst are both in full clown get-up, with ruffs and slap, exchanging macabre stories of maimings and butchery, crashes and crimes, all the while drinking and smoking; every now and then Hirst squeezes a toy horn and they get the giggles. But on the whole it's an exercise in callousness. Hirst's game of chicken soon began to pall.

He's now playing for real and for very high stakes. Can value be added – literally – to a work of art? Once, nature's own artistry did it for him: the butterflies, the lambs, the sharks. Fabrication followed: the properties of proprietary medicines, the gleaming and cunning tackle of surgical instruments, the splendour of tropical butterflies mounted in kaleidoscopes of colour to create stained-glass windows (*Doorways to the*

Kingdom of Heaven (2007), the mystic rose of *Sympathy in White Major – Absolution II* (2006); see p. 210). Now, in the latest phase of his work, he is harnessing craft of the highest technical standard: gem-cutting as can only be done today, with precision tools and the nano-calculations of the cyber-age.

Some of the votive offerings of the past were highly wrought: their efficacy was bound up with the intricacy and technical complexity of the artefact. Alfred Gell, in *Art and Agency*, took the prows of Papuan war canoes as his prime example of magical prophylaxis: the brain-teasing involutions of the carving were intended to bamboozle hostile forces. He showed that similar desires are in play when contemporary artists make objects as instruments that exert some kind of power over their surroundings, either to make things happen (to assure health, fertility, luck in love, wealth, to cleanse a pollution), or to stop things happening (to prevent death, destroy enemies, ward off nightmares, forestall revenge). Rather than inquiring into phenomena by representing them, as Monet magnificently struggled to do with the *Nymphéas* series or the façade of Rouen cathedral in different light and weather, Surrealist artists and their kin – conceptualists, performers, language artists – began using mimesis according to the principles of magical thinking, as a talisman: you reproduce the horror to avert it. Hirst's anatomies are closer to relics than to Rembrandt still lifes. His glittering medicine cabinets, now exhibiting dazzling zirconia crystals as well as pills, are tabernacles as lustrous as Counter-Reformation propaganda for the Eucharist. Even the spot paintings, which have a look of pretty minimalism (and have been much copied by packaging and in fashion), reveal an allegorical purpose through titles such as *The Four Seasons* (2010), while the reiteration, multiplicity and essential meaninglessness of the spots relate them to the processes of charms and spells – often nonsensical, always repeated.

The Japanese artist Yayoi Kusama, to whom Hirst is greatly indebted – as he acknowledges and she likes to recall – has painted spots obsessively since the 1960s, and in her work they convey her own mental disturbance, a hallucination of 'infinity nets' spreading over the universe. The titles of Hirst's *Pharmaceutical* sub-series of spot paintings invoke various chemical substances, poisons as well as others; this strains, at least to

my ears and eyes, for the kind of higher meaning that Kusama achieves gracefully and poignantly. There's a space of mystery in her art: we can't know what she is experiencing, only glimpse at it.

By contrast, Hirst's desire to speak in symbolic images ultimately outruns his imaginative energy. His paradoxical effort to be in control of his own human fears and instincts, his mortality, his fortune, leaches the enigma and vitality from his work. A stuffed white dove hovering in a vitrine, *The Incomplete Truth* (2006), remains at a level of literalism that leaves no breathing space for the viewer. When Paul Ricoeur was thinking about the working of metaphor in *The Symbolism of Evil*, he pointed to the necessary enigma of the thoughtful symbol: it 'does not conceal any hidden teaching that only needs to be unmasked for the images in which it is clothed to become useless'.[5] He suggests that symbols should be thought of as a gift to reflection, 'an occasion for thought, something to think about'. The door must not slam on reverie.

The word 'symbol' has unexpected but revealing origins, as Trías has also written about most illuminatingly. It is derived from the Greek verb *ballein*, 'to throw', as in the geometrical figure of the hyperbola for a cone that's extended far from its base: thrown wide and far, as it were, as in 'hyberbole'. It persists in *diabolus*, Latin for 'devil', where it evokes the devilish work of throwing everything apart and athwart, scattering into disorder and cacophony. *Sym-bol*on means 'that which is thrown together', and it was first used to describe a tally, a coin, token or stick cut in half to solemnize an agreement which would be concluded when the two parts were joined together again. 'The fragment in one's possession,' Trías writes, 'may be thought of as the "symbolizing" component of the symbol.' The other fragment is needed to complete the meaning: 'The drama (of their conjunction) leads towards the final scene of reunion and reconciliation, in which both parts are "pitched" into their desired coming together.'[6] This site of conjunction is key to the effect of a work of art in the symbolic mode; what happens there gives the artefact a quality of presence, makes it radiate significance, sometimes quite softly but still irresistibly and ultimately ungraspably. Then you want to go on looking and looking again.

What is the halo of art that radiates beyond the viewer's ability to comprehend it? How can this happen? Ricoeur keeps to philosophy and

language, but he identifies a crucial difficulty: the transition between the subjective thinker and the community in which the thought is formed, along with its wider historical continuum. He emphasizes the dynamics of this mutual exchange and reminds us that Plato's 'know thyself' is not enough if one is simply gazing at oneself in the mirror: such knowledge can be gained only in the complexity of social interaction.

There are too many equations in Hirst's art, too many comprehensible metaphors with no outer rings of mystery and resonance; he doesn't voyage into those spaces of thought between the outer code and the referent. There is nothing compelling you to look at his works for long, not only because of the way they're made (with the exception of that jeweller's masterpiece, the diamond-encrusted skull, bling-bling though it is), but also because as he's grown older and richer, the glee with which he mocks death has needed a stronger fix to feel real. His limitations as an artist are bound up with the transparency – you could say the obviousness – of his symbolism.

Votive offerings, spells as artefacts, used to be very costly: it adds potency if you're prepared to invest in the embodied prayer, the wish wrought into a thing. Metaphysical symbols of value gain efficacy from vehicles of value: crushed lapis lazuli, or Mary's blue, 'the sapphire that turns all of heaven sapphire', was the most expensive pigment in the world after gold. I remember visiting the cathedral in Zaragoza: the sacristan swung open the huge heavy doors of the treasury, where gifts to Nuestra Señora del Pilar, Our Lady of the Pillar, were kept. A blaze of diamonds burst from the dark cupboard: emeralds, rubies, gold, crystal, every precious gem and mineral cut and polished and set into adornments for her statue. The kings of Spain and then General Franco were leading donors (it strikes me that the Church could part with some of this bullion to help the country – and, indeed, others). The Virgin was being supplicated: these artefacts were the most valuable things that could be wrought to propitiate the just vengeance of heaven.

Hirst's notorious skull is called *For the Love of God* (2007), after a remark of his Irish mother, he tells us: 'For the love of god, whatever will you think of next?'[7] It's a knowing imitation of the *calaveras* of the Mexican Day of the Dead, though they're often made of sugar. The diamonds shoot light

wonderfully, sparkling with the colours of the spectrum. Yayoi Kusama's show at Tate Modern, which overlapped with Hirst's for a while,[8] climaxed in a hall of mirrors lit by tiny spheres that moved through the spectrum in a random sequence, reflected *ad infinitum* as in a fairy planetarium. It's called *Infinity Mirrored Room – Filled with the Brilliance of Life* and she first made it in 1965. The colours were the same as those from Hirst's diamonds – it was comforting for the visitor that only one guard was needed at the door.

Hirst's iridescent skull is missing a tooth, though the rest of its former occupant's gnashers have been polished for their eternal prestigious preservation in the multi-million pound platinum gums and jawbone. Talking about his diamond-encrusted skull, Hirst explains: 'I just want to celebrate life by saying to hell with death.'[9] One of the earliest pieces in the Tate exhibition shows Damien as a sixteen-year-old urchin, snaggle-toothed and grinning, beside a cadaver's head in the Leeds University anatomy department. The missing tooth makes the diamond-encrusted skull a living thing; it brings back the Yorick in the artefact; it turns it into a self-portrait.

FELICITY POWELL

Marks of Shame, Signs of Grace

Hot Air (obverse)
2009

Medals are usually given as accolades – for military heroism, for public service, for achievements in various spheres. Medallic art is ancient, traditional and official, often an uncontroversial and unremarkable form of expression. But the artist and curator Felicity Powell, who died aged 53 of cancer, made the art of the medal her special sphere of interest and expertise, and uncovered a startling strand in its history: a tradition of defamatory statements in this form, attacking the iniquities of tyrants and murderers, scrooges and leeches, cast to issue lasting shame on their subjects.

In the 1930s the sculptor David Smith struck a famous series called *Medals of Dishonour*, which he awarded to corrupt officials and warmongers. In 2009, taking a cue from Smith, Felicity Powell asked several contemporary artists whose work she admired to take part in a similar project.[1] The small missiles that resulted target abuses of the times: Steve Bell remembered the invasion of Iraq, Michael Landy struck an *Asbo Medal* and Grayson Perry singled out, with a medal *For Faith in Shopping*, the consumerist age. The Chapman Brothers, Mona Hatoum, Cornelia Parker and others also rose gleefully to the occasion. Powell herself responded to a Dutch medal made to denounce Louis XIV, in order to mount an attack on government attitudes to climate change. Her medal is called *Hot Air* (see opposite page and p. 222). The obverse shows a Medusa head with a serpent's forked tongue, while on the reverse a powerful pair of buttocks rises out of the ocean and explodes in a blast of carbon emissions; round the rim she wound a tape measure embroidered with politicians' lies about climate change. Under her inspiring direction, an ancient Renaissance practice had regained fresh and surprising vigour. Andrew Graham-Dixon singled out the exhibition for 'bringing a dead language suddenly and startlingly back to life'.

The medals of dishonour are iconoclastic in spirit, inverting the usual blandishments of the typical insignia, and they assume the power of an image to shame as well as praise. They are *damnationes memoriae*, in the phrase used by Reformers when they obliterated the faces of idols and idolaters. Powell's initiative did not go unnoticed, and it led to some difficulty in Russia: when the show was being installed, viewers saw a resemblance to Putin in the profile heads on the medals she had

made (although they are based on her own features) and demanded that the quotations on the tape measure be cut to remove all references to the Russian President. Once she had survived the diplomatic furore, the artist could laugh at the memory, but it was very tricky at the time – the show was nearly cancelled.

Felicity Powell was born in Woolwich in London in 1961; her father was an engineer who had been in the Royal Air Force in the war; she went to Falmouth College of Art in 1983 and then to the Royal Academy to study sculpture; in 1986 she won a Gulbenkian scholarship to the British School at Rome. There she met the painter Ansel Krut, who had completed his MA at the Royal College of Art. They stayed on in Rome for three more years and married in 1996. It was when her students at Falmouth College of Art were working towards the annual medallic art competition run by the British Museum that Felicity discovered her own affinity with this complex, multi-layered form.

From lost wax casting to glasswork, drawing and film-making, her technical skills were many, and she used them to adapt Renaissance symbols and narratives and fashion them into new emblems. In 1999, for example, her design for a silver medal was chosen by the British Art Medal Association to commemorate the millennium. Breathtakingly beautiful in its simplicity, it showed the fluffy globe of a dandelion 'clock'

Hot Air (reverse), 2009

on the obverse; on the reverse, tiny spores floating, poised on the rim. Mark Jones, one of the judges, commented, 'How elegantly it evoked the passage of time.... Blown away in an instant: a reminder that a millennium is of as much account in the infinity of time as the passing of a second to a child on a summer's day. Yet at the same time it seemed to speak of continuing hope for the future as the seeds of this, the most resilient of plants, trodden under foot yet

golden-flowered, common piss-in-the-bed and noble lion's tooth, would take root in the new millennium and flourish there.'

Three years later, Jones, who was director of the Victoria and Albert Museum in London, invited Powell to create an installation in the famous cast court. The result was *Drawn from the Well*, covering the courtyard's ancient wellheads with mirrors on which appeared her delicate drawings of tears and ripples, also symbols of transience. All her artefacts convey a mood of absorptive intimacy – authoritative yet often tender, qualities caught in her video *Sleight of Hand* (2011), which shows the artist at work modelling wax on a miniature scale. The images of metamorphosing creatures that she often created are born of close natural observation, but are fantastical in effect: zooplankton, seedpods, seaweeds and snakes, mosses and corals, pomegranates and crustaceans which keep about them a feeling of unease, of concealed forces.

In collaboration with Ansel Krut and the environmental artist and activist Lauren Bon, Powell worked at the Farmlab centre in Los Angeles on a multimedia inquiry into the ambiguities of Arcadia; at the time of her death, she was engaged in a vast installation of a tree, to be hung upside down in a silo in the desert in California – a protest and a memorial to the drying up of water sources.

II

In 2011, Felicity Powell became interested in a vast collection – 1400 items – of lucky charms, amulets and folk remedies found mostly in London by Edward Lovett, a civil servant, in the early part of the 20th century. In the resulting exhibition, 'Charmed Life: The Solace of Objects', she displayed these magic helpers – keys, shoes, a stuffed mole, horseshoes – in a great sweeping procession, like one of Escher's metamorphic fugues.[2] They communicated powerfully the beliefs and hopes of vanished men and women, especially in relation to sickness and death. One of her favourite items from the collection was a disc inscribed with the Lord's Prayer written out in a circular pattern; she copied it exactly and laid it over CAT and MRI scans of her body, for a film called *Scanning* (2011). She found that, although she was not a believer in higher powers of any kind, the repetitive act of copying calmed her and strengthened

her during her treatments. The music on the soundtrack comes from the recording the composer William Basinski was making when the attack on the World Trade Center began, and which he continued to make as he watched the fall of the towers from his apartment in Brooklyn. Called *Disintegrating Tapes*, it records an old magnetic tape literally falling to pieces during the attempt to copy it. In Powell's film, she pursues her own steady, mantra-like act of imitation to the sound, correspondingly transforming destruction into art.

Felicity Powell was an elegant, thoughtful, fascinating presence in any gathering, and she liked to stand tall – once, when I met her at an opening, she was glorying in new six-inch platform heels. Though she was unassuming about her own status, she had decided views on that of others. She was fiercely witty and had a vivacious sense of pleasure and mischief, an unusual and poetic imagination and great curiosity about lesser-known corners of mythology and art. No believer in providence or in an external scheme of salvation, she did invest something like belief in the act of making art, and she made it with rare subtlety, insight and meticulous skill.

FRANS MASEREEL

Naked in The City

The City
1925

Be good, oh my sorrow, try and stay more still [...]

While the vile mortal multitude,
under the lash of pleasure, that merciless gaoler,
goes gathering remorse in the menial feast,
my sorrow, give me your hand; come this way,

Far from them. See [...]

The dying sun fall asleep beneath an arch,
and, like a long winding-sheet trailing to the Orient,
hear, my dear, hear the sweet night's tread.[1]

CHARLES BAUDELAIRE, 'RECUILLEMENT'

I

Two sharp chevrons over the brow, a vertical furrow between the eyes and four deep grooves rising from the corner of the sceptical lips to the hollow of the artist's cheek create a portrait of a stern observer, who could look at anything but minded what he saw. The economy of means – the very few cuts in the wood Frans Masereel made for this portrait – is characteristic of the artist's graphic authority; more profoundly personal, however, is the angle from which the artist views himself. Unlike the mirror images of Rembrandt or Van Gogh, Masereel does not hold his own gaze; his eyes travel beyond his reflection; he's looking outwards, through round gold-rimmed spectacles, at something beyond his own image. I cannot think of another self-portrait that presents its maker so uncompromisingly as a witness, rather than a protagonist.

The artist himself is protagonist of *The Idea* (1920; see p. 233), one of his marvellous series of novels in pictures: *The Passion of Man* (1918), *A Passionate Journey* (1919), *The Sun* (1919), *A Story Without Words* (1920) and *The City* (1925). In its wordless pages, Masereel takes over the traditional image of Naked Truth and introduces her to the world after the First World War, to mobsters and bosses, scholars and thugs, editors, nightclub touts and sex workers. He was a friend of Georg Grosz, as can be felt in both artists' work; but he was determined to see the good of

the modern, too, to inventory the possibilities held out by the discoveries of the age. His tiny nude heroine is spurned, burned, violated; but she resists and multiplies, reproduced again and again, circulating through society from friend to adversary, from scoffer to believer. Masereel shows her diving into the printing press of a newspaper, flying down telegraph wires, issuing from a speaker's mouth.

At the conclusion, however, he strikes a note of bitter melancholy, when another Idea – a blonde – replaces the first. Masereel foresaw the rise of right-wing racism in Europe, and his silent book is a rallying cry, calling out for a stand against bigotry and brutality.

He reinvented the picture book genre in response to the woodcut tradition of 15th-century Germany and the Lowlands, and his interest in universal themes and humanity's fate reflects the content of such popular medieval printed books as the *Biblia Pauperum* (the Bible of the Poor) and the macabre, German tradition of the Dance of Death. His are secular chapbooks, instruments of their maker's human ideology, the true successors of the colporteur's travelling library.

Masereel's wordless novels, in which he cast himself as an Everyman out to experience the world, its pleasure and its pain, its ideals and its crimes, culminated in *The City*, which narrates a day – and a night – in the life of the city in a series of 100 woodcuts. The disappearance of the single protagonist, and her replacement by the multitude of individuals who make up the city, might at first seem to weaken this volume's emotive power; but at a second glance, the work gains in depth as an extraordinary testimony to the conditions of modern urban existence, to a city's energy, splendours and misery.

Masereel's city is Paris: he lived on the Butte de Montmartre; but he had come there via Berlin from Ghent, and the excitements and horrors of the German capital in the 1920s also inform the witness he bears in *The City*. Since the 19th century, it had been Paris that epitomized the special character of modern life, the frenzy of urban existence, the new tumultuous conglomeration of the masses. In the writings of Baudelaire, Balzac, Zola – to name only a few – Paris is the city where the streets teem with new classes of rich and poor, where the boulevards and avenues are adapted to mass parades and riots, where luxury and shoddy goods

alike invite getting and spending; it is the city where everything happens, where nothing cannot be encompassed, where there's no good nor evil that cannot be discovered – and bought.

The year before *The City*, Masereel made a magnificent independent woodcut, titled *Spleen* after the poem by Baudelaire. It features a huddled man, his face sunk in his hands, set against a cluster of thrusting buildings; he returned to the poet's work later, in 1946–47, with an illustrated *Fleurs du Mal*. To seize the images of *The City*, Masereel wandered the streets, a Baudelairean flâneur. The opposing emotions he communicates to us, of fascination on the one hand and anguish – horror – on the other, translate the poet's own conflict into pictures. Detaching himself to observe the scene, yet knowing himself to be one of the crowd, Masereel conveys Baudelairean spleen – but it is only one of the many feelings he expresses. The images of squalor, prostitution, sex, murder, summary justice, drink and brawling are recognizable from the melancholic and sometimes lurid accounts of journalists like the Goncourt Brothers, as well as from the yellow press. Masereel also brings to *The City* the observations of someone who had survived the First World War as a youth, and been involved with the most important developments in political thought of the century.

His city may be Paris in its particulars – the cobbles, the street-lamps, the cafes, the billboards – but it is also the universal city, where 'Man is a wolf to man', as he once said in an interview, continuing, 'he creates wealth on the one hand, on the other wretchedness, despair; hatred'. In several woodcuts, Masereel's wordless novel dramatizes the conditions of labour, the press of the crowds at the factory door, in the traffic-choked streets and on the construction site. In a recurring gesture, a workman raises his hand to his eyes out of weariness and a need to blot out the sight of the densely stacked city around him. The type of crowd that Elias Canetti describes in *Crowds and Power* (1960) as 'the increase pack' has taken occupation of Masereel's emblematic *polis*: he shows swarming masses in the stock exchange, the bank, the shops, the travel agency, outside the cinema at closing time, marching, rallying, queueing, hustling. Some are intent on their own increase, others are being used for the increase of others; everywhere, the multitude is multiple. Masereel's arresting sense

of formal repetition – in the checkerboard of buildings and windows, the perpendiculars of roofs, railway tracks, chimney stacks – intensifies the feeling that the crowding continues beyond the borders of the image. By contrast, his solitary figures – alter egos – often appear doomed: cut off from the teeming mass of the increase pack, they sometimes seem to be withering and dwindling before our eyes, in illness, in weariness, in jail, in the lap of a client, at the end of a noose, on the run howling in the street at night. In this city, only a few activities are pursued separately, without grief: Masereel shows us scholars at work, cats at play and, in the most lyrical of all the woodcuts in this book, lovers transported far above the glittering skyline in a halo of light. He is love's advocate, but he never denies loveless eroticism's strength. Censure isn't his style, but rather a Whitmanesque capacity for general sympathy. No graphic artist has captured the contemporary city-dweller's ambivalence so intensely.

Although Frans Masereel was making woodcuts at a particular historical moment, the city he conjures before us is almost more recognizable today, in the capitals of the West, where children go missing and the homeless wander the streets; where governments reward the wealthy for their wealth and punish the poor for their poverty – but where, uniquely, ideas and imagination, struggle and contest can bear results.

<div align="center">II</div>

Frans Masereel was born Belgian, in 1889, in the small resort town of Blankenberge, the son of a bourgeois, musical family in the Flemish heartland of the country. He spoke French with his family, but also knew Flemish, then the language of the working classes. He was attending the Académie des Beaux Arts in Ghent when he met the Belgian satirical artist Jules de Bruycker, who introduced him to the potential of engraving and pen-and-ink drawing and advised him to leave provincial Belgium for Paris.

Masereel was, however, back in Ghent when the Germans invaded; his first-hand experience of war began his metamorphosis into one of the century's strongest voices of indignation. His use of the printed image to evoke the reality of war places him in a line of descent from Jacques Callot and Goya; both during and after the 1914–18 war, he made scores of images in protest. In *The City*, the maimed figure on the wheeled trolley

in the tenement courtyard, singing for his bread, recalls the horrors of the trenches. The military parade, the funeral oration, the sycophantic acclamation of the leader in the parliamentary scene all strike ominous notes, foreshadowing the events of the next decades. After the Second World War, Masereel produced yet more ferocious prints of atrocities, with the title *Remember* (1946).

René Arcos, whom the young artist met and worked with in Geneva in 1916, when he joined the International Red Cross and collaborated on the pacifist and socialist news-sheet *La Feuille*, later wrote to Masereel in Paris, 'Dear old brigand...what's going to happen? I've no idea... I've the impression we are living in an atmosphere of catastrophe. The bloodthirsty old states are going to expire, and it'll be a dirty business. It's only a question of time, I believe, a few months perhaps. We were born, you see, too soon or too late. We can smell bombs, even in our beds. Bah! He who carries order within himself has no fear of chaos. Come what may, we are ready. We'll be among the last laughers, won't we?... Keep working, my great zealot, there's nothing else that's real.'

Although the touches of drama in Arcos's letter may show that he had his eye on posterity while penning it, he does also reveal the climate in which Masereel was cutting his images: post-apocalyptic, a vision of continuing, bitter exploitation. Yet Masereel denied that he was a pessimist; he believed that his kind of art had a purpose. In 1924, he wrote to his close friend, the writer Romain Rolland, another of the Geneva group of militant pacificists, about meeting George Grosz in Paris: 'He is the only artist with whom I have found much in common, so far. With him, I can speak about my profession. Here the painters only talk about colours, technique, form; he also speaks of "the spirit" [and] believes that art must as far as possible be action, and that the artist must not be indifferent to social questions.'[2] In 1924, Eva Grosz, the painter's wife, wrote to Masereel congratulating him, 'We all love your work very much here.... During the Hamburg revolt interested workers make original wood-cuts after your model for their revolutionary newspapers. This is a far better result, I think, than all the possible aesthetic panegyrics in art magazines and such, because from your own standpoint, your works aren't meant as adornments for aesthetic snobs and art collectors.'

Like those airborne lovers, Masereel's vision flies free, however, from its political purposes. As many commentators on his work have said, this artist's dominating quality is goodness, possibly the rarest quality of all. Thomas Mann, in his introduction to *A Passionate Journey*, wrote that 'the human heart' was Masereel's guiding star, not his revolutionary principles, and declared, 'Here we are in the presence of a good companion – a kind, sincere, naive fellow who lives life to the full and, if he criticizes it for its distortions, does so not out of bitter disillusionment but with natural, unaffected feeling.'[3] If Mann sounds a bit patronizing, he was right in his judgment of Masereel's humanity. Hermann Hesse was also commissioned to write an introduction by a far-sighted German publisher, Kurt Wolff, in Munich. Hesse paid further tribute to Masereel: 'He is not a bearer of a dogmatic manifesto, but simply a man, lover, a sufferer, a comrade and a consoler'.[4] Like a hermit saint of the middle ages, whom kings and nobles would invite to their sumptuous courts to redeem them, Masereel's view of flawed humanity elicits idealism in his audience; it's a paradoxical but immensely powerful effect of his realism that it provokes such near-metaphysical yearnings. Josef Herman, in an admiring and affectionate essay about his fellow artist and engraver, observed that 'through all the "novels" runs a philosophic belief that the most humane passions are of those who transcend the tragic bleakness of living – and Masereel's heroes usually do. This is not to imply that his optimism is flippant or unlimited. Masereel had enough experience of life and a great enough heart not to believe in easy solutions....'[5] But he did possess a kind of hope, which we clutch at as his pages unfold: he opens *The City* with a solitary witness's back to us, as he overlooks the infernal city (see p. 225), but he closes it with another watcher at a window with her face turned to us, illuminated by the light in the night sky, as she gazes up at the stars.

It may seem wishful, a desire to turn black into white, night into day, but Frans Masereel managed to make a virtue of darkness. In a literal fashion, as a woodcut engraver, he boxed himself into the narrow range of contrasts, eliminating half-tones, hatching and other subtleties and gradations available to the metal engraver and arriving at extraordinary eloquence and riches of tone in spite of such thrift. His blanks, the ground

where the white or cream of the paper gleams, dazzle like water catching the light, or sunbeams, halos or a lamp's ring of illumination. His emptinesses call to our imaginations with powerful coherence: we fill in the black and white spaces with volume and depth and texture and warmth without trouble.[6] Of course, his blacks are by no means always shadows; unlike a photograph, the Masereel woodcut can reverse the interplay of light and shade at will to produce emphasis and background, figure and context, focus and ellipsis. The cat who steals down the stairs isn't necessarily a white cat, but a gleaming prowler, the focus of our interest; the beloved who materializes in the garret to hold the sufferer in her large embrace is luminous because she represents shining hope, like the naked figure of the Idea in Masereel's earlier novel without words (see opposite page). Blackness has rarely welled with such promise of peace and consolation as in some of his woodcuts. For Masereel, black and white is as expressive as colour, in a different way. He uses the light and the dark as German and Russian filmmakers did, intent on producing meaning, not recording the appearance of things. He was nocturnal, not because he was drawn to the shadows but because the night could also be *douce*, benign, as in Baudelaire's *Recuillement* (Meditation). Night, personified as a goddess of fruitfulness, a dark angel bringing stars down to earth, appears in several woodcuts throughout his career.

Although *The City* bears a certain resemblance, especially in its liking of the bird's eye view, to René Clair's great film *Paris Qui Dort* (1923), Masereel's work has more in common with the approach and the sensibility of such tours-de-force of the early cinema as *The New Babylon*, a drama about the Paris commune made by the team of Grigor Kozintsev and Leonid Traubert in Russia in 1929, and with Hans Richter's *Everyday* of the same year, in which the camera follows the daily toil of a clerk through urban pandemonium from bed to street, from office to bar and back to bed again, against a background sound of stock market reports. Masereel recognized his kinship with the medium, and collaborated with Berthold Bartosch on a flawed but inspiring animated version of *The Idea* (1932). He also planned to make a film with Abel Gance about the life of Jesus Christ, to be called *La Divine Tragédie*, but unfortunately the project never came about.

The Idea, 1920

Though Masereel was brought up a Catholic, he grew up agnostic, saying to an interviewer, 'I believe in all gods. I believe in you, for example; I believe in the little flower that I find on my way. I believe in a great many things, but not in the god we are taught about in the catechism.... No, that doesn't interest me at all.' Nevertheless, his essential honesty and goodness made him a beacon for religious followers, and towards the end of his life, the Catholic worker priest Father Scholl used Masereel's woodcuts to illustrate the movement's pamphlets.

Masereel was remarkably prolific. During the same period as *The City*, he produced 666 woodcuts for the novel *Jean Christophe* by Romain Rolland; afterwards, he returned to a cottage he had bought in the village of Equihen, by the sea near Boulogne-sur-Mer, and concentrated on painting in watercolour and oil.

His studies of quayside and beach scenes, of bar interiors and fishing boats, have something of the same flavour as Edward Burra's work of this time. His political concerns did not diminish, and in the late 1930s he travelled twice to Russia, for months at a time, and to the Republicans in

Spain. He even became popular in China and visited his public there in 1958. His bibliography is huge: he worked with undiminished energy until his death in 1972. Yet he was never printed in England, not until Julian Rothenstein at Redstone Press began publishing his wordless novels in 1986. It seems an astonishing omission, but it's a testament to the power of Masereel's art that the sixty-year lapse of time has not blunted the acuteness of his vision; that we still know his City, for good or ill, very well. Just recently, reading Peter Handke's novella of 1979, *The Long Way Around*, I came across reflections on urban existence that read as mere verbal echoes of Masereel: 'For a moment he saw the uniform window patterns of whole complexes of high-rise buildings as congealed expectation machines which had been let into those barren walls for this sole purpose and not to admit light or air. Unusually for him in his half sleep he had before him no uninhabited landscapes but instead very close to him, many passing faces, sorrowful and not at all plebeian. Not a single one of them was known to him, but taken together they formed a living multitude, to which he belonged.'[7]

Masereel's city is a living multitude, to which we all belong.

CRISTINA IGLESIAS

Where Three Waters Meet

Tres Aguas at the Torre del Agua
2014

> Beneath one water there is always another water.[1]
>
> RONI HORN

I

Toledo is a citadel on a high outcrop, curled in on itself within historic walls punctuated by watchtowers and, snaking up and over the crags that El Greco painted, the complex machinery that once lifted water from the river up the rock face to the city and its inhabitants.[2] Cristina Iglesias's monumental work, called *Tres Aguas* (2014), includes the Torre del Agua, the water tower, as one of its three sites, which together reflect on the long history of the hilltop city's vital relationship with its encircling river, the Tagus.[3] The bridges, mills, bathing places and laundries – ancient structures that connected the town with its water source – give few signs of use or frequentation today, even where they have been sensitively restored. For a long time, the city kept its back turned to the river: mosquitoes, waste and other ills had made it noisome. But Iglesias wanted to alter this response, and she has restored the town's living link with its centuries-old lifeline.

The threefold character of *Tres Aguas* also sets out to remember the period of La Convivencia, when different creeds, cultures, forms of worship and aesthetic values co-existed and Toledo was the capital of Spain, first under Muslim rulers and, after the town passed into Spanish hands in 1085, under Christian rulers who accepted – encouraged – the mix of peoples and faiths, languages and skills. In 1492, Los Reyes Catolicos, as the Castilian monarchs Ferdinand and Isabella came to be known, took the calamitous step of expelling the Jews and the 'Moors' or demanding their conversion; they also moved the capital to Madrid, where, incidentally, the water supply proved much less steady and abundant. Historians differ over the degree of harmony and the multi-cultural success of al-Andaluz, which at its largest stretched from Granada and Malaga in the south to Zaragoza in the north. But it was certainly the case that tolerance was enshrined by law and by custom, and that the later Catholic rulers overturned this tradition and promoted a philosophy of intolerance grounded in ethnic division. Their repression announced many of the most terrifying features of the modern era.[4]

In different parts of the city, *Tres Aguas* performs quiet and powerful variations on Convivencia, protesting against the way history has forgotten that time. The trio of works is linked by the common flow of the river underneath, but each site's installation sets a different mood and stirs different meanings. Each of them enters deeply into the metaphor of water as life force, as biologically necessary as blood and breath, and issues an invitation to remember where we come from and how we survive.

To reach the water tower at the former Arms Factory of Toledo, Iglesias has mapped a way around the walls of the city, above the ravine where the Tagus flows. Down the slope past the medieval gate, the ground soon turns to scrub, here and there blooming with oleander, acanthus and citrus, mostly parched and neglected. The river unfurls far below; greeny-brown and opaque, it looks lethargic, even viscous, until it pours itself out over the transverse ridges of the weirs, where the speed and energy of the current rushes the water sheer over the stone into a roiling, dirty froth. The path the artist has identified keeps circling the city, giving views of its walls and buildings, dramatically perched above on its rocky pinnacle. As the way leads deeper into the city's edgelands and passes underneath the main bridge across the river (painted by hopeful graffiti artists and scattered with rubbish), the mood darkens; it then skirts a large cemetery and, in the last stretch before reaching its destination, runs close by a tall water mill. Though the building is no longer in use, the Tagus still swells the millrace that gushes through its rusted girders and brick foundations.

The river once powered the arms factory where the water tower stands. Toledo steel, tempered in its waters, was famous for qualities that gave the weaponry of the Spanish empire a deadly reputation: the dagger, the rapier and the poignard. Mercutio describes how Queen Mab can make a sleeper dream 'of cutting foreign throats,/Of breaches, ambuscadoes, Spanish blades...' (*Romeo and Juliet* 1.4.84–85). Spanish armourers learned their skills from the Arabs, and continued the tradition of fantastic, ornamental metalwork on swords and body armour, pistols, scabbards and cannon. The effect is called 'damascened' because, as with damask cloth, it originated in Damascus. But it was the legendary properties of Toledo's waters that gave Spanish steel its high reputation.

This royal ordnance factory once occupied whole streets of harmonious stone and brick buildings, with clear, classically proportioned windows, arranged in an orderly chequerboard pattern of leafy allées. At the edge of this historic ground, on the side closest to the river, Cristina Iglesias picked out an abandoned brick tower for the site of the most architectural of her sculptural installations (see p. 235).

External stairs, reconstructed for Iglesias's work, take the visitor to the top; there, in huge steel tanks on the roof, water from the Tagus was stored to be released, to rush downwards into the channels below in the factory with the force necessary for tempering steel. They now stand empty, while far below – twelve metres down – at the bottom of the building, the entire floor and footings of the tower open onto a cistern, where a dark pool gathers at a slow and steady pace. The water's flow is barely visible or audible, yet the waterline gently rises, as in a tide pool, running into the cracks and fissures and welling in the dips and hollows of Iglesias's cast basin, gradually forming a surface dark as an iris, in which the building stands reflected, upside down. Light is filtered through several translucent alabaster windows installed by the artist, softly illuminating the depths of the basin wherein lies an irregular, moonscape-like mass of vegetation. The steady ebb and flow of the Tagus, filling and draining slowly in a constant cycle, establishes a quiet music; the pool floods and empties to a gentle rhythm, like the sea's long tidal intake and exhalation of breath in a serene summer, as it is tugged and let go by the moon. Now and then, the water prinks or gives a small, animal cry; but on the whole, the pulsing life of the pool is subtle and calls for the viewer's full attention in order to experience its cyclical transformations.

A second staircase, conceived by the artist to mirror the one outside, leads down inside the tower to ground level and to the edge of the basin, which is framed by an openwork grid on which the visitor can walk to watch the pool. It has the dark and almost dangerous mysteriousness of a water-hole in a thick forest, that a wanderer might come upon unexpectedly. By bringing such a supply of water into an interior space and enclosing it in the four tall walls of a kind of watchtower, Iglesias has deepened the quiet authority of the water's presence and performed a

variation on ancient methods of preserving and managing the supply: it is a cistern, a well, a reservoir – and a fountain. The artist has rung changes on the tradition of fountains before; artefacts of superlative metallurgy-cum-architecture, they appeal to her ecological, sculptural vision.

The play of water in Renaissance gardens was brilliantly contrived, an example of human playfulness harnessing scientific ingenuity: *homo ludens*, in the historian Johan Huizinga's telling phrase, spurring on *homo sapiens*.[5] At the Villa Lante in Bagnaia, Italy, the water gardens were secretly automated so that a visiting pope or prelate would be suddenly splashed by a frolicsome Nereid or Triton as he strolled by. The spectacular effects at the palace of St Germain-en-Laye, near Paris, inspired René Descartes to compare such fountains to consciousness itself, to the invisible processes by which the mind transmits messages to its bodily host, which the 17th-century philosopher called 'animal spirits': 'As the animal spirits flow, thus, into the cavities of the brain, they pass from there into the pores of its substance, and from these pores into the nerves [...] In the same way, in the grottoes and fountains of the royal gardens, you may have observed that the force with which the water is expelled from its source is alone sufficient to move various machines, and even to make them play instruments or speak a few words, according to the way in which the pipes have been arranged.'[6]

While Iglesias clearly does not indulge in baroque spectacle, her uses of water resonate with the deeper implications of Descartes's analogy. The quiet drama of ebb and flow in *Tres Aguas* evokes the mind-body symbiosis of every living organism, as well as the necessary reciprocity between nature and society, individual and community. The Toledo works – and other fountains and pools made by Iglesias – awaken a city's inhabitants to the natural forces circulating under our feet and the craftsmanship that channels them to us, to sustain us. Her works call to passersby – citizens and visitors – to take note of the ravine beneath the citadel and the water flowing there, Toledo's bloodstream. The fountains move to that 'come and go', as Beckett calls it in one of his short plays, that is the rhythm of life and a promise of eternal recurrence.

The second pool that Iglesias has made for *Tres Aquas* lies quietly in a wing of the convent of Santa Clara, home to members of the Poor

Clares order, inside the city walls. It's enclosed in a cool, dark space, lit only by small apertures in the thick stone walls and separated from the main convent building by screens which the artist constructed from wood, in the tradition of *masharabiyeh*, the lattices of turned wood through which sequestered women in the Middle East used to look out on the world without being seen. These intricate, shuttered embrasures act as architectural equivalents of the veil; they filter vision in much the same way as the perforated visors of a burka. While all three fountains of *Tres Aguas* bring to mind the concealed ebb and flow of the Tagus through the city, this sculpture stands witness to another form of concealment, without exposing its subjects to view. The Poor Clares are an enclosed order, founded by St Francis's beloved friend St Clare, and the few nuns remaining in the cloister in Toledo live behind a screen to maintain their isolation from the world and its pollution. This interior part of *Tres Aguas* has a feeling of intense privacy and serenity; it strikes resonances with water as purificatory, restorative and healing.

Here, as in the water tower, the inside of the basin forms a mysterious relief landscape of small abysses and chasms, peaks and ridges defined and then flooded by the springs and rills which run into them. Composed of amassed, ribbed vegetation cast in metal, this pool is less deeply scooped; the shuttered light inside the convent darkens the surface of the water into a taut mirror and heightens the feeling of tranquility. The effect is not unlike a Japanese Zen garden, a space for solitary recollection and silence.

Interestingly, in Spanish and several other Romance languages, the word for screen, *celosia*, is the same as the word for 'jealousy'; they share a root with the verb for concealment (in French, for example, *jalousie* is both a blind and the passion of jealousy). Does this connection arise because the women behind a screen are being kept from view by fathers and brothers and husbands, who are jealous of their very existence in the eyes of others? Or does the association with jealousy imply blindness, that the woman behind the screen may fall victim to false perceptions, as in the fatal case of Desdemona? Or are both the one who looks in and the one who looks out, unseen by each other, jealous of their own space, their own thoughts?

Confidentiality, even secrecy, becomes the aim, as in the confessional or dark box, where the priest and the sinner only see each other through a pierced screen like a miniature night sky; it heightens the whole aura of the exchange.

The art historian Giuliana Bruno has drawn attention to the memories of Spain and its layered history which are stirred by Iglesias's *celosias*.[7] They record past partitions of power, public and private, male and female, and express 'the relation of outer and inner space at a deep level...and the dimension of time and the flow of memory.'[8] Iglesias has mined the ambiguities of the tradition, drawing out its more tender meanings, so that a screen becomes less a barrier than a conduit through which perception flows like water through a filter, like whispered admissions and prayers in the confessional: 'the screen is a medium that renders porous the relationship between the world and us...emotional partitions to be crossed, affective refuges in which to dwell, mnemonic shelters in which to be enveloped, or even sentimental material from which to shield oneself.'[9] The analogy with consciousness that Descartes found in the fountains of his time could be made again in connection to the *masharabiyeh* and *celosias* in Iglesias's interiors, which recognize the fragmentary and subjective nature of all our perceptions, and guide us towards its pleasures rather than its frustrations. Experiences will always be inflected, framed and contingent, they suggest; the concept of total vision arises from hubris and will only lead to disappointment.

The fountain in the main square of Toledo is the pièce de resistance, the most flamboyant, the boldest, largest and most uncompromising sculptural installation of the *Tres Aguas*. For this authoritative *summa* of the entire project, Iglesias dug into the stone of the main square, the Plaza del Ayuntamiento, and cut a deep furrow right across its width, in front of the Town Hall. The basin looks deceptively simple; the calm, steady coming and going of the flow cools the air in the broad, exposed, public space where visitors and inhabitants stroll and linger; when the pool is full, the long sheet of water dizzily reflects the sky above and, as you walk round it, gives plunging visions of the arcaded classical Town Hall in one direction, while in the other, Toledo's cathedral and its magnificent Gothic spire are reflected deep down, bristling finials and

pinnacles shifting and splintering as the pool fills. This elegant, rectilinear pool has been laid across the centre of the town; it lies at an oblique angle in relation to the trapezoid shape of the plaza, which gives it a dynamic quality. That dynamic character is intrinsic to the vegetal and hydraulic cycles to which the work keeps pulsing. It is not a Euclidian piece of classical proportion, but an opening to the underworld, a cleft in the polite and civilized surface of a great city's main arena. It's an act of supremely confident urban iconoclasm.

In El Transito, one of two surviving synagogues in the Judería, the old Jewish quarter of Toledo, archaeologists have dug a similar shaft to show the earlier, original floor; to bring time up to the surface again.[10] With her heroic surgery on the city's surface, Cristina Iglesias actively reawakens a lost relation to what lies beneath, literally and figuratively.

<div align="center">II</div>

The Tagus surges underneath the paving stones of the plazas and the streets of Toledo: numerous, varied metal covers, some with classical images of the Tagus as a river god pouring water from an urn, mark access to outlets, hydrants and connection points to standpipes and mains water supply. The stone pavements conceal differently shaped mouths where waste water drains back into the system. Iglesias's sculptures concentrate the mind on our fragility and, in Toledo, the citizens' interdependence with the river, as its waters are controlled and raised from far down below. But they also probe historically buried memories. The river flows from the past into the present, and Iglesias taps the current to hear what it has to tell.

Karl Wittfogel's study *Oriental Despotism*, first published in 1957, is a vast and original synthesis by a former Marxist, who takes for his subject not capital but water: the book explores the intertwining of water management and political power in the great empires of the ancient and modern worlds. 'Hydraulic despotism', he argues, characterizes the reigns of the Pharaohs, the Persians and the Chinese dynasties. Wittfogel's theory includes Mao Tse-tung, who succeeded in controlling the perennial flooding of the Yellow River, and anticipates the policies of Gamel Abdel Nasser, who built the high dam at Aswan over the Nile.

Wittfogel singles out the era of Moorish power in Europe for its knowledge and innovations: 'In sharp contrast to the Romans...' he writes, 'the Arab conquerors of Spain were entirely familiar with hydraulic agriculture, and in their new habitat they eagerly employed devices that had been extremely profitable in the countries of their origin.'[11] Dowsers discovered subterranean reserves, concealed very deep below the arid surface; engineers would then drill down to these aquifers and bring their treasure to the surface in wells and cisterns, connected by aqueducts or open channels – this system is called *falaj* in the Arabian Gulf – so that the flow could be held and conserved to be sluiced off onto the fields and orchards when needed.

When *savants* on Napoleon's expedition of 1798 set out to compile the *Description de l'Egypte*, they started with the ruined monuments of the ancient Egyptians, which they hugely admired; but they were also awed by the *noria*, the large water wheels that raised water from the Nile up steep banks to the fields alongside it.[12] The French engineers on the team made meticulously detailed accounts of such achievements of the 'Modern State', as they saw it (the systems went back to antiquity). Prominent among them were waterworks: apart from the wheels, there were pumps, sprinklers, drains, pipes, culverts and other elaborate but efficient devices.[13]

'Moorish Spain,' writes Wittfogel, 'became more than marginally Oriental. It became a genuine hydraulic society [...] A proto-scientific system of irrigation and gardening was supplemented by an extraordinary advance in the typically hydraulic sciences of astronomy and mathematics. Contemporary feudal Europe could boast of no comparable development.'[14] Wittfogel goes on to state that the Reconquista, or the end of the Moorish rule in Spain, 'transformed a great hydraulic civilization into a late feudal society.'

The term 'hydraulic despotism' has a harsh ring, and the tyrants who fill Wittfogel's pages do not conjure the sweets of civilization; he often sounds rather too admiring of such rulers and their *grands travaux*. But the focus on the connections between forms of government, the quest for knowledge and the management of essential resources remains crucial, especially in connection to ecology today. The 'politics of verticality' is Eyal Weizman's powerful term for hydraulic despotism in our time, and

he uses this to analyse the Israeli government's control of underground territory – the sewers as well as the water pipes of the occupied territories.[15]

In Islamic culture, water figures as the symbol of everything that is most precious and life-giving; it is associated with happiness, sexual fulfilment, the joy of children playing.[16] Qur'anic pictures of the afterlife intermingle with the enraptured love scenes of Sufi poetry, evoking fresh water's sustaining and cooling flow. Heaven itself figures as a well-watered enclave – indeed the word 'paradise' comes, via French and ancient Greek, from the Old Persian for a walled garden. The same cluster of images suffuses Biblical metaphors of heaven: the Virgin Mary is prefigured by paradisal metaphors from the Song of Songs, associated with miraculous springs (at Lourdes, for example), while her miraculous body is described as the *hortus conclusus* or enclosed garden. In the Qur'an, the springs in paradise are called Salsabil, Kafoor, Tasnim and, at Mecca, all pilgrims must drink from the miraculous fountain of Zam Zam.[17] In Andalusia, the Arabs built palaces set among gardens with fountains and pools: the Alhambra in Granada, Alcázar in Seville. In Palermo, two of these pleasances, La Zisa and La Cuba, have recently been restored, while at La Favara, now the castle of Maredolce (the name means 'sweet sea'), the Norman kings took over a Moorish fortified summer palace. These pavilions, half shelters, half open-air dwellings, are traces of a practical yet also profoundly aesthetic relation to the heat and dryness of the Mediterranean.

'Any place not feminized should be rejected,' wrote the Sufi thinker Ibn Arabi of al-Andaluz;[18] he was commenting on the interrelationship of ethical and aesthetic ideals, not on women's actual presence, but as the historian Mohammed el-Faïz has noted, it is striking how engaged powerful women in Muslim culture have been with questions of the civil environment.[19] The Caliph Haroun al-Rashid and his most famous favourite, Zubayda, daughter of his vizier Jafar, are historical figures who have passed into legend through *The Arabian Nights* and its numerous film adaptations. But it is not often remembered that Zubayda (d. 831), when she travelled to Mecca around 802, saw the ever-present danger to pilgrims of dying of thirst and determined to bring supplies of fresh water along the route; as a result, she had a huge underground aqueduct built at her own lavish expense, running all the way from Baghdad to

Mecca. [20] In the 13th century, a court historian, Ibn al-Sā'ī, compiled a tribute to the women of the Abbasid court which provides a rare record of the mothers, wives and concubines of the rulers of Baghdad in the city's heyday. He singles out several of them for their good works improving the environment: for example, Banafsha ('Amethyst'), a favourite of the Caliph al-Mustadi, was given a palace on the banks of the Tigris with marvellous water gardens, supplied by an intricate system of water-wheels. But she also had 'a stone bridge built over the 'Īsā Canal and a pontoon bridge fixed across the Tigris', which she opened to the public. Al-Sā'ī quotes a poem he heard circulating about her:

Nothing measures up to the bridge's beauty:
a beauty unparalleled, without compare.
Banafsha has embroidered her name on the Tigris
like *tiraz* on a carpet of azure. [21]

III

The bas-reliefs that line the three pools of Iglesias's sculptures have been cast from an accumulation of organic debris – foliage, branches, twigs, grasses – a heap of vegetation such as gathers after an autumn storm has torn into the trees, with ribs of roots arching above the pile. They give a glimpse of primordial matter, decaying and fermenting and germinating according to the natural life cycle. Primo Levi, imagining the passage of a single atom through different forms and phenomena, evokes a comparable scene of origins in the closing chapter of *The Periodic Table*. The story he tells focuses on the wonder of photosynthesis, the essential process by which an atom of carbon from the air (carbon dioxide) turns into a vine that produces wine, or a cedar of Lebanon where a chrysalis hatches. If carbon is 'the key element of living substance', photosynthesis is 'the narrow door', 'the sole path by which carbon becomes living matter...[and] the sun's energy becomes chemically usable.' [22] Levi ends by declaring, 'If the elaboration of carbon were not a common daily occurrence...whenever the green of a leaf appears, it would by full right deserve to be called a miracle.' [23]

Cristina Iglesias's sculptures fathom the depths of time in an analogous way, by drawing up from the earth its treasure and its vitality and

picturing the process in action in the rotting matter at the bottom of her pools. She allows us to glimpse the deep past of emergence and creation, the stuff of origin.[24] The patina gleams here and there on the encrusted sculptural surfaces of these basins, restlessly various, complex and active as the famous shield of Achilles, the earliest work of cast bronze evoked in detail in literature. An expert botanist might be able to identify the plant species present, but an ordinary viewer is obliged to yield to a vision of bare material life, nameless, beyond or rather before language, before the garden of Eden bloomed with shrubs and flowers that Adam could give a name to. The sculptor concedes no *punctum*-like points of orientation. Each dark coracle is a made thing that hovers on the edge of abstraction, where organic growth has been captured in a form that is near formlessness and near monochrome and near eternity. Iglesias sets in metal the necessary process which returns a single flower to slime, produces wine from squashed grapes, gives birth to a butterfly from the bark of a tree and turns a living plant into featureless, deliquescing, primordial matter. She has gathered together materials as they make this journey and captured the first stuff that, together with water, makes up earthly life. Carbon and water: the primal ingredients.

The encrusted, restless fabric of the reliefs extends Iglesias's absorption in the mingled cultures of the Andalusian past: she has chosen to perform variations on the abstract patterns that Muslim and Jewish artists developed in conformity with the prohibition on figurative human images. The sculptural, textured luxuriance fulfils the aesthetic of plenitude in Moorish art and architecture, which is found, carved in stone and wood and plaster, everywhere in Toledo. Like a current, the twists and curls of arabesque effloresce over walls, arches and doorways, up pillars and around

Capital at Santa Maria la Blanca,
a former synagogue, *c.* 1180

ICONOCLASHES

embrasures and eaves. Vines and racemes scroll and curve and loop over and under one another, flowing together. This currency of art was familiar to the Jewish artists who lavished their imaginations on the adornment of the city: the marvellous Sinagoga di Santa Maria la Blanca (as it is known) has horseshoe-arched colonnades with capitols bursting with arborescent and vegetable forms, not reproduced mimetically as to species but symbolized through swelling shapes and perforated textures (see opposite).

Arboreal imagery also inspired the vernacular of the Moorish artists who built Toledo's Church of San Salvador, a mosque until it became Christian in 1148; the fabric of the building is clothed in this drapery, a sculptured carpet or tapestry. The Christian architects and builders of Toledo patterned the revetment of their churches and palaces in stone tendrils and rills and branches, the language of Mudéjar decoration. The term 'stone blossom', coined by Adrian Stokes in his studies of Italian architecture, also suits the Mudéjar patterns found in Toledo. Stokes was writing against the idea that stone was 'barren', and he related the flowering encrustations erupting from the surface – the restless, dynamic rhythms that he loved – to oriental art and writing.[25]

<div align="center">IV</div>

Stone and metal capture and set in durable form the myriad natural materials – clay, vegetable and insect pigments, oils and fats and glues – which artists have used for their work, subjecting them to chemical or otherwise organic processes of transformation including casting, firing, blending, glazing, setting. Iglesias's casts arrest the natural cycle of material in a state that implies what it was before and what it will become. The basins of *Tres Aguas* have been created by the ancient and complex method of lost wax casting, which involves a sequence of material transformations; the work involves the artist-artificer in a process which corresponds to the natural metamorphoses of the life cycle.

In 1944, Paul Valéry wrote a meditation on creativity called *Eupalinos ou l'architecte*, which takes the form of a dramatic – and often obscure – dialogue between the ghosts of Socrates and Phaedrus in the underworld. Phaedrus tells Socrates about his encounter with the architect Eupalinos, who, as someone who constructs lasting things that take their place in the

world of matter, emerges as the ideal figure of the artist-creator. At one point, Phaedrus describes how this ideal artificer declared:

> It matters to me above all else, to obtain *what is to be*, that it should satisfy, with all the vigour of novelty, the demands of *what has been*.[26]

In other words, in the work of construction that is a work of art, the potential of what is to come must cohere with what it was – the futurity of what is made is there in its vanished past. To illustrate more closely what he means, the architect then describes how he once took a bunch of roses and made a wax cast of them, buried the cast in the sand until the roses had perished, then dissolved the wax by pouring molten bronze into the sand, until 'the dazzling liquor of the bronze came, in the hardened sand, to unite with the hollow identity of the least petal....'[27] The roses are life itself, he goes on to explain; they are moving, changeable, fading and then blooming again in another form, while the wax mould taken from them acts like the artist's faculties, observing and modelling in direct engagement with the flowers. 'These roses which were fresh and which died in front of your eyes, are they not all things, and moving life itself?'[28]

Cristina Iglesias's sculptures ignite a fresh consciousness of the precious, necessary conditions for creating and supporting life, and she has pushed to the very limits the artist's capacity to seize and reproduce them. Whereas Homer describes, on the bronze shield of Achilles, the tumult of exploding passions and war, Iglesias has used the ancient tradition of casting to reproduce an inscrutable and unadorned natural cycle, conceived to elude symmetry or a conventional aesthetic of order and proportion, arranged in such fidelity to organic messiness that its limbs and relations cannot possibly be committed to memory. Her pools look like the bed of a lake, a mangrove swamp or a creek where lies a seemingly waterlogged thatch of branches, sticks, leaves and grasses, breaking down on their way to becoming carbon, being reduced to the bones of themselves – and from that mess of water and matter, in the future that the sculpture foreshadows, this condition will begin to produce oxygenated vitality again – growth, organisms, living things.

JULIE MEHRETU

The Third Space

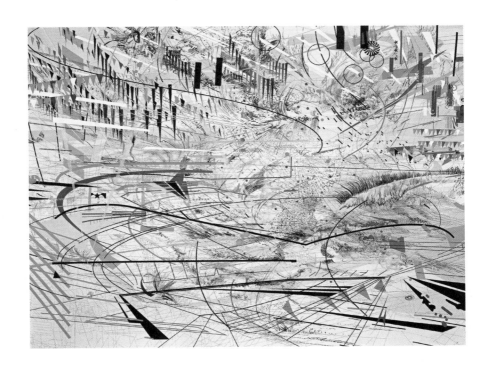

Stadia I
2004

I

Was the Big Bang a song, a dance, a drum solo, a whirling chorus?
Was the alphabet invented by birds high-stepping and wheeling on a
threshing floor, or footing it trippingly on the shore line? Who listened
to the rhythm and understood, and how did they know to read the
marks? Who turned a hand print into a mark which could communicate
a meaning? How did the unintelligible turn into sign?

These are mysteries about the beginning of the world as humans live
in it. I once heard someone ask the Moroccan scholar Abdelfattah Kilito,
'Who invented writing?' He replied, 'Animals. It was animals who taught
us to read.' There was a ripple of embarrassed laughter from the audi-
ence. He went on, 'Because we had to learn how to read the marks they
made.' Tracks on the ground, the flights of birds. Our foraging, hunting,
tracking forebears scrutinized the imprint of a creature's marks in the
earth, a bird's light pronged footfall in the sand, the scrolling slither of a
reptile or an armadillo's trailing tail, the loose skeins of migrating birds,
and these prints and patterns became models for writing: the nib of a
reed into wet clay as in Babylonian cuneiform, and the quill itself, taken
from a bird to inscribe signs that resemble its own tracks. In his ongoing
magnum opus *Science and Civilisation in China*, Joseph Needham points
out how fundamental a part magic played in the pursuit of knowledge:
the earliest known form of script appears on oracle bones, after an augur
touched a heated metal tool to a sheep's shoulder blade and then deci-
phered the cracks to see into the future.

Ancient stories keep puzzling over the origins of writing, and they
invent stories to answer the mystery. An eerie Celtic myth describes how
Aoife, the wife of the God of the Sea, steals the knowledge of written
language from him; it's the fountainhead of his divine power, and so
she is punished for the theft and changed into a crane – a bird whose
footprints are a kind of writing and whose flight used to communicate

portents. The God of the Sea then takes the skin of his wife and makes it into a fishing net, where he keeps all his treasures, including writing – 'and when the sea was full, all the treasures were visible in it, but when the fierce sea ebbed, the crane bag was empty.'[2] At the height of the Troubles in Ireland in the 1970s, a literary magazine took this myth for its title, *The Crane Bag*. Seamus Heaney wrote a foreword for the first issue, a kind of manifesto for literature as a way of participating in society and history through acts of imagination: '…a mind [so] stretched between transcendence and politics produces exactly the kind of fibre from which this trawl-net of the mind is to be rewoven.'[3]

'This trawl net of the mind…' is also a phrase that can be used for acts of visual imagination; and the concept of writing does not only relate to semantic communication, for there are many manifestations of inscription, as Julie Mehretu's art reveals in acts of delineation and picturing beyond language and translation. She mentions 'the need for neologisms in abstraction' and says that she 'is riffing off the idea of visual neologisms in abstraction/figuration/drawing… reinvention/invention from marks known well but can't/haven't been enough.'[4] Over the last three decades, the artist's oeuvre has been characterized by energetic interlacings, arcs and trails, strokes and lines, and volatile, dynamic reticulations in layers that tilt the plane and stir up illusory vortices from the surface of the painting into which we, the viewers, find ourselves plunging, flung into space, our own compass bearings tipped and changed.

Unintelligibility plays with intelligibility in such visual graphism, including the history of oracles, the calligraphic blazons in the Islamic tradition, the experiments of poets and musicians (Stéphane Mallarmé, Hugo Ball, Kurt Schwitters) and the graffiti of city-dwellers as recorded in the art of the Independent Movement in the 1950s, which reappear in the aesthetics of prints and photographs by Eduardo Paolozzi and Nigel Henderson.[5] The metaphor of the trawl-net does not forget that the mind's retrievals and hauls are only ever partial: every fishing community knots specific nets for certain catches, with meshes at different intervals, with twine of different thickness and gauges. All nets have holes and every attempt at capture is accompanied by loss, just as language proliferates but never suffices to cover all of experience. Something will always elude

capture. This is where art and artists can step in, into the field where fruitful, further significance can be generated from unintelligibility; it is an aspect of 'the third space' where Julie Mehretu moves and keeps moving,[6] a mysterious territory where natural forces and human representational systems meet; where wind and water, gravity and magnetism, explosions and fire are rendered through graphic/visual languages – calligraphy, notations for different forms of art (dance, music), measurements, maps, star and weather charts.

This is a highly complex area of philosophy, linguistics and aesthetics and I can only offer provisional thoughts about Mehretu's art as it relates to the history of ideas in this domain, but her search for an expressive, visual language to convey a shared experience of contemporary realities has spoken most powerfully to her audience/viewers; it communicates beyond semantics. It's tempting but entirely wrong to turn to terms such as 'encipherment', 'hieroglyph', 'pictogram' or 'glyph' itself, since they denote too close a translation between a signifier and an object or referent; one stands for the other too neatly, too indexically, to apply to Mehretu's singular mark-making. For example, the long straight rhomb lines that speed through the space projected by her paintings resemble the directions of the wind as drawn on the beautiful sea charts, the portolans of 16th-century navigators. The map-makers set down compass roses in the oceans at various locations and then drew lines radiating from their spokes, to orient sailors by the pole star at due North. Sometimes, these compass or wind roses align the lines with the signs of the zodiac, resembling horoscopes which also project the birth charts of their subjects into space, using quarterings and diagonals to connect them to the stars.[7] In Mehretu's map-like works, by contrast, the lines are not coordinated to precise referents, they don't represent winds or distances or anything else as such that exists in the world outside the painting; they convey the artist's embodied consciousness, expressing her oneness with the subject of the work as she contains the scene she is conjuring into being and at the same time propels its dynamics beyond the margins of the canvas. As Merce Cunningham once commented about his own art, he wanted to express 'the possibility of containment and explosion being instantaneous.'[8] Mehretu's paintings *Back to Gondwanaland* (2000) or *Stadia I* (2004; see

p. 249), *Arcade* (2005) or *Black City* (2007) sweep the viewer into their centrifugal energy. While the lines resemble cartographic conventions, they also recall visual formulae for supernatural forces – the rays which emanate from the seraph who pierces St Francis with the stigmata in Giotto's fresco, or the cascade of sunbeams falling onto Saint Teresa in ecstasy from the cupola in Bernini's side chapel at Santa Maria della Vittoria in Rome. The criss-crossing lattices make power visible, yes, but it's an abstracted energy made of visual neologisms. The lines that form it no longer reproduce a theological concept of divine presence, but communicate to us, according to the artist's signifying system, a novel and widespread experience today: the interlinked electronic globe. Arcs describing space and looping Lissajous curves recur in vernacular imagery in the public realm to communicate concepts of present-day global traffic – broadcasting company logos, flight paths, the movements of hurricanes and other weather systems and the trajectories of ballistic missiles and drones. Above all, the World Wide Web and the Internet (both terms recognizing the aptness of the metaphor of the net) generate comparable maps of a spider's web-like harmonic mesh wrapping the sphere of earth.

The trajectories of the prevailing circulating trade winds – the *alizès* – which Arab and Portuguese master mariners plotted on their charts made it possible to calculate, approximately, how long a voyage would take as well how much distance would be covered. Their perspective on time was linear: a geometry of vertices and coordinates in space, as in the marvellous sundials that lie along the floors of Italian cathedrals, on which a ray falls, marking off the turning of the world and the passage of time in degrees.

A cartographic work such as *Looking Back to a Bright New Future* (2003) reminisces ironically about this tradition of representing time, which dominated until Einstein's revelations of relativity. Since then, our consciousness that space is curved and our experience of accelerated speeds of travel in the contemporary world have led to the replacement of the rule or straight line (time's arrow) by curves, hyperbola and spirals. As technology continues to shrink distances and squeeze us into new proximities, the whirling flows of energy that traverse a paper or canvas

by Mehretu communicate this new relation to time. Many of her works also convey the personal effects of digital communications and their velocity: they bring us closer and they keep us apart, they make us discover friends and like-minded spirits everywhere and yet inflame hatred and rage against imagined and previously unknown enemies. The classical grid of Euclidian orthogony and the ideal of reasoned measurements have proven inadequate in today's world, and Mehretu dynamically communicates the new conditions of physical reality. As the scientist John Archibald Wheeler summed up, 'Spacetime tells matter how to move; matter tells spacetime how to curve.'[9]

Julie Mehretu has internalized these revelations and transformed them into a visual language that also takes account of new optical instruments. As the architectural scholar Mark Dorrian has commented, 'Particularly interesting is the connection between art practices and the changing technologies, meanings and contexts of the aerial view, from the microscope's new optic to the virtual modelling of place today.... The familiar tendency is to associate it with an objective, rational, "cold" and transcendent subjectivity – that of a *savant glacial* as Antoine de Saint-Exupéry put it, comparing the view through his glass cockpit to that seen by a scientist peering through a microscope. The machine eye, disassociated from a human eye as in the video cameras fixed to the nose cones of "smart" missiles in the Gulf Wars, creates a particular form of disembodiment that artists again are exploring.'[10]

However, when Julie Mehretu, in works made from the late 1990s, took up occupation of the airborne view, she enfleshed that vision and charged it with passion; she exploded the serenity that scientific mea-surement promises and that a belief in time's steady flow assures. The convulsions of the world, all the horrors that she knows from her own life's circumstances, the experiences of others and the daily catalogue of horrors on the news, give lie to ideals of rational control, of rectilinear harmony and order. As Dorrian continues, 'The aerial view has also inspired a different, expressive response. Saint-Exupéry himself linked this shift to the angle of vision: to the verticality of the analyst, he opposed the pilot's free obliquity, and the raked or tilted perspective structures lyrical and expressive painting as well as the fantastic inventions of sci-fi, manga

and video game horizons, and CGI drama...which often soar upwards to unfold a tilted vision, with apocalyptic overtones.'[11]

Among the rich archival material collected by the artist, there are many news clippings and images of catastrophes: single events that erupt, earthquakes, tornadoes, waterspouts, tempests. These are often taken from the air. And alongside these, she thinks hard about the waste and wreckage that humans create – by intent – and that others suffer. The artist grasps the truths and media of physics, but interprets their products metaphorically, expressing the warps and vortices with a blazing consciousness of their metaphorical meanings, above all in relation to war, which harnesses natural forces to achieve destruction.

The vortex has a long prior history as a symbol, appearing chiefly as the landscape of hell: Robert Rauschenberg's *Dante* series (1958–60) powerfully conveys this aspect of the abyss, its vertiginous depths and encircling terraces. For *Canto V*, 'The Carnal', in which Dante evokes how lovers are tossed forever on the wind, Rauschenberg gives us a bird's-eye view into the sphincter of the pit of hell, with the sinners rigid in the spinning miasma around it; this cloacal resonance continues as the artist's alter ego plunges deeper down. The medium Rauschenberg uses – solvent transfer – produces a filmy, palimpsestic image, its intensity of personal feeling compacted into the elusive, fragile and subdued palette. These poetic qualities resonate with Mehretu's processes of obscuring and smudging, her increasing choice of monochrome and a sense of involvement with her subject matter that laments ragingly rather than simply raging; that compassionates rather than retaliates in anger and blame.

In the same period as these *Dante* drawings, Merce Cunningham, who, like Rauschenberg, was at Black Mountain College in the 1950s, listed the eight basic movements of the dance he was bringing into being: 'bending, rising, extending, turning, sliding, skimming and brushing, jumping and falling'.[12] He could have been prophesying the kinetics of Mehretu's vision, her graphic, painterly, silent but tumultuous motion. The artist no longer flies high above the plane or surveys the scene of her creation from an axonometric perspective; instead she pulls us into her actions and their desperate summonses of dynamics.

The wreckage of whole cities, innumerable homes as well as necessary urban infrastructure, the deaths of thousands of people in the Middle East, Asia and Africa, including Mehretu's birthplace, Ethiopia, and the iconoclastic attacks on ancient monuments, have inspired many of her most intense works, into which she introduces material, documentary evidence – photographs and architectural reconstructions through computer drawings – which she then overlays with a lattice of radiant lines and a whirl of parabolae. These painterly actions throw a net of signification over the scene and transform it in ways that have become the hallmark of Julie Mehretu's extraordinary vigour, the distinctive vision that over time has been filling a crane bag of her own. Recently, her marks have become more personal, intensely gestural and spontaneous. Graffiti scribbles and scrawls, twirls and jabs, some loose and graceful, others tense and awkward, deepen the artist's connection with certain crucial uses of writing: they are marks, like a signature, that take place at a moment made by an individual body in movement.

In a series of 'Notes on Painting' set out like a prose poem on the page, the artist evokes the gestures involved: 'Push, scratch, mark, cut, stay'.[13] Her visual neologisms happen in the visible world as unique events, and the unique event, the accident of subjectivity captured in time, has gained aura in the digital era and its flows of reproducible, simultaneous data. The character, colour, energy of Mehretu's marks have however fundamentally changed since 2012, when she made the monochrome series *Mogamma: A Painting in Four Parts*. Glenn Ligon rightly observes a major transition: 'Her moves away from marks that represent a collection of individuals to ones that reference the sweep of an individual's hand or the scale of her body signal a new focus on the role each of us plays in helping imagine a better world.'[14] With this shift into monochrome, into haptic and spontaneous, direct work on paper and canvas and ever more intensely personal abstraction, several concerns and themes persist, visited and revisited with passionate, rhythmic fertility.

As the artist's interventions disrupt the flow of time, every graphic mark becomes an accident that evokes unpredictability; each one a throw of the dice that interrupts the continuum and asserts the artist's presence as a generative force. Mallarmé's poem, *Un coup de dés jamais n'abolira*

le hasard... (A throw of the dice will never abolish chance... (1897)) shores up his deliberate work against chaotic chance by attempting to outdo it with a flux of images (words scattered across double pages) that could not have occurred in any other sequence at any other time: the entirely singular event. The rule and measure of mapping thereby cedes to the authority of the subjective play of the artist's hand and mind. In a luminous foreword to Mehretu's show 'Liminal Squared' (2013), Tacita Dean recognizes how Cy Twombly's work shimmers within Mehretu's *Mind Breath and Beat Drawings* (2013), and how the older, male artist's quasi-mediumistic, hallucinatory scatterings of words and his abstract, dancing gestural marks share deep affinities with Mehretu's work: 'the cerebral, the existential, and the rhythmic, where the lines, smudges, chevrons and scudding have taken on their own authority.'[15] Effacing and defacing, both in the earlier layered images and in the recent, more profound abstractions, are deliberate processes the artist has adopted. 'When drawing, pull out of myself, lose place, go deep into pressurized state of disfiguration, disembodiment,' she has written.[16]

William Kentridge, another artist who chooses to show the processes of erosion, erasure and obliteration, is also trying to keep faith with memory and history; he aims to evoke time and motion in the still space of the two-dimensional drawing, and consequently shows the layers of a drawing to 'thicken time'.[17] This palimpsestic process, adopted by Mehretu, owns up to atrocity. The successive layerings of erasures remember what happened and do not allow oblivion to descend, even as the work of the artist's hand struggles to overshadow, to disfigure the events it confronts.

II

There are two contexts for these variations on iconoclastic strategies, which can both offer interesting precedents for Mehretu's ways of making meanings, I think, in a world assaulted by meaningless violence: the first is a chapter in the history of the novel and its emergence; the second a principle of art historical interpretation, situating the visual arts within the ritual pursuit of the sacred.[18]

Mehretu's tragic visions of destroyed cities and death in recent paintings such as *Aleppo* (2014) and *Myriads, Only By Dark (unfolded body*

map, mathematics of droves, indigene, origin) (2014), represent an evolution of her deep engagement with habitats, especially monumental edifices built to contain thousands of people (stadia, colosseums, stadia, bullrings); these are often sites dedicated to spectacles of agonistic combat, sacrifice and death. In an essay for *Julie Mehretu: Black City*, richly illustrated by materials from her archives, Laurence Chua juxtaposes aerial views of these vast works with images of fortified cities and castles also taken from the air, showing the intricate geometry of walls and ditches, ramparts and towers erected to protect inhabitants.[19] The greatest artist-innovator of such star-fort constructions was Louis XIV's military engineer Sébastien Le Prestre de Vauban, who was commissioned by his monarch to defend France on all its borders. Vauban's fortifications at Lille, Neuf-Brisach and Namur are masterpieces of architectural origami, cellular clusters and constellations rising from the ground to raise impregnable bastions and ramparts to all comers.

Regarding the spatial imagination of Julie Mehretu, it is highly suggestive that these monumental military constructions inspired women writers of the 17th and 18th centuries to retaliate with the power of the word and image. The scholar Joan DeJean has argued that at the very same time as Vauban was erecting royal fortifications all over France, the modern novel was taking on its distinctive role as prime cartographer of the heart and psyche and society – and that the original space of the early modern novel is the fortress.[20] Madeleine de Scudéry, in *Clélie,* and Madeleine-Marie Pioche de la Vergne (Madame de Lafayette), in *La Princesse de Clèves,* both reconfigured the battle conventions of the love plot, mapping out an alternative topography and different concepts of boundaries and safe enclaves. DeJean comments: 'Scudéry's *Terres inconnues* [Unknown Territories] would therefore be a utopian no *man*'s land, a non-place, or a place in fiction, where women can protect the female heart by controlling representations of it and by denying men access to the language that expresses it.'[21] The new fictions were to act as redrafted maps of women's desires, as they set out to turn around the language of relationships.

While Daniel Defoe's *Robinson Crusoe* is deeply concerned with defending the island, and Lawrence Sterne's Uncle Toby obsessively models a replica of the 1695 Siege of Namur (fortified by Vaudun), at

which he had been wounded in the groin, a woman writer countered by imagining the *Carte de Tendre* – the map of the Land of Tenderness – which spreads out a flat riverine plain, studded with small hamlets labeled Constant Friendship, Obedience, Generosity, Honesty, A Great Heart – landmarks in a vista that supported an ideal of civility, companionship and sexual equality against the military siege mentality of Sterne in *Tristram Shandy*, in which Uncle Toby responds to the Widow Wagman's amorous inquisitiveness with ever more elaborate renderings of the citadel's trenches, bastions and other defences.

This historic struggle by a certain group of female wits and creative minds to dissolve the hegemony of military metaphors seems to me to foreshadow suggestively Julie Mehretu's heroic resistance to damage and violence in the contemporary world. Through the exuberant spattering and pocking of her hand-wrought, subjective marks, her thickly gathered shadows, she overwhelms computerized, systematic and objective drawings of destruction as if willing her flight of visual signs to counteract and undo their authority.

While her earlier works can be seen as remappings of bombed cityscapes and other environments, Mehretu's more recent series, shown in 2016 under the title 'Hoodnyx, Voodoo and Stelae' at Marian Goodman in New York, adopts another mode of aesthetic iconoclasm and invites us into a sacred space where repetition acts as incantation, while the paintings' titles direct us to epitaphs written by the body, by hands, eyes and tongues, making daubs and scratches and smears and streaks and gougings. The artist's marks remember the first marks of human beings as footprints and handprints, and their relation to language and language's central place is establishing contact with the divine/destiny, in order to propitiate, to forestall, to make amends – the handprint of the Hamza, the gesture of Fatima to ward off the evil eye. The artist's private graphic notations, those scurrying notes and even frenzied scatterings of marks, may seem to hint at intelligibility, but she ultimately withdraws it from our grasp. Hers is a musical language and, like music, can communicate without words: voices made visible of lament, imploration, beseeching, yearning, curses and blessings, conjuration and mourning. Aby Warburg, who worked obsessively on how art reversed its mute and

still condition, was intent on 'pulverizing the mechanisms of iconographic transmission from within, in order to bring out the enigmatic function of the representation of motion: the manifestation of a body irreducible to meaning.'[22] In other words, to search for human communication that bypasses language as a semantic vehicle and inhabits gesture and sound. Cy Twombly's comments that 'every line had its own innate history', and that 'it is the sensation of its own realization',[23] are relevant here, but the attention he draws to the quality of sensation in a work of art forgets the relation of movement to rhetoric and the presence of what Samuel Beckett called 'vociferations' – the howls and whimpers of the wretched human creature.

Many forms of conjuration and entreaty rely on repetition – of word and gesture – that also seek to go beyond meaning. The pediment of the temple of Apollo in Delphi, which Julie Mehretu has photographed, bears incised into the stones in a dense weave of lettering the names and thanks of petitioners who came to consult the oracle. Records of an event, of a question answered, a vow taken, a promise given. Carved thousands of years ago, they are now effaced to the point of indecipherability, but even if they were still clear, the names mean little to us now. Yet it is powerfully affecting – and an inspiration to artists today – because we see in it a chorus of voices, and we still feel the pulse of their vociferations, even from as long ago as that remote past.

In Islamic culture, calligraphy becomes the vehicle of the sacred – the words of the Qur'an or the signature or *tughra* of the Sultan; the exquisite elaboration of the various scripts, each with their own aesthetic on which the scribe performs variations, do not aim at legibility or at communicating what it says as semantic meaning. This is a scribal tradition in which the alphabet functions as a medium of magical power, coiling a rope that binds the event of graphic making to cosmic/divine energy. Apotropaic instruments – bowls, tunics, amulets to be worn on necklaces – are densely inscribed with quotations and magical formulae, including magic squares and noose-lattices to trammel and trap forces of harm.[24] It is significant that the arabesque aesthetic contains two dominant impulses: the spring or jet (*al-ramy* in Arabic, used for the flow and energy of water) and, alongside this fluidity, a concept of constraint (*al-khayt*, meaning a thread, a lace

as in shoe laces or other ties for clothing, a thong or a bond). The spurt and jet of flowing water is contained and held in a lattice, a web or net, in order to produce the characteristic plural forms of Islamic art – this also chimes with Cunningham's vision of containment/explosion. Although the mode has affinities with the labyrinth – the infinite, Borgesian form of it – and with the spider's web, water's fluidity and force and the properties of tying and binding are in themselves endless and centreless: the border or frame is necessary to tether the generative exuberance. Arabesque 'is not a figuration, but a rhythm, an incantation by indefinite repetition of the theme…it is unappeasingly directed – but in vain – towards the limitless', write Chevalier and Gheerbrant in their dictionary of symbols.[25] They then add the crucial remark: that it transcribes – or one could say attempts to transcribe – a heightened mental state, *dhikr*. In Arabic, *dhikr* is a metaphysical, even mystical term meaning the contemplation and remembrance of sacred things.[26]

Calligraphy replicates this restless, repetitive motion; the curling fronds and winding stems of natural forms metamorphose into letters, not to be intelligible but to add power to the words inscribed. Script frequently becomes interwoven with the very fabric of architecture, incorporating the power of the knotted and interlaced word into the sacred enclave's outer walls: a blazon but also a cartography of preferred values made visible. In these contexts, mark-making becomes a form of conjuring, the word Julie Mehretu adopts in the titles of several of her recent *Grey Paintings* (2016). The processes involve her in intensive acts of rubbing out and colouring in, overwriting and obliterating, as she works on a found image – the Syrian soldier standing in the rubble – and makes a repetitive series of physical movements that reproduce the magical repetitions of blessing and praise, of prayers uttered to placate fate. The artist comments that her parents' experiences of struggle for a better world in Ethiopia and their subsequent flight to the United States after their efforts had failed gives her a profound sense that the only hope is to keep on making, keep on inventing, in the face of defeat. 'It is almost an absurdity', she says, 'But it is the only hope.' Her marks are 'dust, vapor, or more atmosphere',[27] the spiralling journey of a wish, a hope, a prayer as it spreads out and suffuses the air.

NOTES

PREFACE

1. Martin Kemp, "'Il Concetto dell'Anima" in Leonardo's Early Skull Studies', *Journal of the Warburg and Courtauld Institutes*, 34 (1971), 34.
2. Jorge Luis Borges, quoted in Suzanne Jill Levine, Introduction to Adolfo Bioy Casares, *The Invention of Morel*, tr. Ruth L. C. Simms (New York, 1992 [1940]), p. viii.
3. An obituary for Helen Chadwick can be found in David Notarius, Sophie Raikes and Marina Warner, *Helen Chadwick: Wreaths to Pleasure* (London, 2014).
4. At London's Hayward Gallery, Ralph Rugoff's startling 'An Alternative Guide to the Universe' ran at the same time as Gioni's show and included some of the same artists. Meanwhile, Mark Leckey's touching, witty touring exhibition, 'The Universal Addressability of Dumb Things', offered another semi-ironized but intense artist's archive. These shows turn out abandoned glory-holes and attics for our inspection, and recall rummage sales, yard sales and cabinets of curiosities. The Museum of Everything was included in the small downstairs space at the Hayward show, and its guiding spirit, James Brett, has been at the forefront of the new enthusiasm for the untaught, organic, virtuously maverick and often ungarlanded artist. Jeremy Deller's quest for folk arts is related to this omnivorous inquisitiveness, though his heart lies with the ordinary, even banal artefact at the point when it too takes off into the curious, the wonderful.
5. Alfred Gell, *Art and Agency* (Oxford, 1998), p. 123.
6. Eugenio Trías, 'Thinking Religion: The Symbol and the Sacred', in Jacques Derrida and Gianni Vattimo (eds), *Religion* (Cambridge, 1998) p. 107.
7. Paul Valéry, 'Mauvaises Pensées et autres' (1899), in *Oeuvres* (Paris, 1983), p. 1461.
8. Paul Ricoeur, *The Symbolism of Evil* (New York, 1992), p. 354.
9. *ibid.*, p. 350.
10. See Marina Warner, *No Go the Bogeyman: On Scaring, Lulling, and Making Mock* (London, 1998), pp. 348–73.
11. Charles Baudelaire, Preface to *Les Paradis artificiels*, quoted in Michael Sheringham, *Perpetual Motion: Studies in French Poetry from Surrealism to the Postmodern* (Cambridge, 2017), p. 148.
12. Seamus Heaney, *The Redress of Poetry* (Oxford, 1990).
13. See Paul Ricoeur, *Oneself As Another*, tr. Kathleen Blamey (Chicago, 1992).

I. PLAYING IN THE DARK

1. William Shakespeare, *A Midsummer Night's Dream*, 5.1.23-27.
2. See D. W. Winnicott, *Playing and Reality* (London, 2006 [1971]), pp. 38–64.

HENRY FUSELI

1. Robert Kirk, Stewart Sanderson et al., *The Secret Commonwealth* (Cambridge, 1976), pp. 49–71, especially pp. 49, 53–54. See also Marina Warner, Introduction to Robert Kirk, *The Secret Commonwealth* (New York, 2006); Michael Hunter, *The Occult Laboratory: Magic, Science and Second Sight in Later-Seventeenth-Century Scotland* (Woodbridge, 2001). For more on British fairies, see Thomas Keightley, *The Fairy Mythology* (London, 1910); Katharine Briggs, *The Fairies in Tradition and Literature* (London and New York, 2002). For an excellent study, see Nicola Bown, *Fairies in Nineteenth-Century Art and Literature* (New York, 2001).
2. Robert Herrick, *The Poetical Works* (Oxford, 1915), pp. 119–20, 165–69.
3. Milton, 'L'Allegro' <https://www.poetryfoundation.org/poems/44731/lallegro> [accessed 19 March 2018].
4. Fuseli even taught himself Dutch (his sixth or seventh language), in order to read a leading work on entomology. See John Knowles, *The Life and Writings of Henry Fuseli*, (London, 1831), I, p. 361.
5. David H. Weinglass reports that the original painting *The Nursery of Shakespeare* (1810) survives only in fragments at the Courtauld Institute. See *Prints and Engraved Illustrations by and after Henry Fuseli* (Aldershot, 1994), pp. 331–32.
6. See Terry Castle, *The Female Thermometer: Eighteenth-Century Culture and the Invention of the Uncanny* (New York, 1995) and Marina Warner, *No Go the Bogeyman: On Scaring, Lulling and Making Mock* (London, 1998), pp. 254–61.
7. Knowles, pp. 225–26.
8. Edward Said, *Out of Place: A Memoir* (London, 1999), p. 51.
9. Adelbert von Chamisso, *Peter Schlemihl*, tr. J. Bowring et al. (London, 1824). This edition mistakenly cites La Motte Fouqué as author, but is compellingly illustrated; an 1851 edition in the British Library, *The Wonderful History of Peter Schlemihl*, tr. Falck Lebahn (London, 1851) attributes it correctly.
10. Knowles, p. 190.

11. Werner Hofmann, 'A Captive', in Gert Schiff, *Henry Fuseli 1741–1825* (London, 1975), p. 29.
12. Knowles, p. 195.
13. *ibid.*, pp. 225–26.
14. Weinglass, pp. 44–45, 53–54, 73–74, 81, 110–11. Several images featuring Belisane and Percival and an enchantress called Urma also derive from 'ghost' originals.
15. See Samuel Warren, 'The Spectre-Smitten' in Chris Baldick (ed.), *Tales of Terror from Blackwood's Magazine* (Oxford and New York, 1999), pp. 215–41 for a terrific short story published in 1831, concerned with the states that Fuseli explores.
16. Henry Fuseli, 'Letter dated at St Petersburg', in J. C. Lavater, *Essays on Physiognomy* (1775–78), tr. Thomas Holcroft (*c.* 1844), p. 103, quoted by Ross Woodrow, <https://quod.lib.umich.edu/e/evans/N20712.0001.001/1:5?rgn=div1;view=fulltext>[accessed 14 Feb 2018].
17. Edgar Allan Poe, 'How to Write a Blackwood Article', in T. O. Mabbott (ed.), *The Collected Works* (Cambridge, MA, 1978), II, p. 340; see also Baldick, p. xiv.
18. John Milton, *Paradise Lost* (New York, 1993), xi, p. 272, 11.480–86.
19. Schiff, p. 134.
20. *Allegory of a Dream of Love*, also known as *Falsa ad coelum* from the line of *The Aeneid* Book VI inscribed on the floor, was etched by Blake; the elephant-goblin may be suggested by association with ivory, the same word in Greek. See Weinglass, pp. 121–22.
21. Lynn Hunt (ed.), *The Invention of Pornography: Obscenity and the Origins of Modernity, 1500–1800* (New York, 1993).
22. The celebrated, very mischievous literary hoax, *The Travels of Hildebrand Bowman, Esquire, into Carnovirria, Taupiniera, Olfactaria, and Audidatne, in New Zealand etc.* (London, 1778), was identified in 1994 as the work of John Elliott, a midshipman on *The Endeavour* under Captain Cook. See *Imaginary Voyages and Invented Worlds*, exh. cat. (Sydney, 2002), p. 56.
23. See Claire Tomalin, *Mrs Jordan's Profession: The Story of a Great Actress and a Future King* (London, 1994).
24. Angela Carter, 'The Loves of Lady Purple', in *Burning Your Boats: Collected Short Stories* (London, 1995), pp. 49–51.

JANINE ANTONI

1. Aristotle, *De Anima*, tr. W. S. Hett (Harvard and London, 1995 [1936]), II.ix.421a, pp. 120–21.

RICHARD WENTWORTH

1. Conversation with the artist, Spring 1993. I am very grateful to Richard Wentworth for the observations he made and help he gave in December 1992 and March 1993. All quotations from the artist, unless otherwise noted, arose in the course of these meetings.
2. The series has been published since this essay was written. See Richard Wentworth and Hans Ulrich Obrist, *Making Do and Getting By* (London and New York, 2015).
3. Lynne Cooke, 'Making Good', in *Richard Wentworth*, exh. cat. (London, 1984), p. 11.
4. Anne M. Wagner, 'How Feminist are Rosemarie Trockel's Objects?', *Parkett* 33, (1992), 61–74.
5. Giovanni Anselmo, 'Untitled' (1968), in *Gravity & Grace: The Changing Condition of Sculpture 1965–1975* (London, 1993), p. 53.
6. *After Modernism: The Dilemma of Influence*, dir. Michael Blackwood (1991).
7. A. P. E. Ruempol and A. G. A. van Dongen, *Pre-Industrial Utensils 1150–1800*, exh. cat. (Rotterdam, 1991).
8. Ian Jeffrey, 'Things, with Words', in *Richard Wentworth*, exh. cat. (London, 1986), p. 13.
9. Ian Buruma, 'Japanese Avantgarde', in *A Cabinet of Signs: Contemporary Art from Post-Modern Japan*, exh. cat. (Liverpool and London, 1991), p. 17.

KIKI SMITH

1. See, for example, the raunchy popular version of 'Little Red Riding Hood', 'The False Grandmother' (recited by Antonio de Nino in 1883), retold in Italo Calvino, *Italian Tales*, tr. George Martin (London, 1980). See also Maria Tatar (ed.), *The Annotated Classic Fairy Tales* (New York, 2003), pp. 3–24; Jack Zipes (ed.), *The Trials and Tribulations of Little Red Riding Hood* (London and New York, 1993), and 'Cinderella (Ashputtel)' and 'The Goose Girl' in Maria Tatar (ed.), *The Annotated Brothers Grimm* (New York, 2004), pp. 113–27, 310–21.
2. See Caroline Walker Bynum, *Metamorphosis and Identity* (New York, 2001) and Marina Warner, *Fantastic Metamorphoses, Other Worlds* (Oxford, 2002).
3. Chuck Close, 'Interview with Kiki Smith', *Bomb* 49 (Fall 1994), 44. On this topic, see Eleanor Heartney, 'Blood, Sex and Blasphemy: The Catholic Imagination in Contemporary Art', *New Art Examiner* 26/6 (March 1999), 34–39.
4. Close, 40.
5. Wendy Weitman, 'Experiences with Printmaking: Kiki Smith Expands the Tradition', in *Kiki Smith: Prints, Books & Things*, exh. cat. (New York, 2003), p. 15.

6. The aesthetic of the abject, discussed by Julia Kristeva in her influential book *Powers of Horror* (New York, 1982) is closer to the Catholic cult of suffering than to Kiki Smith's reevaluation of its forms. See Simon Taylor, 'The Phobic Object: Abjection in Contemporary Art', in *Abject Art: Repulsion and Desire in American Art*, exh. cat. (New York, 1993), pp. 59–83.

7. Robin Winters, 'An Interview with Kiki Smith' in Paolo Colombo et al., *Kiki Smith*, exh. cat. (Amsterdam and The Hague, 1990), p. 136.

8. Quoted in Michael Boodro, 'Blood, Spit, and Beauty', *Artnews* 93/3 (March 1994), 129.

9. Charles Baudelaire, 'Morale de joujou', in Marcel A. Ruff (ed.), *Baudelaire: Oeuvres Completes* (Paris, 1968), p. 359.

10. *ibid.*

11. See Jeanne Piaget, *La Construction du réel chez l'enfant* (Neuchâtel and Paris, 1937) and D. W. Winnicott, *Playing and Reality* (London, 2006 [1971]), pp. 38–64. See also Adam Phillips, *Winnicott* (London, 1988); *On Kissing, Tickling and Being Bored* (London, 1993); and *The Beast in the Nursery* (London, 1998).

12. Winnicott, p. 50.

13. *ibid.*, p. 41.

14. Close, 44.

15. Walter Benjamin, 'The Storyteller: Reflections on the Work of Nicolai Leskov', tr. Harry Zohn, in *Illuminations* (New York, 1969).

16. David Frankel, 'In Her Own Words: Interview with David Frankel', in Helaine Posner, *Kiki Smith* (Boston, 1998), p. 38.

17. This sculpture inspired me to write a short story, 'Cancellanda', published in *Raritan* 23/2 (Fall 2003) and *Wasafiri* (Fall 2004).

18. For stories of characters turning into stone, see P. M. C. Forbes-Irving, *Metamorphosis in Greek Myths* (Oxford, 1999), pp. 139–48.

19. Close, 40.

20. Frankel, p. 41.

21. *Jersey Crows* (1995), included in the exhibition 'Kiki Smith: New Work', at PaceWildenstein, New York, September 15–October 21, 1995.

22. Klaus Kertess, 'Kiki Smith: Elaborating a Language of the Body', *Elle Decor* (February–March 1996), 58.

23. See *Rebel in the Soul: A Sacred Text of Ancient Egypt*, tr. Bika Reed (London, 1978).

24. See Norman Bryson, *Looking at the Overlooked: Four Essays on Still Life Painting* (Cambridge, MA, 1990).

25. Quoted in Christopher Lyon, 'Kiki Smith: Body and Soul', *Artforum* 28/6 (February 1990), 102–06.

26. See Tatar (2003).

27. See Zipes (1993) and Tatar (2003), pp. 3–24.

28. Angela Carter, 'The Company of Wolves', in *The Bloody Chamber* (London, 1979), p. 118.

29. Quoted in Dodie Kazanjian, 'Blood Ties', *Vogue* (November 1994), 213.

30. John Updike, review of Italo Calvino's *Italian Tales*, in *Hugging the Shore: Essays and Criticism* (London, 1985), pp. 661–62.

31. Roger Caillois, *La Pieuvre: Essai sur la logique de l'imaginaire* (Paris, 1973).

32. See Wendy Doniger, 'Women, Beasts, and Other Androgynes' and 'The Mythology of Masquerading Animals, or Bestiality', in *Social Research* 62/3 (Fall 1995), 751–72; Annie Dillard, *Teaching a Stone to Talk: Expeditions and Encounters* (New York, 1982); Rebecca Solnit, *As Eve Said to the Serpent: On Landscape, Gender, and Art* (Athens, GA, 2001); and Ruth Padel, *The Soho Leopard* (London, 2004) and *Tigers in Red Weather* (London, 2005). See also John Hollander, 'I Named Them as They Passed', in *Social Research* 62/3 (Fall 1995), 457–76.

2. BODIES OF SENSE

1. John Donne, 'Of the Progress of the Soul: The Second Anniversary' <http://www.bartleby.com/371/434.html> [Accessed 2 November 2017].

HANS BALDUNG GRIEN

* This essay was written before the publication of Joseph Koerner's magnificent study, *The Moment of Self-Portraiture in German Renaissance Art* (Chicago, 1993); see Chapter 14 'Death as Hermeneutic' for his exploration of similar themes in Baldung, pp. 29–316. Several other studies have also appeared since then that illuminate the historical context, and I was able to make some revisions in the light of the work of Bob Scribner, Kathleen Crowther, Lorna Jane Abray, and Charles Zika. I am grateful to Ulinka Rublack for her helpful comments.

1. F. E. J. Raby, *Oxford Book of Medieval Latin Verse* (Oxford, 1959), p. 94.

2. Georges Bataille, 'La Bouche', *Documents* 5 (1930); quoted in Dawn Ades, 'Web of Images', in Dawn Ades and Andrew Forges (eds.), *Francis Bacon* (London, 1985), p. 15.

3. See Robert A. Koch, *Hans Baldung Grien: Eve, the Serpent and Death – Masterpieces in the National Gallery of Canada* 2 (Ottawa, 1974).

4. For instance, Isidore of Seville, *Etymologiarum libri XX*, ed. W. M. Lindsay (Oxford, 1962), p. 76: 'Mors dicta quod sit amara… (sive mors a morsu hominis primi, quod vetitae arboris pominum mordens mortem incurrit).' [death is so-called because it comes from the word bitter (or it is

called death from the bite of the first man, who incurred death by eating the fruit of the forbidden tree)]. Quoted in Jean Wirth, *La jeune fille et la mort: Recherches sur les thèmes macabres dans l'art germanique de la Renaissance* (Geneva, 1979), p. 65.

5. 'Illic dolor, cruciatus, fletus, stridor dentium, adsunt fremitum leonum, sibili serpentium: quibus mini confunduntur ululatus flentium.' Peter Damian, 'De die mortis', quoted in F. J. E. Raby, *A History of Christian-Latin Poetry* (Oxford, 1953), p. 254.

6. See John Phillips, *Eve: The History of an Idea* (San Francisco, 1984), pp. 62–67.

7. See William Wells et al., *Treasures from the Burrell Collection* (London, 1975), p. 9.

8. Martin Luther, 'Praelectiones in Prophetas Minores', xiii, pp. 63–64, and 'Predigten des Jahres 1532', xxxviii, pp. 676–85, in *Werke* (Weimar, 1889). I am very grateful to Steven Wight for his research into Luther's usage and translations.

9. For more on Baldung's life and work, see Gert von der Osten, *Hans Baldung Grien: Gemälde und Dokumente* (Berlin, 1983); James H. Marrow and Alan Shestack (eds), *Hans Baldung Grien: Prints and Drawings*, (Washington and New Haven, 1981); Matthias Mende, *Hans Baldung Grien: Das Graphische Werk* (Unterschneidheim, 1978); and Paul H Boerlin, *Hans Baldung Grien im Kunstmuseum Basel* (Basel, 1978).

10. Martin Luther, 'Commentary on Genesis 1:27', quoted in Ian Maclean, *The Renaissance Notion of Woman* (Cambridge, 1980), pp. 9–10.

11. See Maclean, pp. 16–17.

12. 'Lingua, or the Combat of the Tongue and the Five Senses for Superiority' (1607), quoted in Catherine Belsey, *The Subject of Tragedy: Identity and Difference in Renaissance Drama* (London, 1985), p. 181. The play was popular; it had been reprinted five times by 1657.

13. See Linda C. Hults, 'Baldung and the Witches of Freiburg: the Evidence of Images', *Journal of Interdisciplinary History*, 18/2 (Autumn 1987), 249–76; Sigrid Schade, *Schadenzauber und die Magie des Körpers* (Worms, 1983); and G. F. Hartlaub, *Hans Baldung Grien: Hexenbilder* (Stuttgart, 1961).

14. Erasmus, *Letter to Martin Dorp*, tr. Betty Radice (Harmondsworth, 1971), p. 224.

15. See E. Tietze-Conrat, *Dwarfs and Jesters in Art* (London, 1957).

16. Engraving of 1519, also known as *The Dance of the Magdalen*. See Max Friedlander, *Lucas van Leyden* (Berlin, 1963), pp. 32–33.

17. Tietze-Conrat, p. 57.

18. Gustave Flaubert, *Letter to Louise Colet*, 6/7 August 1846.

19. The titles read 'Only a woman can break his frightful spell – a woman pure in heart – who will offer her blood freely to Nosferatu and... [dissolve] will keep the vampire by her side until after the cock has crowed. See Roger Manwell, *Masterworks of the German Cinema* (London and New York, 1973), p. 89. This is repeated a few frames later, in a film with very few titles.

20. See Siegfried Kracauer, 'Caligari', in *The Cabinet of Dr Caligari, a film by Robert Wiene, Carl Mayer and Hans Janowitz*, tr. R. V. Adkinson (London, 1984), pp. 5–26.

LOUISE BOURGEOIS

1. 'Statements from conversations with Robert Storr', in Louise Bourgeois, *Destruction of the Father Reconstruction of the Father: Writings and Interviews 1923–1997*, ed. Marie-Laure Bernadac and Hans-Ulrich Obrist (London, 1998), p. 217.

2. Louise Neri, 'The Personal Effects of a Woman with No Secrets', in Louise Bourgeois et al., *Louise Bourgeois: Homesickness* (Yokohama, 1997), pp. 141–45.

3. Robert Storr, 'Meanings, Materials, and Milieu – Reflections on Recent Work by Louise Bourgeois', *Parkett* 9 (1986), 82–85, in Bourgeois (1998), p. 143.

4. Marina Warner, 'Nine Turns around the Spindle: The Turbine Towers of Louise Bourgeois', for the publication that went with the installation, 'I do I undo I redo'. See *Louise Bourgeois* (London, 2000), pp. 18–30.

5. Interview with Trevor Rots, 10 May 1990, in Bourgeois (1998), p. 195.

6. Christiane Meyer-Thoss, '"I am a Woman with No Secrets": Statements by Louise Bourgeois', *Parkett* 27 (1991), 44, quoted in Bourgeois (1998), p. 223.

7. Bourgeois (1998), pp. 140–42.

8. *ibid.*, p. 155.

9. The Freud Museum exhibition, curated by Philip Larratt-Smith, hung this work over Freud's couch to act as an emblem of the revelations that it might have heard. See Larratt-Smith, 'The Return of the Repressed', in *Louise Bourgeois: The Return of the Repressed* (London, 2012), i, pp. 71–84.

10. Charlotta Kotick, Terrie Sultan and Christian Leigh, *Louise Bourgeois: The Locus of Memory, Works 1982–1993* (New York, 1994), p. 50; see also <http://www.tate.org.uk/art/artworks/bourgeois-cell-eyes-and-mirrors-t06899> [accessed 1 November 2017].

11. See Larratt-Smith for background material and photographs.

12. Statements from an interview with Donald Kuspit (1988), in Bourgeois (1998), p. 158; see also Elisabeth Bronfen, 'Contending with the Father: Louise Bourgeois and Her Aesthetics of Reparation', in Larratt-Smith, I, pp. 101–12. See also 'cannibalism' in *Louise Bourgeois* (2000), pp 67–68.

ZARINA BHIMJI

1. Work commissioned by the Public Art Development Trust.
2. This was written before hospitals decided, in the interests of hygiene, to ban flowers.
3. Elaine Scarry, *The Body in Pain* (Oxford, 1985).
4. Gianni Vattimo, 'Bottle, Net, Truth, Revolution, Terrorism, Philosophy', tr. Thomas J. Harrison, *Denver Quarterly* (Winter 1982), 25. I am very grateful to Ralph Rugoff for sending me this interview.
5. *ibid.*, p. 29.
6. The Pathology Museum has been combined with several hospitals' teaching collections. See <http://www.imperial.ac.uk/human-anatomy-unit/pathology-museum/history/now> [Accessed 31 October 2017]
7. See Stephen Bann, Introduction to *Frankenstein: Creation and Monstrosity* (London, 1994), pp. 1–15, for an interesting look at cabinets of curiosities and later Victorian specimen collectors such as Charles Waterton.
8. Michel Foucault, *Les Mots et les choses/The Order of Things* (Paris, 1966).
9. See Linda Nochlin, *The Body in Pieces: The Fragment as a Metaphor for Modernity* (London, 1994).
10. Henry Drewal, 'Art and the Perception of Women in Yoruba Culture', *Cahiers d'études africaines* 68 (1977), quoted in Mary H. Nooter (ed.), *Secrecy: African Art that Conceals and Reveals* (New York and Munich, 1993), p. 235.
11. Nooter, pp. 23, 25.
12. Hugo von Hofmannsthal, 'The Book of Friends', in *The Whole Difference: Selected Writings*, ed. J.D. McClatchy (Princeton, NJ, 2008), p. 148.
13. Julian Cox and Colin Ford, *Julia Margaret Cameron: The Complete Photographs*, (Los Angeles, 2003); see Marina Warner, *Phantasmagoria: Spirit Visions, Metaphors, and Media* (Oxford, 2006), pp. 205–18.
14. See Caroline Walker Bynum, 'Material Continuity, Personal Survival and the Resurrection of the Body: A Scholastic Discussion in its Medieval and Modern Contexts', in *Fragmentation and Redemption: Essays on Gender and the Human Body in Medieval Religion* (New York, 1991), pp. 239–97, for a fascinating contextual account of these issues in relation to Christianity.

HELEN CHADWICK

1. *Enfleshings I* (1989), in Thomas McEvilley and Richard Howard, *De Light: Helen Chadwick* (Philadelphia, 1991), p. 11.
2. A doctor who went to 'Bad Girls' at the ICA in London noticed the deterioration of the tissues on Helen's nails and wrote to her, warning that it could be a sign of a heart condition. The woman's thoughtfulness touched her very much; but she had checked and there was no connection to her heart; she was suffering from a condition that usually afflicts men who work in chemical plants. (It wasn't a cause of her death, which remains unknown.)
3. Beautifully reproduced in Helen Chadwick, *Enfleshings* (London, 1989).
4. *Blood Hyphen* (1989), an installation at Clerkenwell and Islington Medical Mission, in Chadwick (1989), pp. 88–93; see also Robert Hewison, *Future Tense* (London, 1990), pp. 160–61.
5. Chadwick (1989), p. 95.
6. See Marjorie Allthorpe-Guyton, 'A Purpose in Liquidity', in Helen Chadwick, *Effluvia* (London, 1994), pp. 9–15, for the complex making of this work.
7. Margaret Soltan, 'Night Errantry', *New Formations* 5 (Summer 1988), quoted in Chadwick (1994), p. 97.
8. Press Release to 'Lamps' at Marlene Eleini Gallery, London, 1989.
9. 'Fetishism', tr. James Strachey, in *The Standard Edition of the Complete Works of Sigmund Freud*, XXI, p. 155.
10. For instance, in *Doubles*, exh. cat. (Herblay, France, 1991).
11. Allthorpe-Guyton.
12. Press Release to 'Lamps'.
13. Michel Foucault (ed.), *Herculine Barbin, Moi-même*, tr. Richard McDougall (Harvester, 1980).
14. *Doubles*.
15. Helen Chadwick, 'Lines that Severed, Bind', in *Lofos Nymphon*, exh. cat. (Sheffield, 1987).
16. Rosalind Pollack Petchesky, 'Fetal Images: The Power of Visual Culture in the Politics of Reproduction', in Michelle Stanworth (ed.), *Reproductive Technologies: Gender, Motherhood and Medicine* (Cambridge, 1987).
17. Chadwick (1987). I wonder what Helen would have thought of the theory of the matrix as the place where two bodies coexist, trying 'not to master, assimilate, reject nor alienate each other; mutuality, dependence, potentiality...

two subjective entities whose encounter at this moment is not an either/or. Matrix is a means, in symbolic language, to allow an aspect of identification that is framed by the invisible specificity of the feminine body (literally, the potentiality within the womb), into this realm of discursive meaning.' I came across this too late to discuss it with her. See Bracha Lichtenburg Ettinger, 'The With-In-Visible Screen', in Catherine de Zegher (ed.), *Inside the Visible* (Boston and Kortrijk, Flanders, 1996), pp. 89–113. The above quotes are taken from the accompanying leaflet.

18. Dated 11 January 1996.
19. Martin Jay, *Downcast Eyes or the Denigration of Vision in 20th Century French Thought* (Berkeley, 1993).
20. Helen Chadwick, in 'Re-visions', Cambridge Darkroom, 1985.

TACITA DEAN

1. I am grateful to Dr Yekaterina Barbash for corresponding with me about the exhibition she curated, 'Body Parts: Ancient Egyptian Fragments and Amulets' at the Brooklyn Museum, 19 November 2009–October 2011.
2. Gerard Manley Hopkins, 'That Nature is a Heraclitean Fire and of the Comfort of the Resurrection' <http://www.bartleby.com/122/48. html> [accessed 18 August 2017]. I am very grateful to Matt Saunders, artist and curator of the exhibition 'Out Riding Feet' at Harris Lieberman Gallery, New York, 12 January–9 February 2008, for his insights into sprung rhythm.
3. *ibid.*
4. It was discovered in 2004, in a bundle of drawings left behind after her residency at Delfina Studios. See Marina Warner, 'Tacita Dean: Light Drawing In', in Theodora Vischer (ed.), *Gehen/Walking*, (Basel, 2008), pp. 15–28.
5. Tacita Dean, 'The Story of Perfect Feet', talk given 7 July 2006, in Fisher, p. 7.
6. *Czech Footage Sequence* (1990s), *ibid.*
7. *ibid.*, p. 11.
8. *ibid.*, p 7.
9. Tacita Dean to Marina Warner, email 11 February 2009.
10. Dean (2006), p.7.
11. Paul Ricoeur, *The Symbolism of Evil*, tr. Emerson Buchanan (New York, 1992).
12. *Homeric Hymns* (London, 2003), tr. Jules Cashford, p. 5, line 3. See <www. earlywomenmasters.net/demetermyth> for a Greek version [accessed Jan 1 2011].
13. Apollodorus, *The Library*, tr. Sir James Frazer,

(Cambridge, MA and London, 1976 [1921]), I, pp. 36–37.
14. *Homeric Hymns*, pp. 13–14, lines 201–06.
15. *ibid.*, p. 15, lines 229–30.
16. *ibid.*, lines 239–40.
17. Iambic meter was introduced by the satirists Archilochus, Seminodes and Hipponax from the mid-7th to 6th century BCE. The latter created one which ended in three spondees, *dum dum dum*, or *dum dum da*. This meter is called a scazon, literally dragging or limping. See Oliver Taplin, *Comic Angels: And Other Approaches to Greek Drama Through Vase-Painting* (Oxford, 1994), pp. 50–51. Semonides used iambics in his notorious diatribe against women ('Females of the Species') in which he derives different female types from animals. Though extremely hostile, the work reveals the ironic ambiguity intrinsic to satire: it is never stable in meaning and similar obscenities, when voiced by women, might have an apotropaic or defensive function.
18. See Marina Warner, *From the Beast to the Blonde* (London, 1994), pp. 151–52.
19. Clement of Alexandria, *Exhortation to the Greeks*, ed. W. Butterworth (London and Cambridge, MA, 1960), pp. 40–43; Otto Kern (ed.), *Orphicorum Fragmenta* (Berlin, 1963), p. 128.
20. Demeter may have been hallucinating when she saw a baby dancing in Iambe's womb; or Iambe was holding in her arms the god Bacchus/Iacchos, whose cult was also kept fervently at Eleusis, hiding him in a fold of her dress; or some think she performed a kind of belly dance, animating a painting on her abdomen (an idea which brings to mind the famous lewd Magritte image of a torso as a face, with breasts for eyes and pubic triangle for the mouth). See Georges Devereux, *Baubo ou La Vulve mythique* (Paris, 1983), pp. 27–29, for a psychoanalytic discussion of the myth's meanings.
21. Paul Muldoon, 'Maggot', *Poetry Book Society Bulletin* (Winter 2010), 12–13.
22. Margaret Atwood, *Negotiating with the Dead: A Writer on Writing* (Cambridge, 2002), p. 156.
23. 'An Aside: Selected by Tacita Dean' at Hayward Gallery, 2005.
24. Robert Graves, *The White Goddess: A historical grammar of poetic myth*, (London, 1961 [1948])
25. *ibid.*, p. 303, and 'The Bull-Footed God', pp. 314–41.
26. *ibid.*, pp. 302; 318, 324–25.
27. Carlo Ginzburg, *Ecstasies: Deciphering the Witches' Sabbath*, tr. Raymond Rosenthal (New York, 1991), especially p. 257.
28. Carlo Ginzburg, 'Witches and Shamans' tr. Stuart Hood, *New Left Review* I/200 (July–August

1993), 83.

29. Ginzburg (1991), p. 243. Rather in the same way as Tacita Dean can spot four-leaved clovers, or even five- or six-leaved clovers, she began to notice and make an imaginary family from other figures who are lame: Tutankhamun; Sarah Bernhardt; Neil Young; a friend told her that the artist Cecil Collins always limped while he was making a painting.

30. Ginzburg's argument has received macabre support from a recent archaeological find: an ancient burial in a cave between the Mediterranean and the Sea of Galilee, from a time around 12,000 years ago when the Natufian culture of hunter-gatherers flourished. The grave contains the skeleton of an old woman who suffered from various 'pathologies which would have affected the woman's gait (ie limping or foot dragging) and would have given her an unnatural, asymmetrical appearance.' She was laid on her side, curled up foetus-style in a position often found in ancient burials, except that in her case her pelvic basin is spread out flat, her legs parted and bent inwards at the knees as if giving birth. Precious things were assembled as grave goods around her: 'an auroch's tail, two skulls of a stone marten, two bones from the wing-tip of a golden eagle…pelvic bones of the extremely rare *Panthera pardus*, the foreleg of a wild boar/ the horn of a male gazelle/fifty tortoise shells' (the archaeologists think they were eaten for the funeral feast, and say they must have taken time to gather, since tortoises are not common in those parts) and 'one large, severed human foot.' The exceptional character of this burial, write the three women archaeologists, shows that its subject was someone of the highest prestige. 'All of these efforts', they continue, 'were invested in the burial of an elderly disabled woman.' They surmise as a result that, 'this burial is consistent with expectations for a shaman's grave.' Leore Grosman, Natalie D. Munro and Anna Belfer-Cohen, 'A 12,000-year-old Shaman burial from the southern Levant (Israel)', *PNAS* 105/46 (18 November 2008) 17665–69.

31. For example, 'All That Fall' (1957), 'Embers' (1959), 'Quad' (1984), in Samuel Beckett, *Collected Shorter Plays* (London, 1985).

32. 'Footfalls', *ibid.*, pp. 237–44.

3. SPECTRAL TECHNOLOGIES

1. René Descartes, 'La Dioptrique', in E. Haldane (ed.), *Philosophical Works* (Cambridge, 1911), p. 253.

2. Plato, *The Republic*, x, tr. Benjamin Jowett (1894 [c. 306 BCE]). Italics added.

3. Claudia Swan, 'Eyes Wide Shut: Early Modern Imagination, Demonology, and the Visual Arts', *Zeitsprünge* 7 (2003), 560–81.

4. Robert Fludd, *Utriusque Cosmi* [*Of This World and the Other*] (Oppenheim, 1617–19).

5. See Marina Warner, 'Camera Ludica', in Laurent Mannoni et al., *Eyes, Lies and Illusions* exh. cat. (London, 2004), p. 14.

6. Robert Smithson, 'Incidents of Mirror Travel in the Yucatan', in *Collected Writings* (Berkeley, 1996), p. 132.

JOAN JONAS

1. Contribution to the US pavilion at the 2015 Venice Biennale.

2. Ronald Caplan (ed.), *Cape Breton Book of the Night Stories of Tenderness & Terror* (Wreck Cove, 1991).

3. Stephanie Dalley, *Myths from Mesopotamia: Creation, the Flood, Gilgamesh, and Others* (Oxford, 2000), p. 155.

4. 'Hunc circum innumerae gentes populique volabant;/ac velut in pratis ubi apes aestate serena/ floribus insidunt variis et candida circum/lilia funduntur, strepit omnis murmure campus.' Virgil, *Aeneid*, VI.705–10; or 947–51 in *Virgil: The Aeneid*, tr. Robert Fitzgerald (New York and Toronto, 1990).

5. See Philip Ball, *Nature's Patterns: A Tapestry in Three Parts*, Part II: *Flow* (Oxford, 2009), pp. 124–63.

6. Georges Didi-Huberman, Foreword to Philippe-Alain Michaud, *Aby Warburg and the Image in Motion*, tr. Sophie Hawkes (Brooklyn, 2007), pp. 7–19; and pp. 173–74. See also Marina Warner, *Fantastic Metamorphoses, Other Worlds* (Oxford, 2002), pp. 90–93.

7. Homer, *Odyssey*, x.568–95.

8. *ibid.*, XI.205–24.

9. *Aeneid*, VI.938–42.

10. Jean-Claude Schmitt, *Ghosts in the Middle Ages: The Living and the Dead in Medieval Society*, tr. Teresa Lavender Fagan (Chicago, 1999).

11. *Cape Breton Book*, pp. 131–32.

12. Halldór Laxness, *Under the Glacier*, tr. Magnus Magnusson (London, 2005).

13. *ibid.*, pp. 221–22.

14. Roger Caillois, *Pierres* (Paris, 2005 [1966]), p. 9.

15. For Mi Fu see Caillois, 74–76, 85–106; Marina Warner, 'The Writing of Stones', *Cabinet Magazine*, 29 (Spring 2008); a different version of this text appeared as 'The Language of Stones' / 'Il Linguaggio delle pietre' in Anna Deneri (ed.), *Joan Jonas* (Milan, 2007).

16. Marina Warner, *Phantasmagoria: Spirit Visions, Metaphors and Media* (Oxford, 2006), pp. 308–16.

17. Caillois, p. 89.

18. Warner (2006), 113–16.
19. Caillois, p. 103.

SIGMAR POLKE
1. Albert M. Dalcq, 'Form and Modern Embryology', in L. L. Whyte (ed.), *Aspects of Form*, (Bloomington, 1961), pp. 91–116.
2. Roger Caillois, *Pierres* (Paris, 2005 [1966]); also *The Writing of Stones*, tr. Barbara Bray (Charlottesville, 1985[1970]).
3. Caillois (2005), p.8.
4. Pliny, *Natural History*, tr. H. Rackham (Cambridge, MA and London, 1984), XXXVII.LIV:10. I've also used Alan Woolley, *Rocks & Minerals* (Falmouth, 1985).
5. See for example Martin Henig, *The Content Family Collection of Ancient Cameos* (Oxford and Houlton, Maine, 1990).
6. Jacqueline Burckhardt, 'A "Wall Transformation" by Sigmar Polke', in Ulrike Jehle-Schulte Strathaus (ed.), *Novartis Campus- Fabrikstrasse 16. Krischanitz und Frank Architekten* (Basel, 2008) pp. 22–23.
7. Sigmar Polke, quoted in Bice Curiger, '*Works and Days*: "If you can't figure it out, you'll have to swing the pendulum yourself!"' in *Works and Days*, exh. cat. (Zurich, 2005) pp. 8–27; p. 25.
8. *ibid.*, pp. 16–17; 19–20.
9. I explore the phenomenon of *fata morgana* and the changing approaches to deciphering messages in mirages, clouds, stains and other 'insubstantial pageants' in *Phantasmagoria: Spirit Visions, Metaphors, and Media* (Oxford, 2006), pp. 95–144, and also 'Camera Ludica', in Laurent Mannoni et al., *Eyes, Lies and Illusions*, exh. cat. (London, 2004), pp. 13–23.
10. Thomas Browne, 'The Garden of Cyrus', in *Religio Medici, Hydriotaphia, and The Garden of Cyrus*, ed. Robin Robbins (Oxford, 1972), pp. 168–69, quoted in *Sir Thomas Browne: Selected Writings*, ed. Claire Preston (Manchester, 2006), p. 140. The first exclamation is found in a hyacinth, and means "alas"; the other two 'signatures' have not been traced.
11. Sir Thomas Browne, 'Notebooks', in *The Complete Works of Sir Thomas Browne*, ed. Sir Geoffrey Keynes (Chicago, 1964), pp. 246–48, quoted in *Selected Writings*, pp. 139–40.
12. The initial is in the French Sens Bible, Sens, Bibl. Mun. 001, fol. 163v. See Walter Cahn, *The Twelfth Century: Romanesque Manuscripts*, (London, 1996), II.
13. See https://www.youtube.com/watch?v=UEyaIDO7sjI; https://www.youtube.com/watch?v=VxhDwqwMgaY [accessed 7 March 2018].

AL AND AL
1. Euripides, *Helen*, tr. Frank McGuinness, performed at the Globe Theatre in 2014.
2. Hesiod, *Theogony*, lines 569–601, and *Works and Days*, lines 59–64, in *Hesiod and Theognis*, tr. Dorothea Wender (Harmondsworth, 1982).
3. Homer, *Iliad*, tr. Richmond Lattimore (Chicago, 1961), p. 386, lines 416–22.
4. 'In conversation with Grant Morrison', in Al and Al, *Eternal Youth* (Liverpool, 2008), pp. 120–21.
5. Steven Millhauser, 'Eisenheim the Illusionist', in *The Barnum Museum* (Normal, IL, 1997), pp. 215–37.
6. Ann Ziegler, *Photograph 51* (London, 2015), p. 11.
7. Mikel Dufrenne, quoted by Andrea Scrima, review of *Seiobo There Below* and *Music and Literature* 2, *Quarterly Conversation* 33 (September 2, 2013) <http://quarterlyconversation.com/seiobo-there-below-by-laszlo-krasznahorkai-and-music-literature-issue-2> [accessed 15 October 2015].
8. László Krasznahorkai, *Seiobo There Below*, tr. Ottilie Mulzet (New York, 2012), p. 307.
9. *ibid.*, p. 309. The passage continues: 'He just grows dizzy and doesn't understand how these lines, constructed from star-shaped points, can lead into infinity, the entire space allotted to them is so tiny, and it is this that leads to the thought that in the Alhambra, a truth never before manifested reveals itself, that is to say that something infinite can exist in a finite, demarcated space; well but this, how can this be?'
10. *ibid.*, p. 311.
11. Gilles Deleuze, *The Fold*, tr. Tom Conley (Minneapolis, 1992); see Giuliana Bruno, 'Pleats of matter, Folds of the Soul', *Log* 1 (Fall 2003), 113–22.

JUMANA EMIL ABBOUD
1. A film piece called *Something to Confuse a Thief in the Dark* was included in a show at the Baltic, Gateshead, 2016; the exhibition 'Horse, Bird, Tree and Stone' was held at the Bildsmuseet, Umeå, Sweden, until 17 September 2017; under a new title, 'The Pomegranate and the Sleeping Ghoul', it was held at Darat al-Funoun, The Khalid Shoman Foundation, Amman.
2. Collection held at Birzeit University. <http://virtualgallery.birzeit.edu/tour/ethno/coll-cat?id=01> [accessed 20 March 2017].
3. See for example 'The Tale of the Greek King and the Doctor Douban', 'The Tale of the King's Son and the She-Ghoul', in *The Arabian Nights*, tr. Malcolm Lyons (London, 2010), I.
4. Tawfiq Canaan, *Haunted Springs and Water*

Demons in Palestine (Jerusalem, 1922), p. 12.

5. 'The Woman Whose Hands were Cut Off', in Ibrahim Muhawi and Sharif Kanaana, *Speak Bird, Speak Again: Palestinian Arab Folktales* (Berkeley, Los Angeles and Oxford, 1989), pp. 241–43.

6. Salim Tamari, 'Lepers, Lunatics and Saints: The Nativist Ethnography of Tawfiq Canaan and his Jerusalem Circle', in *Mountain Against the Sea: Essays on Palestinian Society and Culture* (Berkeley, 2009), p. 35.

7. Tawfiq Canaan, *Mohammedan Saints and Sanctuaries in Palestine* (London, 1927) <http://digital.soas.ac.uk/LOAA003475/00002/9j> [accessed 19 March 2017], p. v.

8. Canaan (1922), p. 18.

9. Jumana Emil Abboud, *The Book of Restored Hands* (Ramallah, 2016), published for the exhibition, 'O Whale, Don't Swallow Our Moon' at Qalandiya International III, 2016.

10. Alfred Korzybski, 'A Non-Aristotelian System and its Necessity for Rigour in Mathematics and Physics', in *Science and Sanity: An Introduction to Non-Aristotelian Systems and General Semantics.* (Lakeville, CT, 1958 [1931]), pp. 747–61.

11. Octavio Paz, 'Vrindaban', tr. Lysander Kemp, in *Configurations* (New York, 1971), p. 149.

12. Aerial photographs taken by Fazal Sheikh in the Negev desert reveal, imprinted in the rocks and the sand, the ghostly outlines of Bedouin encampments, cemeteries and other buildings which have been taken over by official Israeli agricultural development and settlements and otherwise obliterated. See Eyal Weizman and Fazal Sheikh, *The Conflict Shoreline: Colonization as Climate Change in the Negev Desert* (Göttingen and Brooklyn, 2015); also Eyal Weizman, *Forensic Architecture: Violence at the Threshold of Detectability* (New York, 2017); map reproduced in Ahdaf Soueif and Omar Robert Hamilton (eds), *This Is Not a Border: Reportage and Reflection from the Palestine Festival of Literature* (London, 2017).

13. An ambitious video film made in 2015 by another Palestinian artist, Larissa Sansour, sets up a Borgesian scenario about planting archaeological evidence for future generations to find and remember that Palestinians were there; using bluescreen and CGI simulations, the film shows plates decorated with the lattice blue and white of the *keffiyeh*, or Palestinian scarf, raining down on the desert landscape and planting themselves in the ground. *In the Future They Ate from the Finest Porcelain*, screened at 'Into the Unknown', Barbican Centre, 2017.

CHRISTIAN THOMPSON

1. With thanks to the artist for sharing his thoughts; to Anthony Gardner for his comments and insights; and to Kira Hartley for background research.

2. 'Ritual Intimacies', Monash University Art Gallery, 27 April–8 July 2017.

3. Stuart Hall, *Familiar Stranger: A Life between Two Islands* (London, 2017), p. 3.

3. *ibid.*, p. 14.

4. See Tracey Warr, 'Camouflage, Display, Dazzle', in Christian Thompson et al., *We Bury Our Own*, (Fitzroy, Australia, 2012).

5. Christian Thompson, 'Creative Responses to Australian Material Culture in the Pitt Rivers Museum Collection: Parallels between "We Bury Our Own" and "Mining the Museum"', D.Phil thesis, University of Oxford, 2017, p. 4.

6. Walter Benjamin, 'Little History of Photography', tr. Rodney Livingstone, in Michael W. Jennings (ed.), *Selected Writings: Volume 2: 1927–1934*, (Boston, 1999), pp. 507–30; p. 527.

7. Hannah Fink, 'Tradition today: Indigenous art in Australia' <https://www.artgallery.nsw.gov.au/collection/works/393.1993/> [Accessed 17 March 2017].

8. Michael Fried, *Absorption and Theatricality: Painting and Beholder in the Age of Diderot* (Berkeley, CA, 1980), pp. 125–27.

9. Thompson, 2017, p. 140.

10. *ibid.*, p. 124.

11. See Hal Foster, 'The Artist as Ethnographer?', in Jean Fisher (ed.), *Global Visions: Towards a New Internationalism in the Visual Arts* (London, 1994), pp. 302–09.

12. Abdelfattah Kilito, *Thou Shalt Not Speak My Language*, tr. Waïl Hassan (Syracuse, NY: Syracuse University Press, 2008).

13. See Australian Institute of Aboriginal and Torres Strait Islander Studies (AIATSIS) and the Federation of Aboriginal and Torres Strait Islander Languages and Culture (FATSILC), *National Indigenous Languages Survey*, (Canberra, 2005), pp. 20–21.

14. Epigraph to Standing Committee on Aboriginal and Torres Strait Islander Affairs, House of Representatives, *Our Land Our Languages: Language Learning in Indigenous Communities* (Canberra, 2012), p. 8.

15. Walter Benjamin, 'Theses on the Philosophy of History', tr. Harry Zohn, in *Illuminations,* p. 249.

4. ICONOCLASHES

1. An old Soviet joke, reused as a title for a group show at Calvert 22, August 2017, on writing and rewriting history <http://calvert22.org/future-is-certain/> [accessed 2 November 2017]

2. See Bruno Latour et al, *Iconoclash* (Karlsruhe

and London, 2002).

3. Pierre Nora, 'Between memory and history: Les lieux de mémoire', tr. M. Roudebush, *Representations* 26 (Spring 1989), 19.

4. David Freedberg, 'Holy Images and Other Images' (1995) <https://doi.org/10.7916/D89W0QMJ> [Accessed 19 March 2018]; Freedberg's book, *The Power of Images* (London, 1956), is the key work on this theme; see especially pp. 76–78, 246–82.

5. Paul Ricoeur, *The Symbolism of Evil*, tr. Emerson Buchanan (New York, 1992), p. 354; see also Beverley Butler, 'The Efficacies of Heritage: Syndromes, Magics, and Possessional Acts', *Public Archeology* 15, 2-3, 113-135 <https://doi. org/10.1080/14655187.2016.1398390>[Accessed March 15 2018].

HIERONYMUS BOSCH

1. See Webster's New World College Dictionary, 4th Edition.

2. I am grateful to Phil Oeltermann for his research into German language proverbs, including this example. He adds that Gottfried Keller's novella, 'Romeo and Juliet from the Countryside', tr. Ronald Taylor (London, 2015), describes the lovers making love for the first time in a ship of hay which then becomes the vessel carrying them to their deaths.

3. More recently, the Eton Boating Song, anthem of the most privileged of English public schools, paints a picture of a perfect early summer scene on the river in its famous opening lines: 'Jolly boating weather/And a hay harvest breeze…'

4. For more on Bosch's work, see Jos Koldeweiji et al., *Hieronymus Bosch* (Milan, 2001); Jos Koldeweiji et al., *Hieronymus Bosch: The Complete Paintings and Drawings* (Rotterdam and Amsterdam, 2001); Joseph Koerner, 'Bosch's Contingency', in Gerhart von Graevenitz and Odo Marquard (eds.) *Poetik und Hermeneutik* XVII (Munich, 1998), pp. 245–74; and Dino Buzzati, *L'Opera completa di Hieronymus Bosch* (Milan, 1977)

5. Joseph Koerner, 'Everyman in Motion: From Bosch to Bruegel', lecture given at the British Academy, November 2005. I am most grateful to the author for lending me the typescript.

6. The preacher's didacticism is even more marked in another Everyman painting by Bosch. *The Pedlar* (c. 1500), in the Boymans van Beuningen Museum, Rotterdam, once formed the outer image of a triptych composed of a Ship of Fools in the centre and *The Allegory of Gluttony and Death* and the *Usurer* on the inside wings. See Koldeweiji et al. (2001), p. 88.

7. Hans Belting, *Garden of Earthly Delights*, tr. Ishbel Flett (Munich, 2002), p. 85.

8. Sebastian Brant's *Ship of Fools* (1494) and Erasmus's *In Praise of Folly* (1511) could have been known to Bosch. They appeared very close to the date of the painting on this subject now in El Escorial Monastery (1498–1504) and the Prado panel (around 1510–16).

9. Koerner, 2005.

10. For a discussion of the 'gryllus' and 'grylloi', see Marina Warner, *No Go the Bogeyman: On Scaring, Lulling, and Making Mock* (London, 1998), pp. 284–301.

11. *The Triumphs of Caesar* (1431–1506), now in Hampton Court Palace.

12. In his ferocious carnival suite of woodcuts, Hans Holbein the Younger showed Death whirling away pope and peasant alike: another fatal harvest.

13. See also *The Pedlar* (*c.* 1500).

14. 'Here shall Jacke, Charles, my brother Robyn hyll/ With Myllers and bakers that weight & mesure hate,/All steylynge taylers, as Soper & Manshyll,/ Receyve their rowme, bycause they come to late;/The foulest place is mete for their estate…' Sebastian Brant, *The Ship of Fools*, tr. Alexander Barclay (Edinburgh and London, 1874), quoted in Aurelius Pompen, *The English Versions of the Ship of Fools* (London, 1925), p. 303, lines 1877 ff.

15. Strictly speaking, hay comes from grass and other pasturage, filled with wild flowers, which animals that chew the cud can enjoy after it has been harvested and stored; by contrast, straw comes from the stalks of cereals such as wheat, oats and barley – a residue useless for nourishment. Yet, with different nuance, both harvests lend themselves to metaphors for vanity. Brant compares the impossibility of a fool keeping a secret to 'straw blowing from a windy hill.' In English, 'clutching at straws' is to hold on to improbability; 'straws in the wind' are vain hopes; a 'man of straw' is someone of no account. Straw is deeply entangled with the Vanitas tradition. Webster's gives its figurative meanings as 'a thing of smallest worth', and 'a mere trifle'.

16. See Nicola Bown, *Fairies in Nineteenth-Century Art and Literature* (New York, 2006), p. 119 ff., for a perceptive account of Bosch's use of miniaturization and grotesque.

17. Ludwig von Baldass, *Hieronymus Bosch* (Vienna, 1943), Plate 55.

18. Held at El Escorial Palace, near Madrid.

19. For a brilliant and detailed discussion of the topos, see Joseph Koerner, *The Reformation of the Image* (London and Chicago, 2004).

20. Raphael interpreted this with spiritual intensity in a fresco of 1512 in Palazzo Pontifici, Stanza

di Eliodoro, Vatican City.

21. His audience seems to have grasped this meaning, if you look at the later tapestry interpreting *The Haywain*. This magnificent work shows the central panel of the triptych within a sphere – a globe, as in the outer wings of the *Garden of Earthly Delights*. This sphere is surmounted by a cross, and so represents the orb traditionally held by God. In the tapestry, it is tilted as if falling sideways into a turbulent seascape, where huge, wonderful sea monsters are surfacing to swallow their victims, several of whom are tumbling or being dragged off the tipping world by devils lying in wait on the edges. One of these devils has even raised a ladder from its boat to the world, echoing the ladders against the hay load in the earlier painting. In the foreground, on the left, a monk is ferociously resisting his demon captor. The sphere is also, disconcertingly, as round as a host; a host profaned and disgraced by its occupants, who have turned god-created human flesh into withered grass, shipwrecked in a sea of demons and monsters. It is central to this scene that 'host' means a sacrifice or offering. The globe also resembles a bubble. *Homo bulla* (man the bubble) is one of the proverbial adages in Vanitas pictures. In the tapestry it serves as a mirror of human error, vain pursuits and pleasures. The tapestries reached El Escorial in 1593, after the death of the Duke of Alba. They reverse the paintings' composition, suggesting an interim image. See Belting, p. 84.

22. Michel de Certeau, *The Mystic Fable* (Chicago and London, 1992), I, p. 51.

23. Belting, p. 17; see also Joseph Koerner, 'Impossible Objects: Bosch's realism', *Res* 46 (Autumn 2004), pp. 73–97.

DAMIEN HIRST

1. Eugenio Trías, 'Thinking Religion: The Symbol and the Sacred', in Jacques Derrida and Gianni Vattimo (eds), *Religion* (Cambridge, 1998), p. 110; he is quoting Ernst Cassirer, *The Philosophy of Symbolic Forms*, tr. Ralph Manheim (New Haven, 1955), II, pp. 106–09. See John Gale's letter in *London Review of Books (LRB)* 34/15 (2 August 2012) <https://www.lrb.co.uk/v34/n15/letters#letter4> [accessed 19 March 2018].

2. 'The simplest spatial relations, such as left and right and forward and backward, are differentiated by a line drawn from east to west, following the course of the sun, and bisected by a perpendicular running from north to south – and all intuition of temporal intervals goes back to these intersecting lines.' Cassirer, II, p. 107.

3. Trías, pp. 103, 109.

4. 'The connection between mass assemblies, their precincts and stretching time became clearer during the 2012 Olympic Games in London, which led to intense displays of secular public symbolism. I hadn't noticed before just how important accurate *demarcations* of the lanes, the pitch, the track, the field and the ring are in every sport during the Games: all those shots of the ground being examined to ascertain exact measurements, talk of *split* seconds being *shaven* off speed records, world champions surpassing their nearest rivals' highest and longest jumps by infinitesimal increments. But even as the athletes were running or swimming faster than anyone ever had, the effect of all these sections and truncations was to prolong the passage of time. For a sports virgin like myself, it was unimaginable that a nano-slice – how long is 0.014 of a second? – could count at all, let alone make a difference after a race of ten kilometres. And it was astonishing to experience an interval of less than ten seconds as a momentous event: the 100 metres race seemed to take longer than I would shuffling along for miles. In the setting of a temple on a global platform, the athletes were in effect cutting up the passage of time in different ways, according to the logic of imagining space-time, and the stadium turned into a gigantic and special kind of clock, in which time was moving both faster and slower in front of our eyes.' Marina Warner, letter in *LRB*, 34/16 (30 August 2012) <https://www.lrb.co.uk/v34/n16/letters#letter7> [accessed 19 March 2018].

5. Paul Ricoeur, *The Symbolism of Evil*, tr. Emerson Buchanan (New York, 1992).

6. Trías, pp. 104, 109.

7. See 'Damien Hirst: For the Love of God', Tateshots – 11 April 2012 <http://www.tate.org.uk/art/artists/damien-hirst-2308/damien-hirst-love-god> [accessed 9 March 2018].

8. 'Yayoi Kusama', Tate Modern, 9 February–5 June 2012.

9. Sean O'Hagan, 'Hirst's diamond creation is art's costliest work ever', *The Observer* (21 May 2006).

FELICITY POWELL

1. 'Medals of Dishonour', co-curated with Philip Attwood, Keeper of Coins and Medals at the British Museum. Two years later the exhibition travelled to the Hermitage Museum, St Petersburg.

2. 'Charmed Life: The Solace of Objects' at the Wellcome Collection, 6 October 2011–26 February 2012.

FRANS MASEREEL

1. 'Sois sage, ô ma douleur, et tiens-toi plus

tranquille…/Pendant que des mortels la multitude vile,/Sous le fouet du Plaisir, ce bourreau sans merci,/Va cueillir des remords dans la fête servile,/Ma Douleur, donne-moi ta main; viens par ici,/Loin d'eux. Vois…/Le Soleil moribond s'endormir sous une arche,/Et comme un long linceul traînant à l'Orient,/Entends, ma chère, entends la douce Nuit qui marche.' Charles Baudelaire, 'Recueillement' (Meditation), in *Selected Poems from Les Fleurs du Mal*, tr. Jan Owen (Todmorden, 2015), pp.172–73.

2. Letter dated June 21st, 1924 (Paris, Bibliothèque Nationale).

3. Thomas Mann, Introduction to Frans Masereel, *Passionate Journey: A Novel Told in 165 Woodcuts*, tr. Joseph M. Bernstein, in Jeet Heer, Kent Worcester (eds.), *Arguing Comics: Literary Masters on a Popular Medium* (Jackson, 2004), p. 14.

4. For a translation of Hesse's introduction see Frans Masereel, *Story Without Words: A Novel in Pictures* (New York, 2001)

5. Josef Herman, *Frans Masereel, 1889–1972: The Radical Imagination* (London, West Nyack, NY, 1980), p. 16.

6. See Mann (2004), p. 14.

7. Peter Handke, 'The Long Way Around', in *Slow Homecoming*, tr. Ralph Manheim (New York, 1985), p. 24.

CRISTINA IGLESIAS

1. Roni Horn, *Another Water (The River Thames, for Example)* (Göttingen, 2000). Artwork commissioned by the Public Art Development Trust, 1999.

2. The waterworks were built by a Spanish-Italian clockmaker, Juanelo Turriano, in the first half of the 16th century.

3. *Tres Aguas* (2014) was commissioned by Artangel with Fundacion El Greco.

4. Maria Rosa Menocal, *The Ornament of the World: How Muslims, Jews, and Christians Created a Culture of Tolerance in Medieval Spain* (New York, 2002).

5. Johan Huizinga, *Homo Ludens: A Study of the Play-Element in Culture* (London, 1949)

6. Michel Baridon, *A History of the Gardens of Versailles* (Philadelphia, 2008), p. 161.

7. Giuliana Bruno, 'The Thickness of Surface: Projections on a Screen-Wall', in Cristina Iglesias et al., *Metonymy* (Madrid, 2013), pp. 67–81.

8. *ibid.*, p. 70.

9. *ibid.*, pp. 70–71.

10. See the excellent guidebook to the Synagogue and its restoration: Ana María López Álvarez, Santiago Palomero Plaza and M. Luisa Menéndez Robles, *Guia del Museo Sefardí*, (Madrid)

11. Karl August Wittfogel, *Oriental Despotism: A comparative study of total power* (New Haven, 1957), p. 215.

12. Mohammed El Faïz, *Les Maitres de l'eau Histoire de l'hydraulique arabe* (Arles, 2005), pp. 183–90, 251–63. I am grateful to Omar Berrada for this reference and below, in note 16.

13. See section of plates called 'Arts et Métiers', in E. F. Jonard (ed.), *Description de l'Égypte: ou Recueil des observations et des recherches qui ont été faites en Égypte pendant l'expédition de l'armée française* (1809–28), II, p. 10.

14. Wittfogel, p. 215.

15. Eyal Weizman, *The Politics of Verticality: The Architecture of Israeli Occupation in the West Bank*, PhD thesis, Birkbeck College University of London, 2008). See also Eyal Weizman, *Hollow Land: Israel's Architecture of Occupation* (London, 2007).

16. See José Miguel Puerta Vílchez, *La Poética del agua en el islam/The Poetics of Water in Islam*, tr. Jeremy Rogers (Gijon, 2011).

17. See *Qur'an*, tr. Tarif Khalili (London, 2009), pp. 502–03, Suras 47, 78, 83.

18. Ibn Arabi, 'Treatise on What Is It To Be Rejected, 2009', in Vílchez, p. 105.

19. El Faïz, pp. 110–14.

20. *ibid.*

21. Ibn al-Sai, *Consorts of the Caliph's Women and the Court of Baghdad*, ed. Shawkat M. Toorawa, tr. Editors of Library of Arabic Literature (New York, 2015), pp. 86–88. *Tiraz* are 'embroidered or woven bands bearing the name and regnal title of the ruler, that were set into the sleeves of the robes of honour that the ruler bestowed.' I am grateful to Julia Bray for this explanation.

22. Primo Levi, *The Periodic Table*, tr. Raymond Rosenthal (London, 1985), p. 231.

23. *ibid.*, p. 227.

24. In August 2014 the spacecraft Rosetta succeeded in coming alongside the comet it had been chasing for ten years; by November, Philae, the landing craft, had landed on the jagged, desolate frozen surface of the meteor and sent back the first information of its kind into the origins of life on earth. 'Comets are fragments from the time when the planets exploded into existence,' commented one of the astronomers involved, 'and they might have brought the water and carbon that catalyzed life on earth…. These are the veritable ingredients of life, and by going to the comet, we are going back in time, to four and a half billion years ago, to study the frozen remnants of that, staring at the ancestral ingredients, at

the stuff that existed before life existed.' I took notes from BBC news report; see also <https://www.newscientist.com/article/2090696-building-blocks-of-life-spotted-around-comet-for-the-first-time/> [accessed 19 March 2018]

25. Adrian Stokes, 'The Quattro Cento', in *The Critical Writings* (London, 1930–37), II, p. 53.

26. 'C'est qu'il m'importe sur toute chose, d'obtenir *ce qui va être*, qu'il satisfasse, avec toute la vigueur de la nouveauté, aux exigencies *de ce qui a été*.' (Emphasis in the original) Paul Valéry, 'Eupalinos ou l'architecte', in *Eupalinos, L'Ame et la danse, Dialogue de l'arbre* (Paris, 1944), p. 42.

27. 'la liqueur éblouissante vient épouser, dans le sable durci, la creuse identité du moindre pétale…', *ibid.*, p. 43.

28. 'Ces roses qui furent fraiches, et qui périssent sous tes yeux, ne-sont-elles pas toutes choses, et la vie mouvante elle-meme?', *ibid.*, p. 42.

JULIE MEHRETU

1. Yves Bonnefoy, 'Sao Domingos, After the Fire', in Emily McLaughlin and Patrick McGuinness (eds.), *The Made and the Found: Essays in Honour of Michael Sheringham* (Oxford, 2017), p. 1.

2. Seamus Heaney, 'Preface', in M. P. Hederman and R. Kearney Dublin (eds.), *The Crane Bag Book of Irish Studies* (Dublin, 1982 [1977–81]).

3. *ibid.*

4. From a conversation with the artist, 2 March 2017.

5. See Clive Coward, *Nigel Henderson's Streets: Photographs of London's East End 1949–53* (London, 2017).

6. T.J. Demos, 'Painting and Uprising: Julie Mehretu's Third Space', in Julie Mehretu, Tacita Dean, T.J. Demos et al., *Julie Mehretu: Liminal Squared* (New York and London, 2013), p. 59.

7. See Jean-Yves Sarazin, *Portulans: Grandes Découvertes* (Paris, 2016).

8. Mary Emma Harris, *The Arts at Black Mountain College* (Cambridge, MA and London, 1992), p. 53, quoted by David Herd, '"From him only will the old State-secret come": what Charles Olson imagined', *English* 59/227 (2010), 375–95.

9. J. A. Wheeler, *Geons, Black Holes, and Quantum Foam*, (New York, 2000), p. 235.

10. Mark Dorrian and Frédéric Pousin (eds), *Seeing from Above: The Aerial View in Visual Culture* (London, 2013).

11. *ibid.*

12. Roger Copeland, *Merce Cunningham: The Modernizing of Modern Dance*, (New York and London, 2004), p. 77.

13. Julie Mehretu, 'Notes on Painting', in Isabelle Graw and Ewa Lajer-Burcharth (eds.), *Painting Beyond Itself: The Medium in the Post-medium Condition* (Berlin, 2016), p. 271.

14. Glenn Ligon, 'On the Ground', in Julie Mehretu, *Grey Paintings* (unpublished), p. 84.

15. Tacita Dean, 'The Journey of Return', in Mehretu et al. (2013).

16. Julie Mehretu, 'Notes on Painting', *ibid.*

17. William Kentridge, *Six Drawing Lessons* (Cambridge, MA, 2014).

18. Alfred Gell, *Art and Agency* (Oxford, 1998).

19. See *Julie Mehretu: Black City*, exh. cat. (Berlin, 2007).

20. Joan DeJean, 'No Man's Land: The Novel's First Geography', *Yale French Studies* 73 (1987), pp. 181–82.

21. *ibid.*, p. 184.

22. Philippe-Alain Michaud, *Aby Warburg and the Image in Motion* tr. Sophie Hawkes (Brooklyn, 2007), pp. 79–80.

23. Mary Jacobus, *Reading Cy Twombly: Poetry in Paint*, (Princeton, NJ, 2016), p. 5.

24. See Irini Gonou, *Al-khatt, l'écriture magique* (Athens, 2008); also Francesca Leoni et al., *Power and Protection*, exh. cat. (Oxford, 2016).

25. 'L'arabesque n'est pas une figuration, mais un rythme, une incantation par répétition indéfinie du thème, une transcription du *dhikr* mental.' Jean Chevalier and Alain Gheebrant, *Dictionnaire des Symboles, Mythes, Rêves, Coutumes, Gestes, Formes, Figures, Couleurs, Nombres* (Paris, 1973–74), I, p. 59.

26. *ibid.*

27. Julie Mehretu, 'To Be Felt As Much As Read', *art21*, <https://art21.org/read/julie-mehretu-to-be-felt-as-much-as-read/>[accessed 7 April 2017].

FURTHER READING

The endnotes give references to sources for each essay, and those are not reprised here. The list that follows is eclectic, as it recalls writers on art who have been important to me at different stages of my life – though it is hard to remember everyone and everything. I began with a love of the Italian Renaissance alongside a keen interest in modern abstraction, and soon fell under the spell of the Warburg Institute, its founder and its many scholars. I also once taught a course called Writing Art, which explored the approaches of writers better known for their fiction or poetry than their criticism; the different forms, so often kept apart, interact with one another in crucial ways and create a significant literary tradition in its own right.

Arnheim, Rudolf, *The Split and the Structure: Twenty-Eight Essays* (Berkeley, Los Angeles and London, 1996)

Ashbery, John, *Reported Sightings: Art Chronicles, 1957-1987*, ed. David Bergman (Manchester, 1989)

Bann, Stephen, *The True Vine: On Visual Representation and Western Tradition* (Cambridge, 1989)

Barnes, Julian, *Keeping an Eye Open: Essays on Art* (London, 2015)

Barthes, Roland, *Mythologies*, tr. Annette Lavers (London, 2013 [1973])

Baudelaire, Charles, 'Salon de 1845'; 'Salon de 1846'; 'Salon de 1859', in *Charles Baudelaire, Oeuvres Complètes*, ed. by Marcel A. Ruff (Paris, 1968), pp. 204-24; 227-61; 391-424.

Baxandall, Michael, *Words for Pictures* (London and New Haven, 2003)

Bell, Julian, *What is Painting? Representation and Modern Art* (London, 1999)

Berger, John, *And Our Faces, My Heart, Brief as Photos* (London, 1984)

Bourriaud, Nicolas, *Relational Aesthetics*, tr. Ute Meta Bauer and Anca Rujoiu (Dijon, 2010)

Brett, Guy, *Carnival of Perception: Selected Writings on Art* (London, 2004)

Broude, Norma, and Mary D. Garrard (eds.), *Feminism and Art History: Questioning the Litany* (New York, 1982)

Bryson, Norman, *Vision and Painting: The Logic of the Gaze* (London and Basingstoke, 1983)

Caillois, Roger, *La Pieuvre: Essai sur la logique de l'imaginaire* (Paris, 1973)

Chadwick, Whitney, *Women, Art, and Society* (London, 1990)

Clark, T.J, *The Sight of Death: An Experiment in Art Writing* (New Haven, 2006)

Crow, Thomas, *The Rise of the Sixties* (London, 1996)

Danto, Arthur C., *The Madonna of the Future: Essays in a Pluralistic Art World* (New York, 2000)

Derrida, Jacques, *The Truth in Painting*, tr. Geoff Bennington and Ian McLeod (Chicago and London, 1987)

— *Memoirs of the Blind: The Self-Portrait and Other Ruins*, tr. Pascale-Anne Brault and Michael Naas (Chicago and London, 1993)

Diderot, Denis, *Salons* (Paris, 1995)

Dillon, Brian, *Objects in This Mirror: Essays* (Berlin, 2014)

Eden, Xandra, John Roberts and Sarah Cook, *The Lining of Forgetting: Internal & External Memory in Art* (Greensboro, N.C., 2008)

Elkins, James, *The Object Stares Back: On the Nature of Seeing* (New York, 1996)

Flam, Jack (ed.), *Robert Smithson: The Collected Writings* (Berkeley, Los Angeles and London, 1996)

Focillon, Henri, *The Life of Forms in Art*, tr. George Kubler (Boston, 1989 [1942])

Foster, Hal, *Design and Crime (And Other Diatribes)* (London, 2002)

Gombrich, Ernst, *Art and Illusion: A Study in the Psychology of Pictorial Representation* (London, 1959)

— *Meditations on a Hobby Horse and Other Essays on the History of Art* (London, 1971)

— *Symbolic Images: Studies in the Art of the Renaissance* (Oxford, 1966–76)

Gómez-Peña, Guillermo, *Warrior for Gringostroika* (St Paul, MN, 1993)

Kovats, Tania (ed.), *The Drawing Book: A Survey of Drawing – The Primary Means of Expression* (London, 2007)

Kunkel, Benjamin, *Utopia or Bust: A Guide to the Present Crisis* (London and New York, 2014)

Lippard, Lucy R., *Overlay: Contemporary Art and the Art of Prehistory* (New York, 1983)

Lord, James, *A Giacometti Portrait* (New York, 1980)

Malbert, Roger, *Drawing People: The Human Figure in Contemporary Art* (London, 2015)

Manguel, Alberto, *Reading Pictures: A History of Love and Hate* (London, 2001)

McClatchy, J. D, *Poets on Painters: Essays on the Art of Painting by Twentieth-Century Poets* (Berkeley, 1990)

McEvilley, Thomas, *Art & Otherness: Crisis in Cultural Identity* (Kingston, 1992)

Nochlin, Linda, *Representing Women* (London, 1999)

— *Women, Art and Power and Other Essays* (London, 1989)

Panofsky, Erwin, *Studies in Iconology: Humanistic Themes in the Art of the Renaissance* (New York, Hagerston, San Francisco and London, 1972)

Petherbridge, Deanna, *The Primacy of Drawing: Histories and Theories of Practice* (New Haven and London, 2014)

Van der Plas, Els, Malu Halasa and Marlous Willemsen (eds.), *Creating Spaces of Freedom: Culture in Defiance* (London and The Hague, 2002)

Pliny, *Natural History,* ix, Libri xxxiii-xxxv, tr. H. Rackham (Cambridge, MA and London, 1984)

Proust, Marcel, *On Reading Ruskin*, ed. Jean Autret, William Burford and Phillip J. Wolfe (New Haven and London, 1987)

Read, Herbert, *Art Now* (London, 1960)

Schor, Mira, *Wet: On Painting, Feminism and Art Culture* (Durham and London, 1997)

Smith, Ali, *Artful* (New York, 2012)

Stein, Gertrude, *Matisse, Picasso, and Gertrude Stein, with Two Shorter Stories* (Mineola, N.Y., 2000)

Stokes, Adrian, *The Critical Writings of Adrian Stokes* (London, 1978)

Sylvester, David, *About Modern Art: Critical Essays, 1948-2000* (London, 2002)

Tsvetaeva, Marina, *Art in the Light of Conscience: Eight Essays on Poetry,* ed. and tr. Angela Livingstone (Hexham, 2010)

Verschaffel, Bart, *Essais sur les genres en peinture: nature morte, portrait, paysage,* tr. Daniel Cunin (Brussels, 2007)

Wagner, Anne M., *Mother Stone: The Vitality of Modern British Sculpture* (New Haven and London, 2005)

Walser, Robert, and Susan Bernofsky, *Robert Walser: Looking at Pictures* (New York, 2015)

Warner, Marina, and Griselda Pollock et al., *New Hall Art Collection: Catalogue of the Women's Art at New Hall* (Cambridge, 2004)

Wind, Edgar, *Pagan Mysteries in the Renaissance* (London, 1967)

— and John Bayley, *Art and Anarchy* (Evanston, IL, 1985)

Wollen, Peter, *Raiding the Icebox: Reflections on Twentieth-Century Culture* (London and New York, 1993)

Zeri, Federico, *Derrière l'image: Conversations sur l'art de lire l'art,* tr. Jean Rony (Paris, 1988)

Zbigniew, Herbert, *Still Life with a Bridle: Essays and Apocryphas* (London, 1993)

LIST OF SOURCES

The essays and articles have all been revisited and some of them thoroughly recast for this selected volume.

1. PLAYING IN THE DARK
See 'Self-Portrait in a Rear-View Mirror' in: John Leslie, Antonia Harrison et al., *Only Make Believe: Ways of Playing* (Warwickshire: Compton Verney House Trust, 2005), pp. 4–19.

PAULA REGO
Adapted from an interview with Paula Rego, 'Shame of Secrets' in *New Statesman and Society* (26 January 1990); Marina Warner, Introduction to Paula Rego, *Nursery Rhymes* (London and New York, 1994), pp. 2–3; Marina Warner, 'Paula Rego: My Hero', *The Guardian* (24 August 2012); and a birthday tribute I gave for the artist's birthday, held at Enitharmon book shop, Bury Place, London, 2015.
See also Marina Warner, '"An artist's dreamland": Jane Eyre through Paula Rego's eyes' in *Paula Rego: Jane Eyre* (London, 2003), pp. 7–17.

HENRY FUSELI
First published in Martin Myrone (ed.), *Gothic Nightmares* (London, 2008), pp. 23–29.

JANINE ANTONI
First published as 'Child's Play' in Dan Cameron (ed.) et al., *Janine Antoni* (Küsnacht, Switzerland, 2000).

RICHARD WENTWORTH
First published as 'Richard Wentworth: A Sense of Things' in *Richard Wentworth* (London, 1993), pp. 9–16.

KIKI SMITH
First published as 'Wolf-Girl, Soul-Bird: The Mortal Art of Kiki Smith' in Siri Engberg, Linda Nochlin et al., *A Gathering, 1980–2005* (Minneapolis, 2005), pp. 42–53.

2. BODIES OF SENSE
See 'Le vil et le vigoureux, la toison et le poil: des cheveux et leur langue', trans. Marie-Ange Dutartre, in Marie-Laure Bernadac, Bernard Marcadé et al, *Féminin-Masculin: le sexe de l'art* (Paris, 1995), pp. 303–11; reprinted as 'Fur and fleece and the language of hair' in Cornelia Meyer et al., *Haare – Obsession und Kunst* (Zürich, 2000).

HANS BALDUNG GRIEN
First published as 'Eve, the Serpent and Death (Hans Baldung Grien)', *FMR* 31 (1988).

LOUISE BOURGEOIS
Adapted from Marina Warner, 'Family enfer', a review of 'Louise Bourgeois, Recent Works' at the Serpentine Gallery, London, 1998, and Louise Bourgeois, *Destruction of the Father Reconstruction of the Father*, ed. Marie-Laure Bernadac and Hans-Ulrich Obrist (London, 1998) in *The Times Literary Supplement* (15 January 1999) <https://www.the-tls.co.uk/articles/private/family-enfer/> [accessed 2 November 2017].
See also Marina Warner, 'Nine Turns Around the Spindle: The Turbine Towers of Louise Bourgeois', in *Louise Bourgeois,* exh. cat. (London, 2000), pp. 18–30.

ZARINA BHIMJI
First published as 'Secret Ceremonies of Innocence' in Zarina Bhimji et al, *Zarina Bhimji* (Cambridge, 2017) [unpaginated].

HELEN CHADWICK
Adapted from Marina Warner, 'In Extremis: Helen Chadwick & the Wound of Difference' in *Stilled Lives* (Edinburgh, 1996) [unpaginated].
See also 'In the Garden of Delights: Helen Chadwick's 'Of Mutability' in Helen Chadwick and Institute of Contemporary Arts London, *Of Mutability: Helen Chadwick* (London, 1986) [unpaginated], and 'Helen – A Eulogy', in David Notarius, Sophie Raikes et al., *Helen Chadwick – Wreaths to Pleasure* (London, 2014), pp. 53–57.

TACITA DEAN
First published in Marina Warner and Tacita Dean, *Footage* (Wien and Göttingen, 2011), pp. 9–37, as part of Tacita Dean et al., *Tacita Dean: Seven Books Grey* (Wien and Göttingen, 2011). See also 'Light Drawing In: The Art of Tacita Dean' in Theodora Vischer (ed.), *Gehen/Walking* (Basel, 2008); and interview with the artist in Jean-Christophe Royoux, et al, *Tacita Dean* (London, 2013).

3. SPECTRAL TECHNOLOGIES
See Marina Warner, 'Camera Ludica', in Laurent Mannoni, Werner Nekes and Marina Warner (eds.), *Eyes, Lies and Illusions: The art of deception* (London and Melbourne, 2006), pp. 13–23;

reprinted in *Fifty Years of Great Art Writing From the Hayward Gallery*, ed. Ralph Rugoff (Manchester, 2018).

JOAN JONAS
First published as 'Joan Jonas: The Taste of Clouds', in Jane Farver (ed.), *They Come To Us Without a Word*, exh. cat. (Cambridge, MA, 2015), pp. 30–39
See also Marina Warner, 'Joan Jonas and the scene of time' in Ute Meta Bauer and Anca Rujoiu (eds.), *Theatrical Fields: Critical Strategies in Performance, Film, and Video* (Singapore, London and Umeå, 2016), pp. 56–81, and Marina Warner, 'On Oracles & Treacle: Some Reflections of the Art of Joan Jonas' in Valerie Smith and Warren Niesluchowski (eds.), *Joan Jonas: Five Works*, (New York, 2003), pp. 89–93.

SIGMAR POLKE
First published as '"Algebra, Taumel und Ordnung": Zeichen im Stein. Form ist niemals trivial oder gleichgultig; sie ist die Magie der Welt/"Algebra, Vertigo and Order": Signs in the Stone. Form is never trivial or indifferent; it is the magic of the world', in *Sigmar Polke: Fenster – Windows, Grossmünster Zürich* (Zürich and New York, 2010), pp. 160–75

AL AND AL
Adapted from 'Al and Al', in Al and Al, *Eternal Youth* (Liverpool, 2008), pp. 12–16, and from 'Al and Al: Visions of the Honeycomb', in Al and Al et al., *Incidents of Travel in the Multiverse*, ed. Bren O'Callaghan and Sarah Perks (London, 2016), pp. 68–73

JUMANA EMIL ABBOUD
Written for Jumana Emil Abboud's exhibition, 'The Horse, the Bird, the Tree and the Stone', Umeå Bildmuseet, Umeå, Sweden (20 May 2017–17 September 2017), and for 'In Aching Agony and Longing I Wait for You by the Spring of Thieves', Tate Liverpool, 2018. Unpublished.

CHRISTIAN THOMPSON
First published as 'Magical Aesthetics' in *Christian Thompson: Ritual Intimacy*, exh. cat. (Victoria, 2017), pp. 63–76.

4. ICONOCLASHES
See 'Falling Idols: Public monuments, Islamic State and contesting the story of the past', *Frieze* <https://frieze.com/article/falling-idols> [accessed 18 January 2018].

HIERONYMUS BOSCH
First published as 'Ángeles y máquinas: el destino de los seguideors del carro de heno' in *Amigos del Museo del Prado*, *El Bosco y la tradición pictórica de lo fantastico* (Barcelona, 2006).

DAMIEN HIRST
First published as 'Once a Catholic...', *London Review of Books*, 34/13 (5 July 2012), pp. 16–17.

FELICITY POWELL
Adapted from the obituary I wrote in *The Guardian*, 12 May 2015 <https://www.theguardian.com/artanddesign/2015/may/12/felicity-powell> [accessed 2 November 2017].

FRANS MASEREEL
Introduction to Frans Masereel, *The City: 100 Woodcuts (*London, 1988) [unpaginated]. *The City* was originally published in 1925 under the title DIE STADT.

CRISTINA IGLESIAS
Originally published as 'The Springs Beneath, the flow above, the light within' in Beatriz Colomina, James Lingwood and Marina Warner, *Cristina Iglesias: Tres Aguas* (London, 2016), pp. 55–67.

JULIE MEHRETU
First published as 'Signature Measures: Julie Mehretu's Disfigurations' in Julie Mehretu, *A Universal History of Everything and Nothing* (Milan, 2017), pp. 32–38.
For the epigraph, see Yves Bonnefoy, 'Sao Domingos, After the Fire', tr. Hoyt Rogers, in *The Made and the Found: Essays in Honour of Michael Sheringham*, ed. Emily McLaughlin and Patrick McGuinness (Oxford, 2017), p. 1. Reproduced with kind permission of Hoyt Rogers.

PICTURE CREDITS

ACKNOWLEDGMENTS

This book owes much to many friends and colleagues, art historians and exhibition curators, who have inspired and informed me over the years. I want to give special thanks to the artists who talked to me, showed me their work and, in many cases, gave me the images to reproduce in this book. Roger Malbert, who commissioned some of my earliest writing on art and artists, helped me think through the sequence and selection; Beatrice Dillon made the whole thing possible through her unfailing encouragement in the endeavour: to them both, infinite thanks. Jacqueline Burckhardt and Bice Curiger, Mary-Kay Wilmers and Alice Spawls, Sina Najafi and Brian Dillon have often suggested ideas which have made me think and pushed me onwards; Evelyn Stern, Ulinka Rublack, Caroline van Eck, Elizabeth McGrath, David Scrase, Martin Kemp, Suzanne Cotter and Vivian Sky Rehberg have at different stages read things I've written and made invaluable suggestions. My profound thanks to them all. And also, much gratitude to Roger Thorp, who undertook to publish the book, and to his splendid team at Thames & Hudson – Amber Husain, Poppy David, Kate Edwards. Antonia Karaisl gave me patient, meticulous support on the notes and sources – many thanks to her. My dear Graeme Segal is endlessly forbearing and stimulating; Conrad Shawcross and Carolina Mazzolari, Riccardo, Sofia, and Hartley are in my heart and my mind always, foremost among reasons for trying to think and write about art and artists.

INDEX

Page references to illustrations are in *italics*.

INDEX